Runway

Runway
The Spectacle of Fashion

Alix Browne

Rizzoli
NEW YORK

New York · Paris · London · Milan

"You had to be a witness."

That was Sarah Mower, writing in *Harper's Bazaar* about John Galliano's much acclaimed Spring 1995 runway show at Studio Pin-Up in Paris. Back in the early '90s, I worked at the magazine as a fashion writer, and Mower, who was based in London, would send her copy to our office in New York via fax. As I transcribed that particular line, it struck me as pretentious. Mower, or so I thought, was gratuitously flaunting her status as one of the privileged few with access to the rarified world of fashion. "To understand what had taken place… to grasp the magic of the clothes, you had to be there," she continued. "Anyone who saw the crowd spilling out into the street or overheard the conversations in the restaurants and hotel bars had a right to think the audience must have been drugged or intoxicated. In a way, we were."

As a young writer just starting out in fashion, before I too was granted the privilege of attending "The Shows," as insiders refer to them, I was constantly frustrated by the lack of what I deemed to be pertinent information in the runway reviews, which were, bafflingly, all about the clothes. There was plenty of commentary on hemlines, pants versus skirts, and color palette, but very little about the shows themselves. In those days you couldn't just scroll through your Instagram feed for front-row views, or stream a video in real time on the Internet. A handful of media outlets, most of them newspapers, controlled the flow of information, so I would doggedly piece together as full a picture as I possibly could from the pages of *Women's Wear Daily*, *The New York Times*, and the *International Herald Tribune.* But if you wanted to know where a show took place, what the set looked like, what music was played, how fast or slow the models walked, or what it felt like to be in the room as Linda Evangelista, dressed in a cloud of yellow tulle, leaned back onto the grille of a gleaming vintage Oldsmobile, Mower was right, you had to be there.

Of course, not every fashion designer was John Galliano, and not every show commanded such a level of scrutiny. In New York and in London, the majority of the runway shows on the official calendar were staged in generic white tents; in Milan the main venue was the Fiera, a soulless tradeshow complex; and in Paris it was the Carrousel du Louvre, a group of auditoriums in an underground shopping mall. While consolidating the shows under one roof certainly made it easier for editors and buyers to navigate the tightly packed schedule and helped to raise the profile of the fashion industry in each city, many

designers chafed against these one-size-fits-all venues. Those who tried to distinguish themselves with fancy backdrops or elaborate choreography were occasionally criticized for emphasizing showmanship over fashion.

But fashion is nothing if not an act of showmanship. A designer doesn't simply generate a new collection with each successive season: He or she creates a context, a rationale, a desire. Alexander McQueen, for one, could scarcely begin to imagine a collection without first envisioning how it would play out on the runway. The fashion show is the ultimate realization of a designer's vision, a coherent act of creativity that separates those who have something compelling to say—about women, about men, about the world— from those who make nice things for people to wear. It is a moment of truth.

It is not just about the magnitude of the spectacle. The '90s were a time when many designers—McQueen yes, but also Hussein Chalayan, Martin Margiela, Viktor Horsting and Rolf Snoeren, Raf Simons—were doing moving, astonishing, and provocative things on the runway with relatively nothing. Chalayan's presentations could be particularly challenging and intense, with minimal staging and complex choreography often accompanied by live music. "I always wanted our shows to be a cultural experience," the designer explained during a panel discussion for his 2010 solo exhibition at London's Lisson Gallery. Chalayan was prone to think of himself as an artist whose medium happened to be fashion. Whatever issues were occupying his mind—the plight of refugees, or the uses of technology—were deeply embedded in the clothes themselves. Fashion for him was not isolated from the world, but connected to it.

Raf Simons, in the handful of years he served as the creative director of Christian Dior's women's collection, learned something about the nature of spectacle: While at the helm of the French luxury house he had seemingly limitless resources at his disposal, enabling him to, say, have thousands of freshly cut flowers installed in the hours right before his show. Simons allows that it is possible to impress people with such money-is-no-object productions, but he questions whether it is possible to touch them emotionally. To this day, he says, the show that made the biggest impression upon him was the one Martin Margiela held in 1989 on a playground in a blighted, largely North African neighborhood on the outskirts of Paris. Local residents were all invited, and young children, too excited to stay in their seats, intermingled with the models as they walked the makeshift runway. Simons recalls being so swept up in the experience that he began to cry, and was embarrassed until he noticed that almost everyone around him had tears streaming down their faces, too. At that moment, he says, "I understood that there was a different way one could be a fashion designer."

Simons's shows for his eponymous menswear label have always combined modest means with grand ambitions. From the beginning, he had a sense of them as performances, ephemeral events that brought together the conceptual, the emotional, and the practical,

6

and that needed to be experienced live. Perhaps for this reason, he doesn't have much in the way of photo documentation of those early shows (though he always made certain to capture them on video). Indeed, this book was first and foremost an exercise in photo research. Today, virtually every fashion show can be viewed, in real time or within minutes, from every possible angle: front row, backstage, close-up, aerial. But in the hunt for the straight-on, front of house photo—that indelible image that provided basic information about the staging of the show, but also, more significantly, something of the designer's intent—I sometimes felt I was sending my photo research editor, Sarah Kalavagno, on a wild goose chase—or in the case of a certain Miguel Adrover show from 2001, a wild sheep chase. Much to my disappointment, the image I was determined to find, of Adrover coaxing a reluctant farm animal down the runway, did not seem to exist. Or if it did, not even Adrover could get it for us. In fact, there were several shows that we might have otherwise included in this book had we only been able to find the right image. But for many years, there was no real media outlet for photos of the actual shows, and therefore no real demand for them. Olivier Theyskens recalls that friends of his in Belgium would somehow manage to get their hands on in-house VHS recordings and hold clandestine viewing parties, where they would all sit and watch show after show. "It was the only way to see a whole collection beyond the one or two images that might get published in the newspaper," he says.

Up until quite recently, the only runway images that mattered were unobstructed head-to-toe shots of the models in the clothes. (Another one of my responsibilities at *Harper's Bazaar* was to sift through hundreds of unedited slides from each show, and pull Polaroids of the clearest shot of each look.) You could practically hear the photographers, crammed cheek by jowl in their scrum at the foot of the runway, moaning over poor lighting conditions or ungainly choreography, cat calling at the models if they didn't stand completely still for the requisite 3 or 4 seconds. So focused on their targets were they that few of them bothered to look around at the scenery, let alone capture it on film. It is perhaps worth noting that there is beautiful documentation of that Margiela show on the playground thanks to Jean-Claude Coutausse, who is not a professional runway photographer, but a war photographer.

The digital age has changed everything. Now that runway shows play to global audiences, they have not only become more photogenic, but easier to photograph. "Now the directive is that everyone—every photographer, every guest—has to be able to shoot and post as much as they can," says Alexandre de Betak, whose firm Bureau Betak has produced thousands of fashion shows over the years. There is no shortage of imagery—official or otherwise. One could devote an entire book to the shows that Villa Eugénie's Etienne Russo has produced for Chanel or Thom Browne alone.

In February 2016, during New York Fashion Week, Kanye West presented his third collection for Yeezy, the clothing and sneaker line he designs for Adidas, at Madison Square Garden. Yeezy Season 3 was not just a fashion show, but also an art installation (his third

collaboration with the artist Vanessa Beecroft, who referenced an image of Rwandan genocide by the photojournalist Paul Lowe) an album release (the debut of West's *Life of Pablo*) and a full-blown media event. The sports arena accommodated some 18,000 guests, many of whom were paying ticketholders from the public. As at any concert, tickets were being scalped outside the venue. The show was also screened in movie theaters in 25 countries around the world. Before the Kardashian clan even took their seats—their dramatic, spot-lit entrance was also part of the performance—*The New York Times* fashion critic Vanessa Friedman had declared on her blog that the smartphone was killing off the fashion show.

And while the news of that death may be somewhat exaggerated, social media has had a profound effect not just on the way fashion is accessed and consumed, but on the way it is being delivered. And not for the better, many would argue. When Dries Van Noten held his first show in Paris in 1993, he imported some mattresses from India and invited guests to lay down on the floor. "No seating—just make yourself comfortable," he recalls. Twenty years later, he cannot afford to be so laissez-faire: "The very first silhouette has to be attractive on a cell phone," van Noten says. "This is now something you have to keep in mind. It's sad, but it's the new reality."

"I think that today the sets of runways are over-curated, turning into a performance of their own," says Helmut Lang, whose highly charged, lo-tech productions were always a highlight of the Paris calendar in the early '90s. "I'm not sure that this is a good idea, as the main subject should always be fashion." Karl Lagerfeld, on the other hand, has embraced the runway show as a new form of instantaneous worldwide advertising and brand visibility. "That is something that never existed before," says the designer, whose sets at Chanel are some of the most extravagant in the industry. "Fashion shows are kind of rock concerts now. To show just dresses on the runway is interesting for buyers and clients but not for the new way of communication. The other designers are not my problem. They think I do too much, but Chanel is a megabrand selling not only dresses and handbags."

Lagerfeld insists that he is not "mad for clothes loaded with theatrics and drama" and that in the end, "there is no upstaging." Nevertheless, one suspects that his collections will ultimately be remembered for their backdrops: the iceberg show, the supermarket show. "Nowadays, shows seem to be more social happenings, where the presentation of a collection is part of a bigger performance," observe Viktor Horsting and Rolf Snoeren. "Exclusivity, once the hallmark of the ready-to-wear and the couture, has been exchanged for extreme accessibility. There is a tension there, because fashion is mainly consumed in images, instead of products. It's the images that are accessible, not the products, which remain for the happy few. For many people, fashion has become virtual."

This may be increasingly true even for those actually in attendance. In the early photos of fashion shows you see pencils and note pads in people's hands, but mostly they are watching, riveted, as if

concentrating on committing the moment to memory. Fast forward to Marc Jacobs's Spring 2016 show, at the Ziegfeld Theater in New York. Even as the models were projected larger than life on the theater's massive movie screen, most of the audience could be seen taking in the spectacle through the 2-inch screens of their phones.

And there is another, unforeseen consequence: When Van Noten presented his masterly Fall 2016 men's show at Paris's Opera Garnier —a spectacular venue he had been trying to secure for 15 years—it represented the fulfillment of a lifelong dream. But as the models took the stage for the finale, he was dismayed by the apparent lack of audience response. "Did they not like it?" he asked a colleague. Where was the applause? There was none. Everyone was filming. "With only one hand," Van Noten says wistfully, "you cannot clap."

So yes, all these years later, I understand exactly what Sarah Mower meant. In fact, it was on her heels—as she waved her invitation above her head, shouting *"Harper's Bazaar* U.S." at the top of her lungs—that I made my way through the agitated mob trying to fight its way into Alexander McQueen's Fall 1995 "Highland Rape" show and into the tent, on the grounds of London's Natural History Museum. As we sat front row, at the edge of the runway, the models staggered straight for us, the bodices of their tartan and lace dresses ravaged, their eyes wild, as if propelled by some ferocious, inner demons.

It's an experience from which I don't think I ever fully recovered.

—Alix Browne

9

A.F. Vandevorst
Adam Kimmel
Alexander McQueen
Ann Demeulemeester
Bernadette Corporation
Bernhard Willhelm
Bruce
Carol Christian Poell
Chanel
Christian Dior
Chloë Sevigny
COMME des GARÇONS
Dolce & Gabbana
Dries Van Noten
Givenchy
Gucci
Gypsy Sport
Helmut Lang
Hood by Air
Hussein Chalayan
Imitation of Christ
Iris Van Herpen
Issey Miyake
Isaac Mizrahi

Jean Colonna
Jeremy Scott
John Bartlett
John Galliano
Louis Vuitton
Maison Martin Margiela
Marc Jacobs
Molly Goddard
Olivier Theyskens
Opening Ceremony
Prada
Raf Simons
Rick Owens
Rodarte
Susan Cianciolo
Thom Browne
ThreeASFOUR
Viktor & Rolf
VPL
W<
X-Girl
Yeezy
Yohji Yamamoto

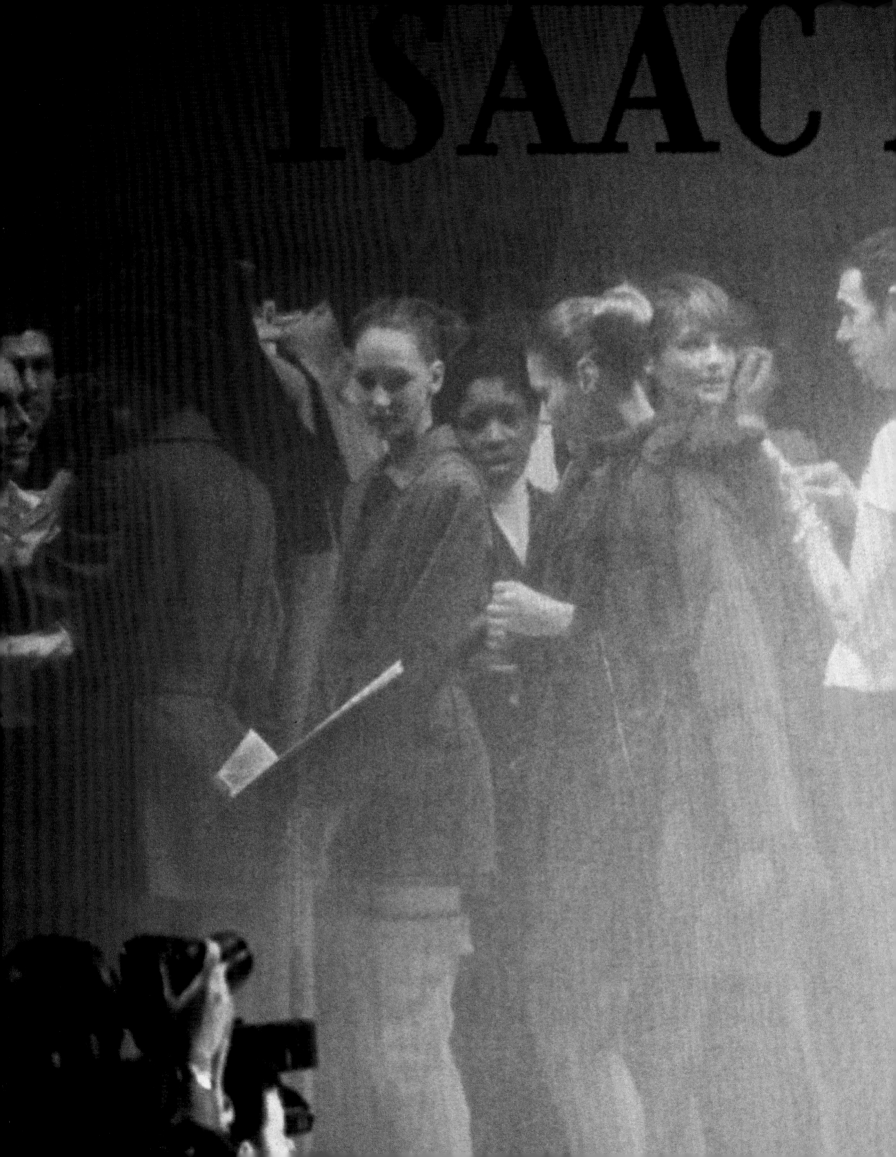

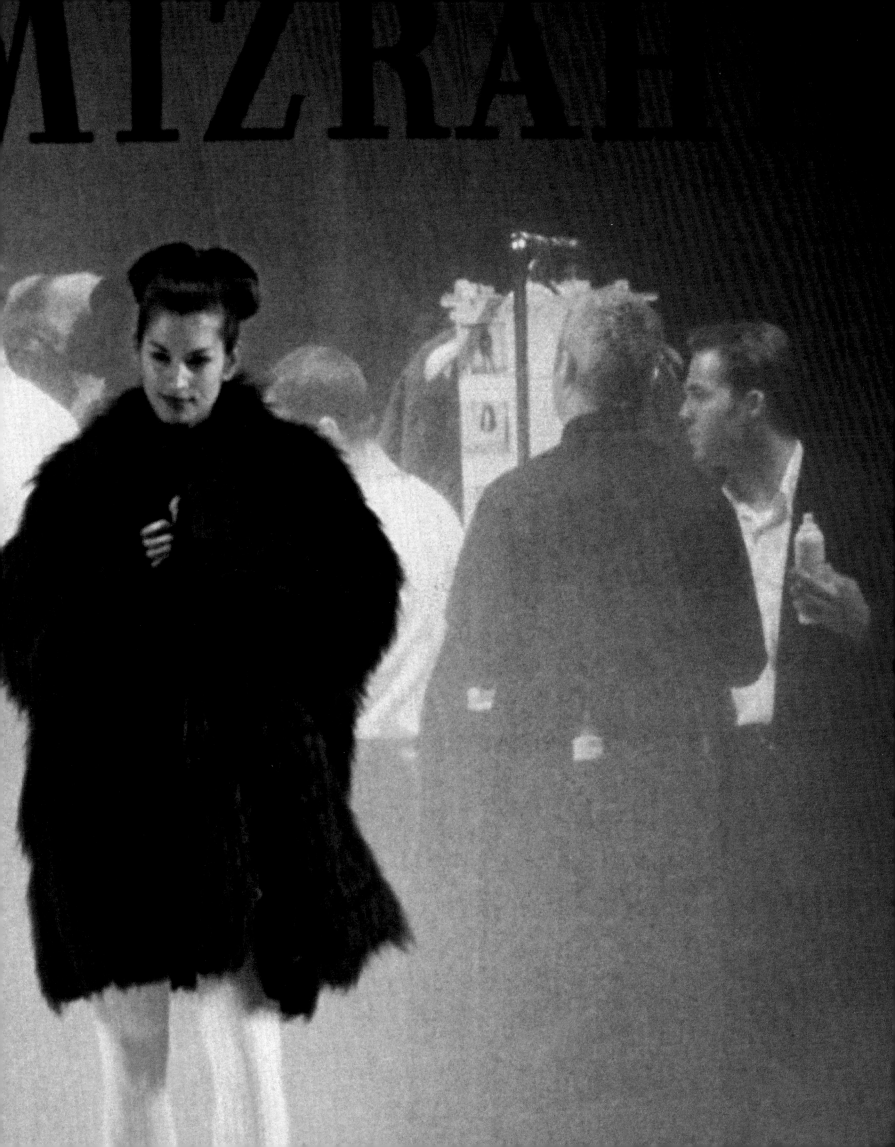

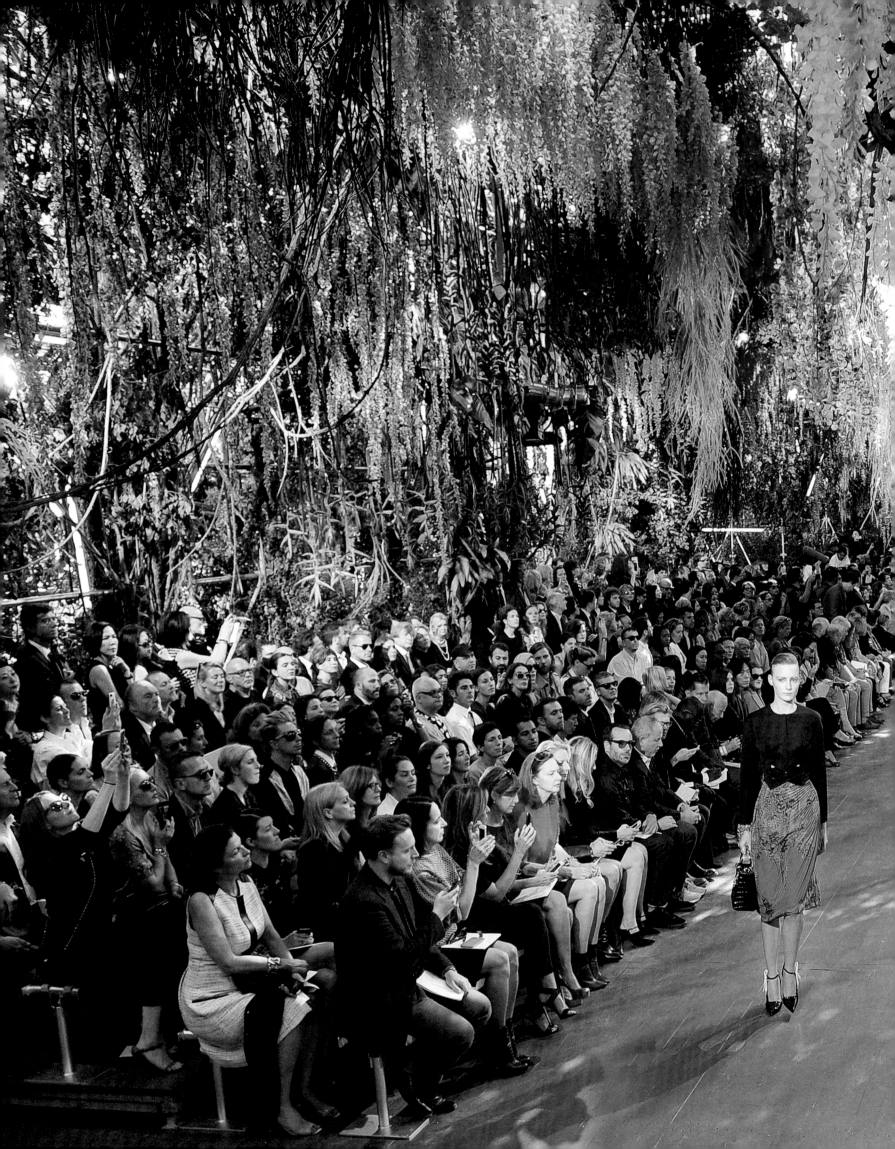

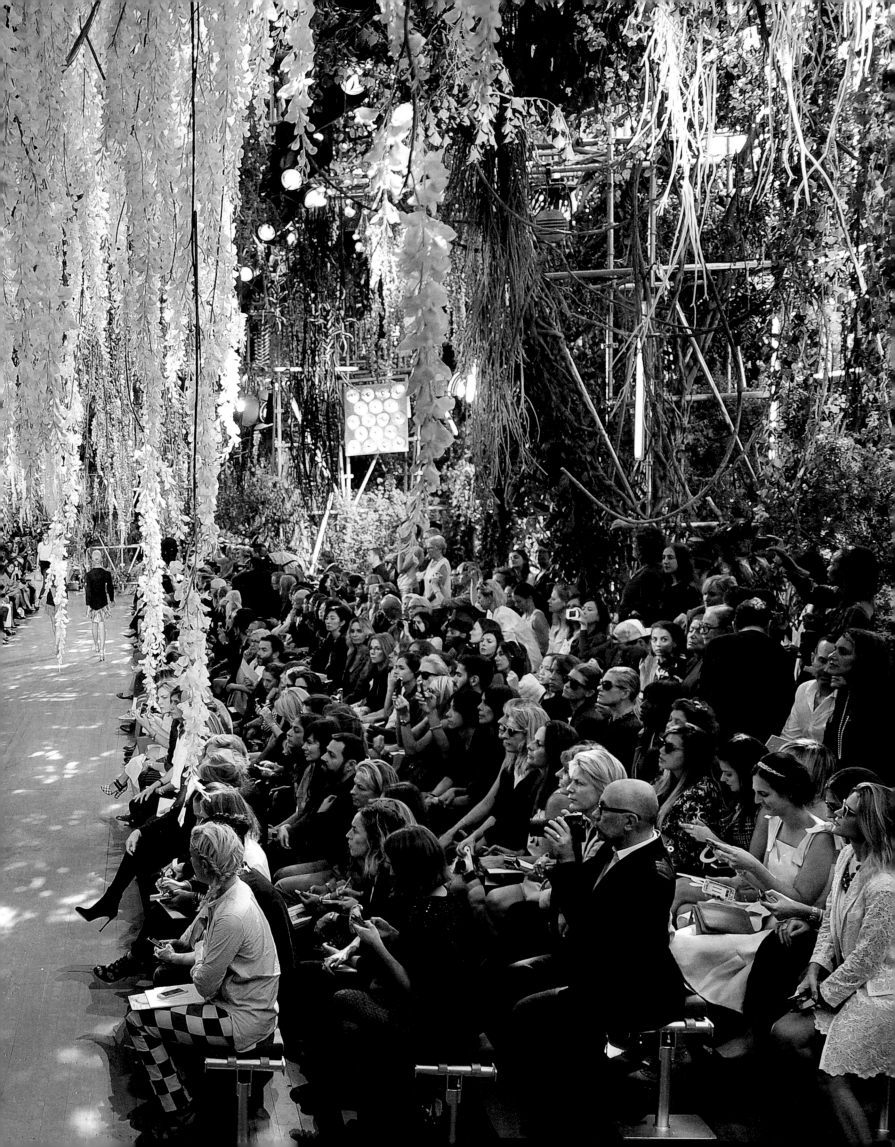

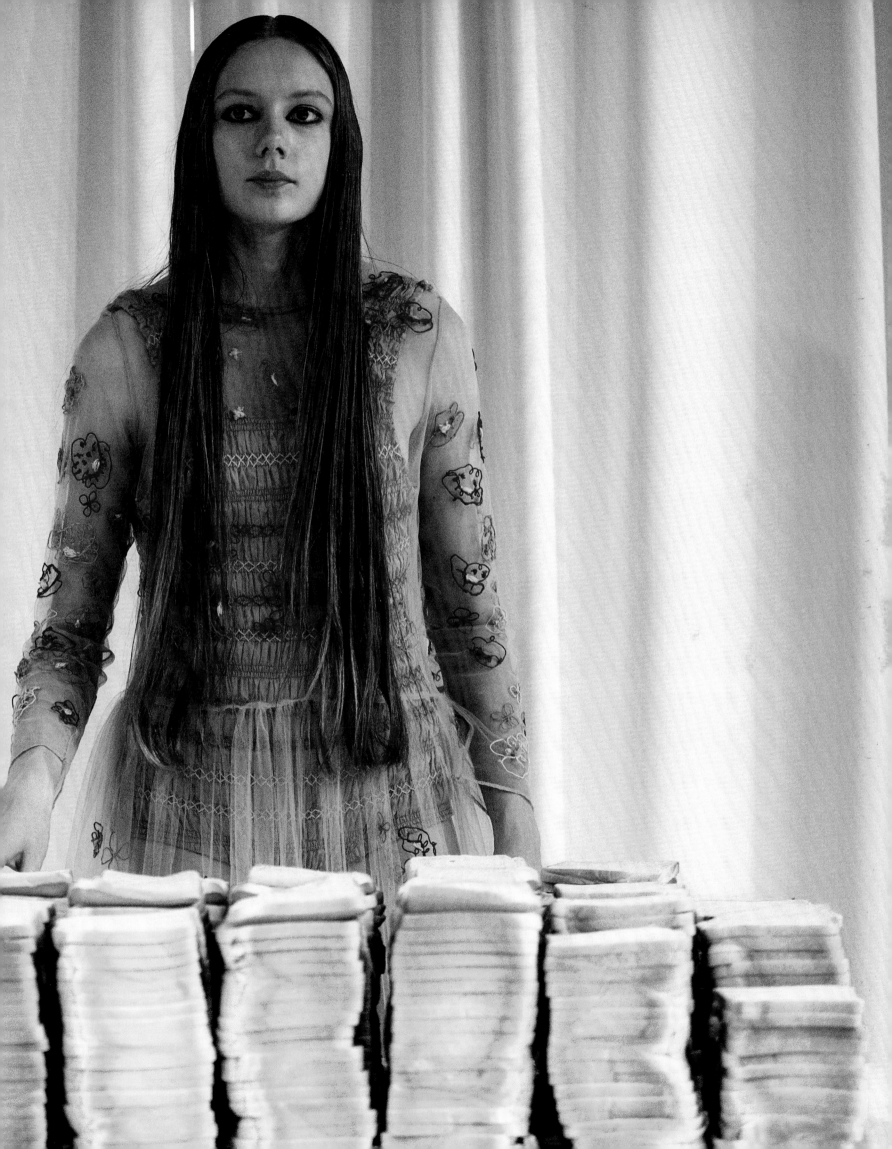

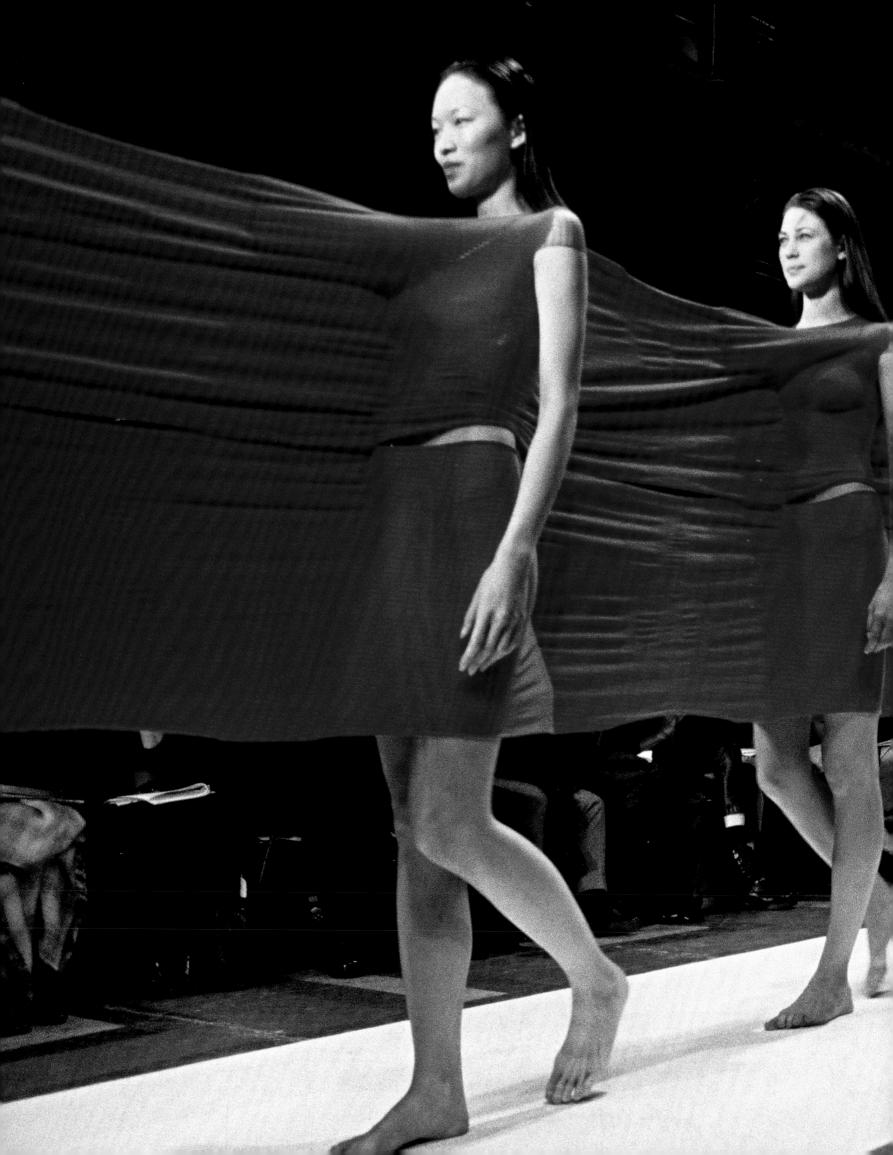

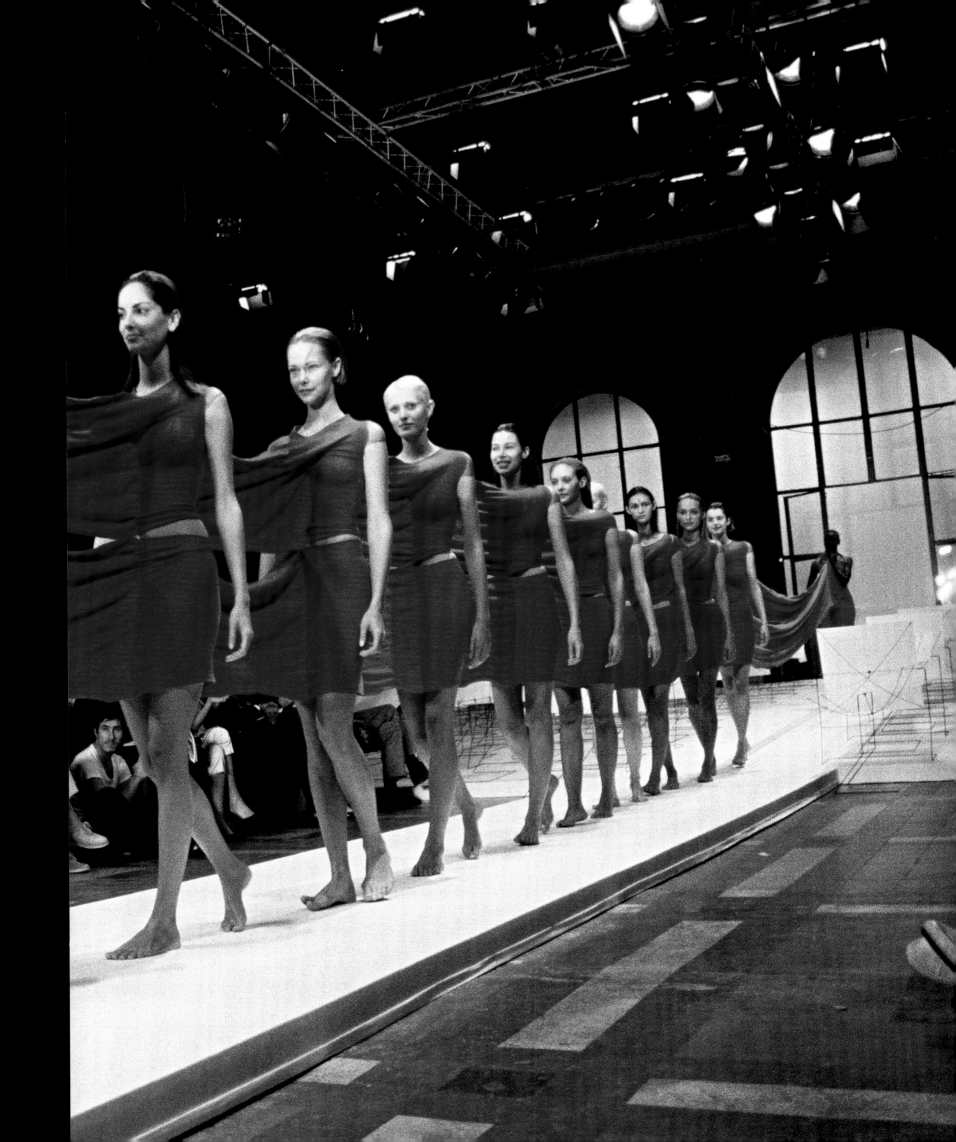

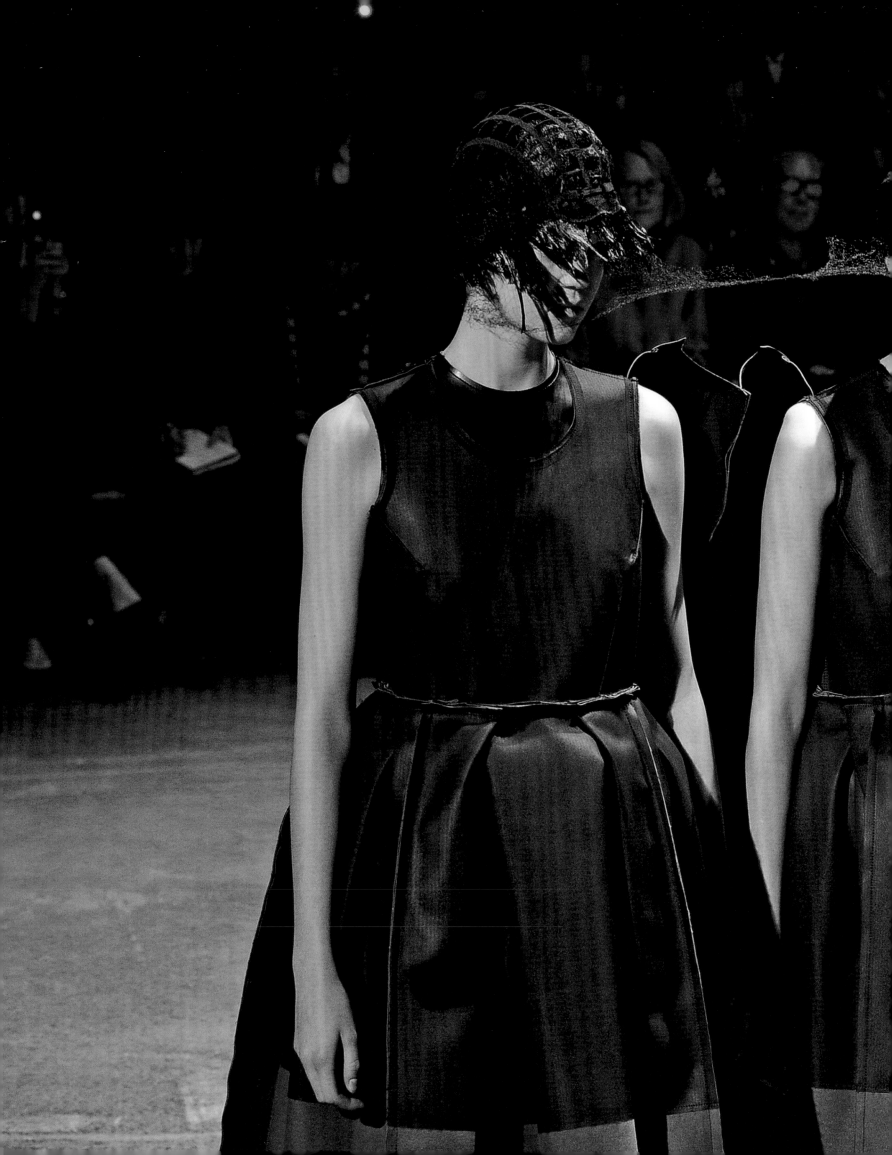

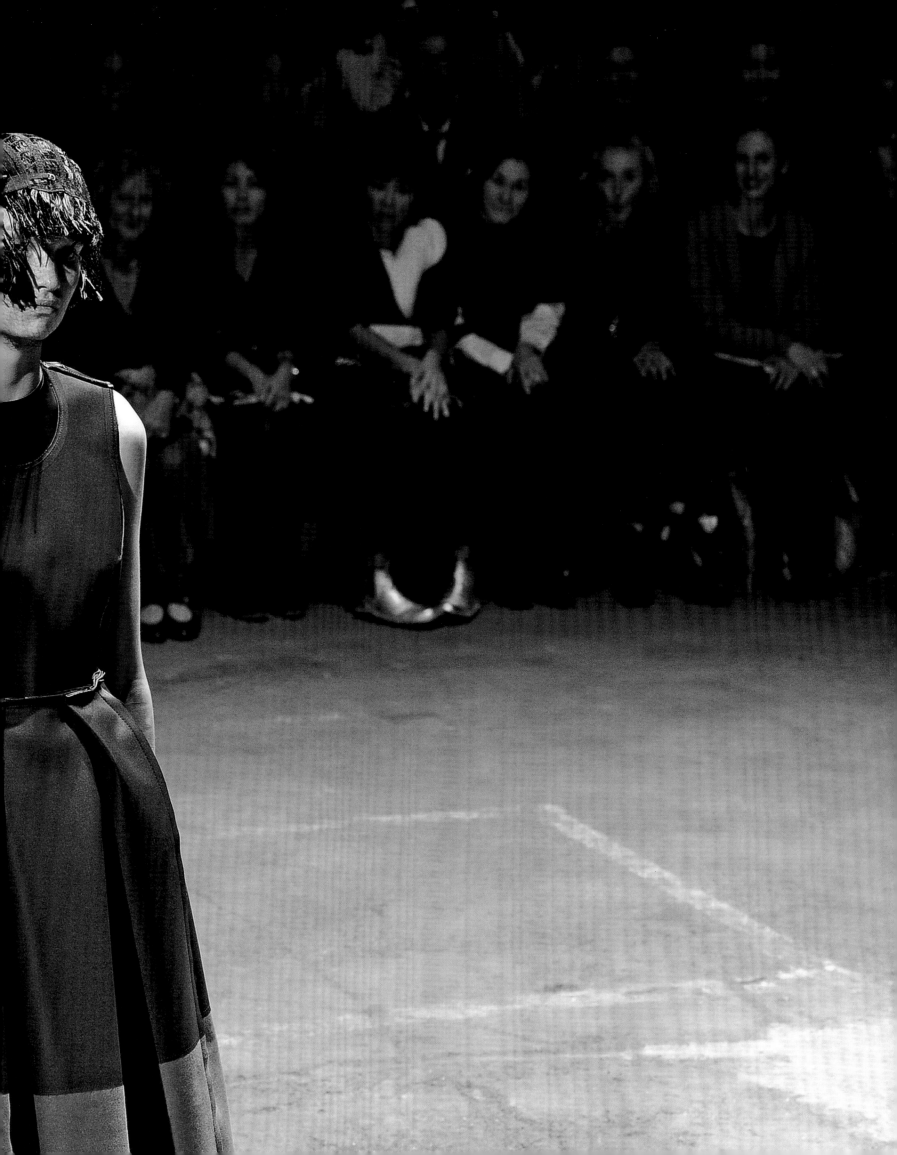

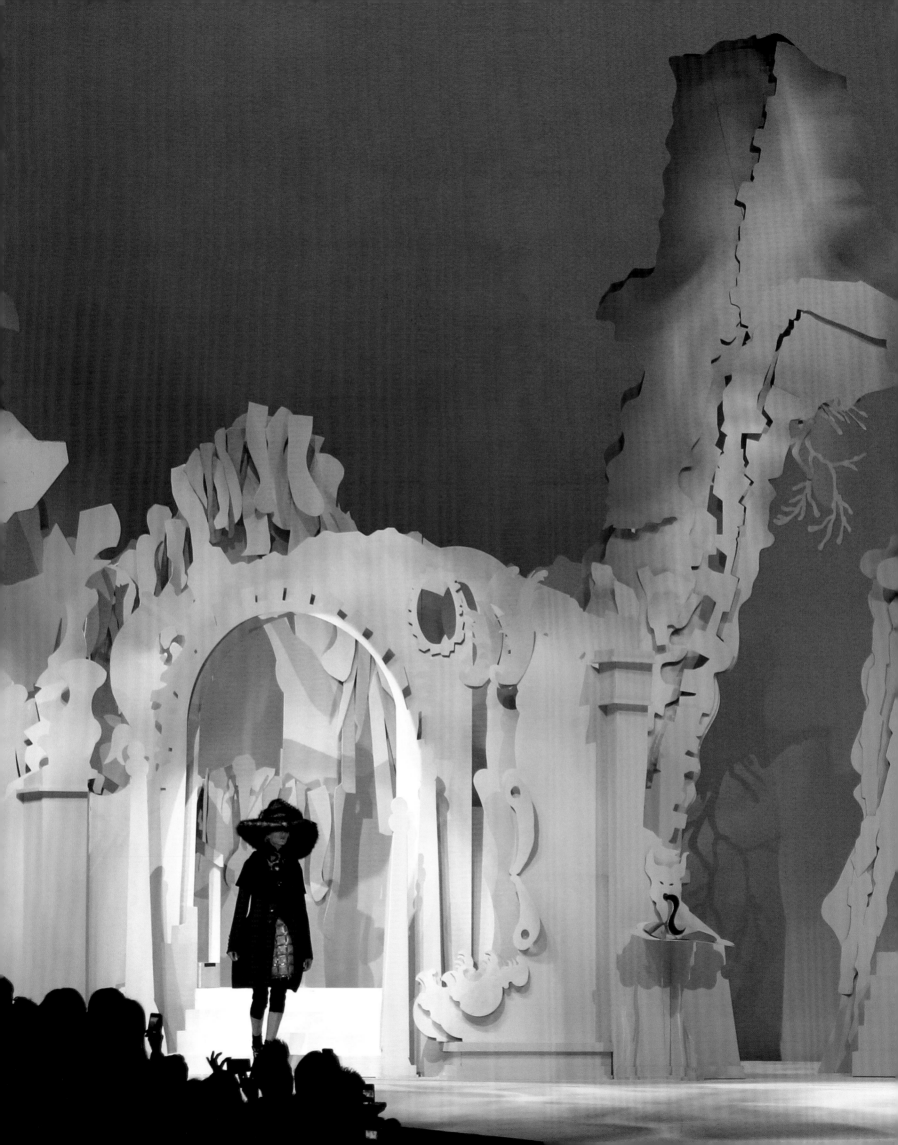

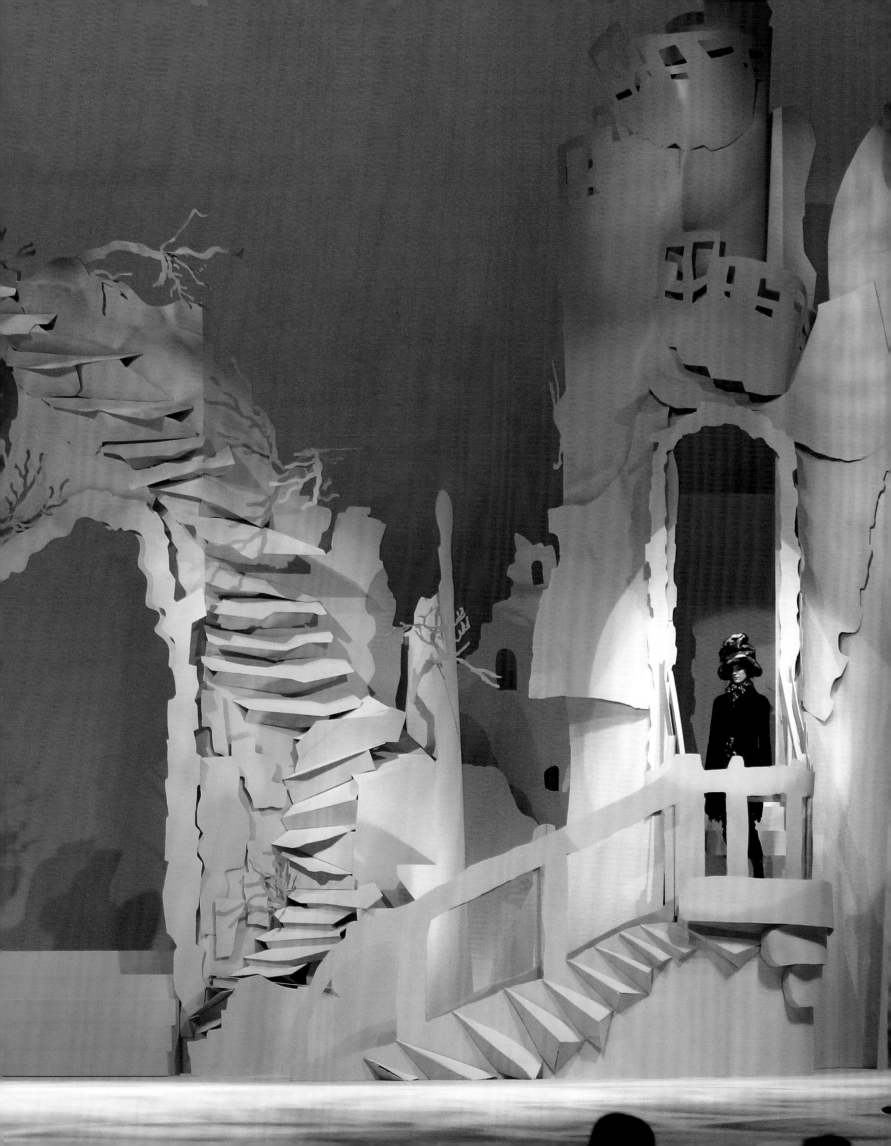

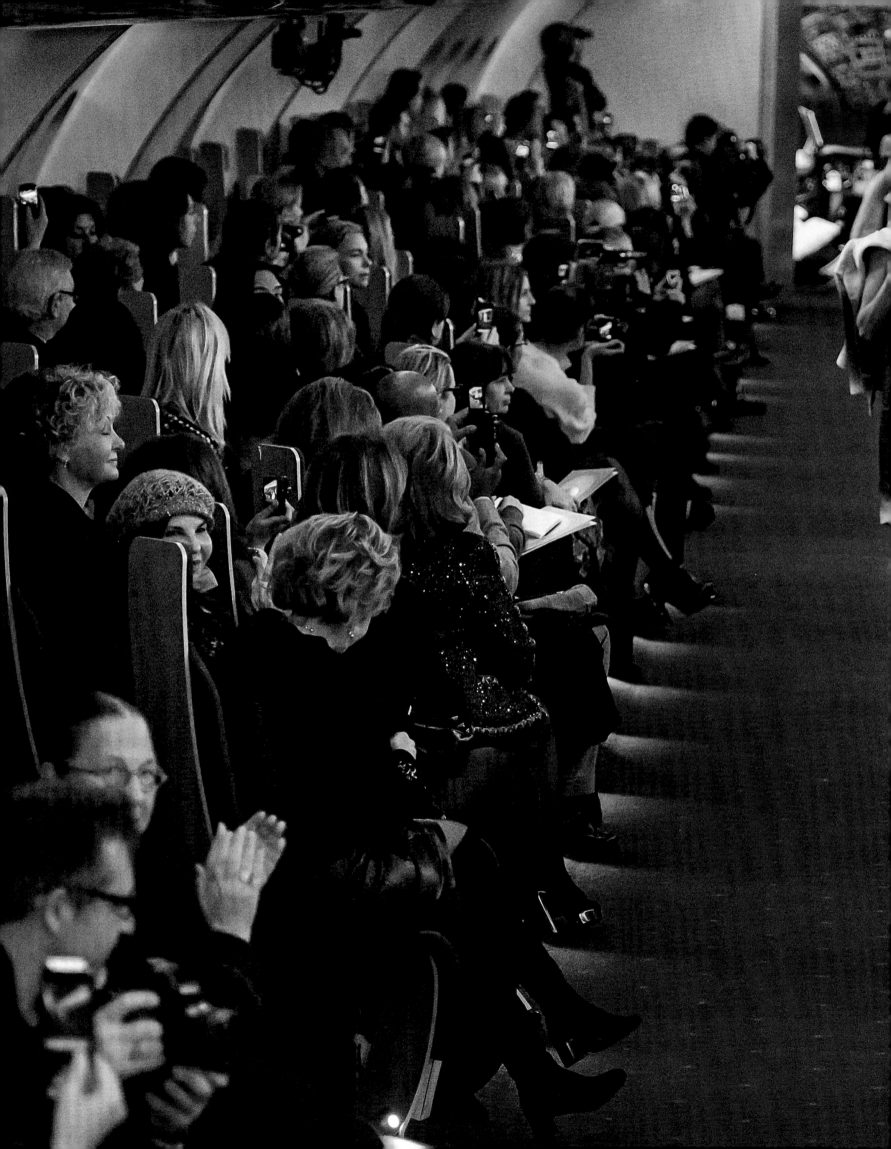

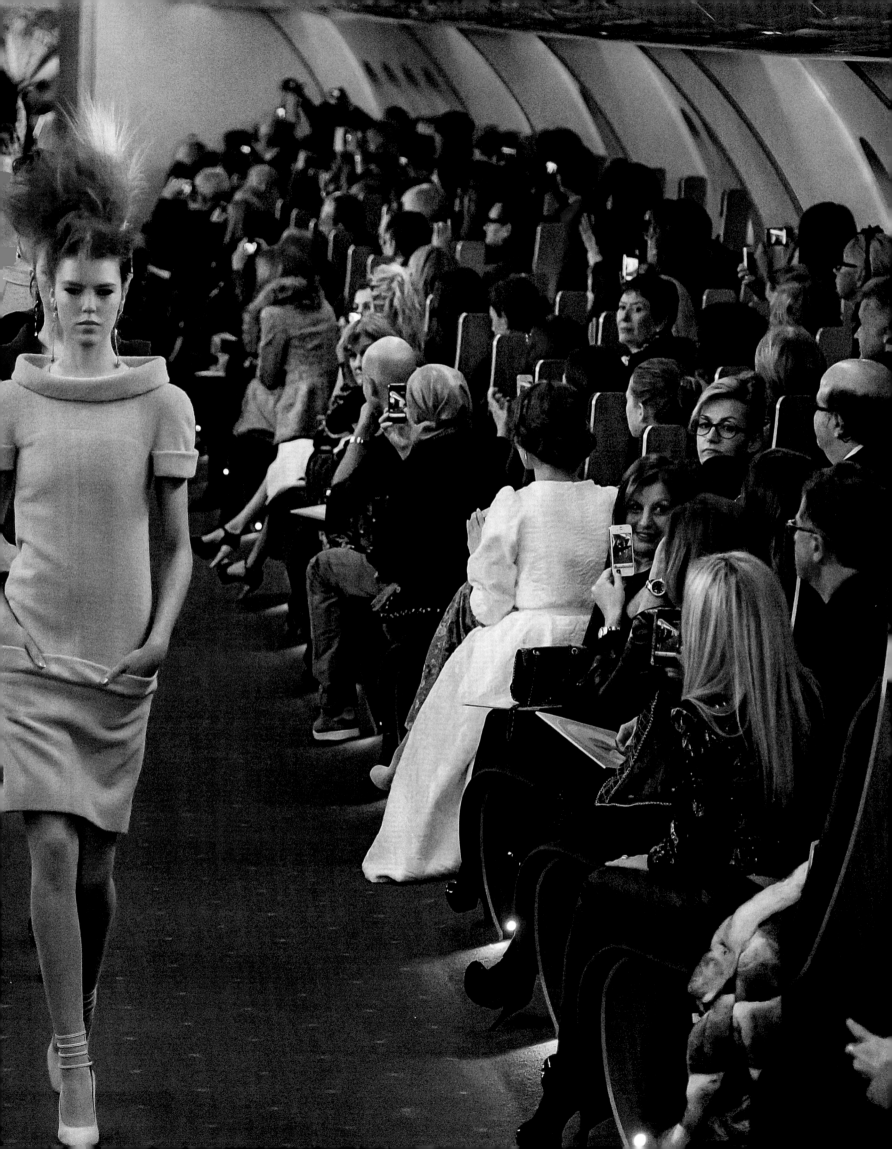

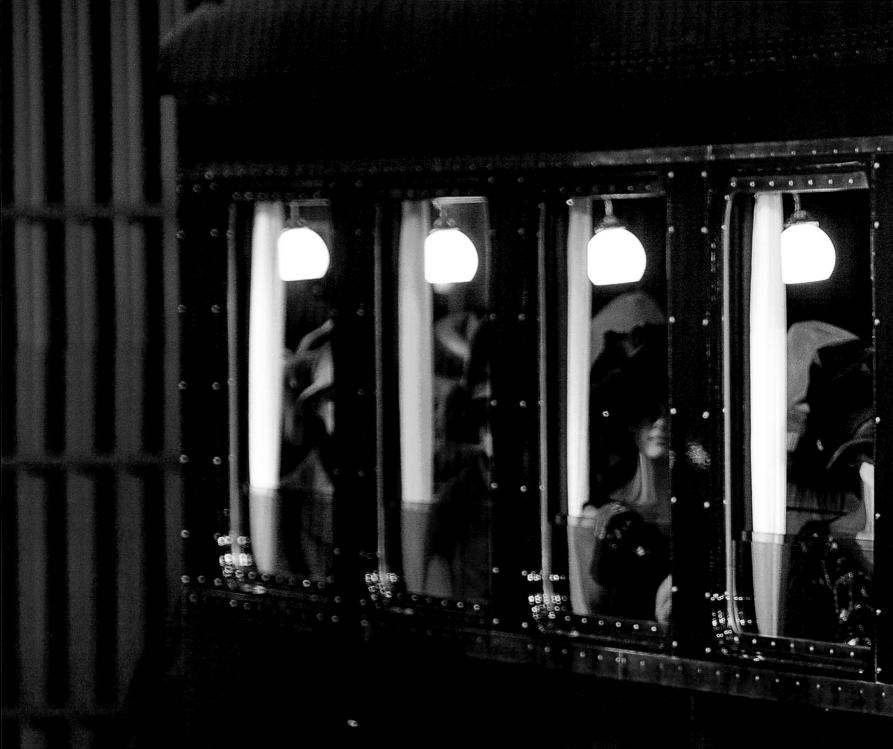

LOUIS VUITTON

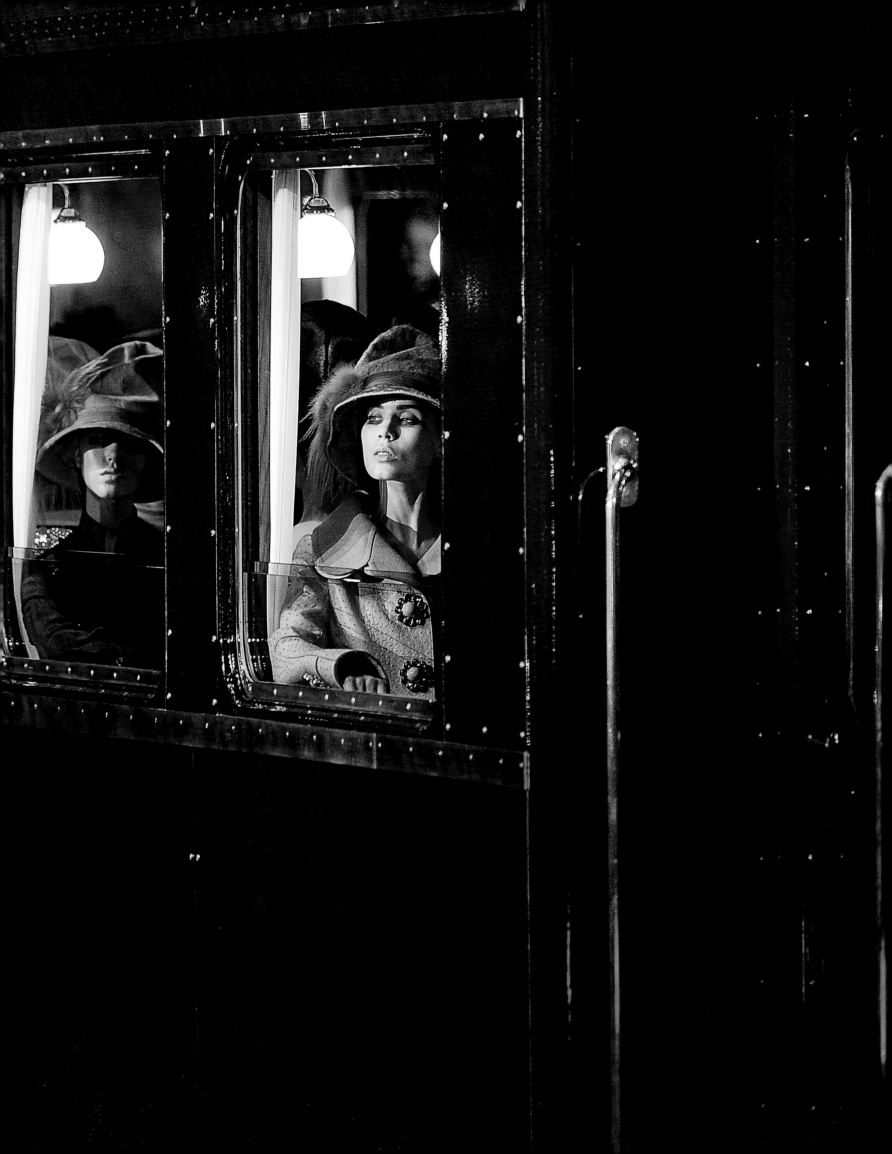

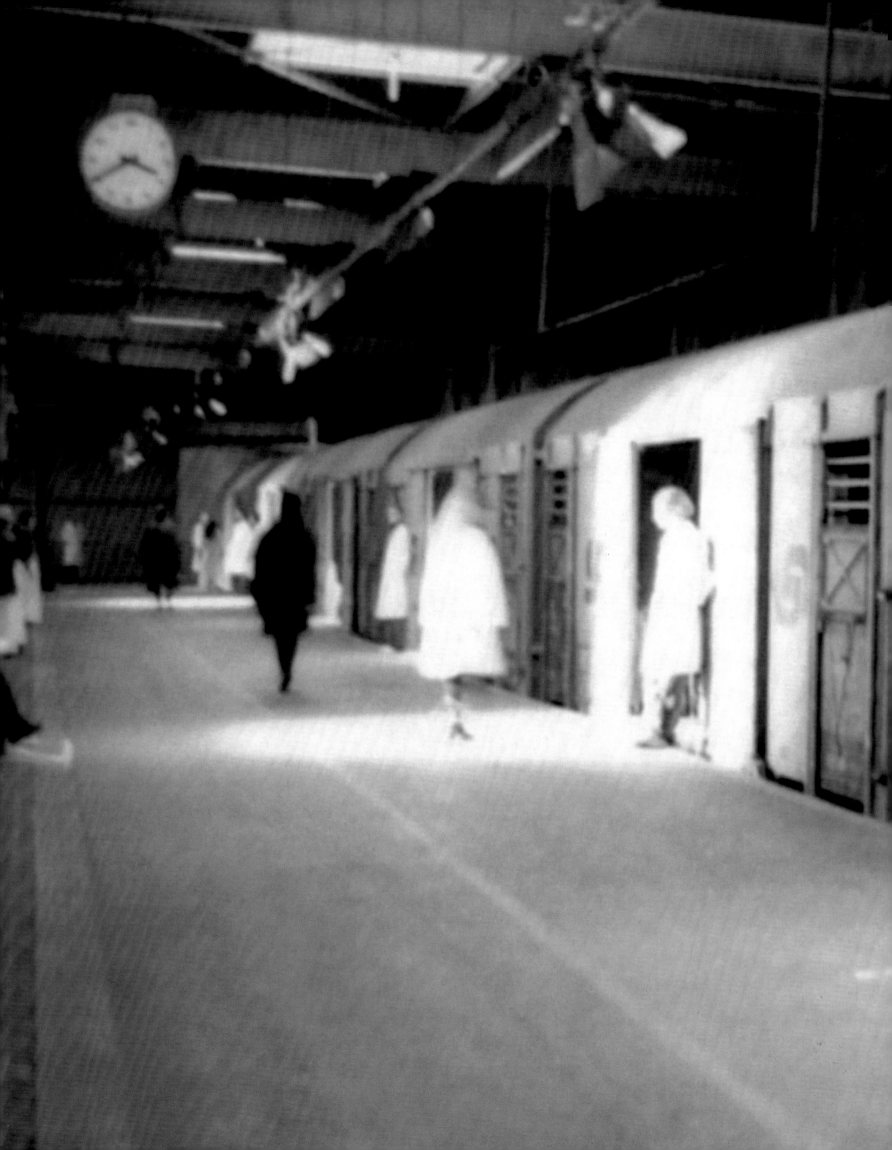

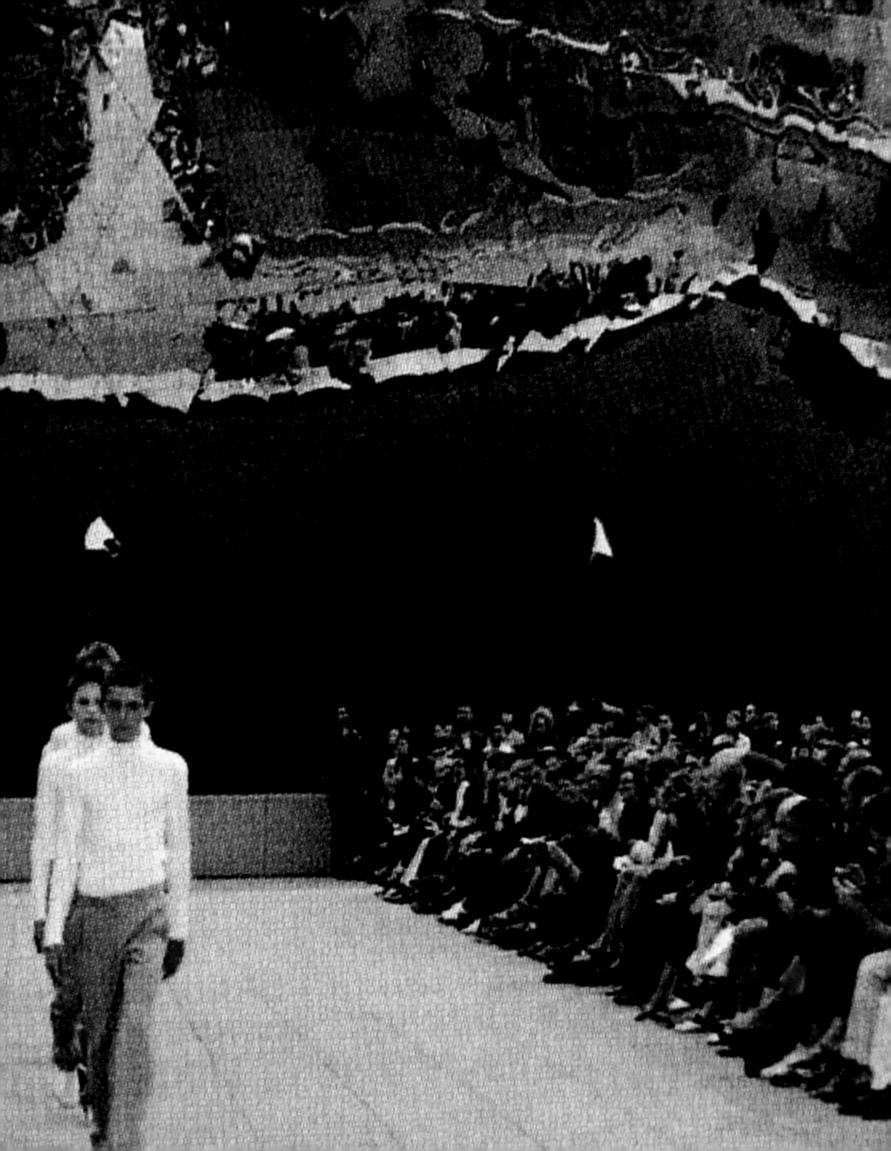

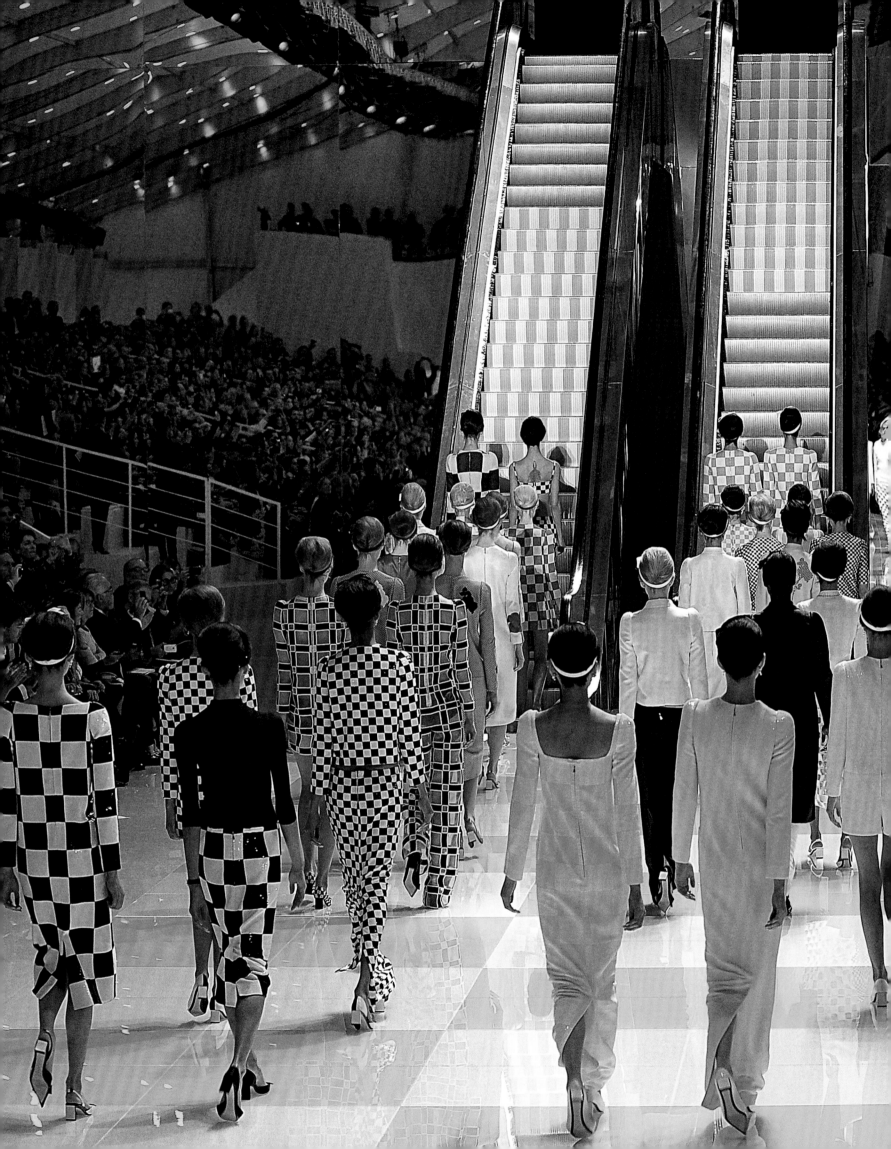

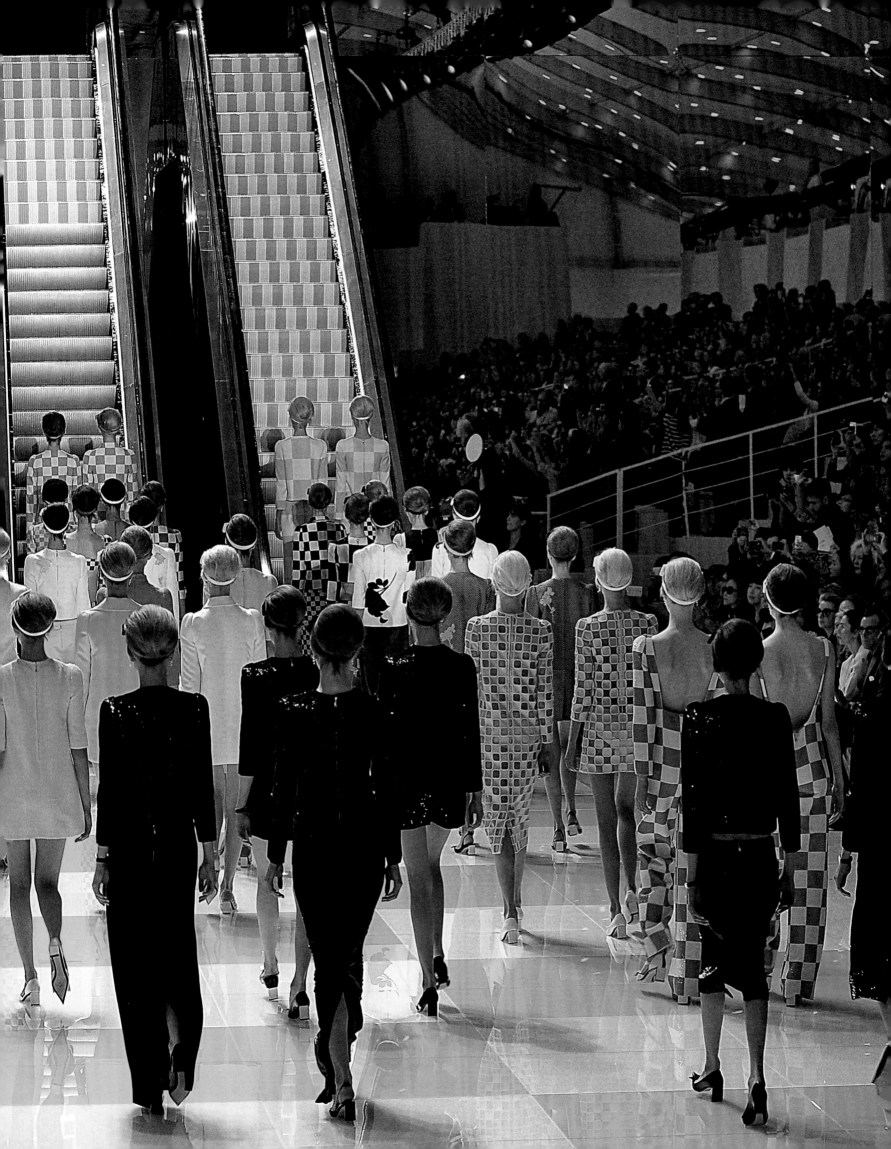

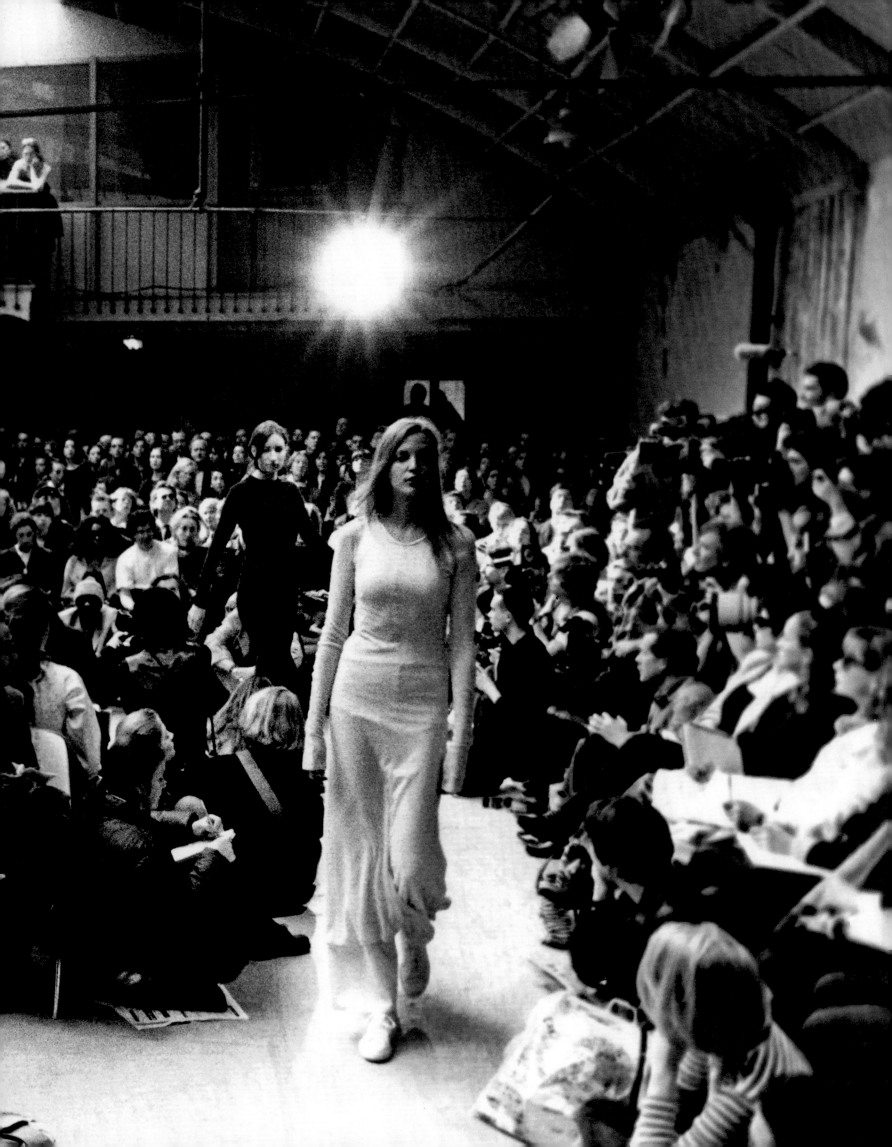

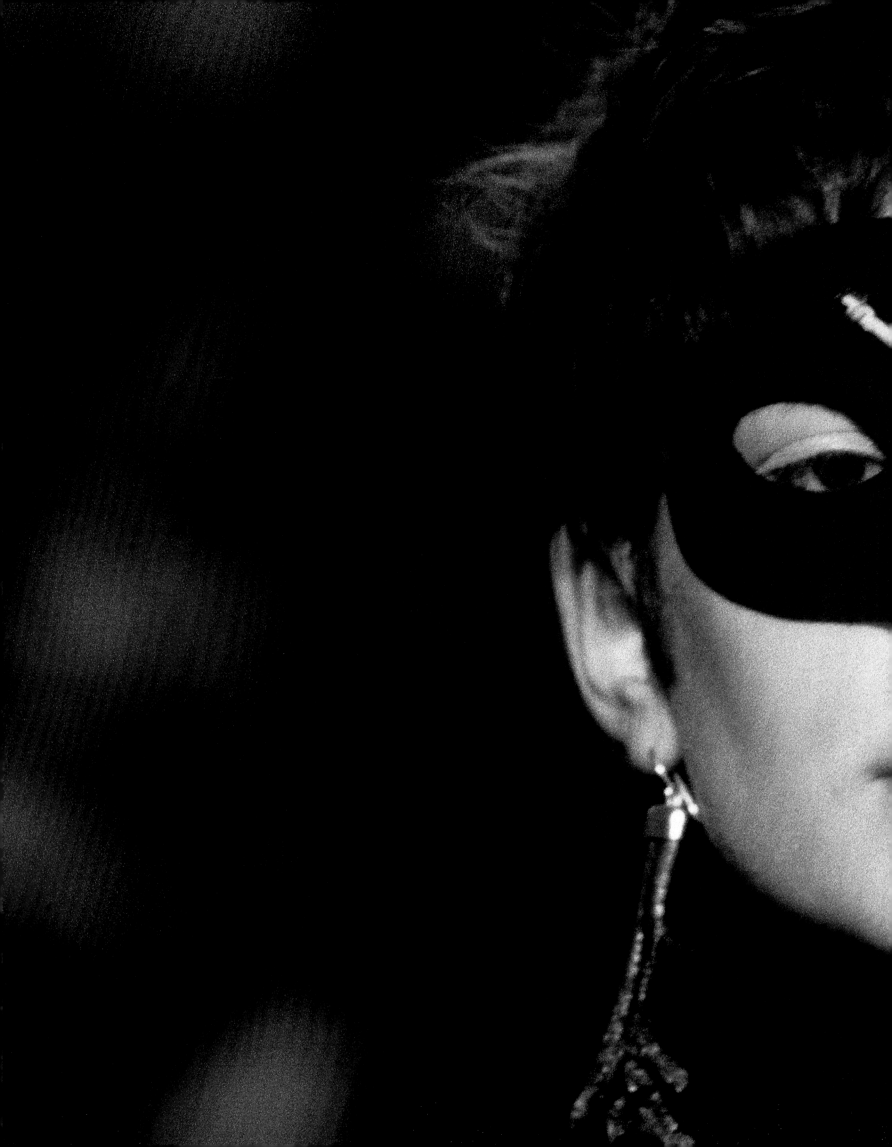

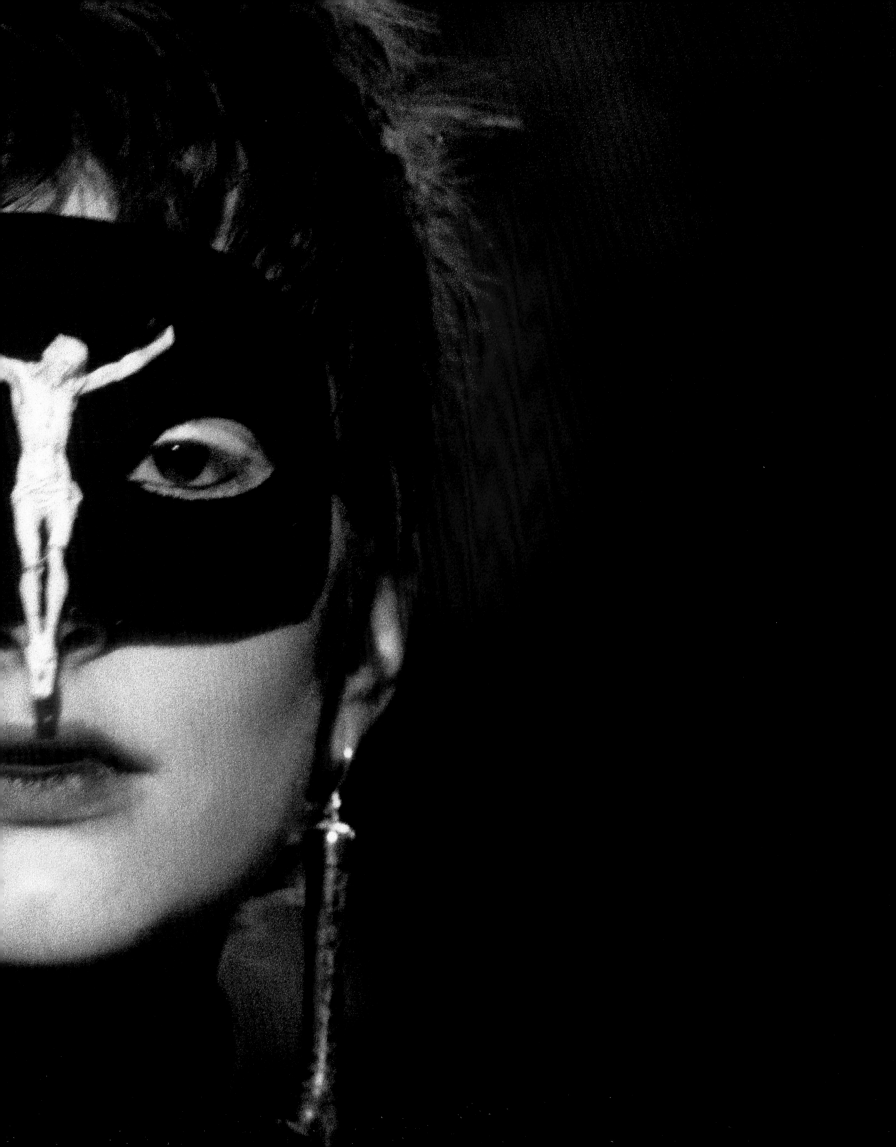

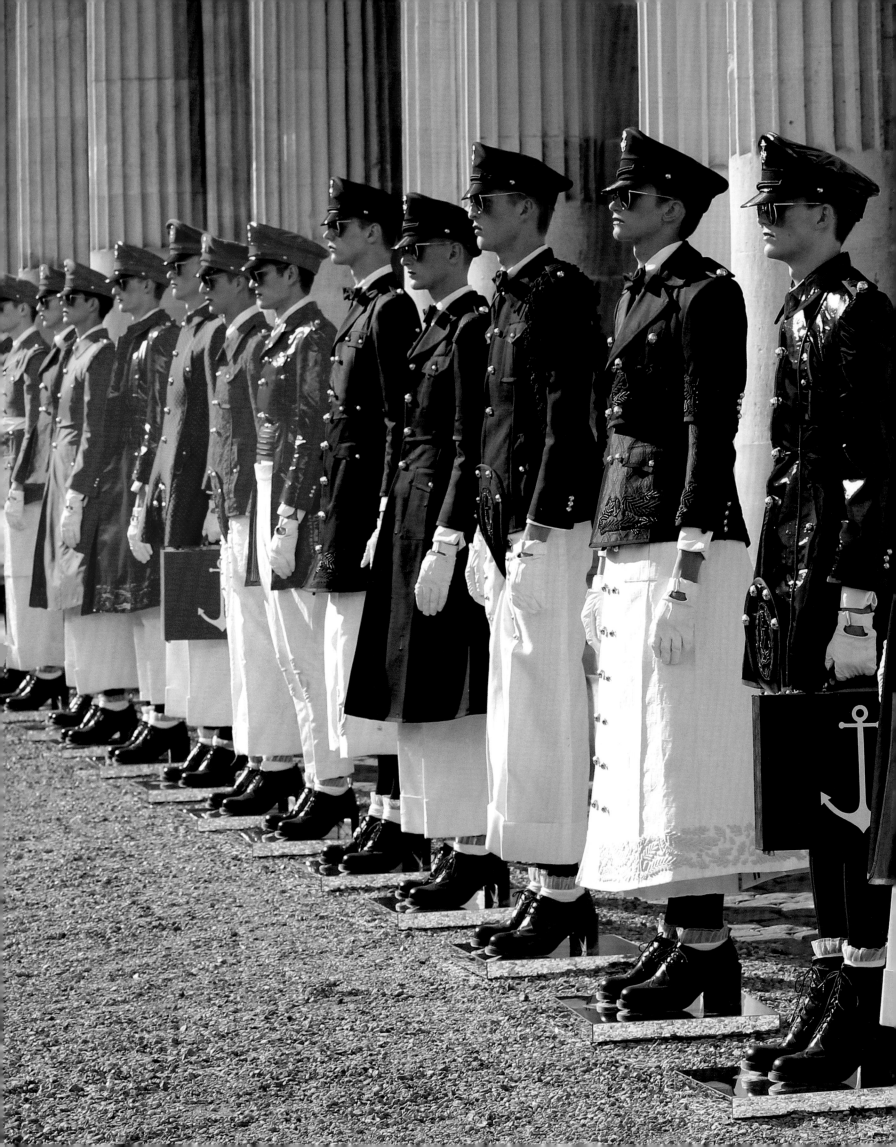

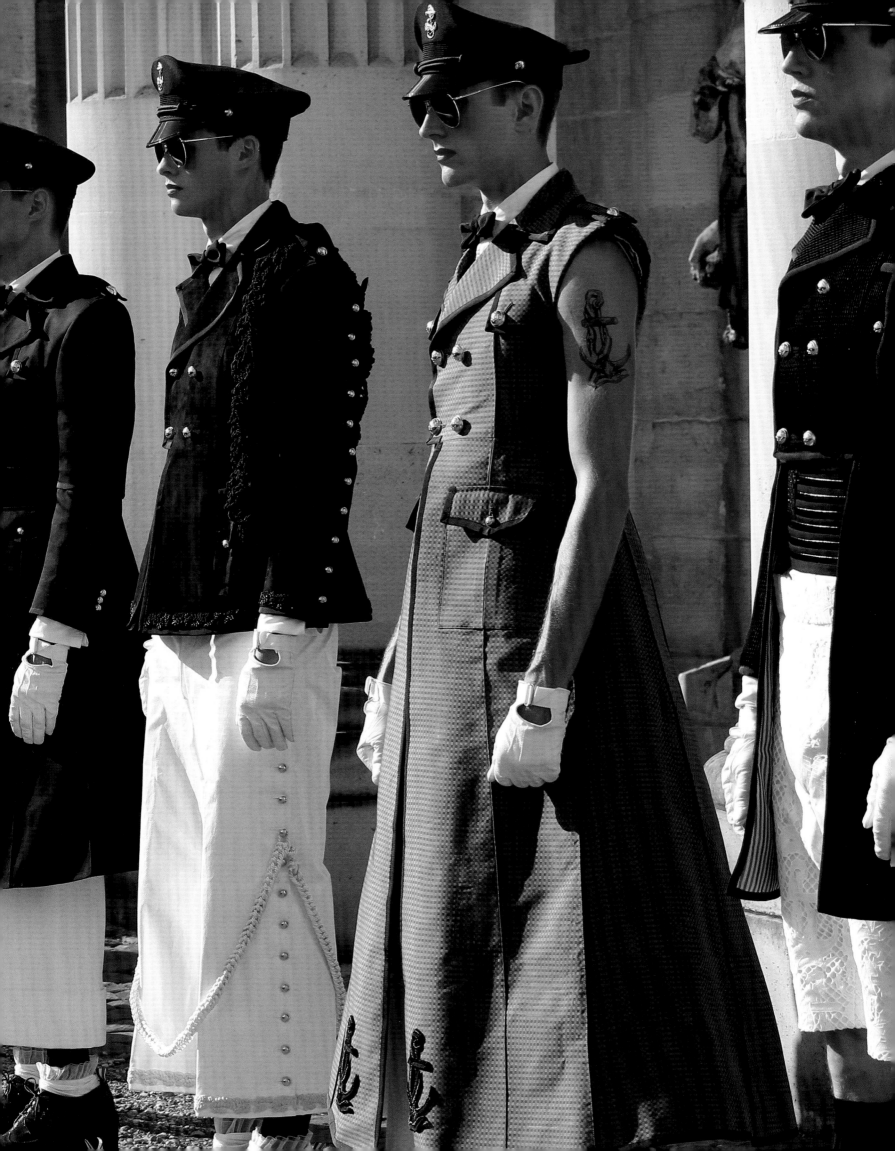

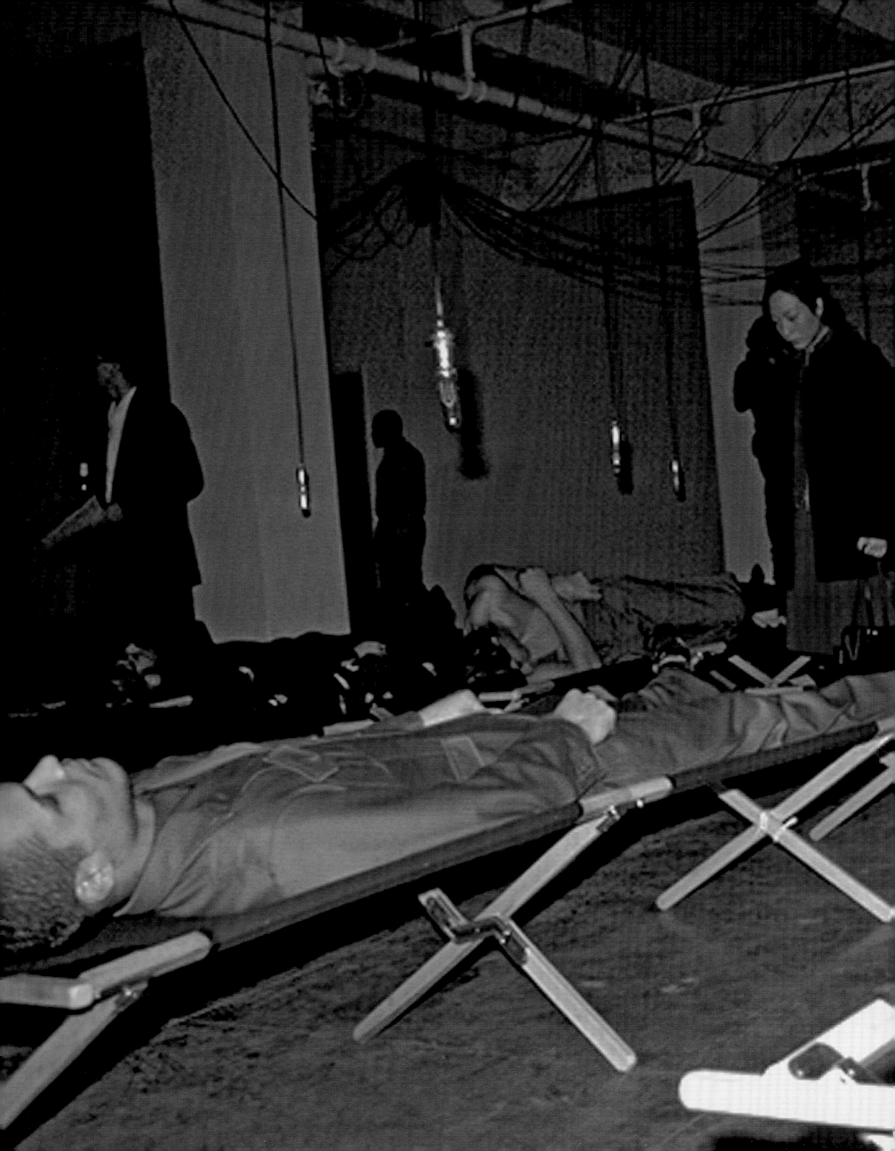

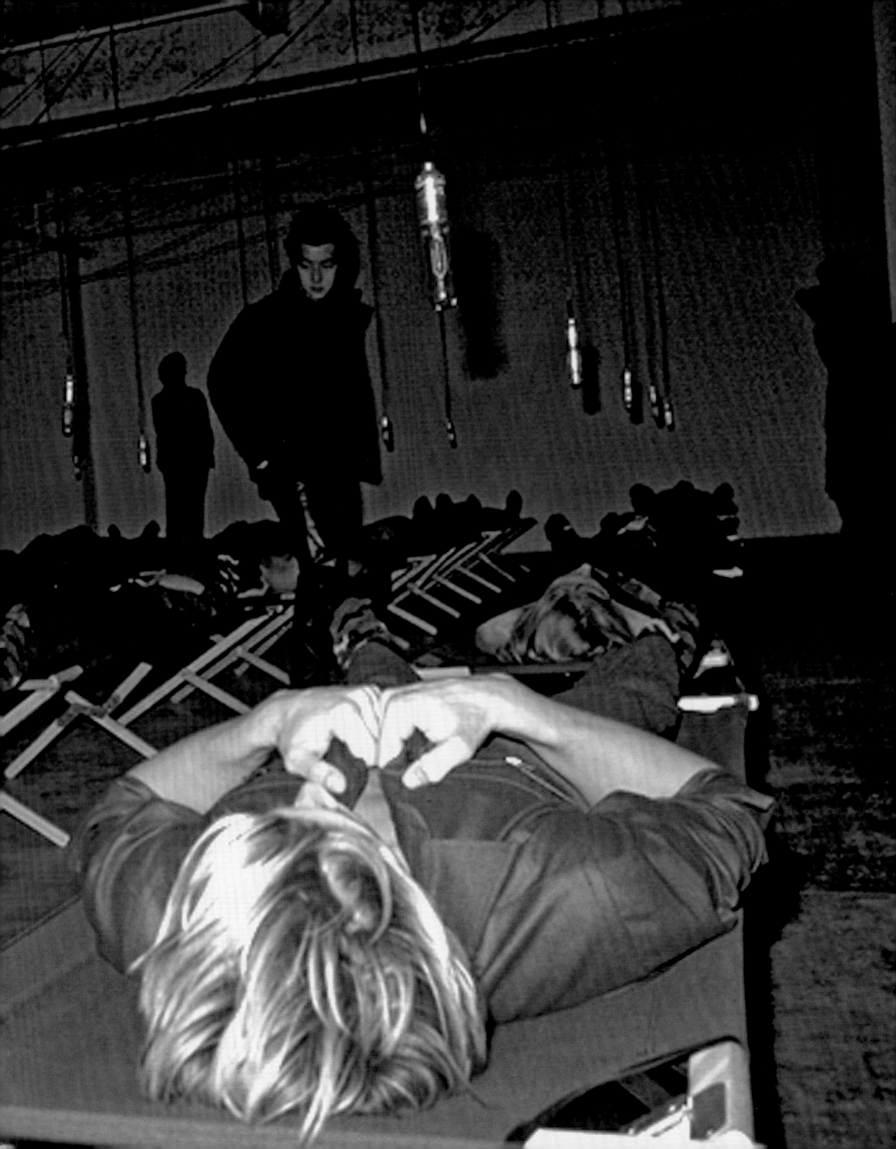

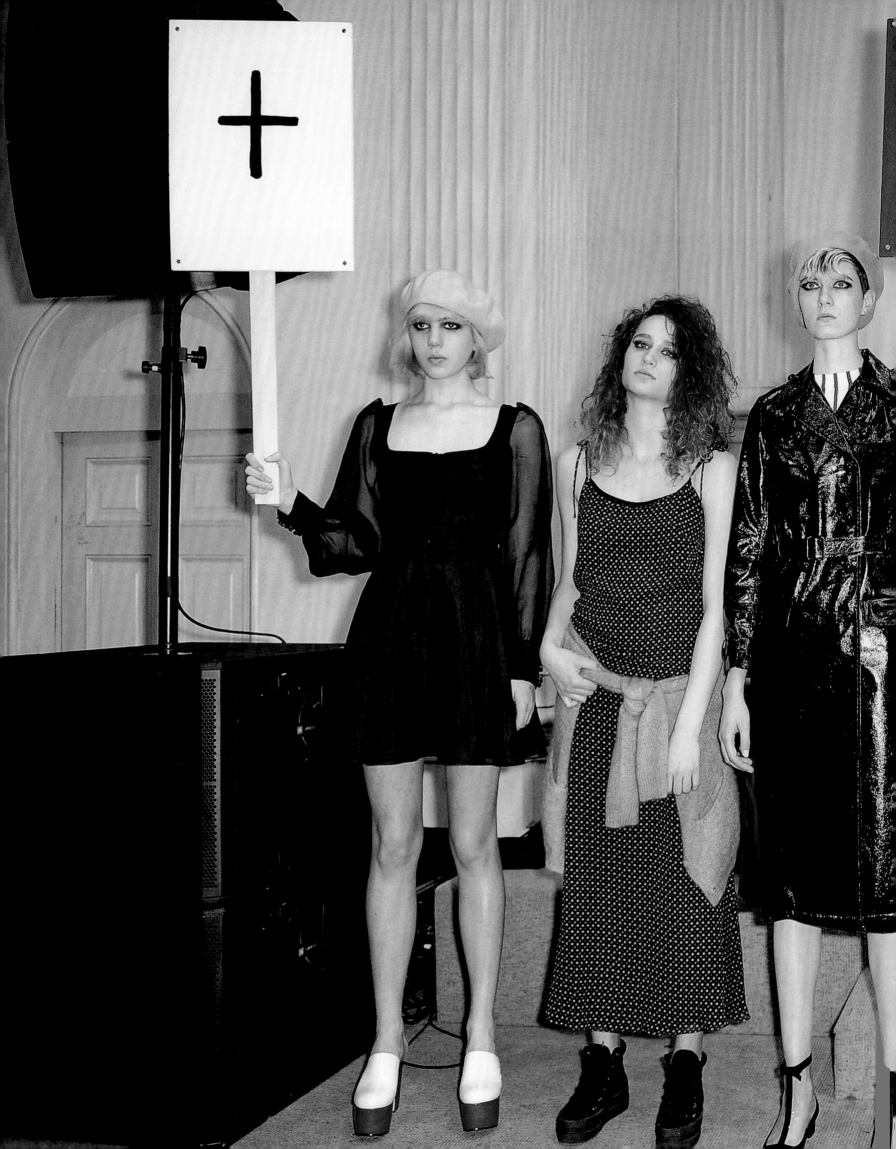

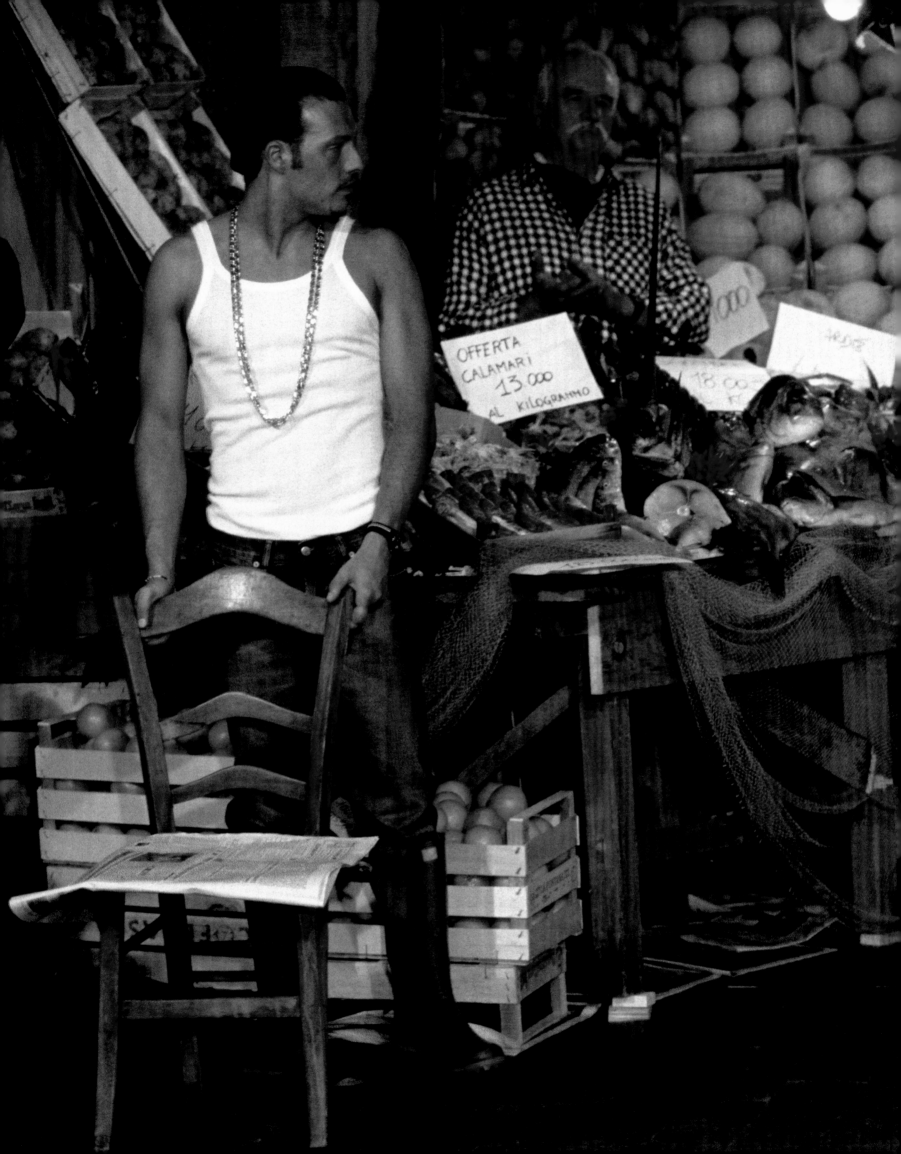

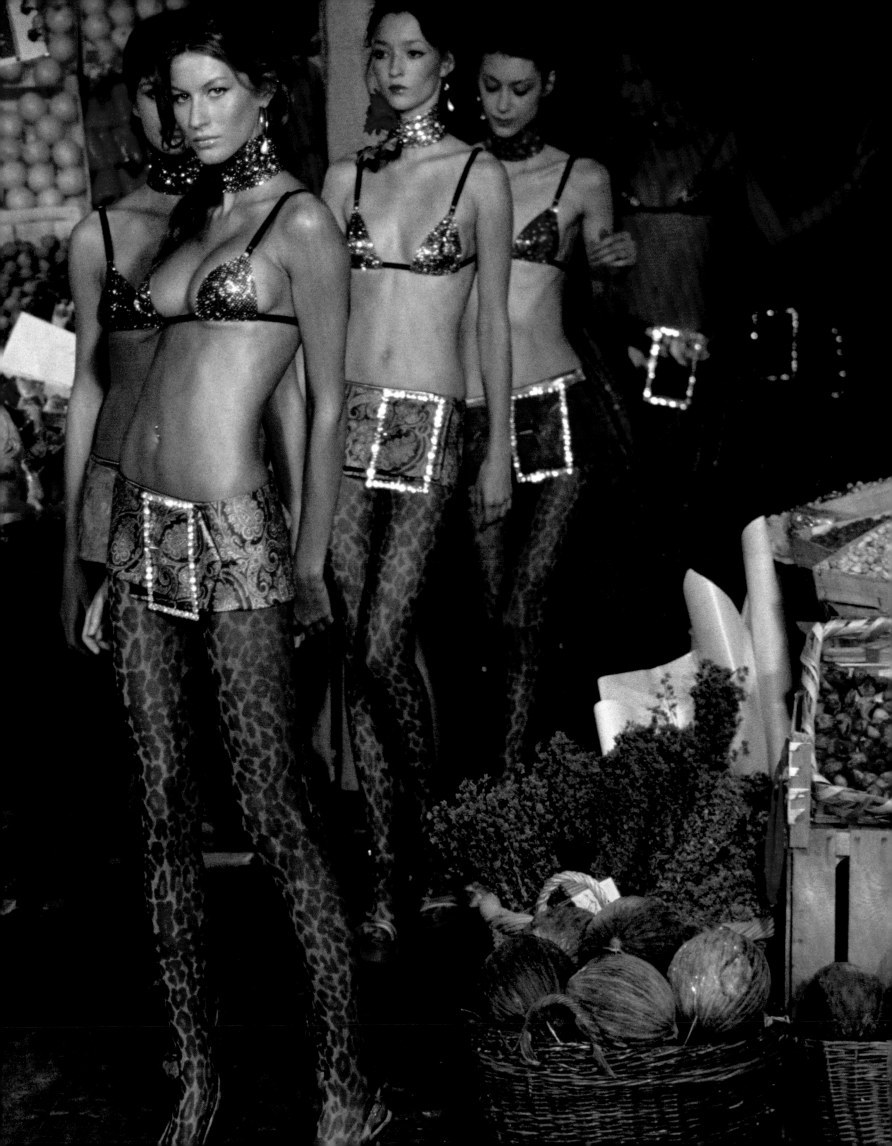

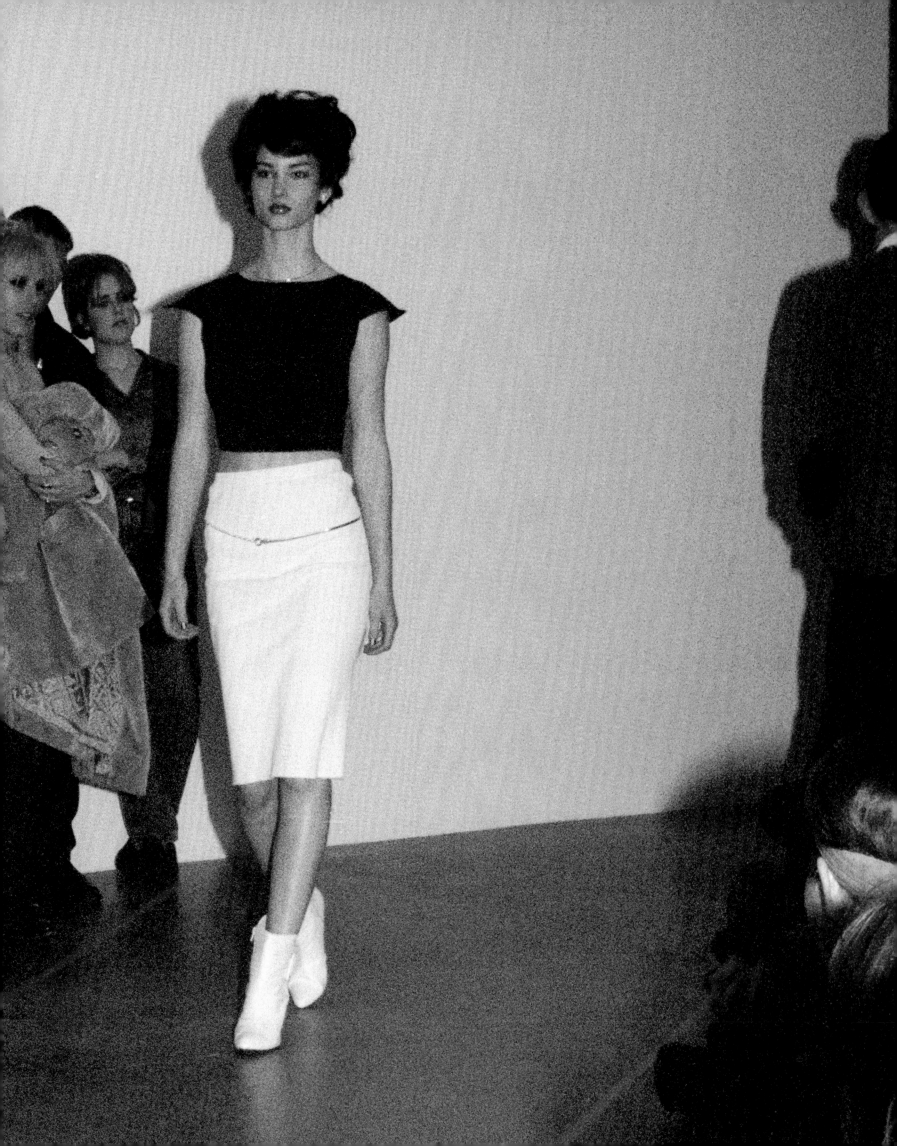

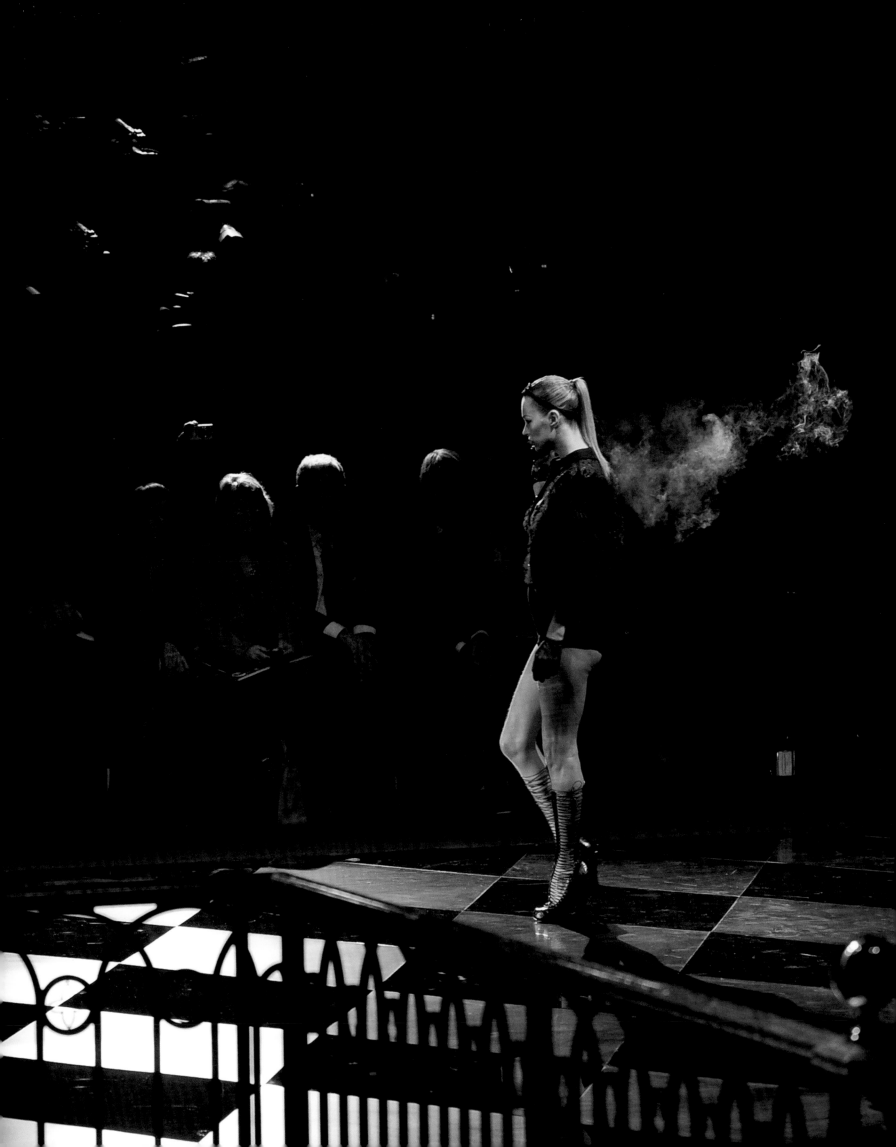

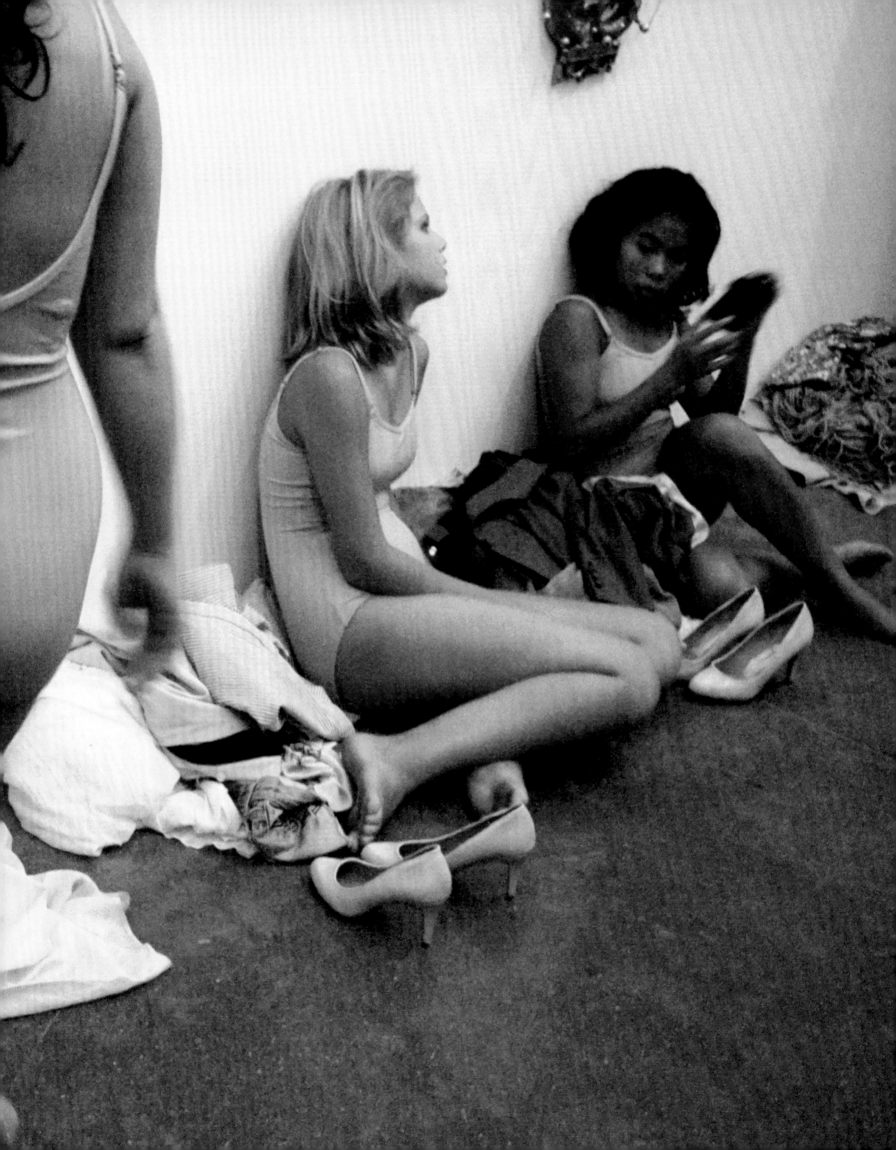

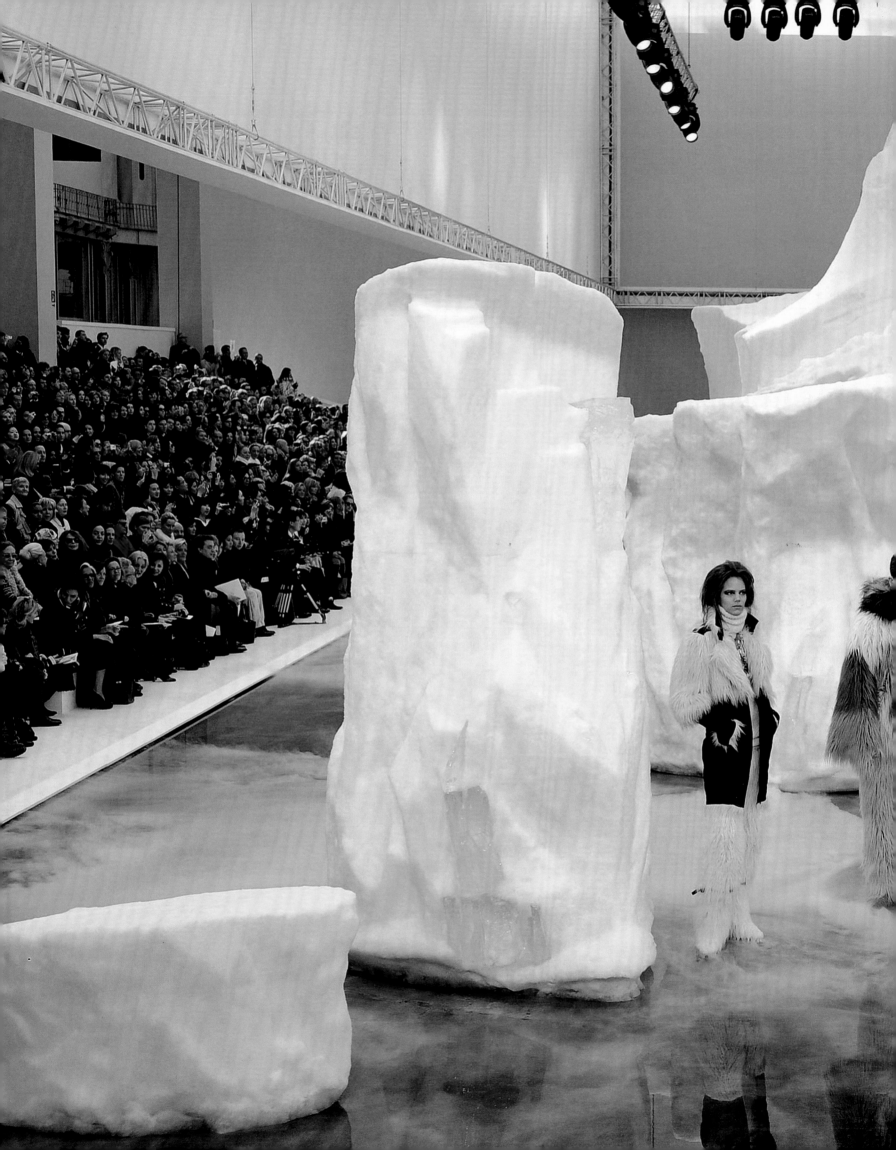

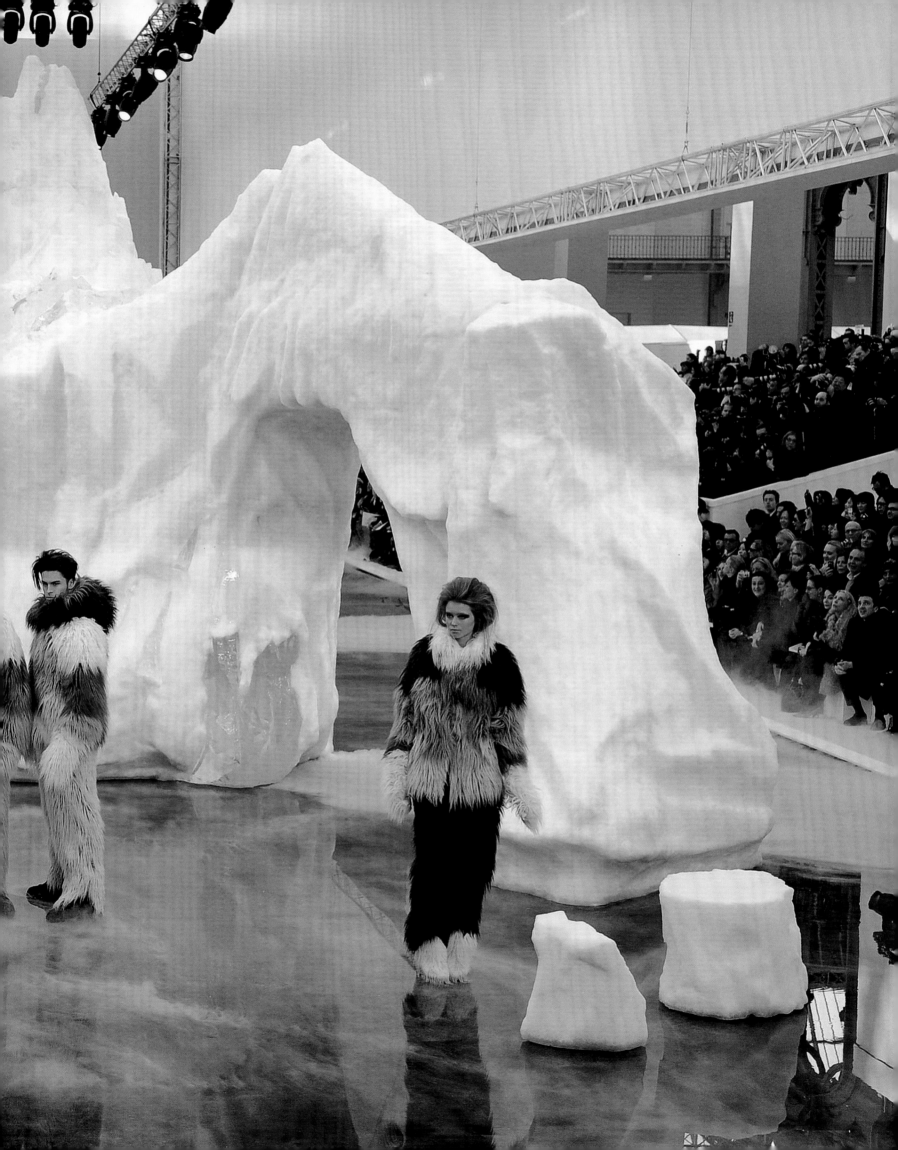

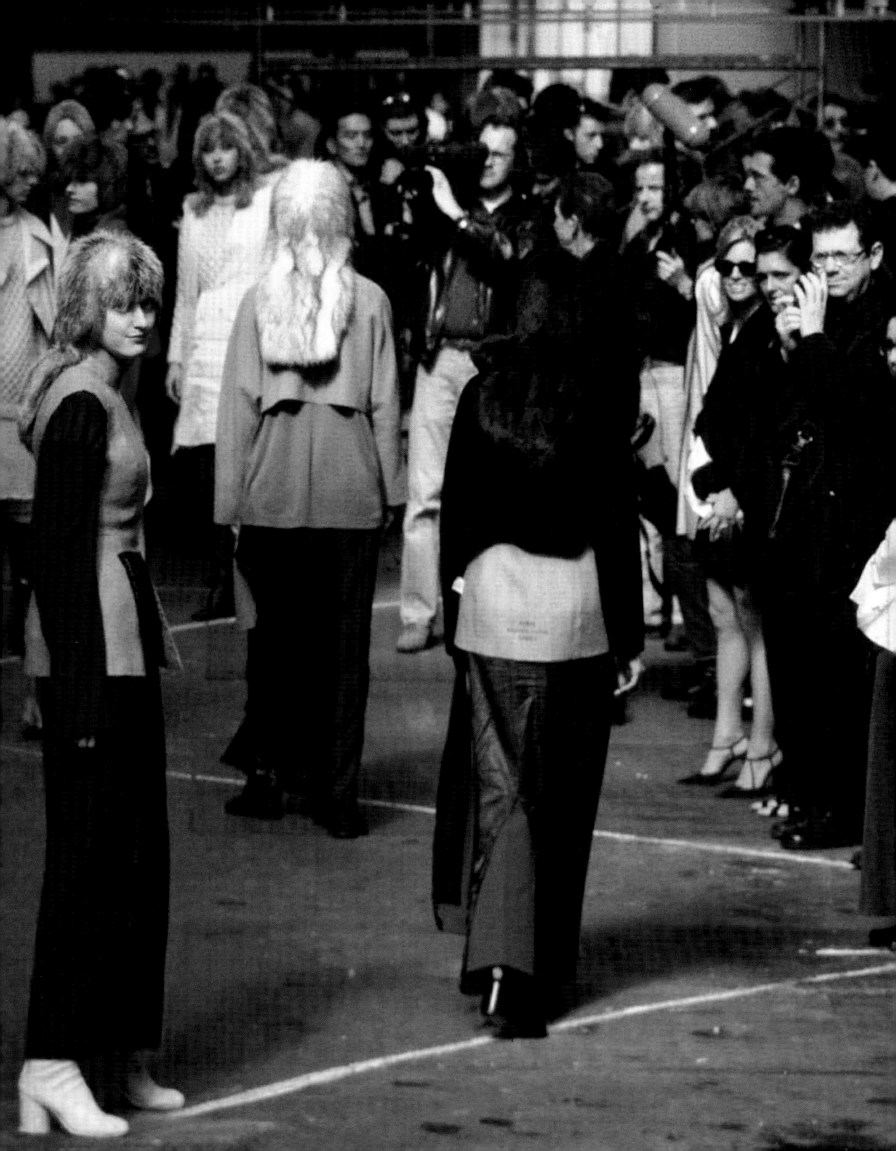

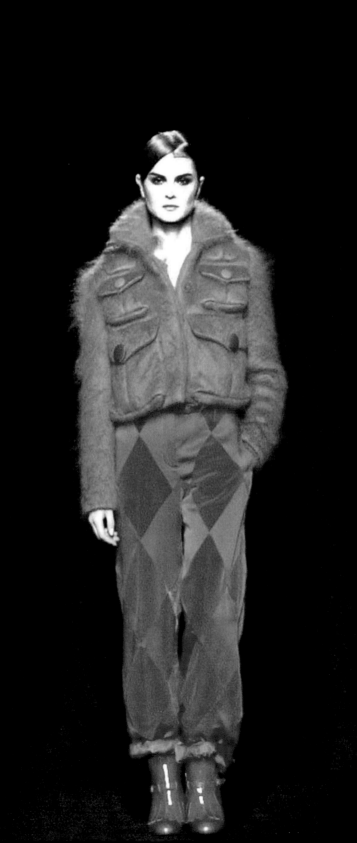

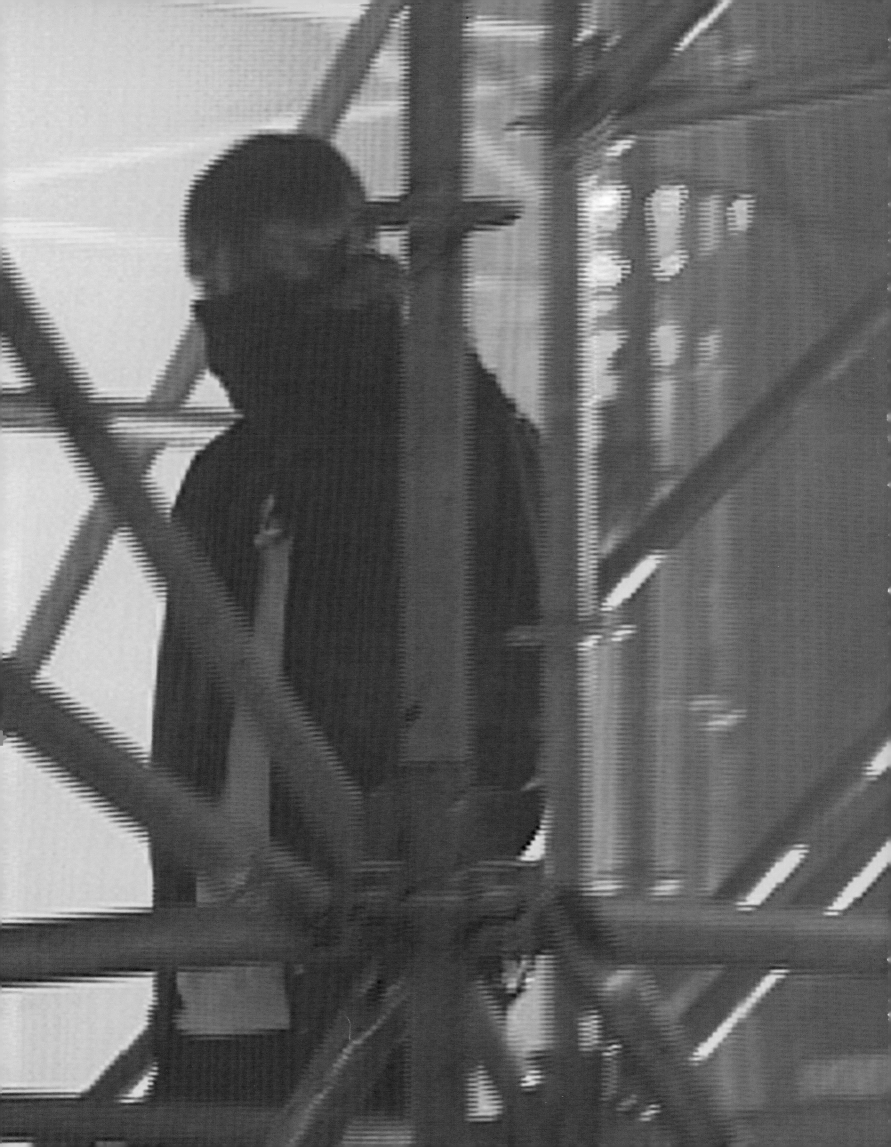

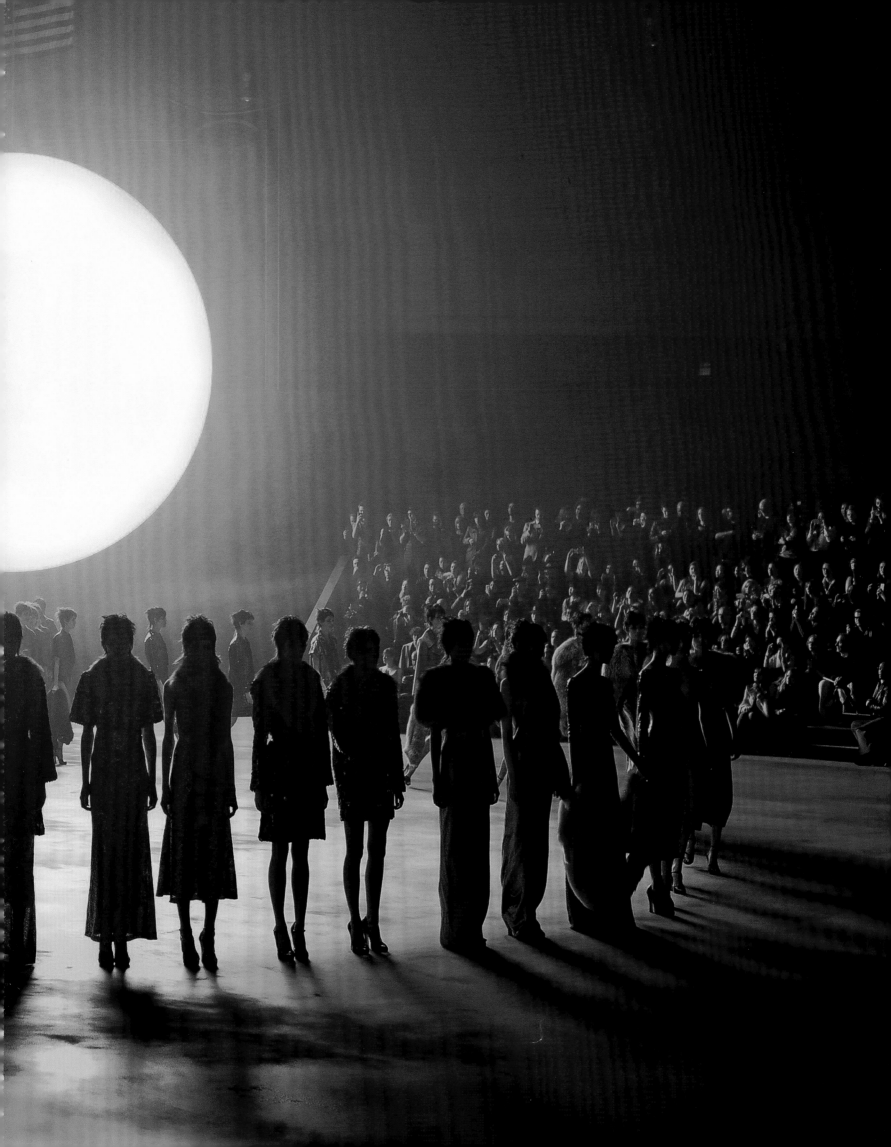

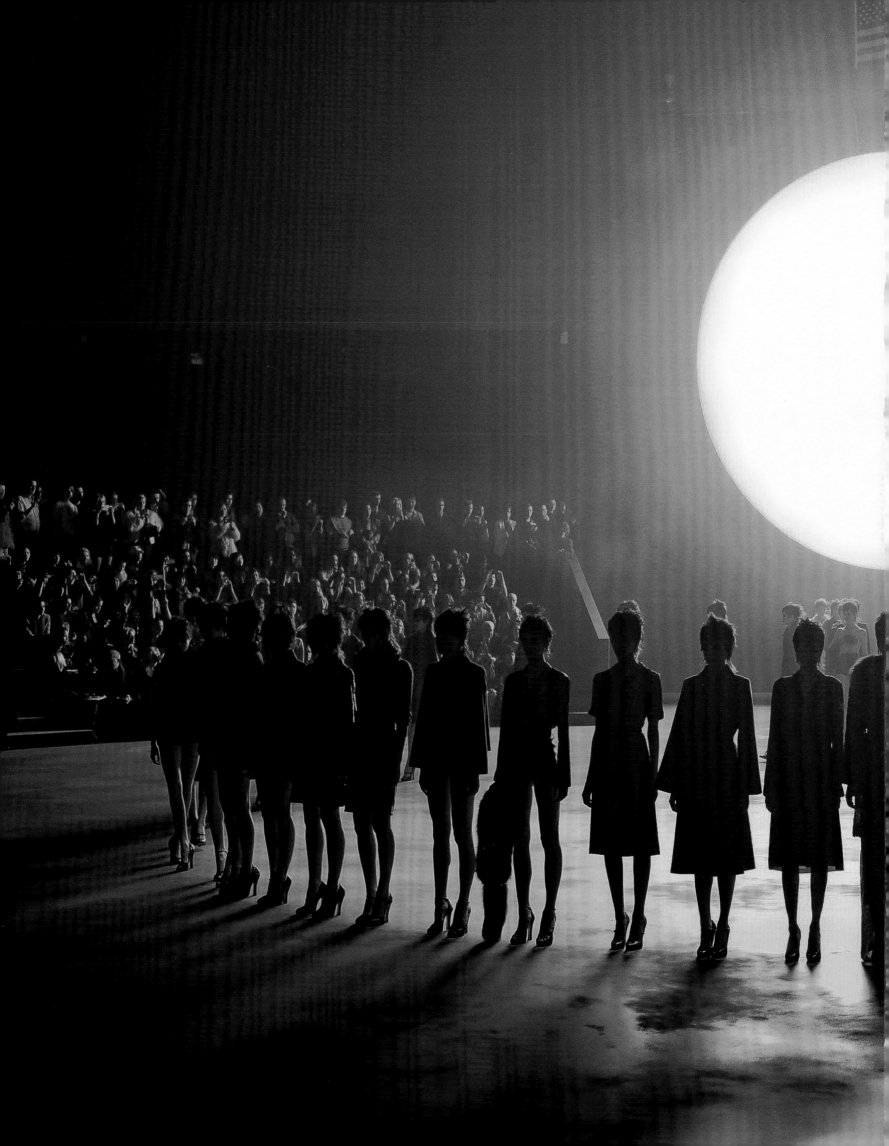

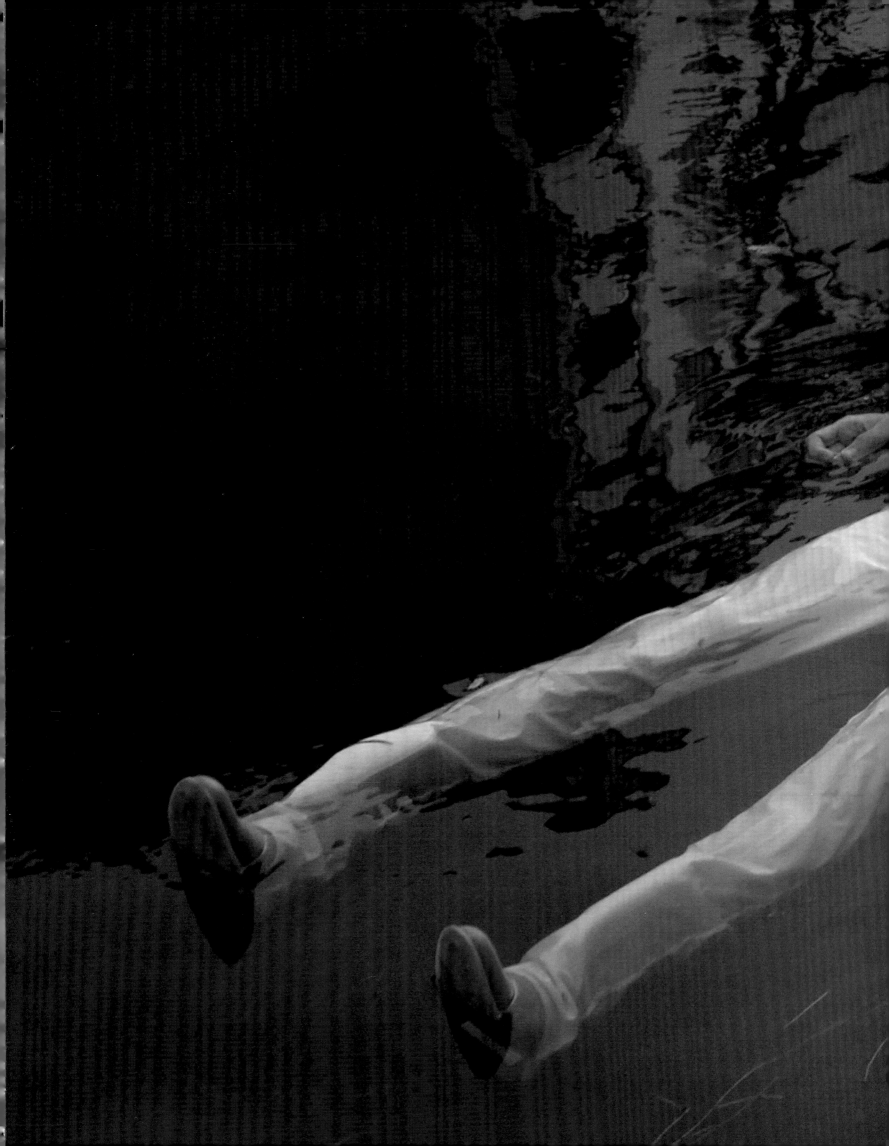

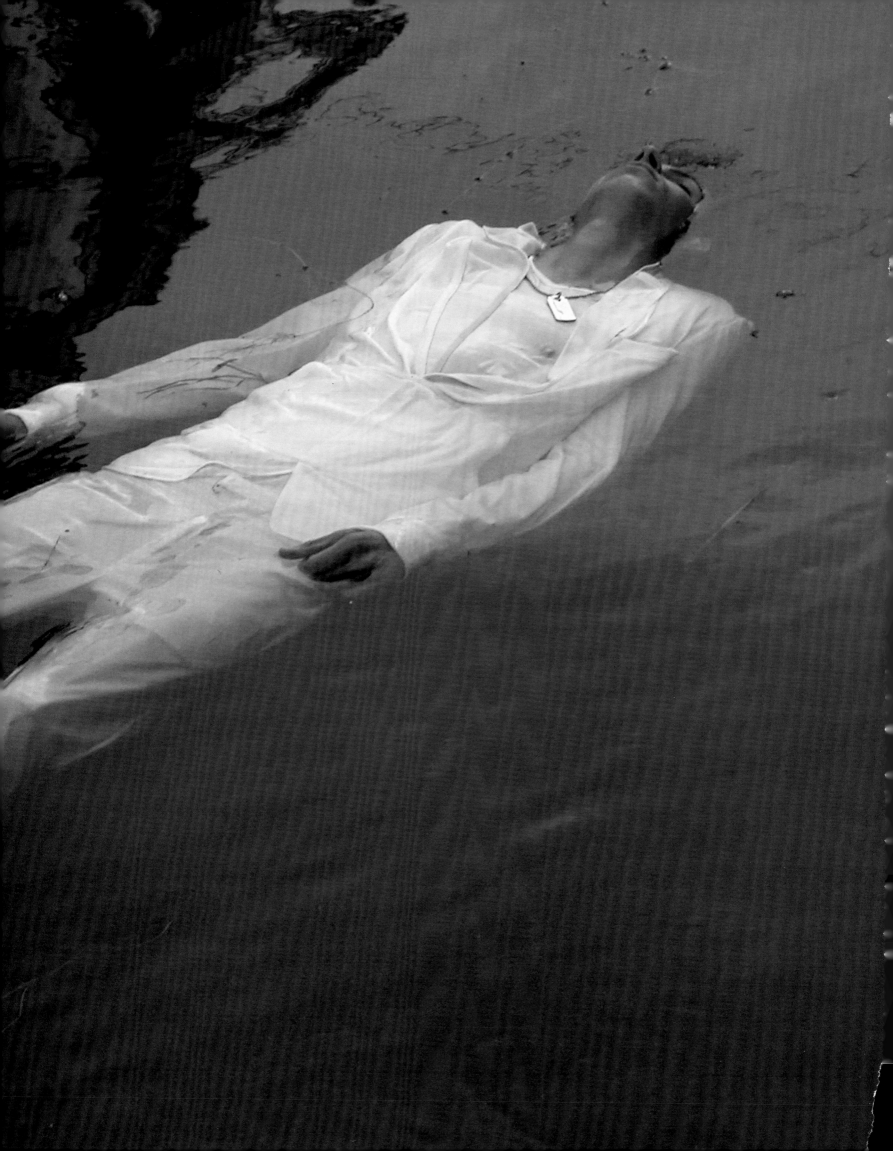

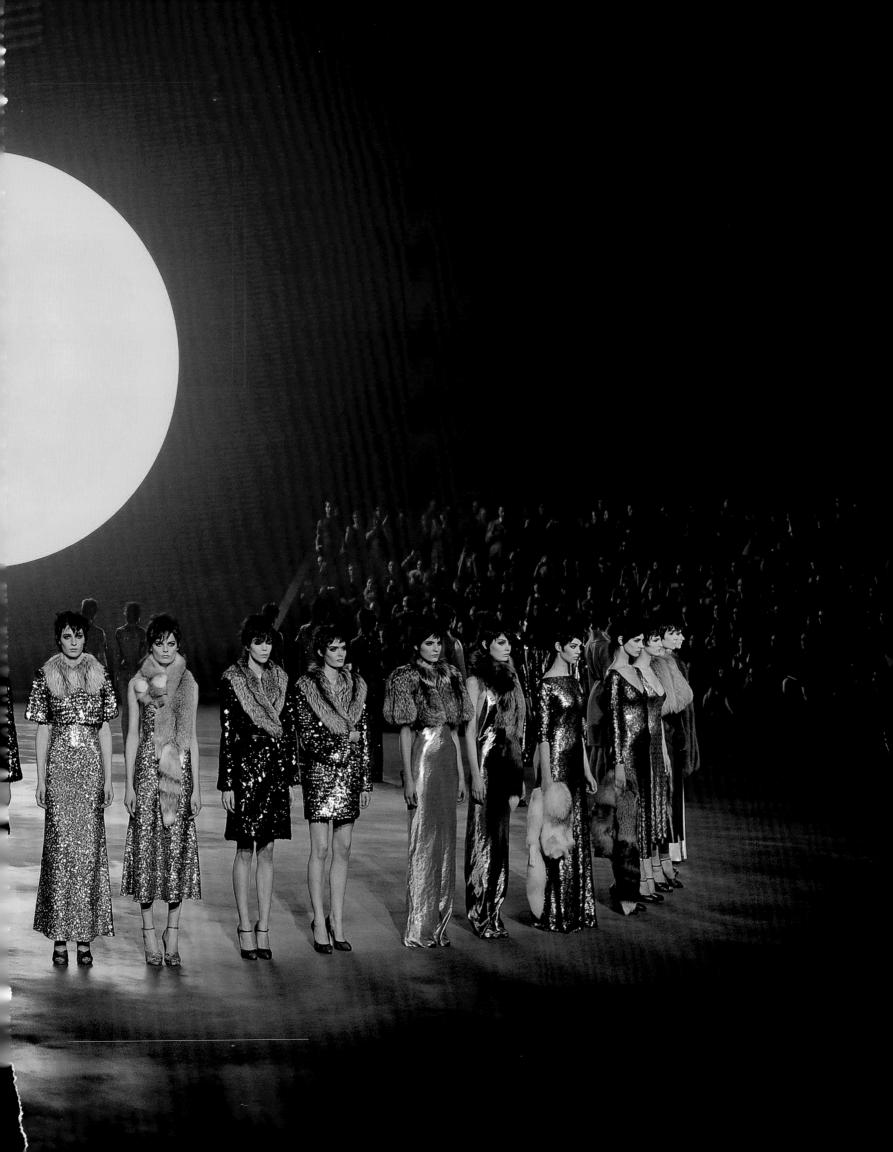

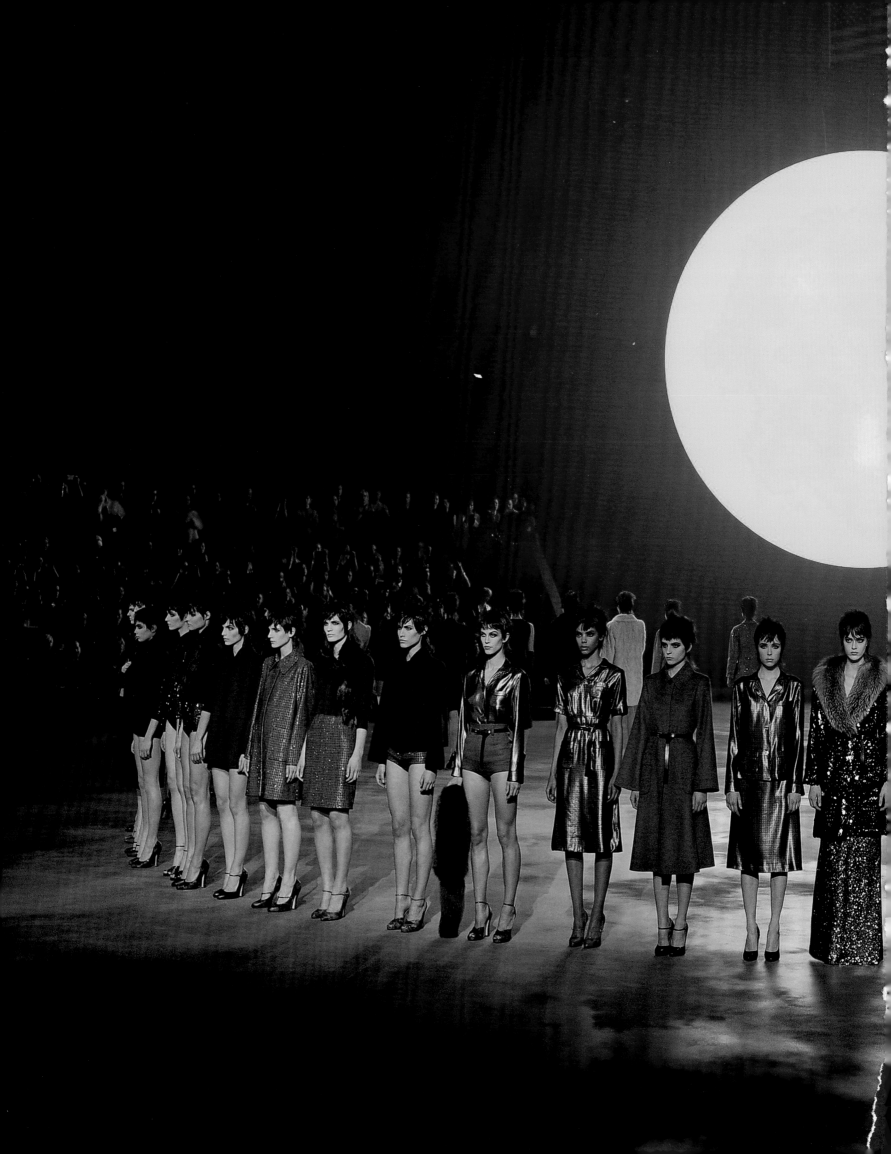

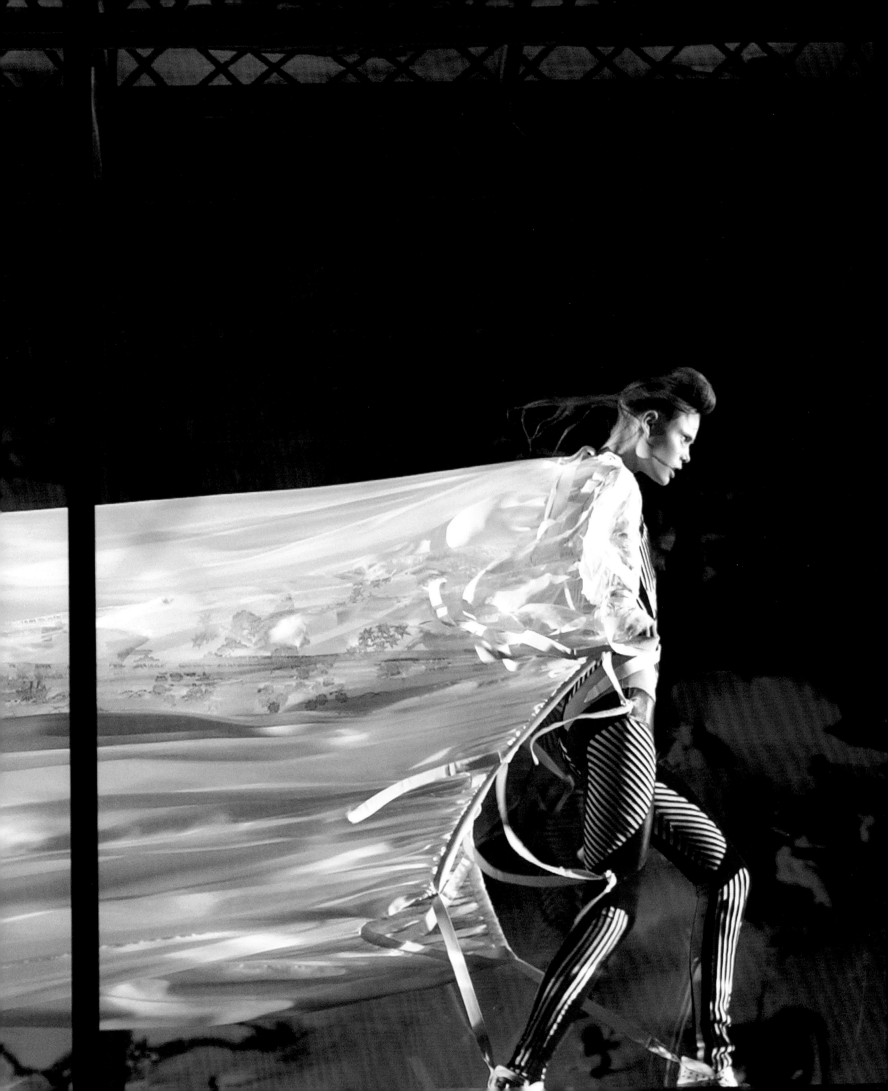

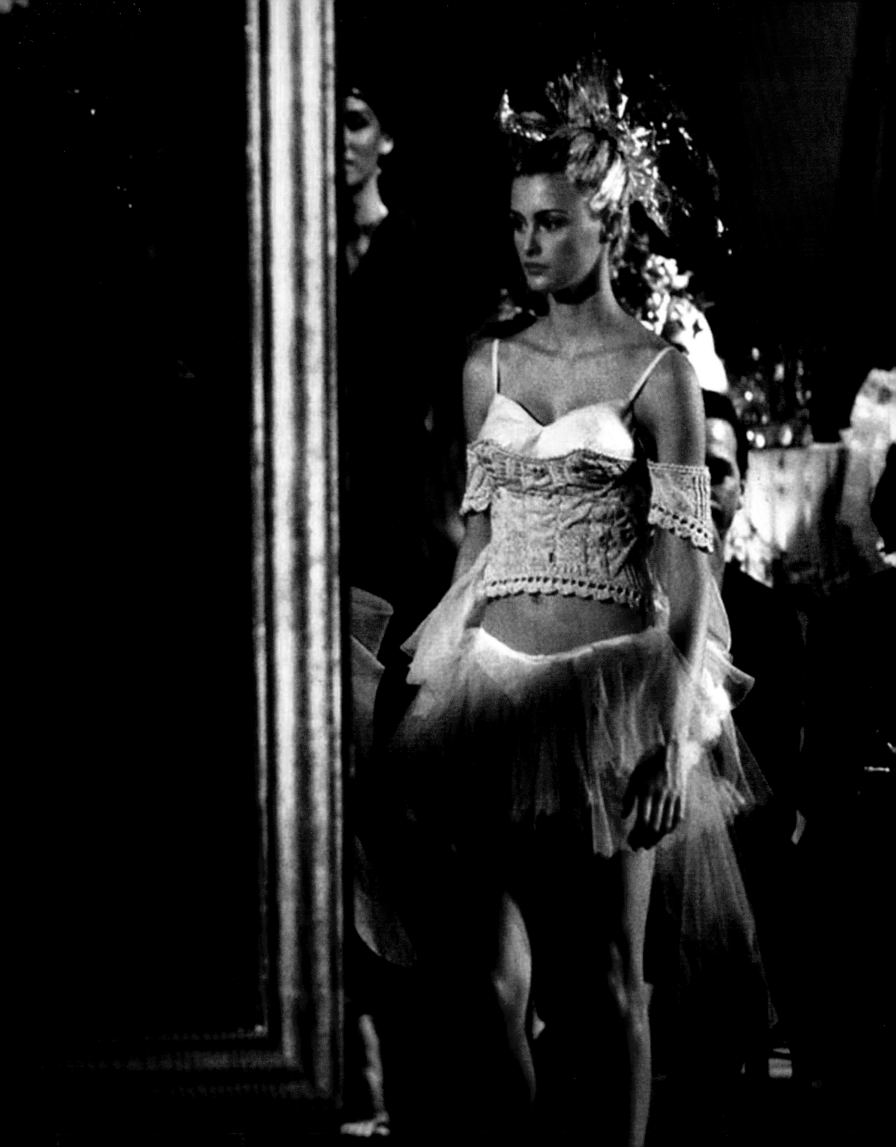

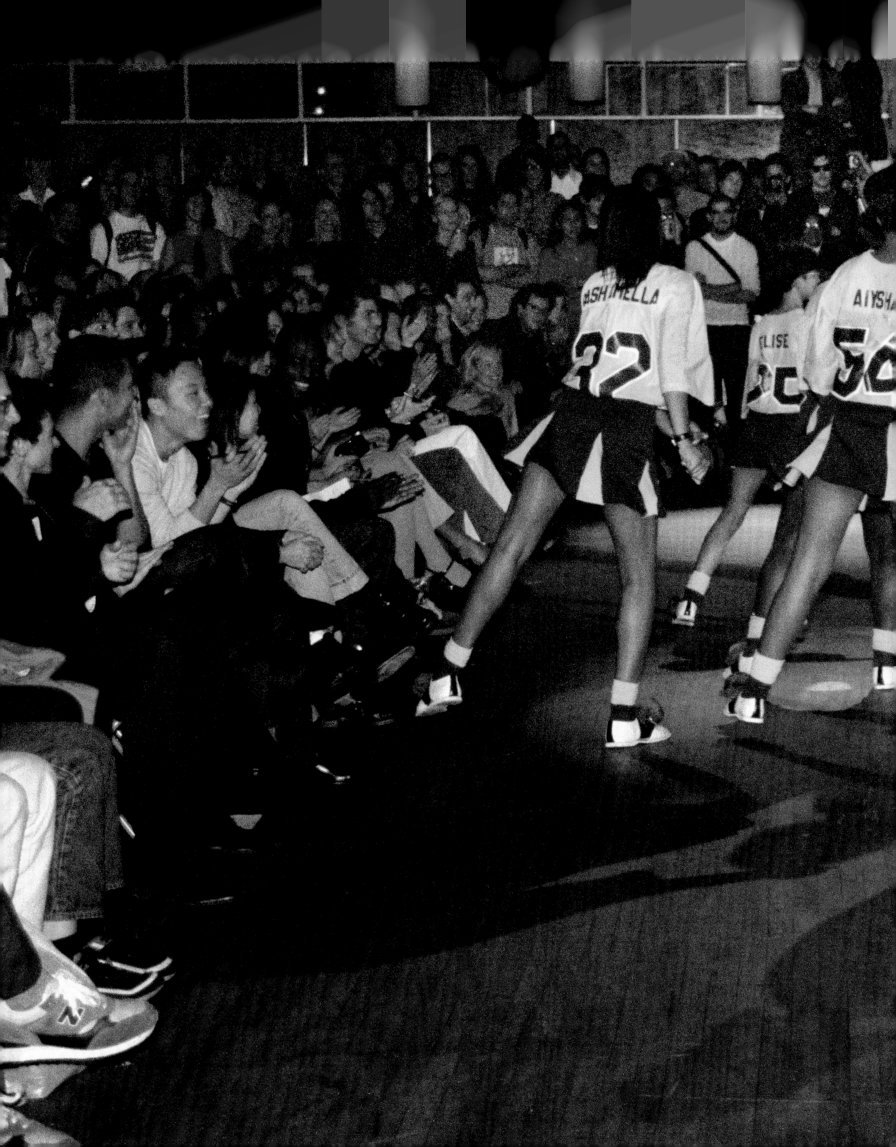

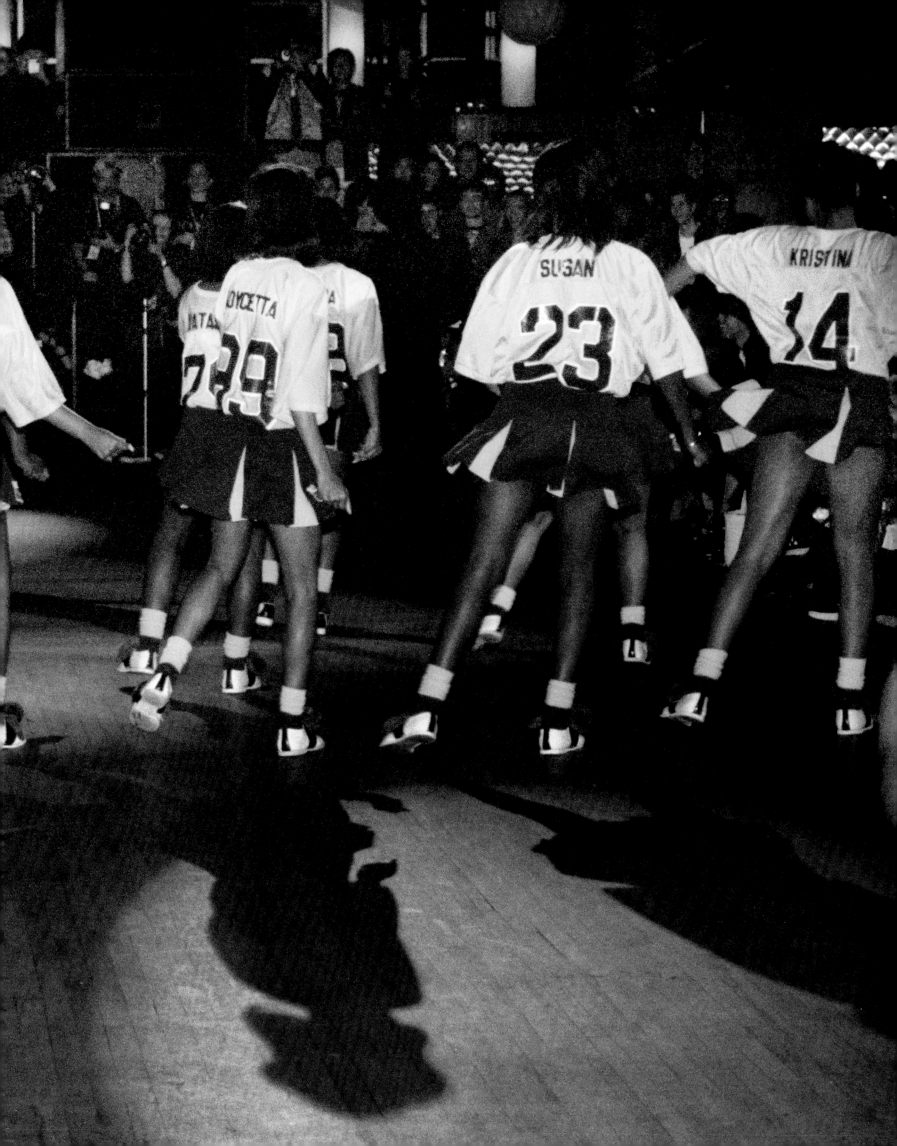

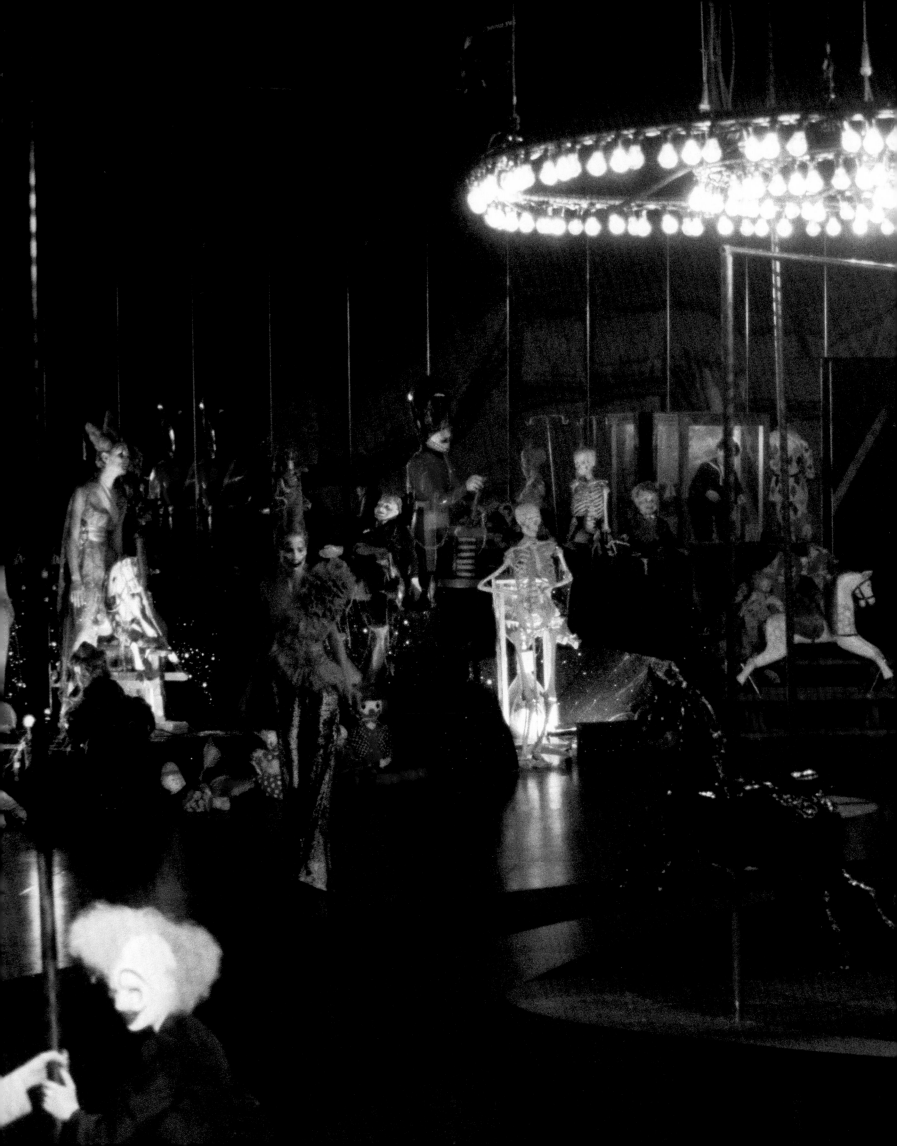

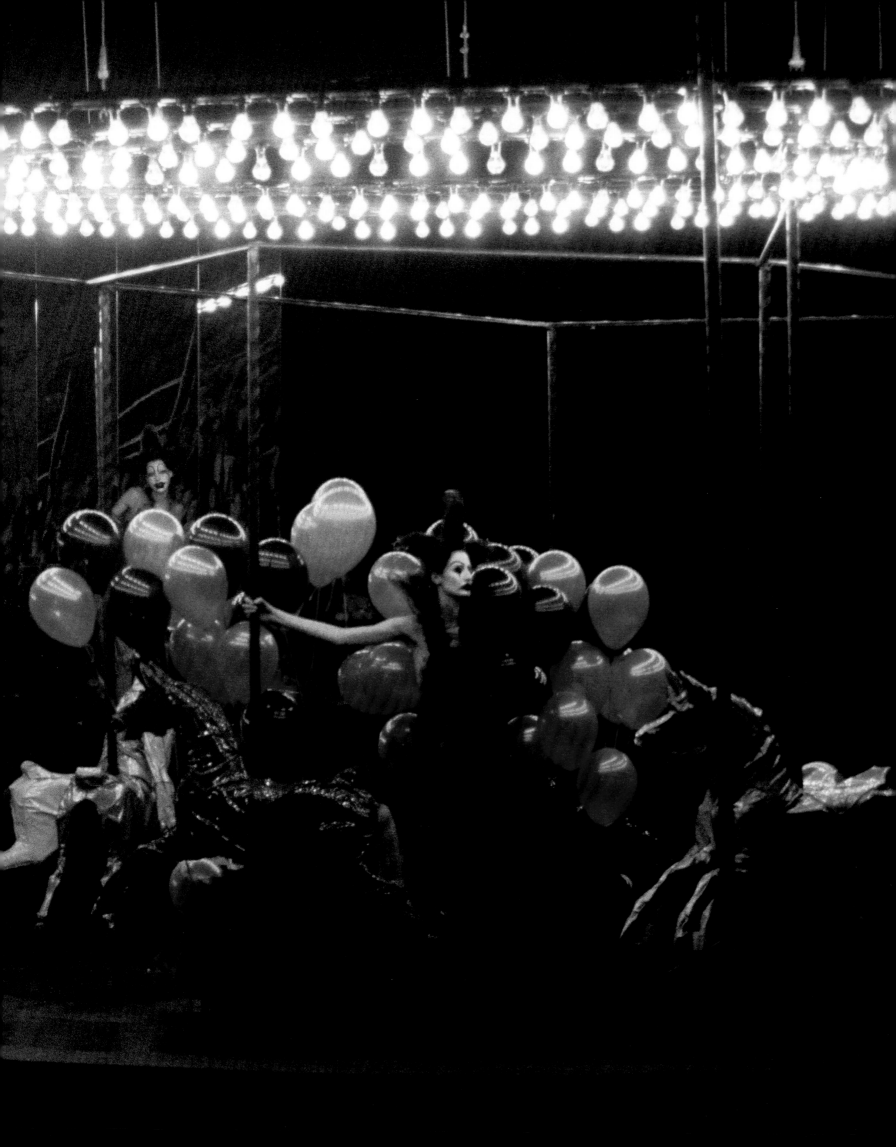

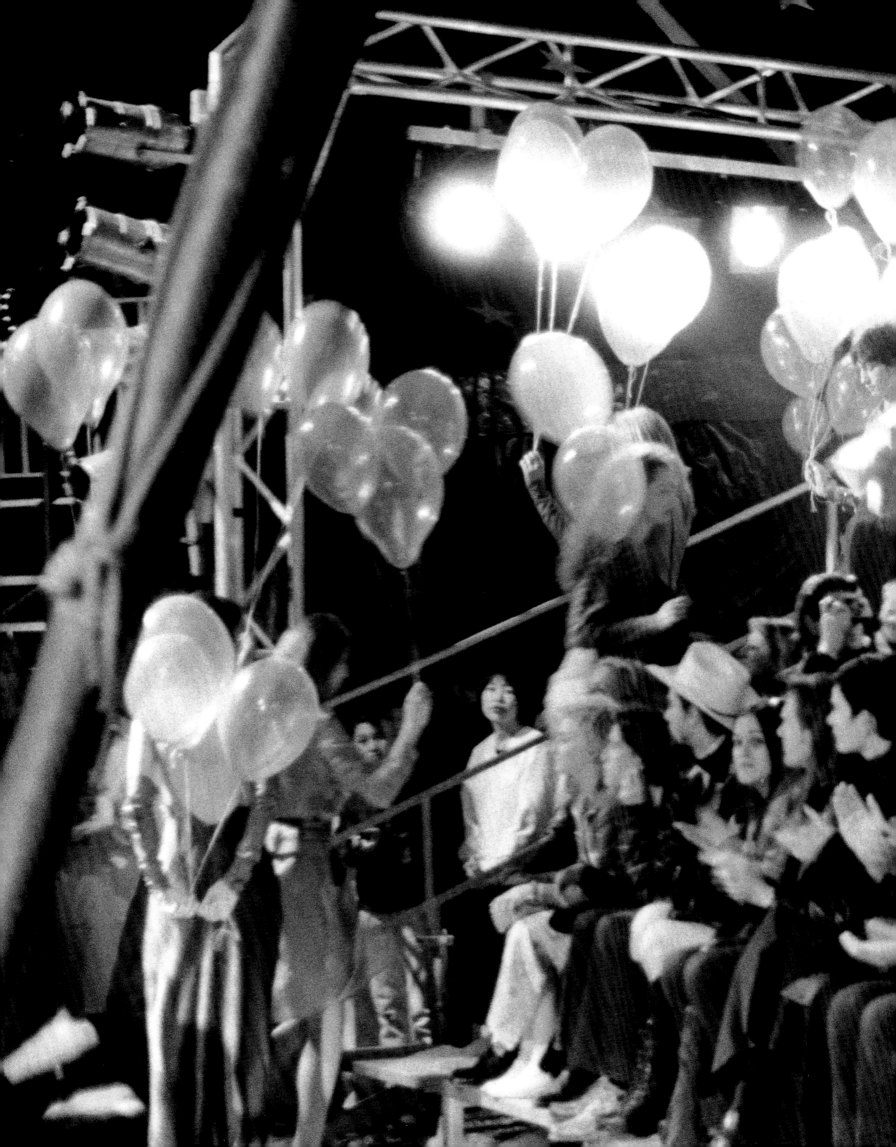

BANK OF AMERICA

PAY TO THE
ORDER OF Winner

 One million d

USA

FOR

2 0 0 1 1 3 1 4 8 8 7 3

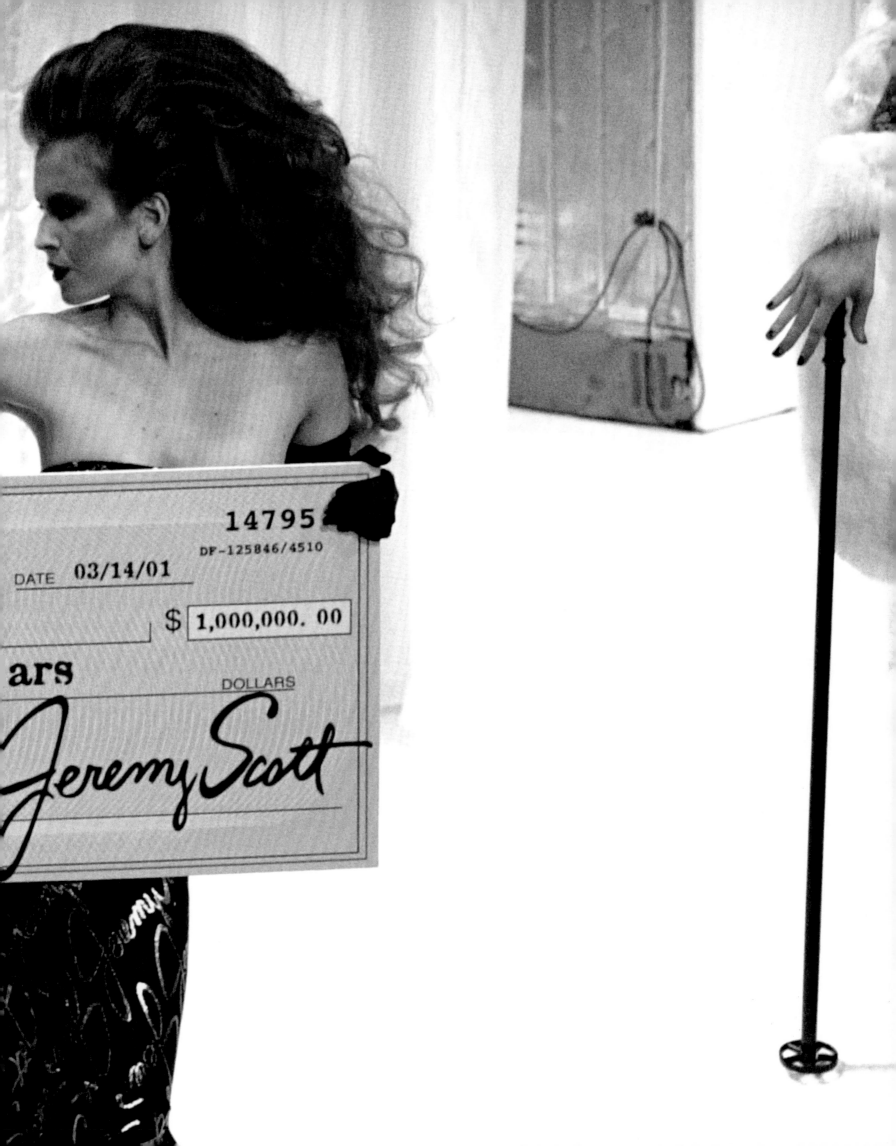

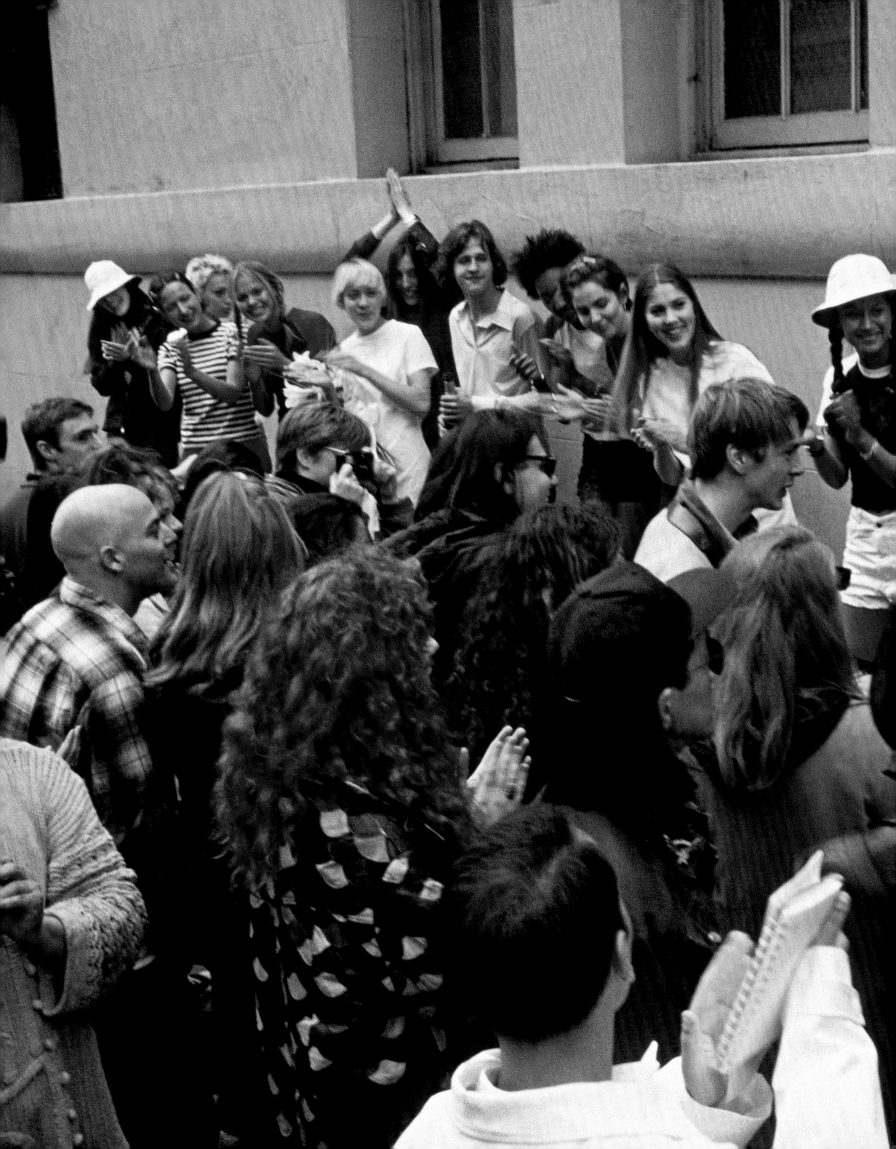

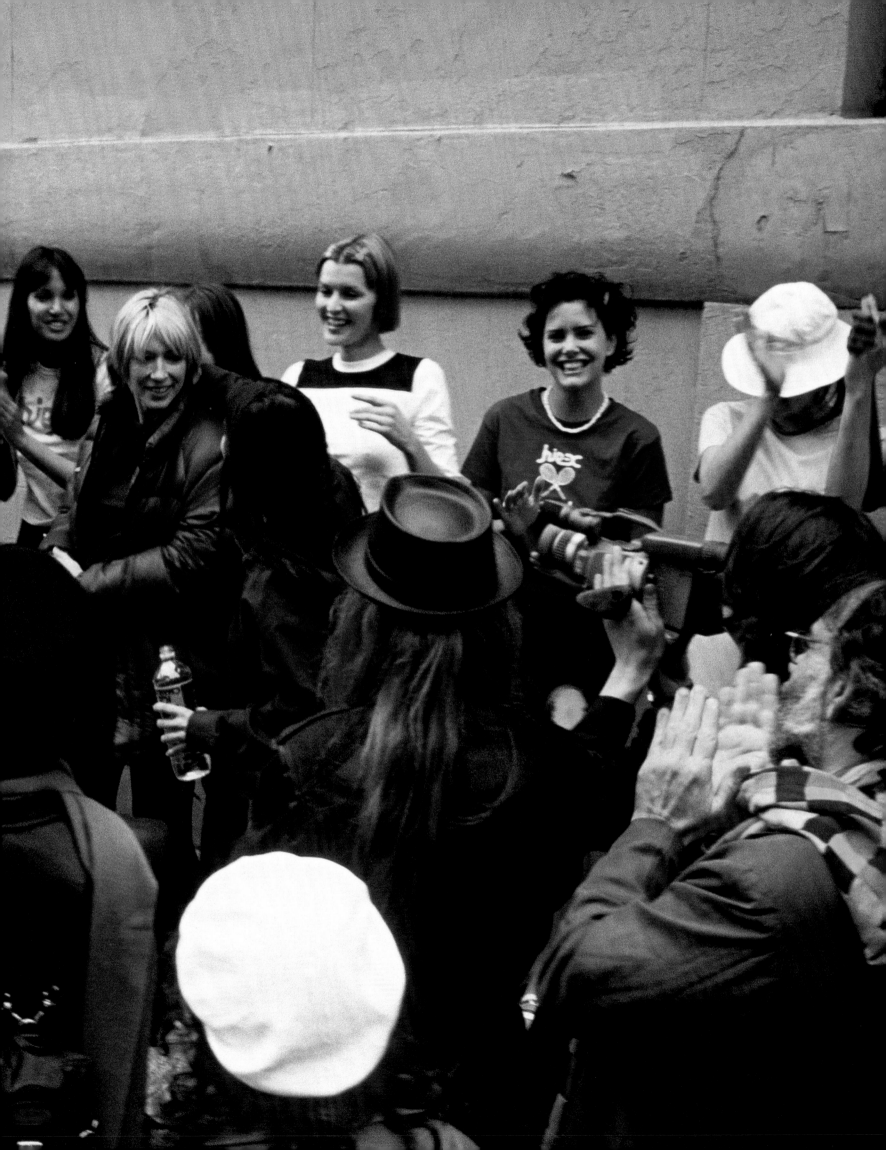

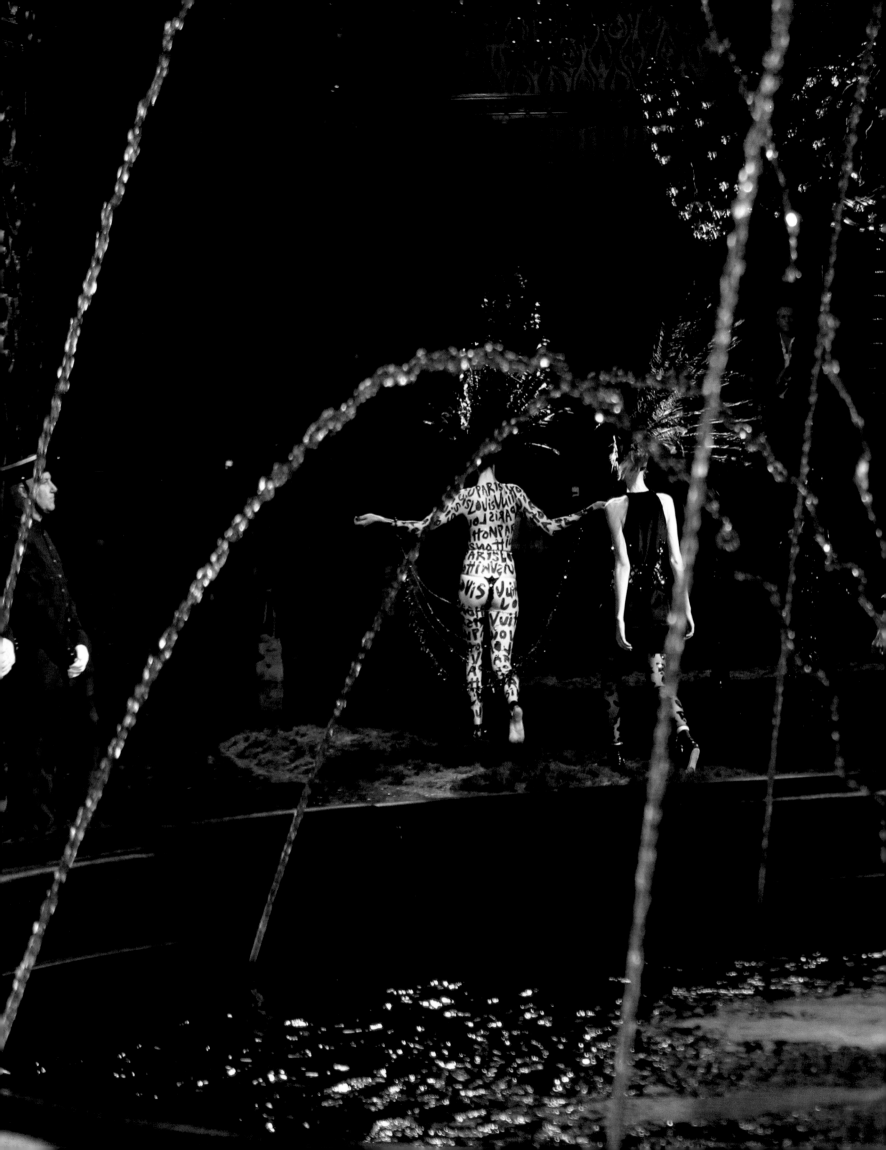

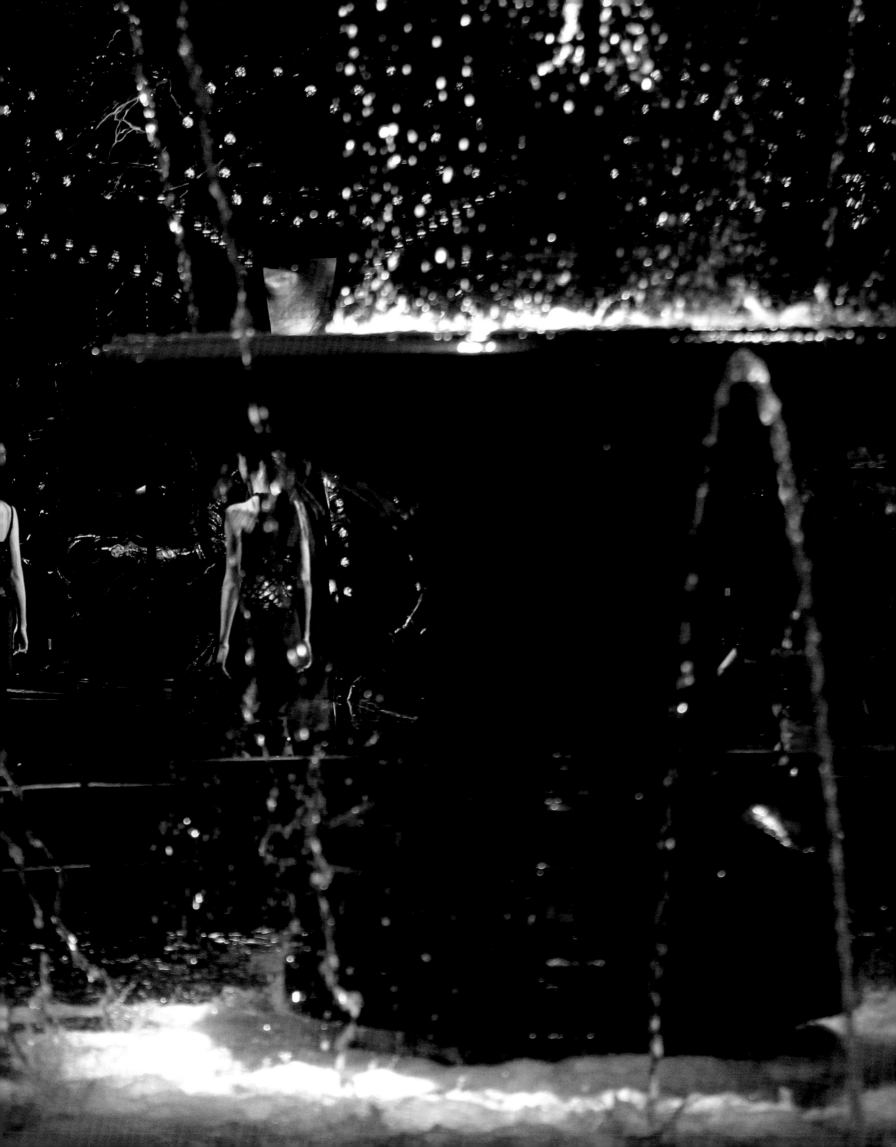

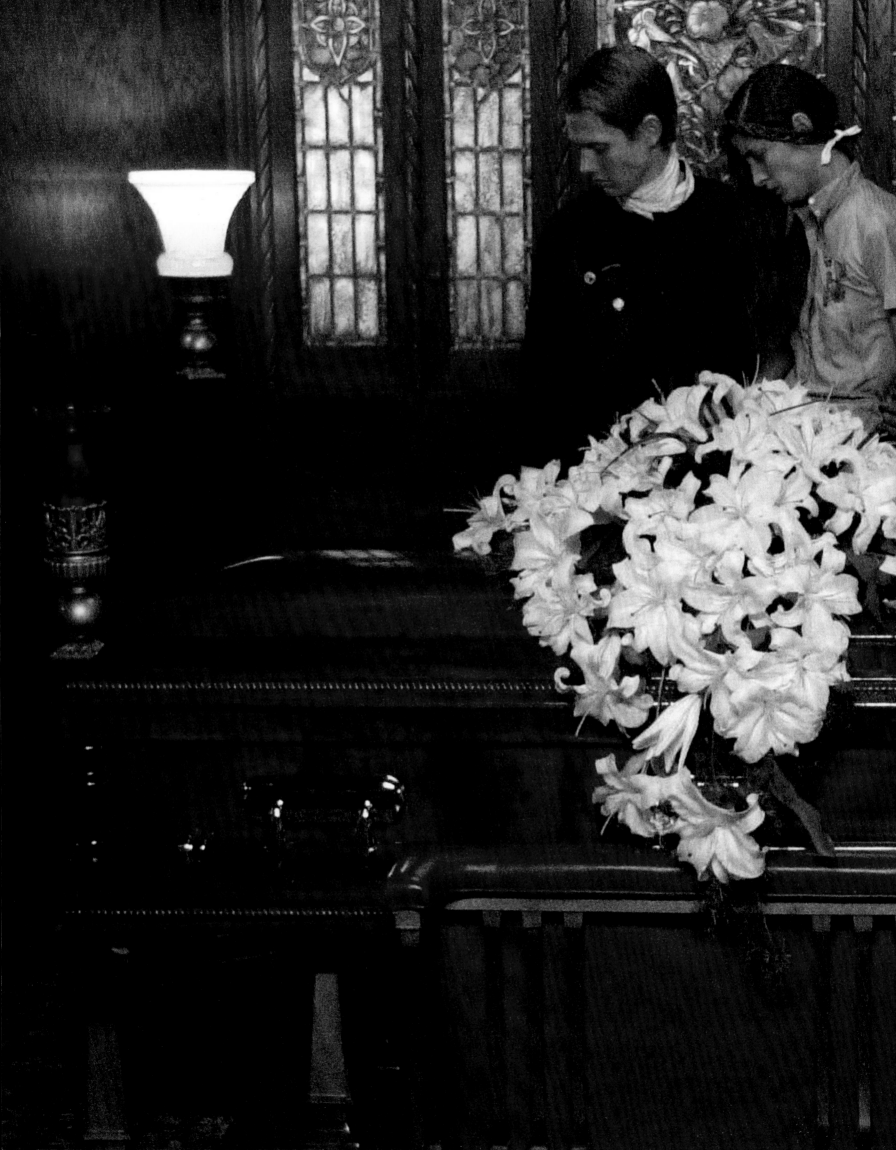

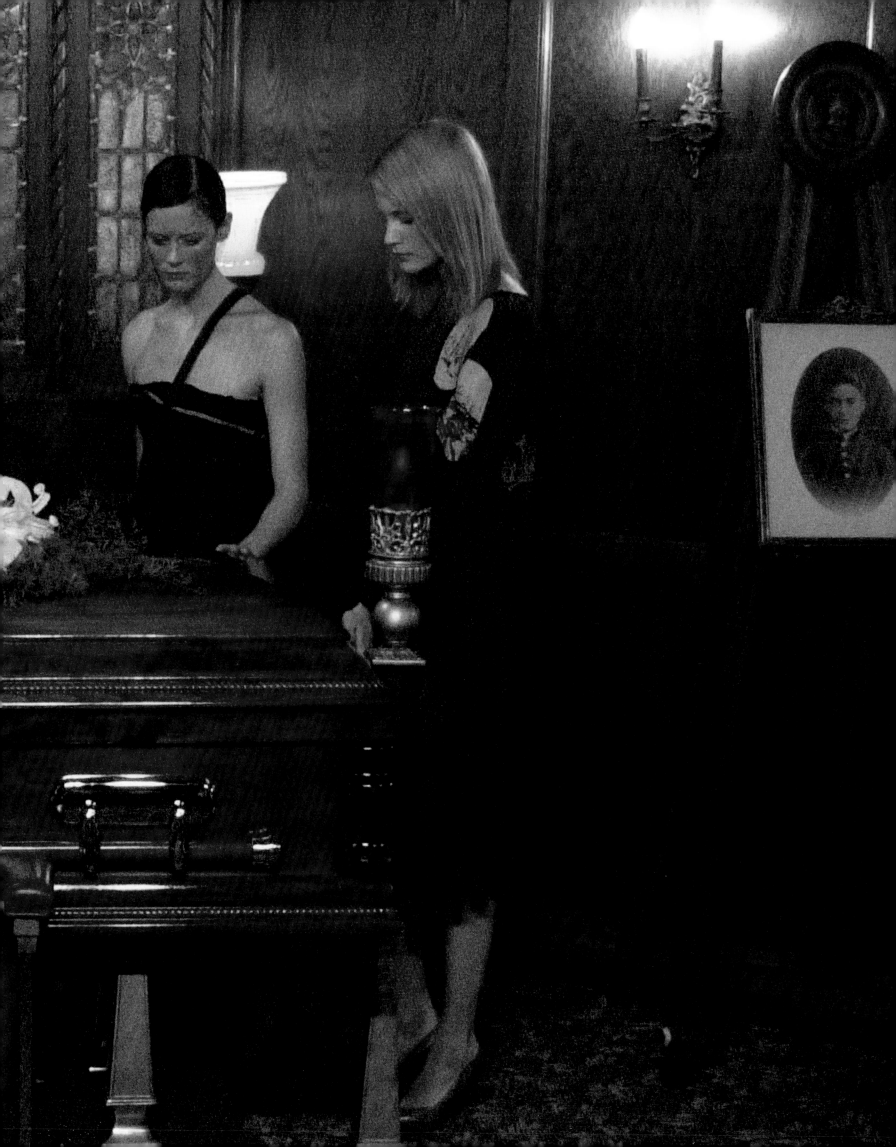

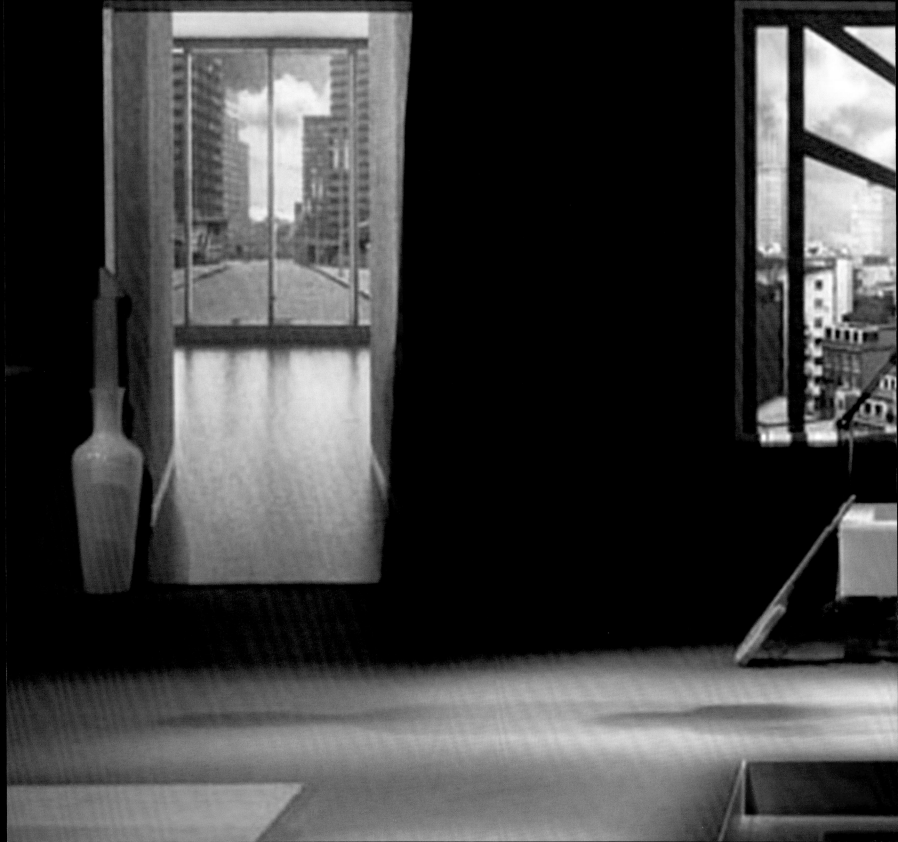

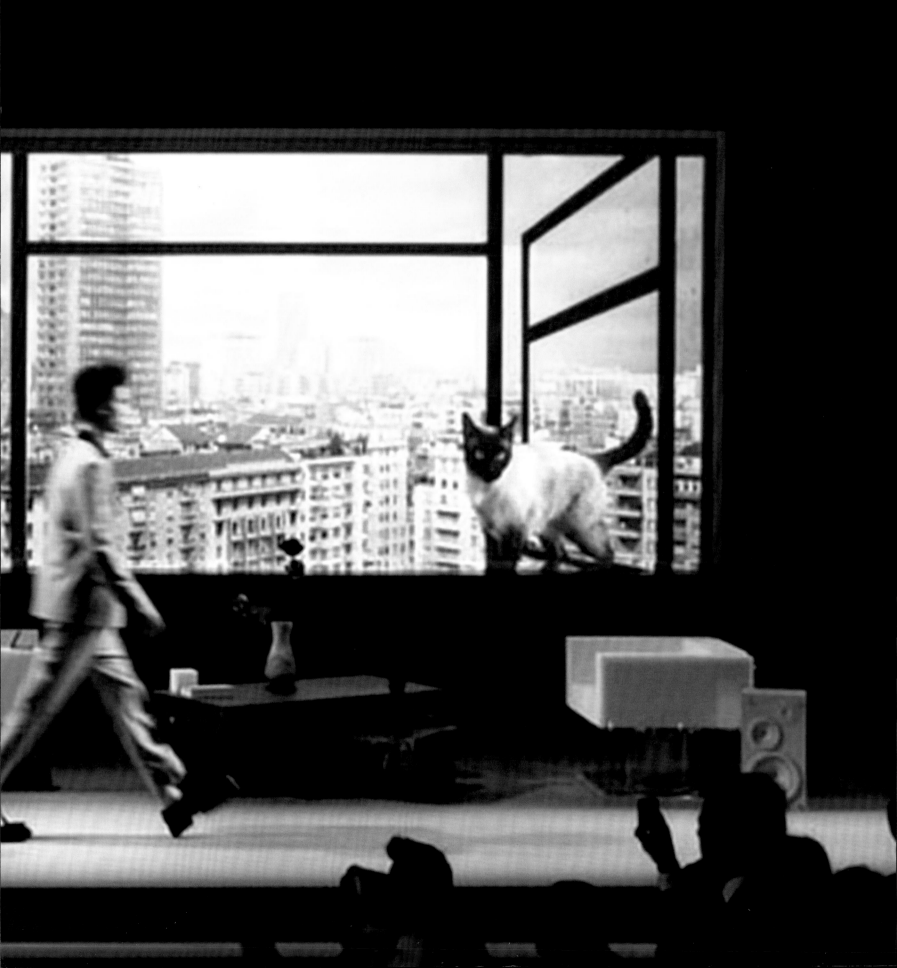

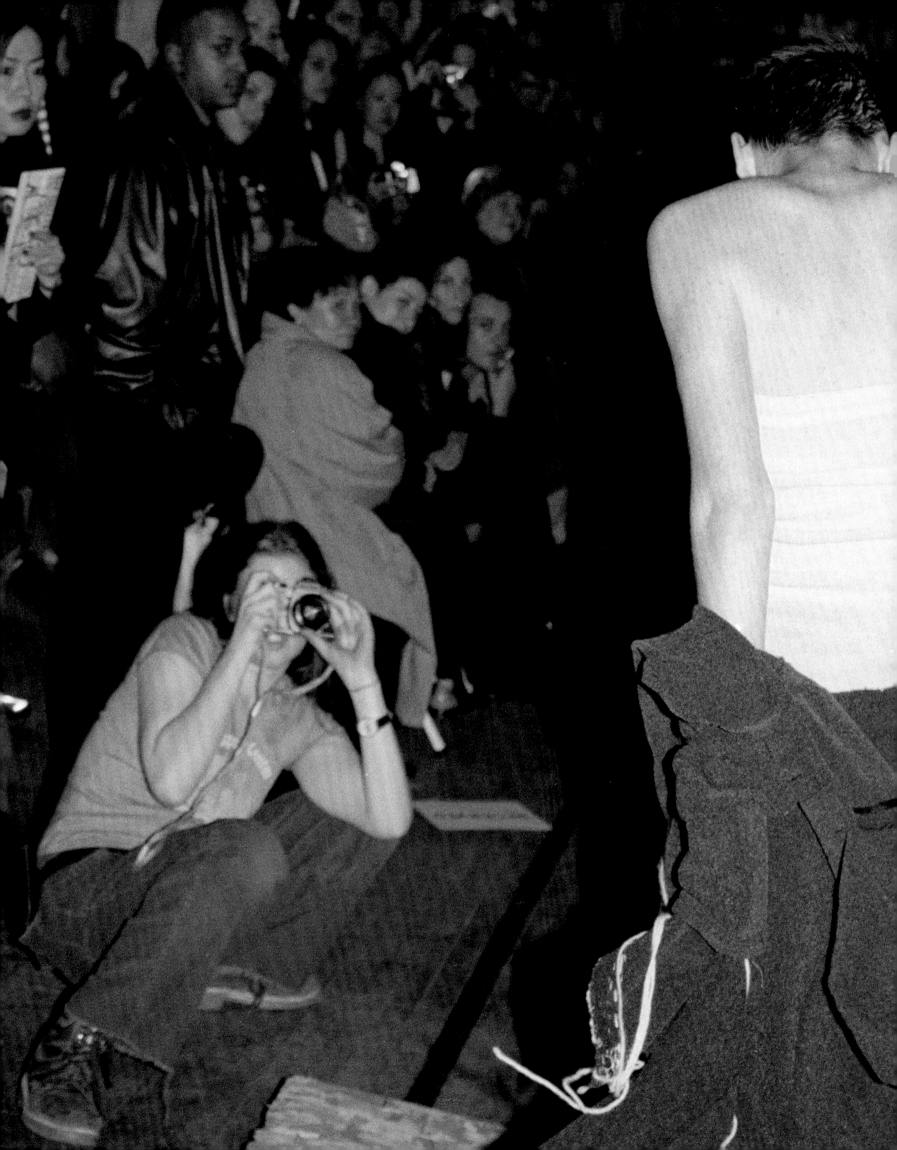

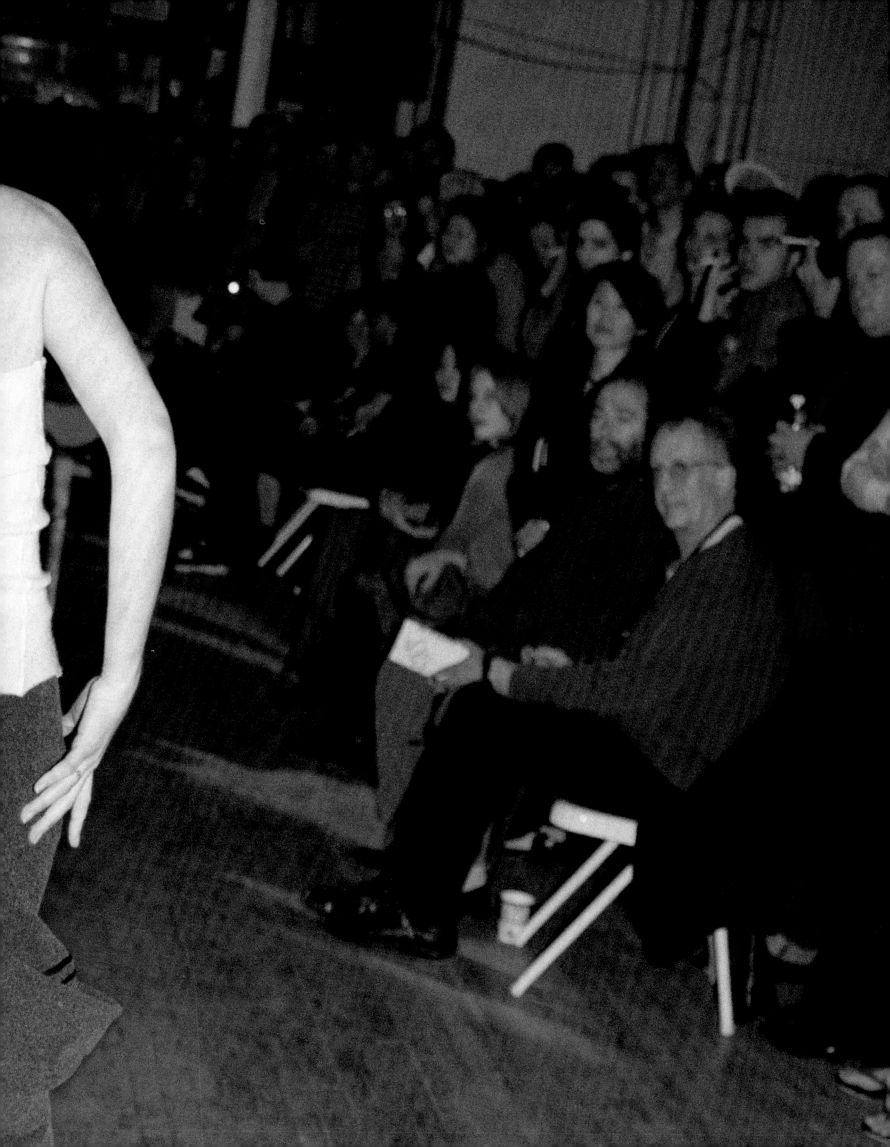

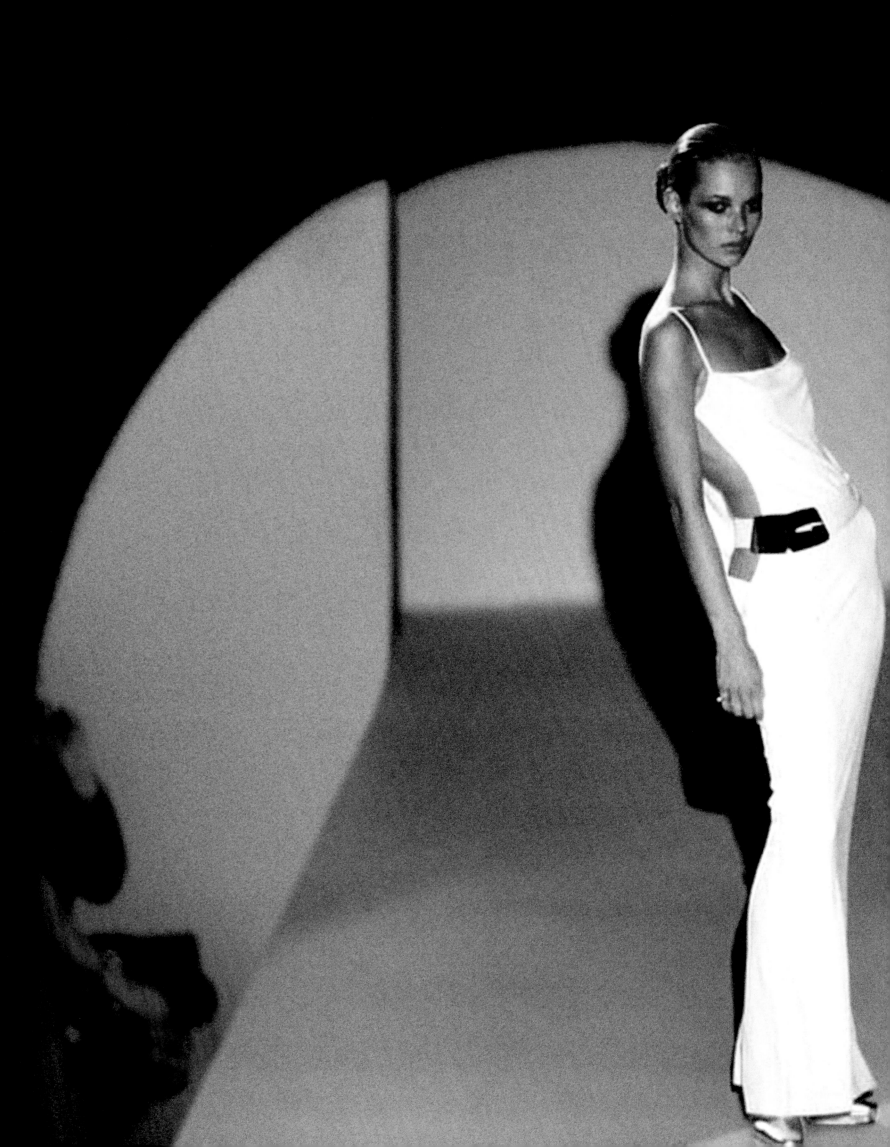

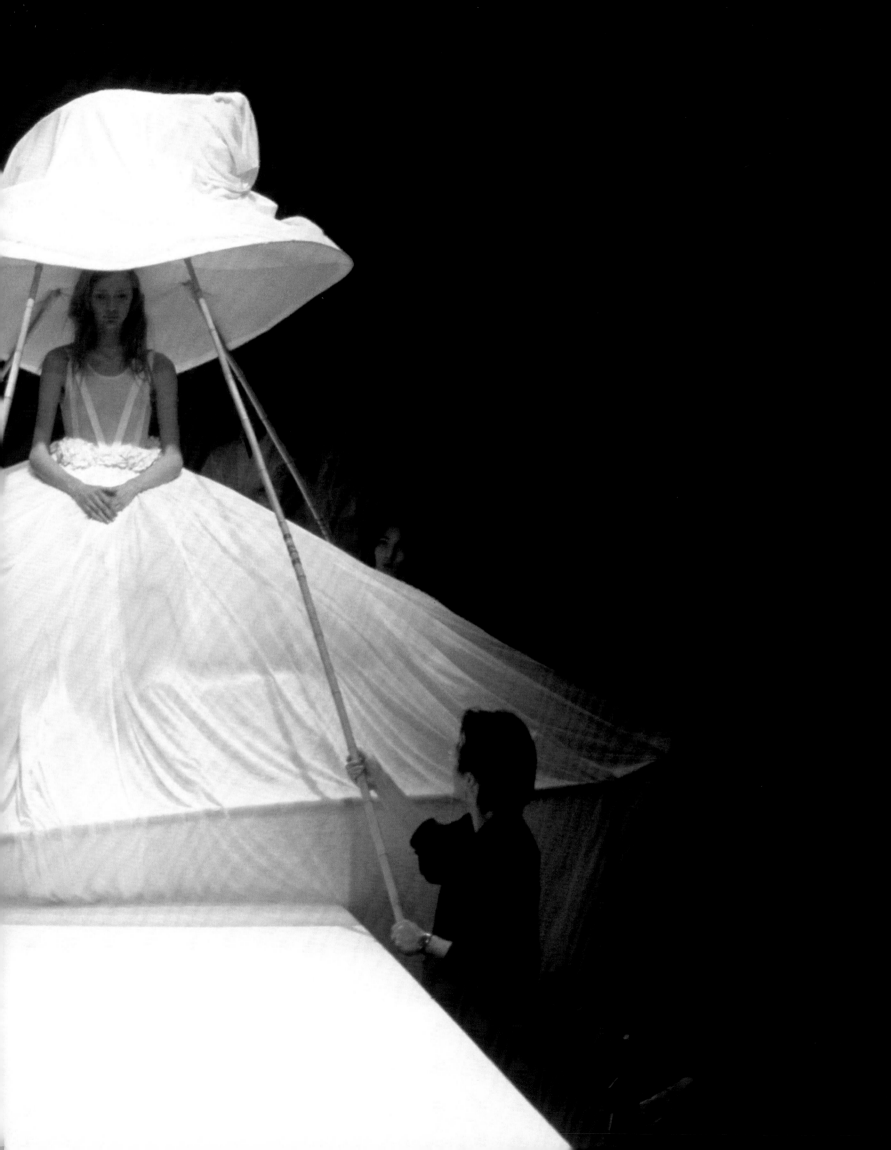

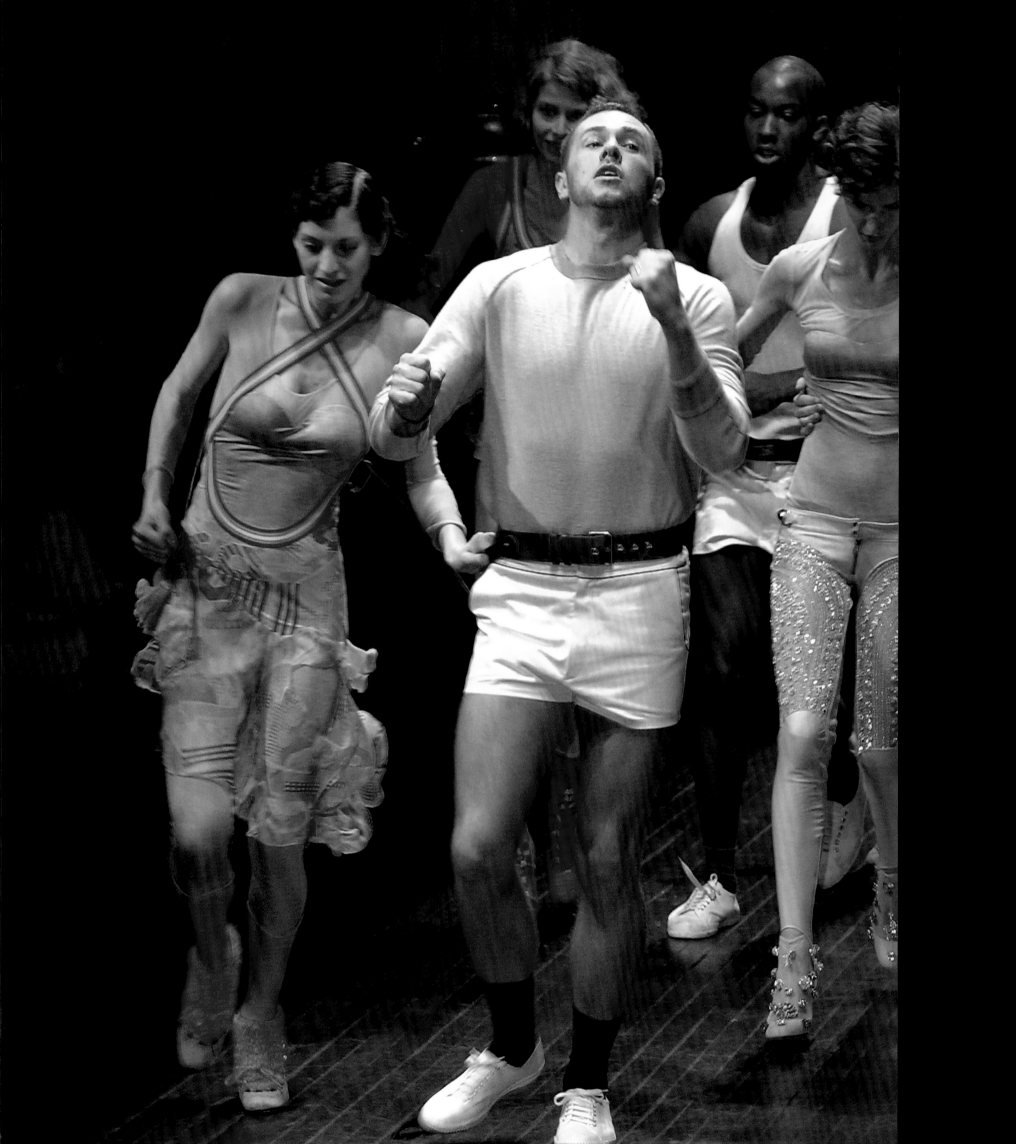

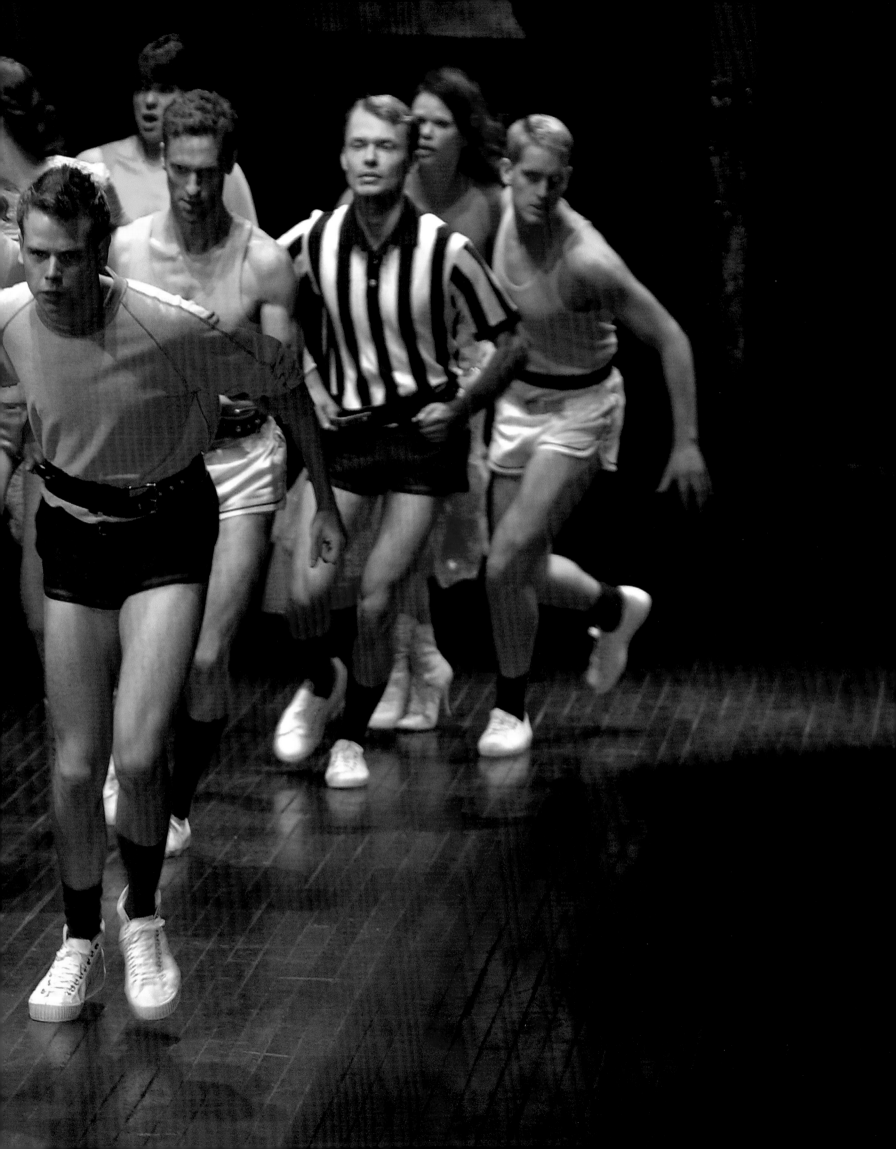

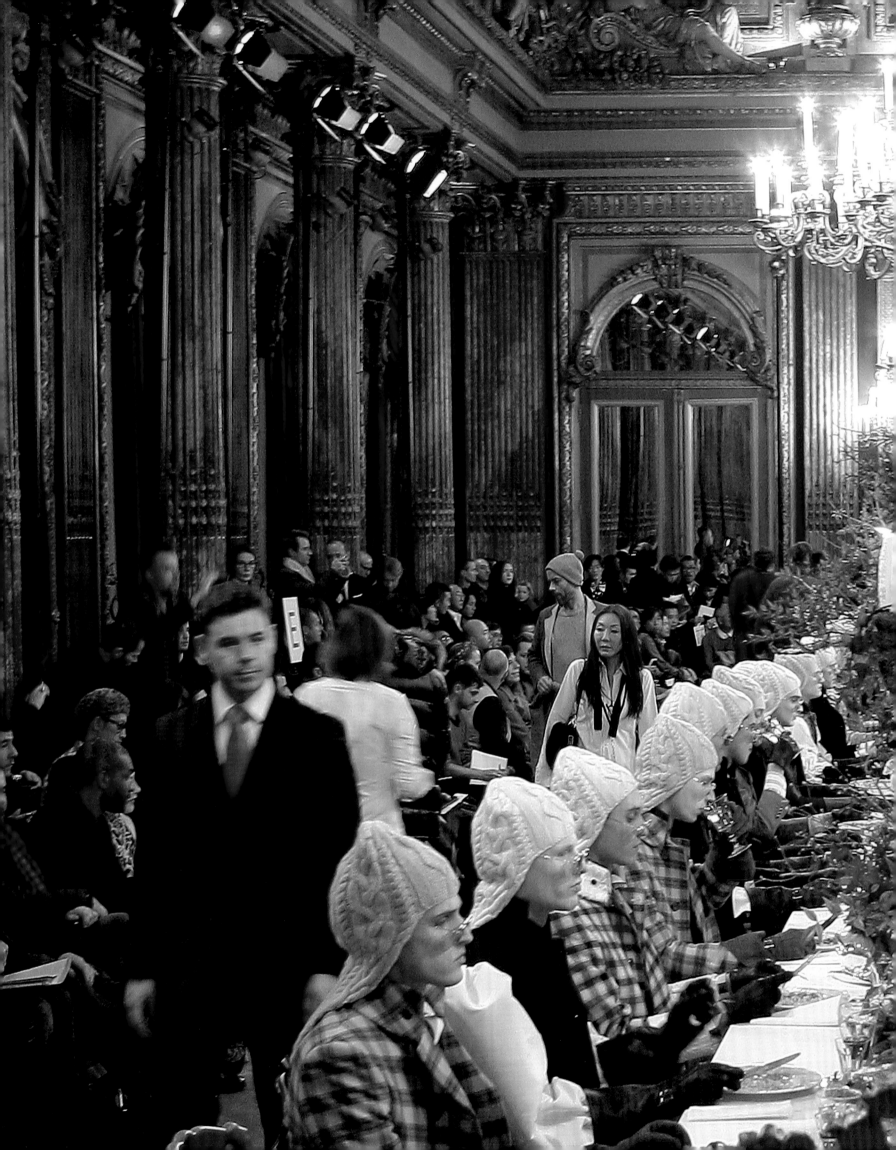

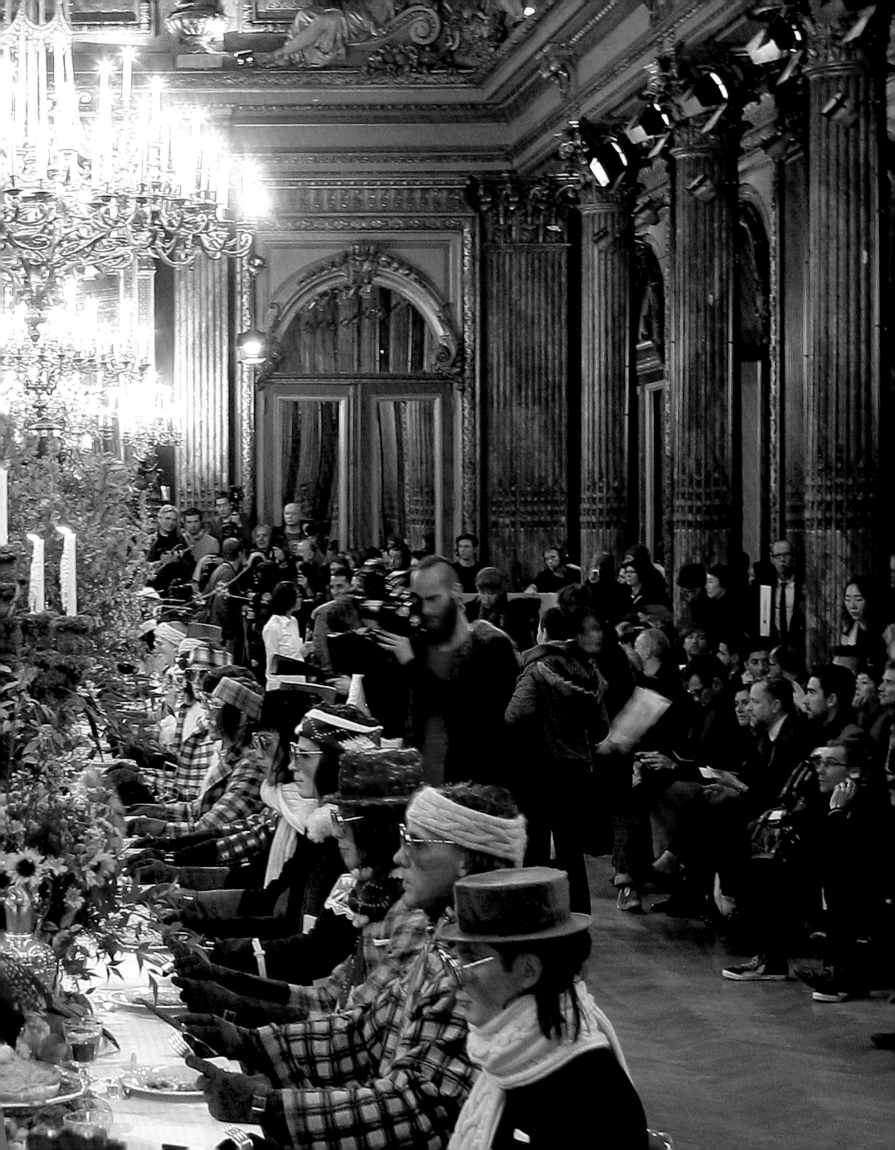

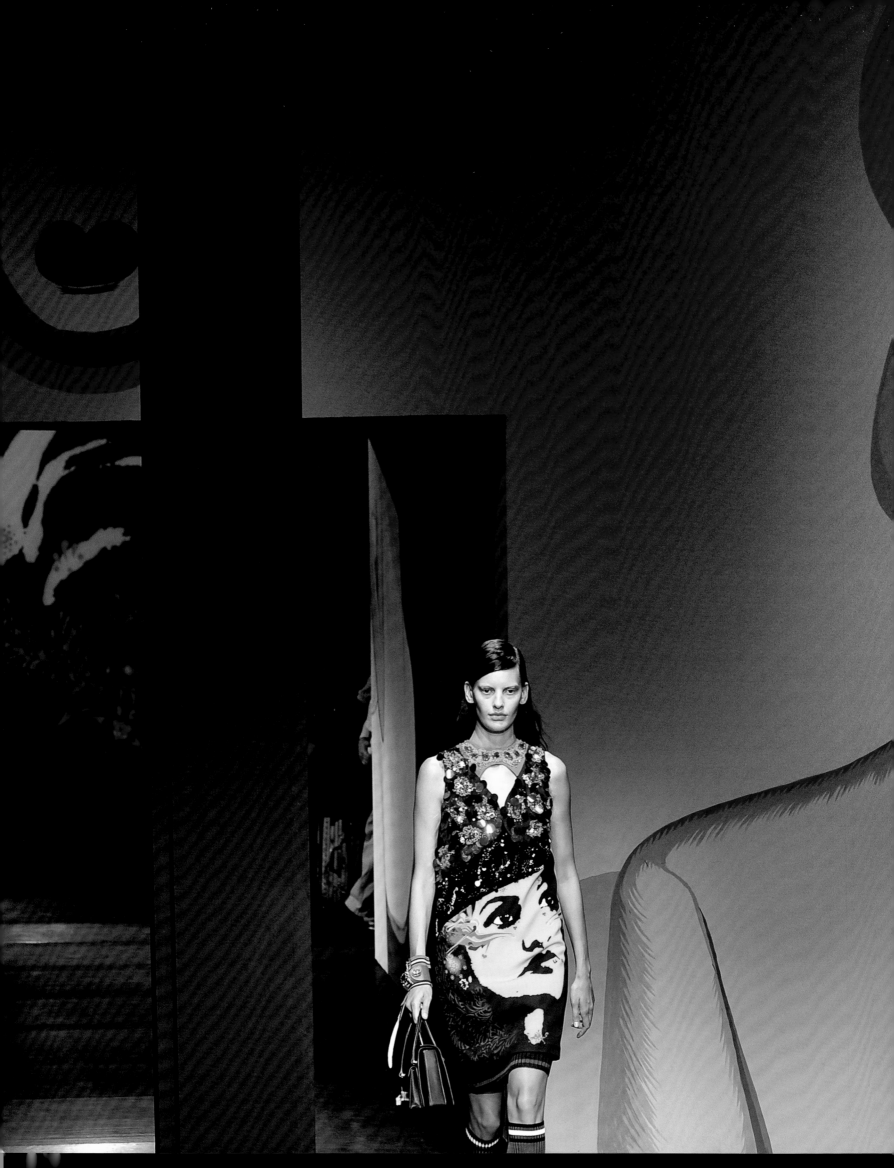

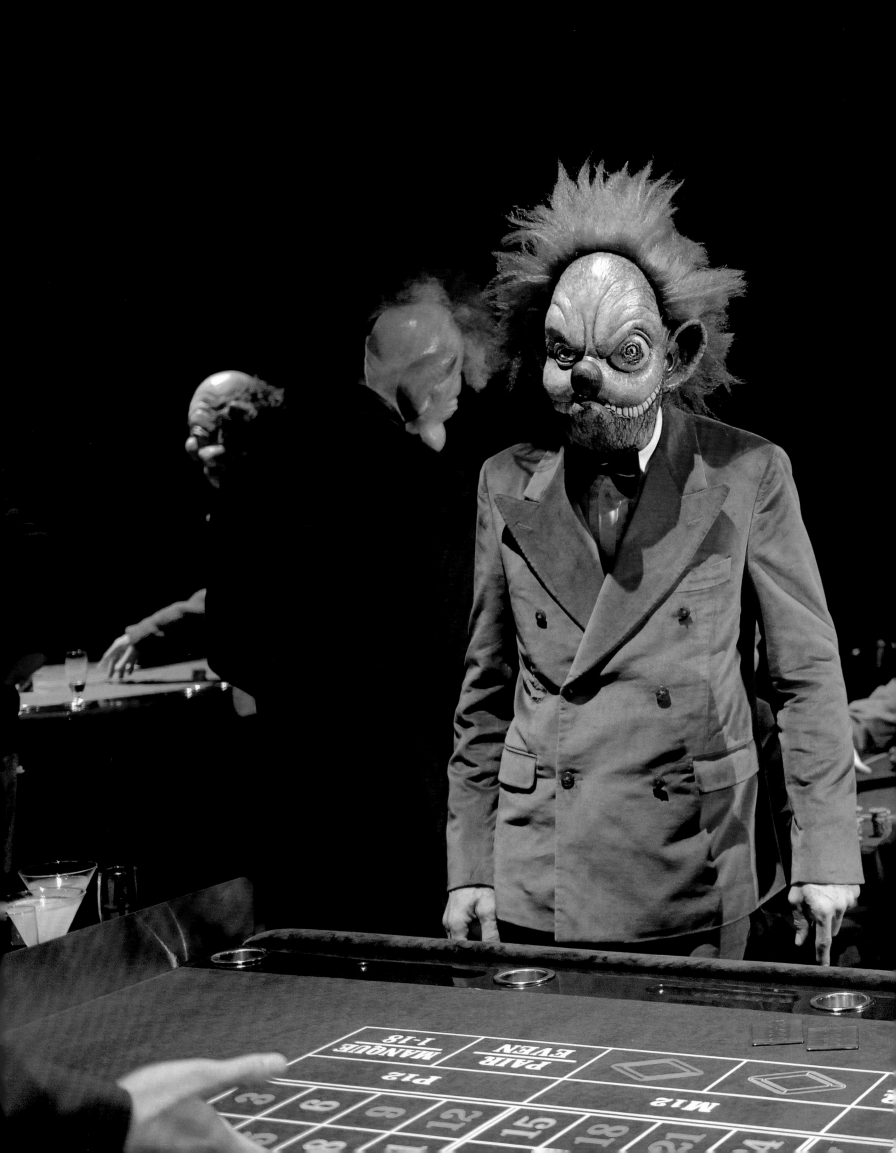

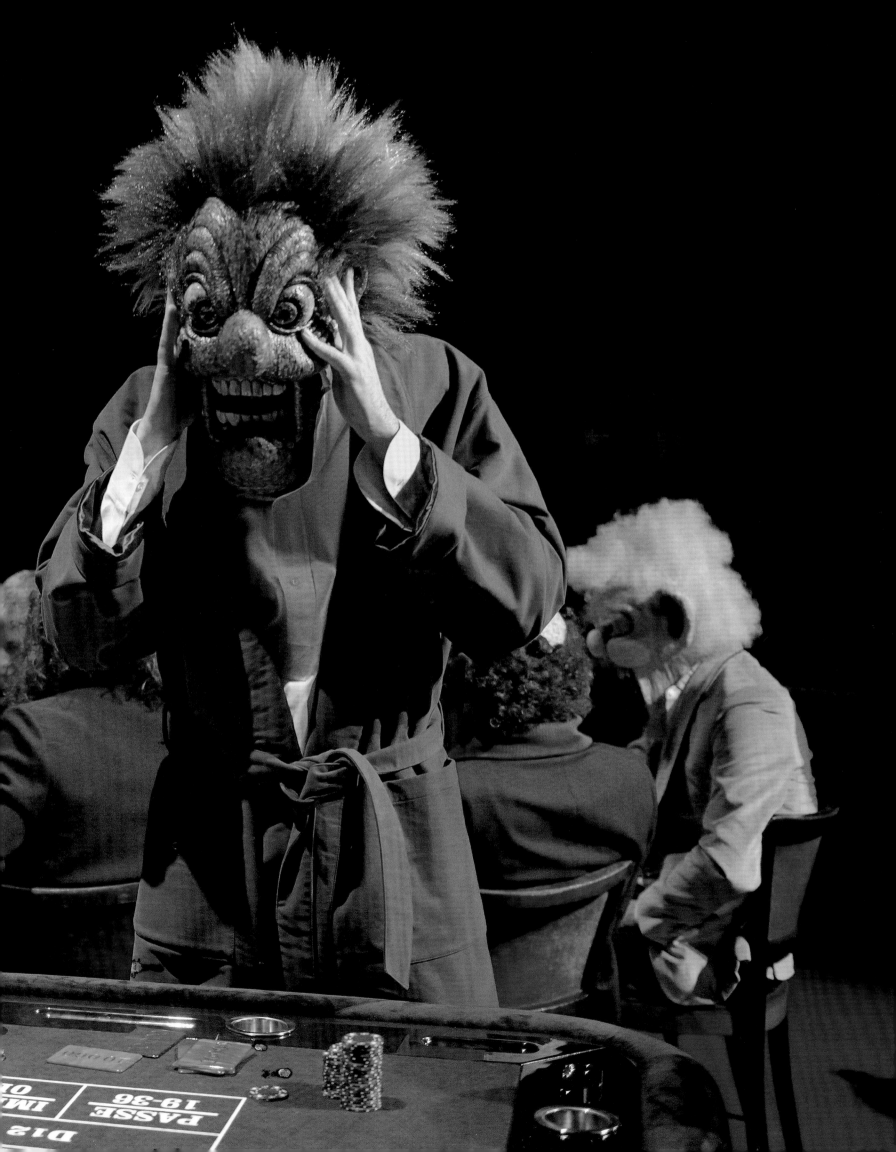

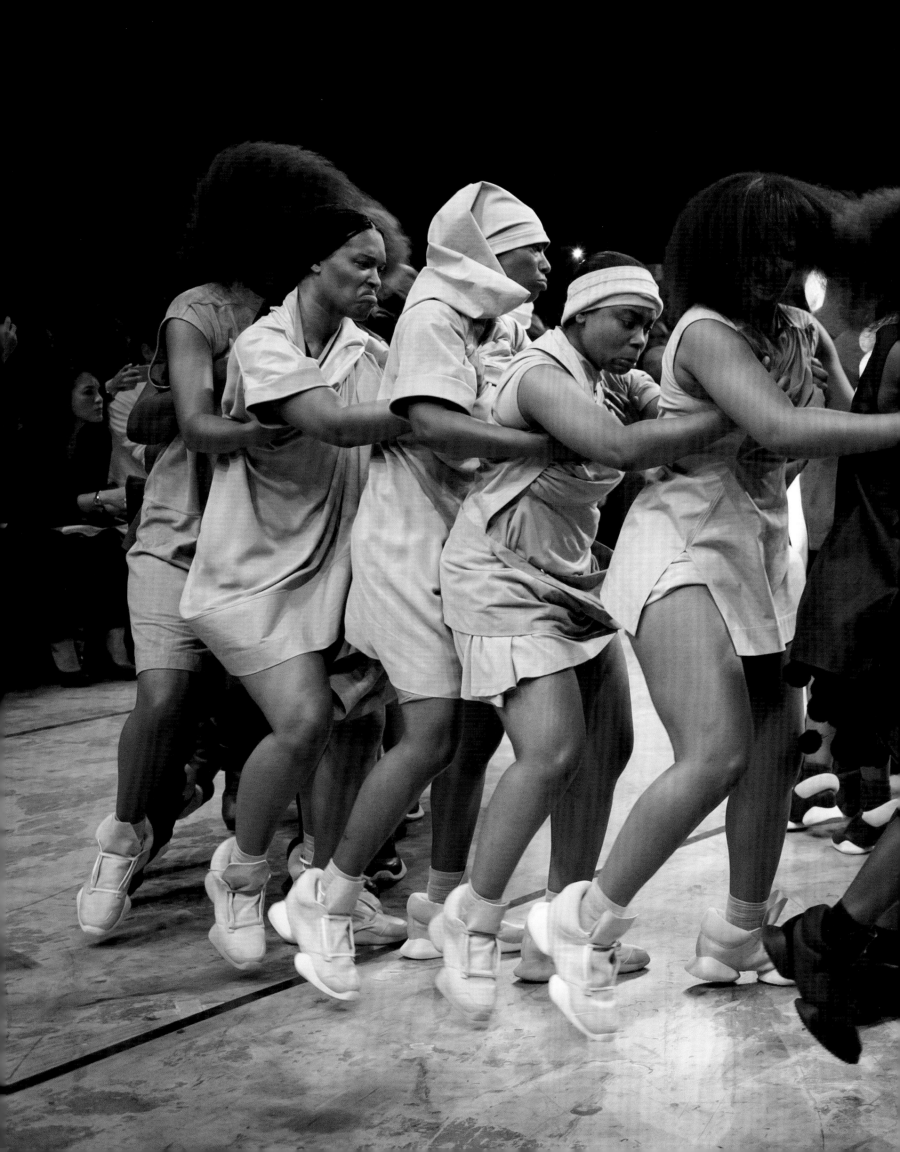

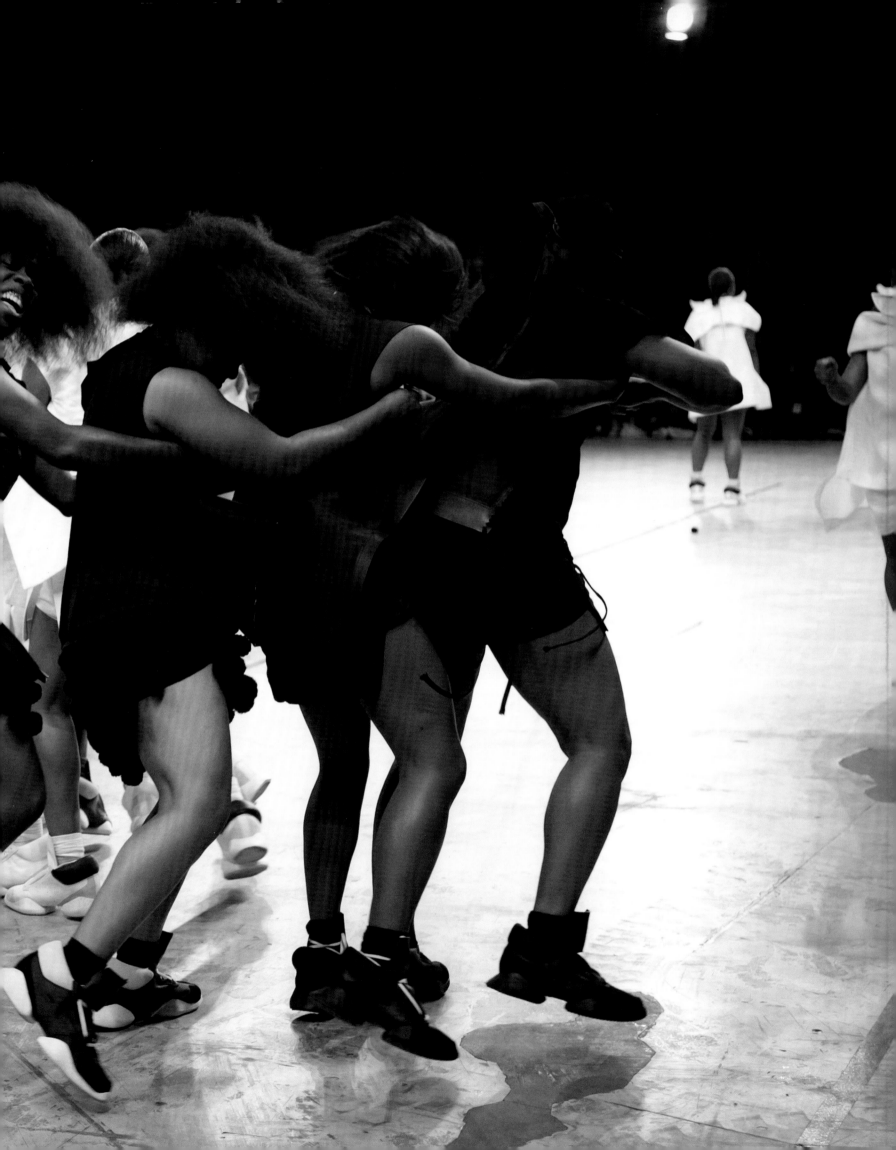

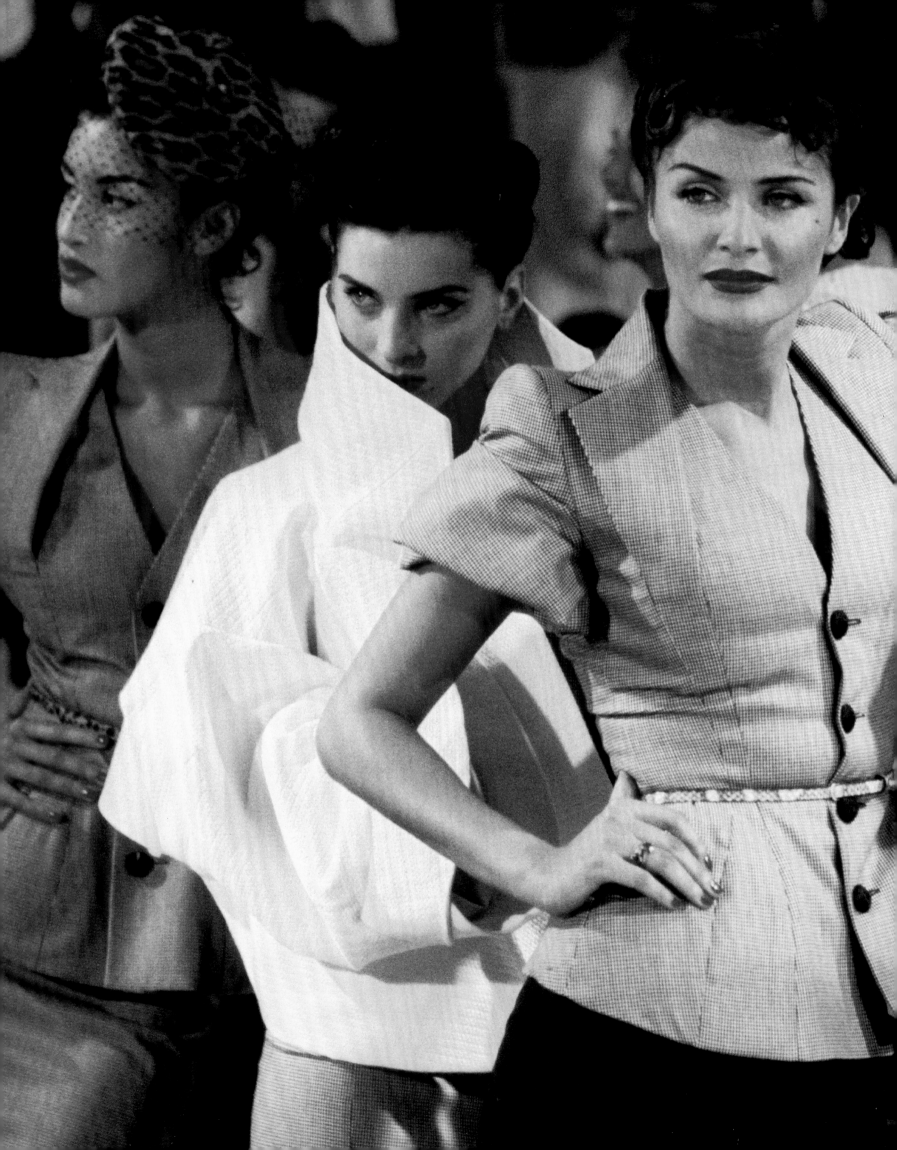

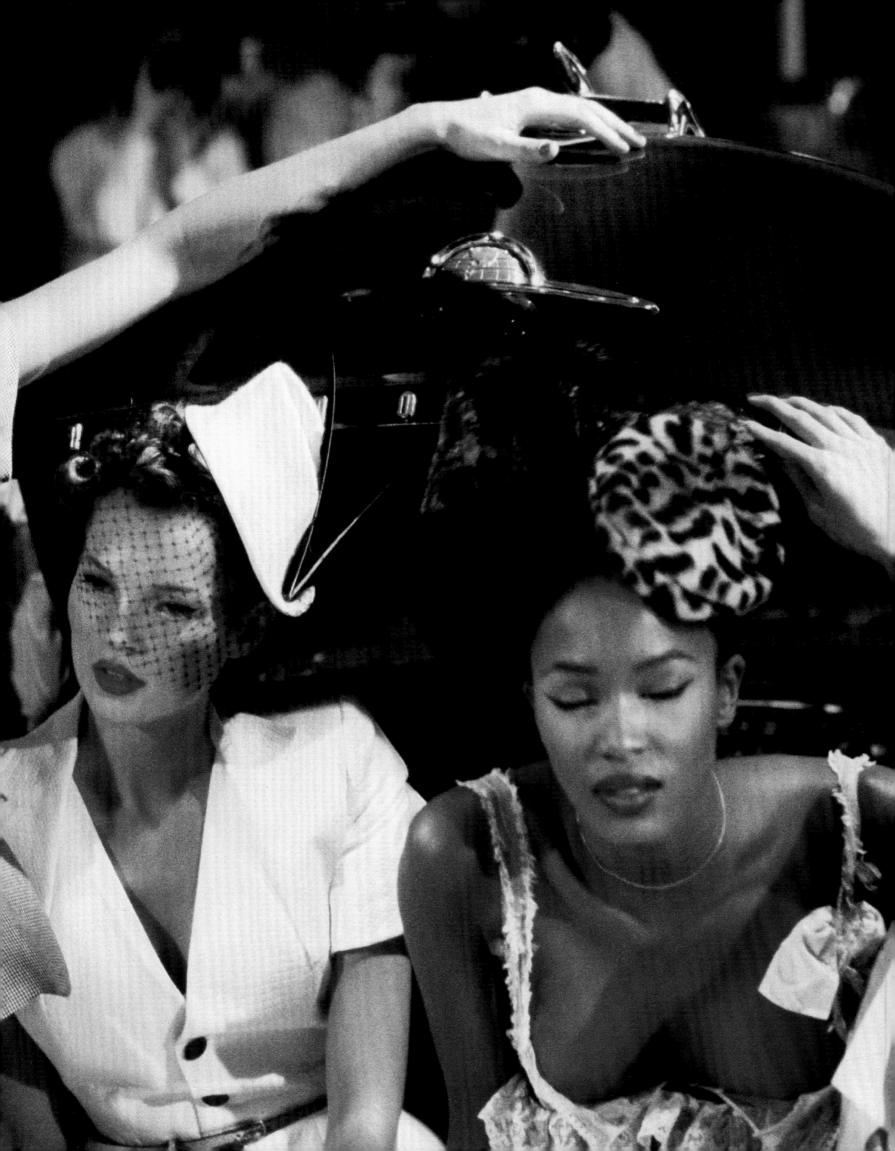

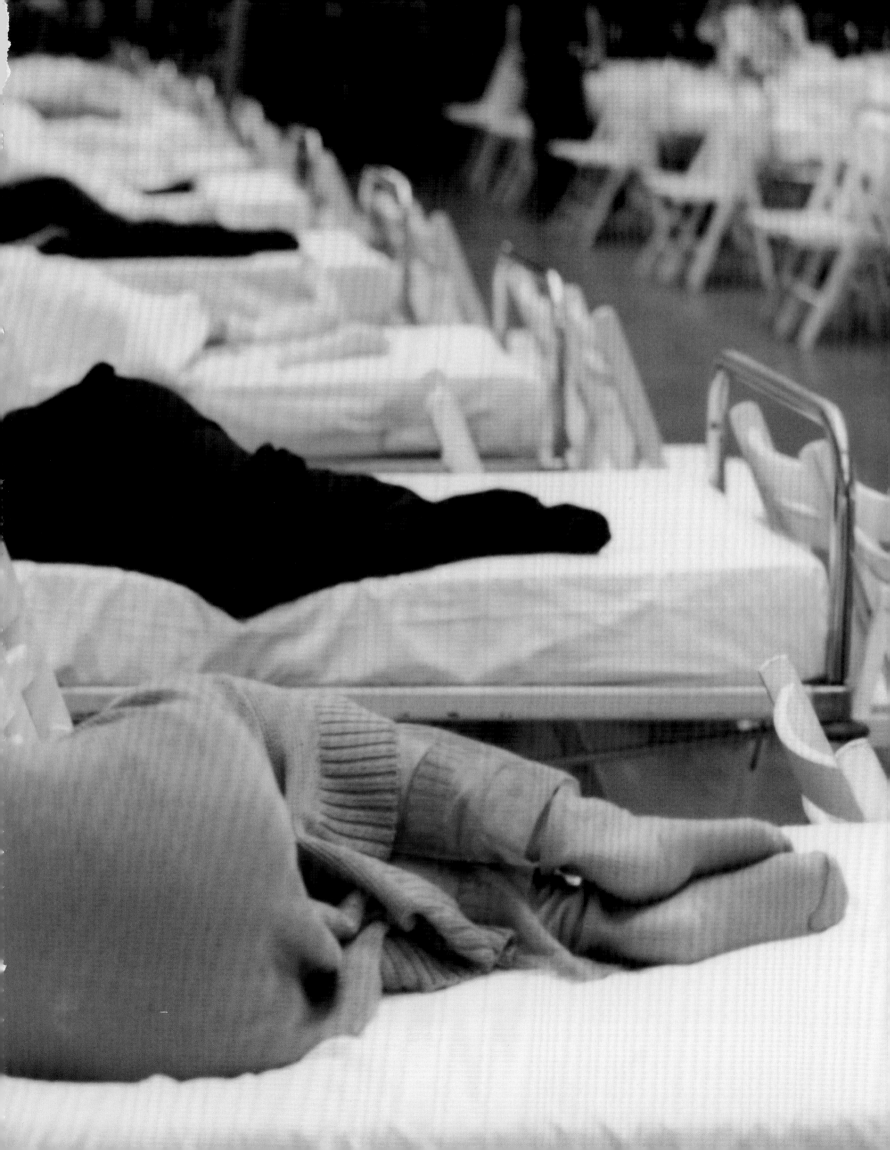

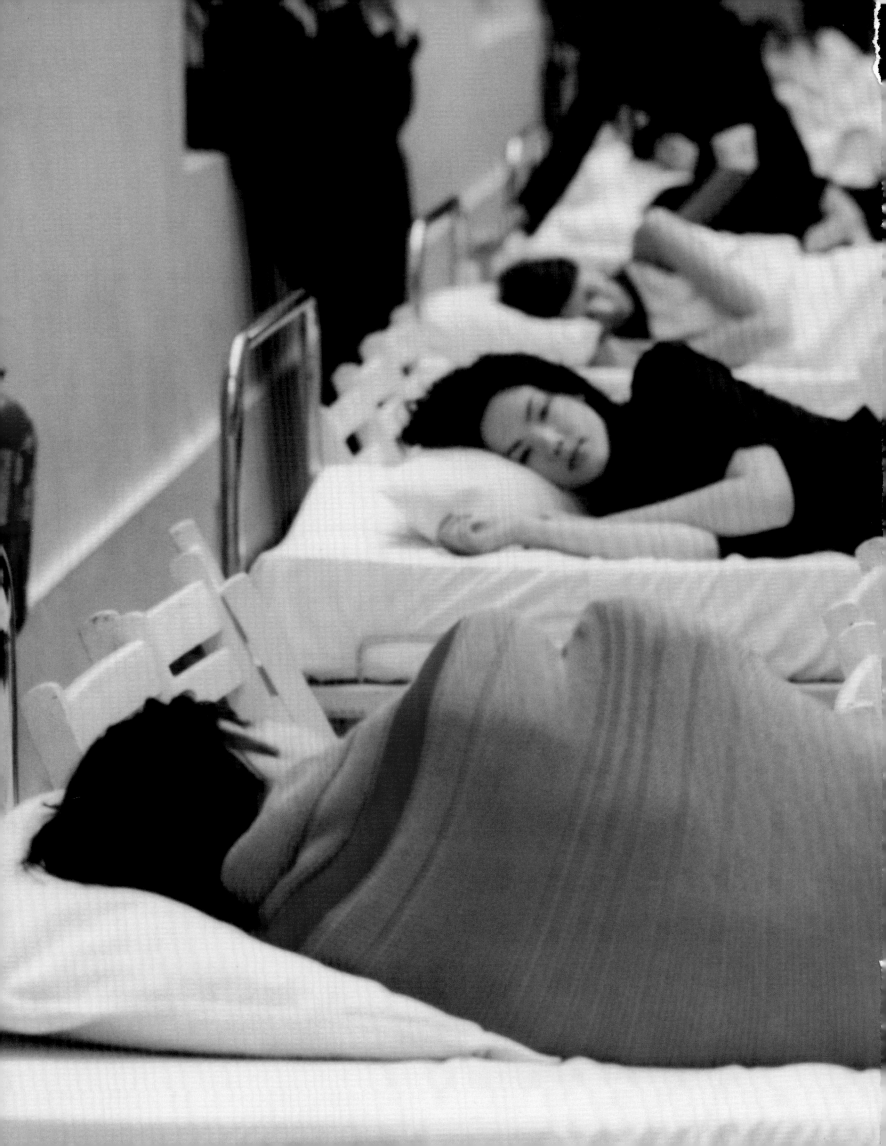

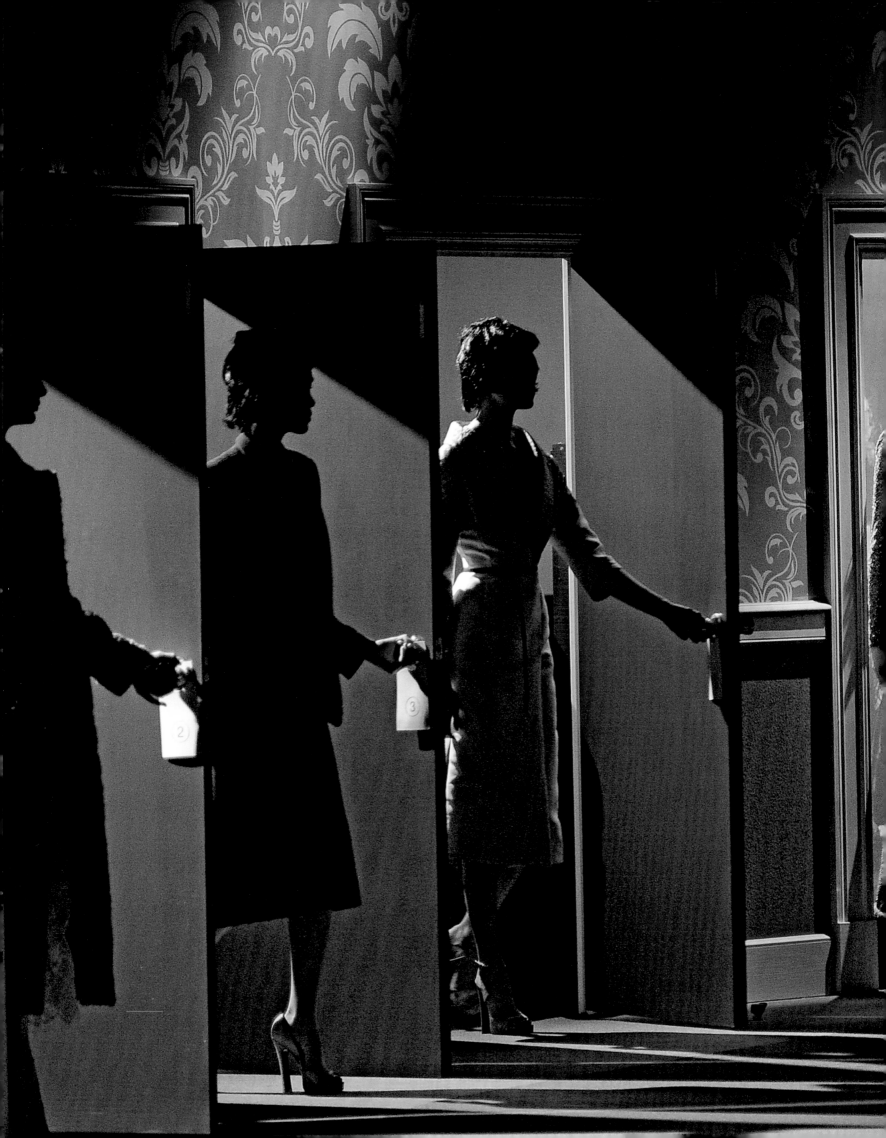

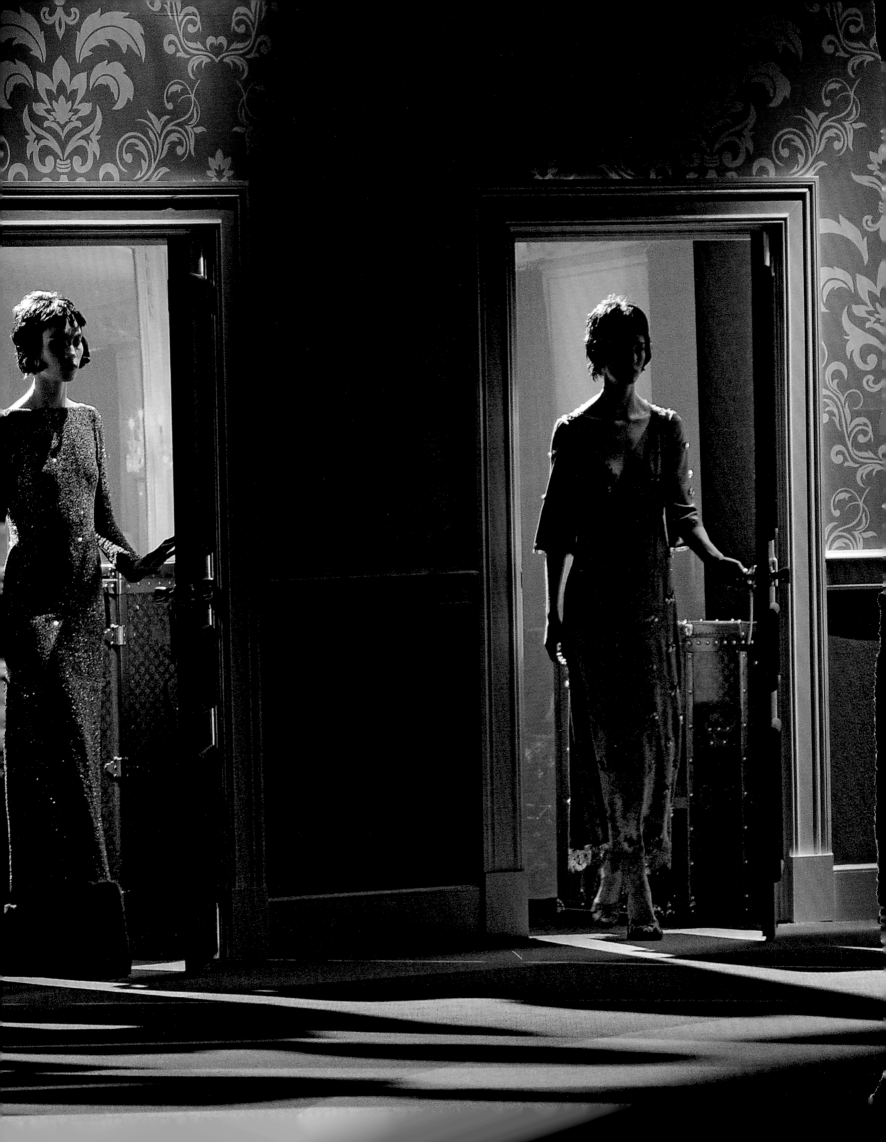

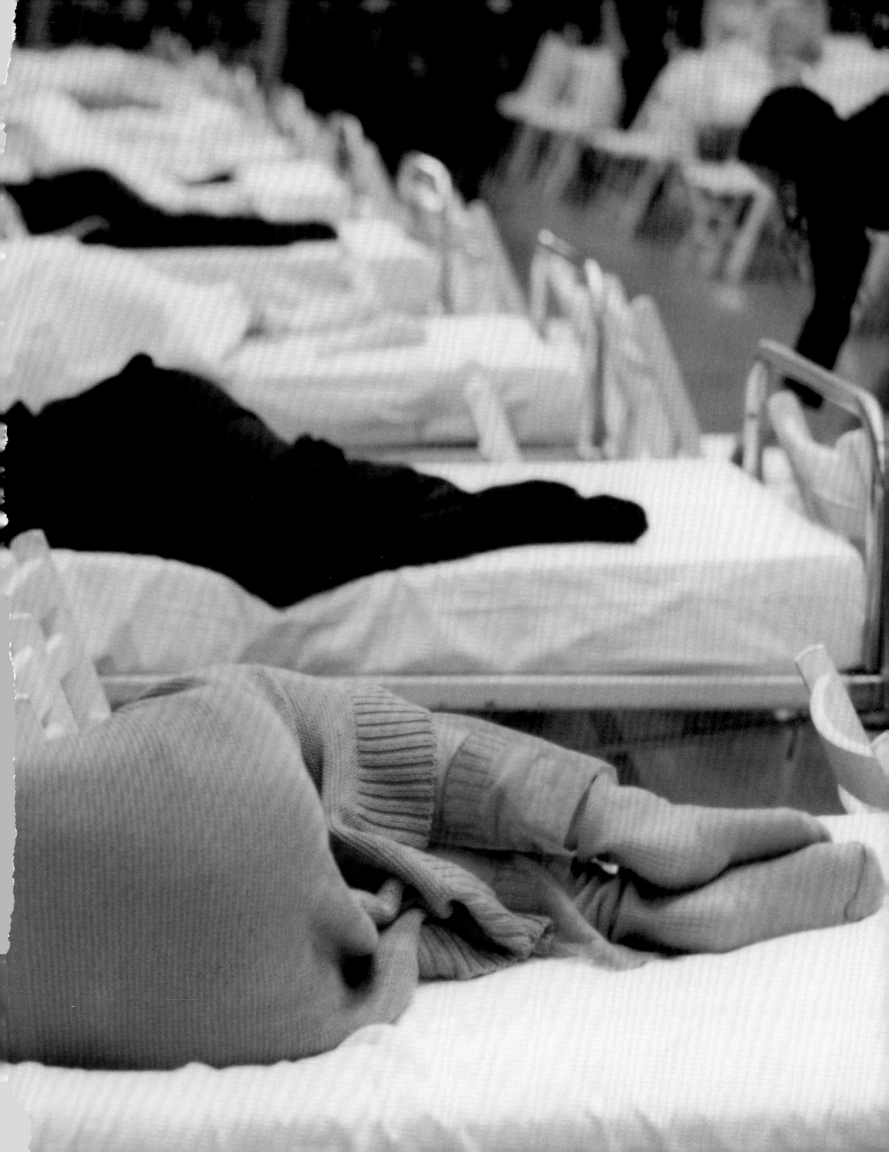

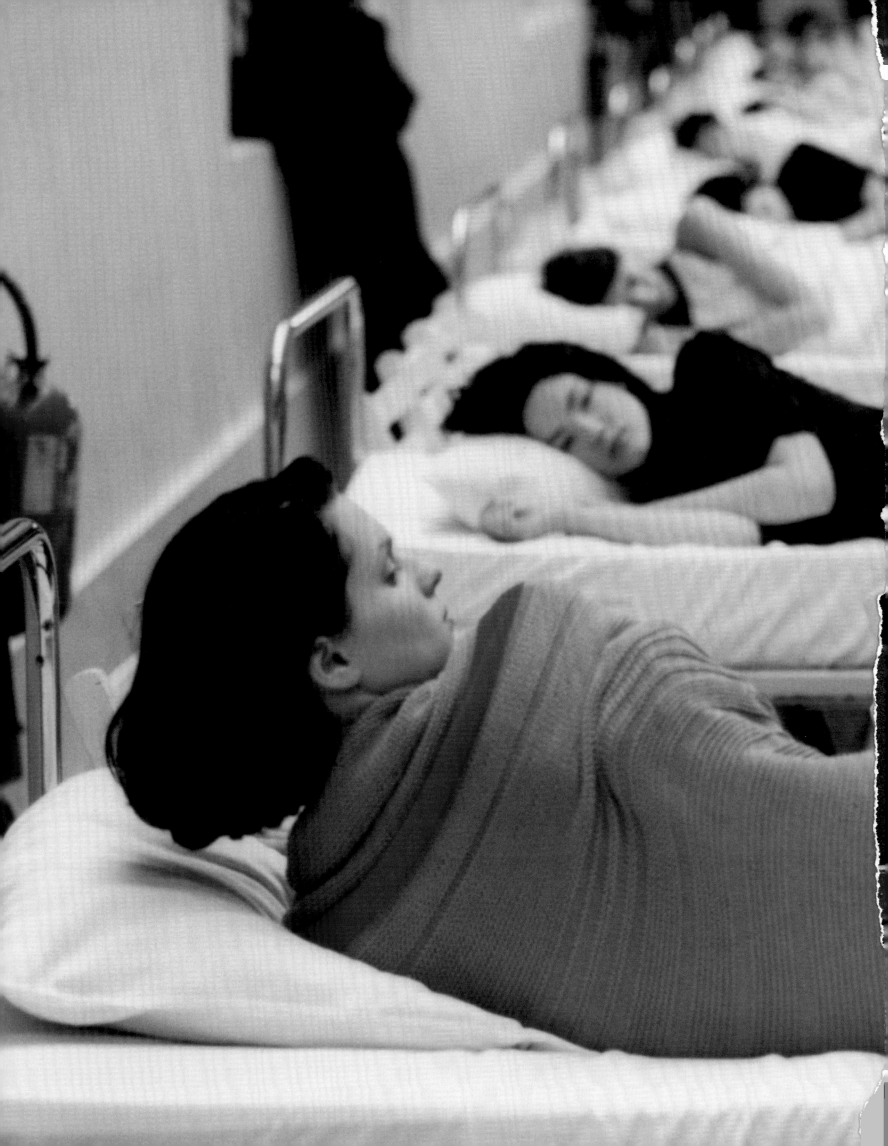

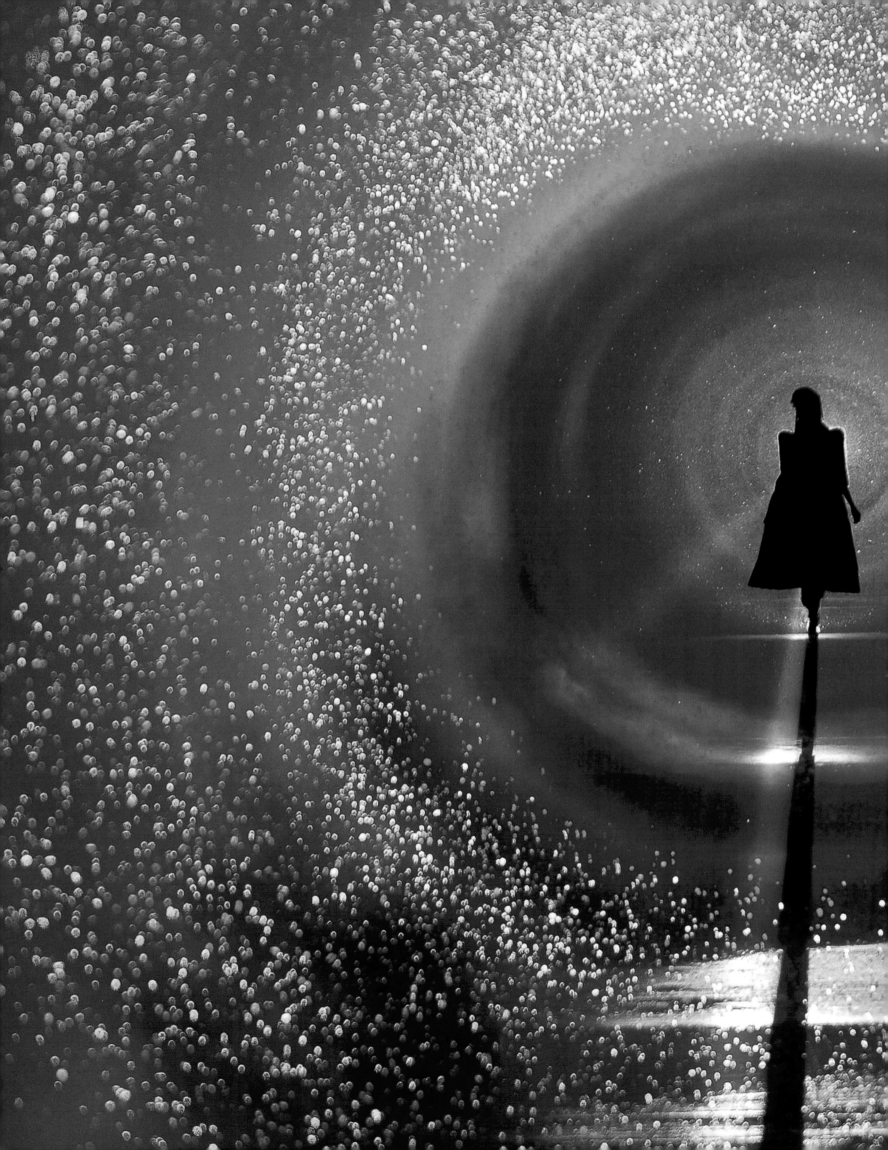

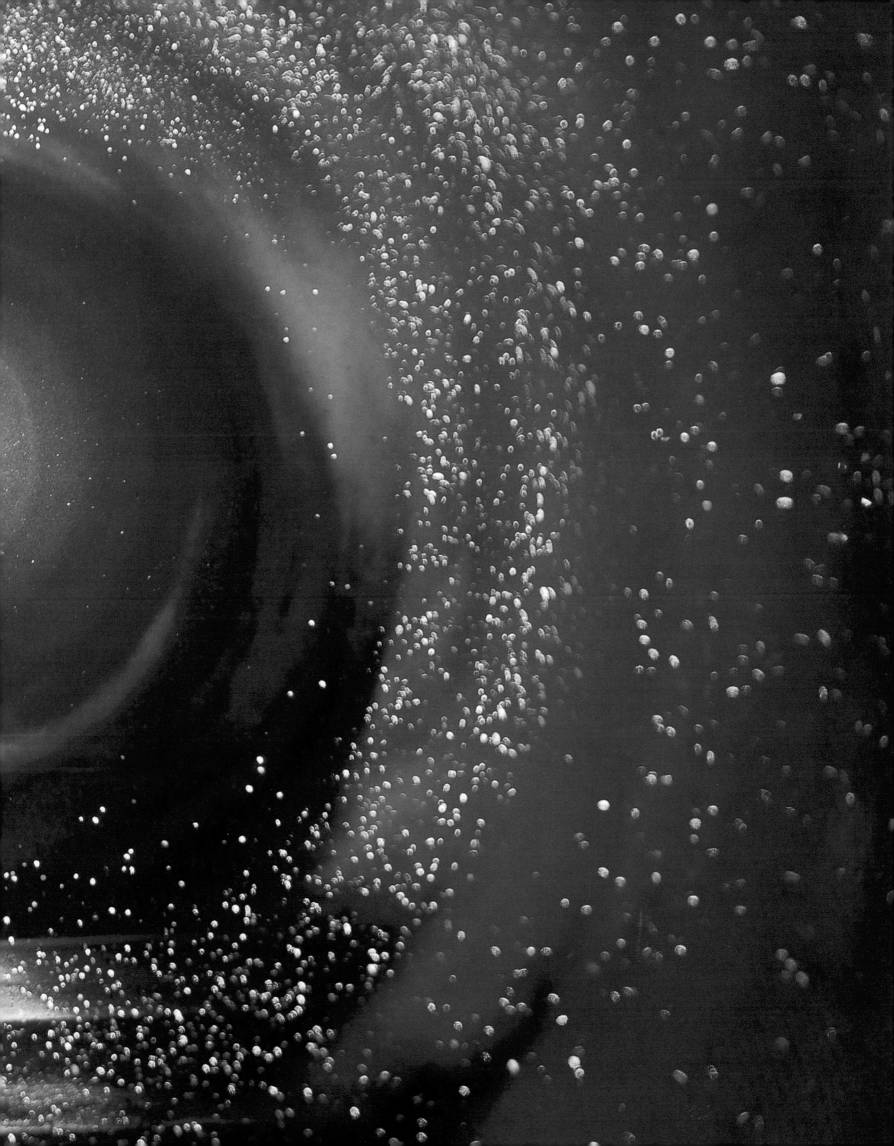

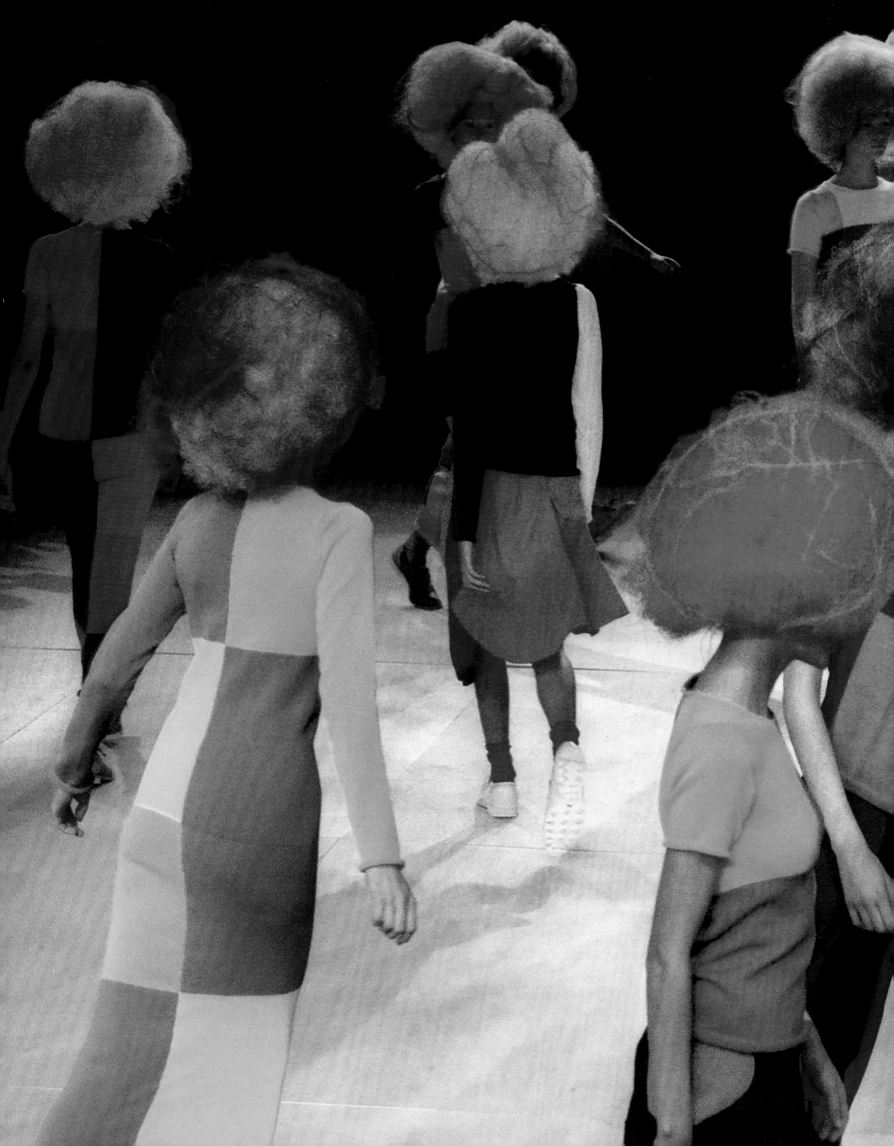

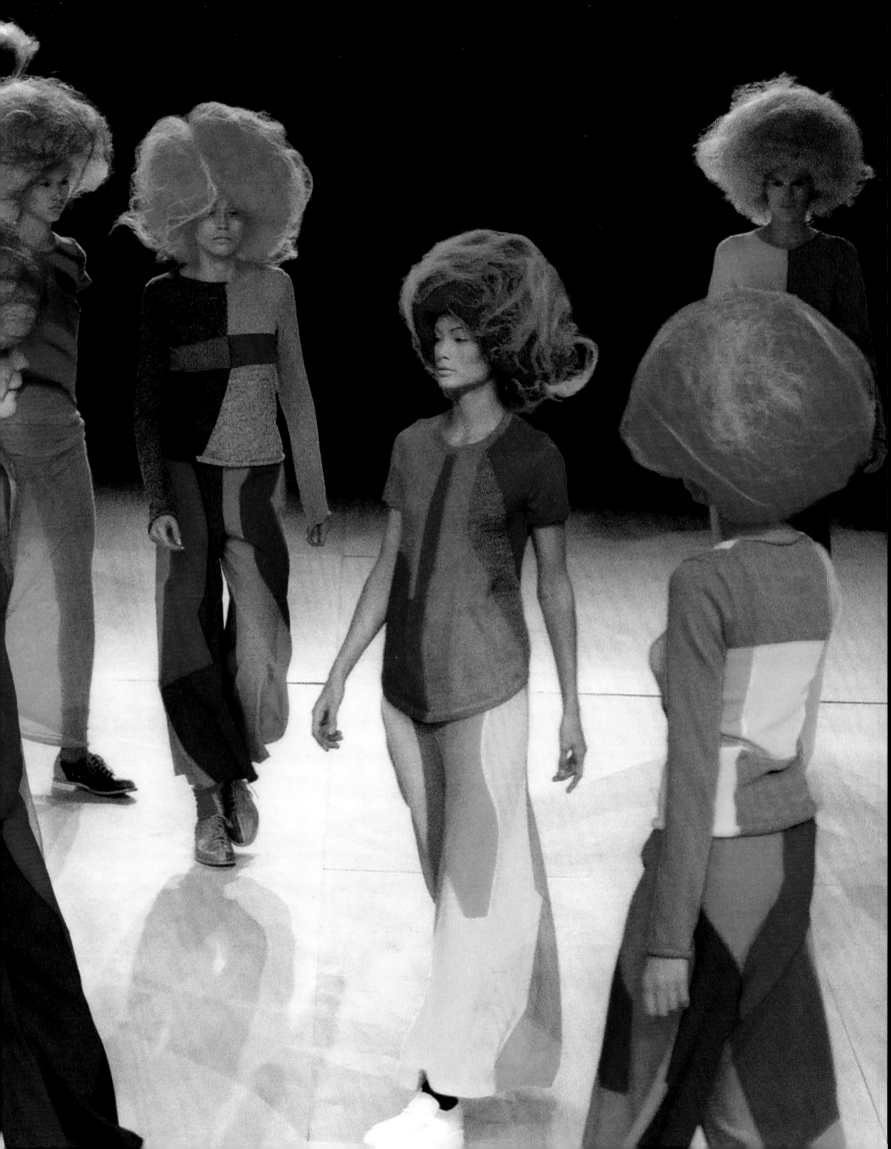

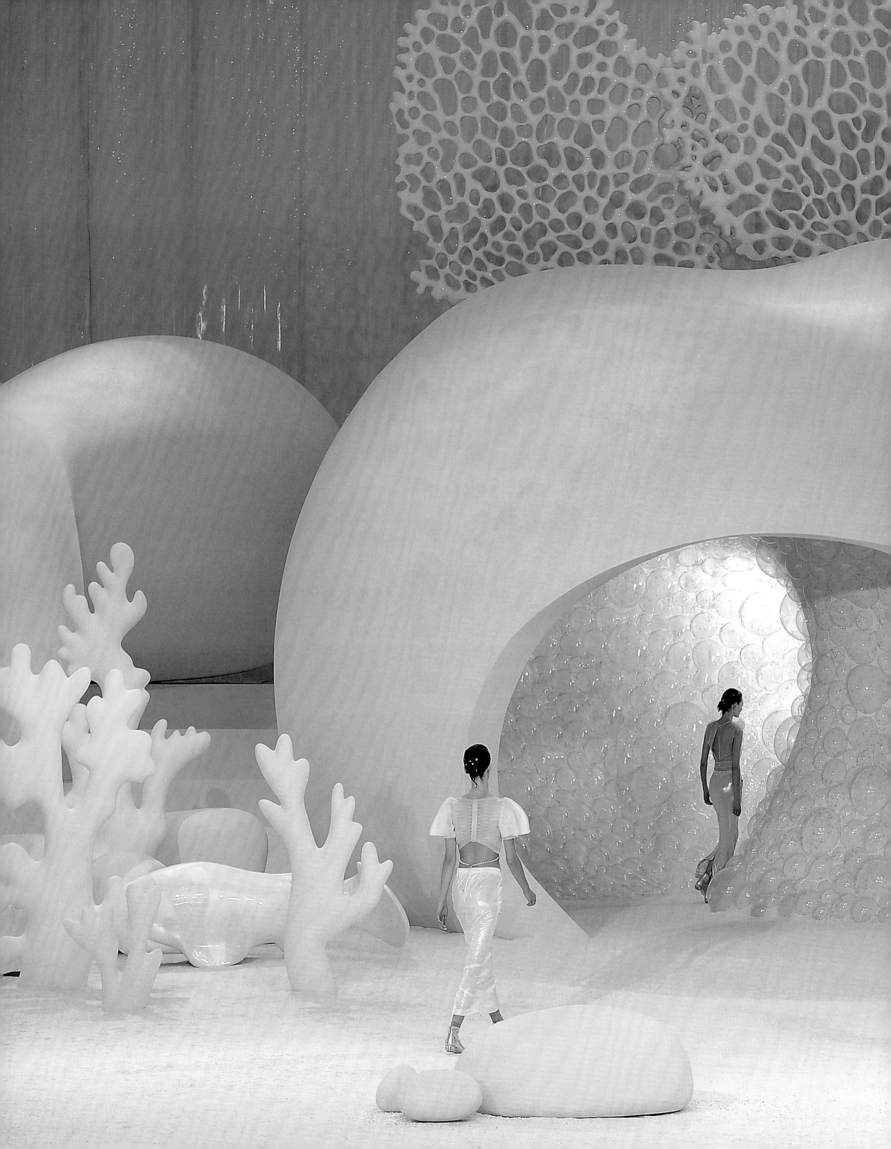

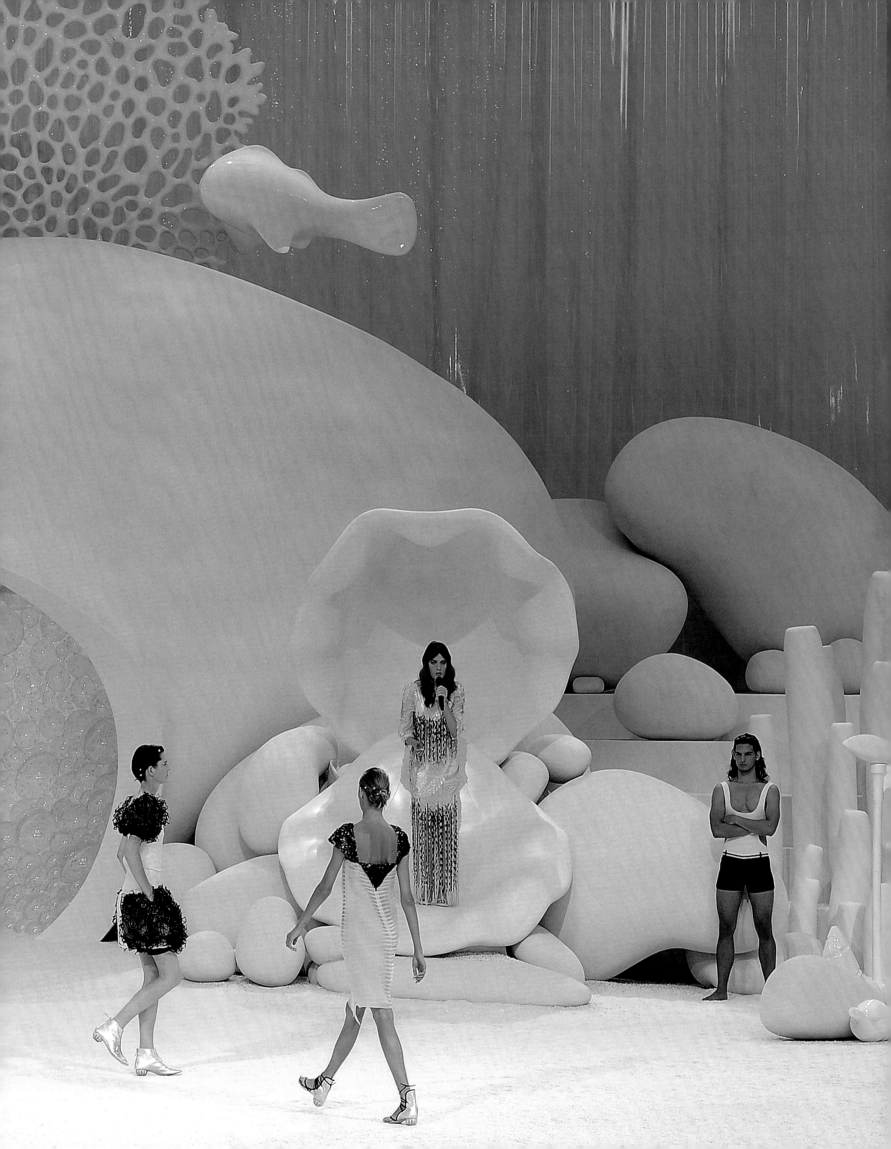

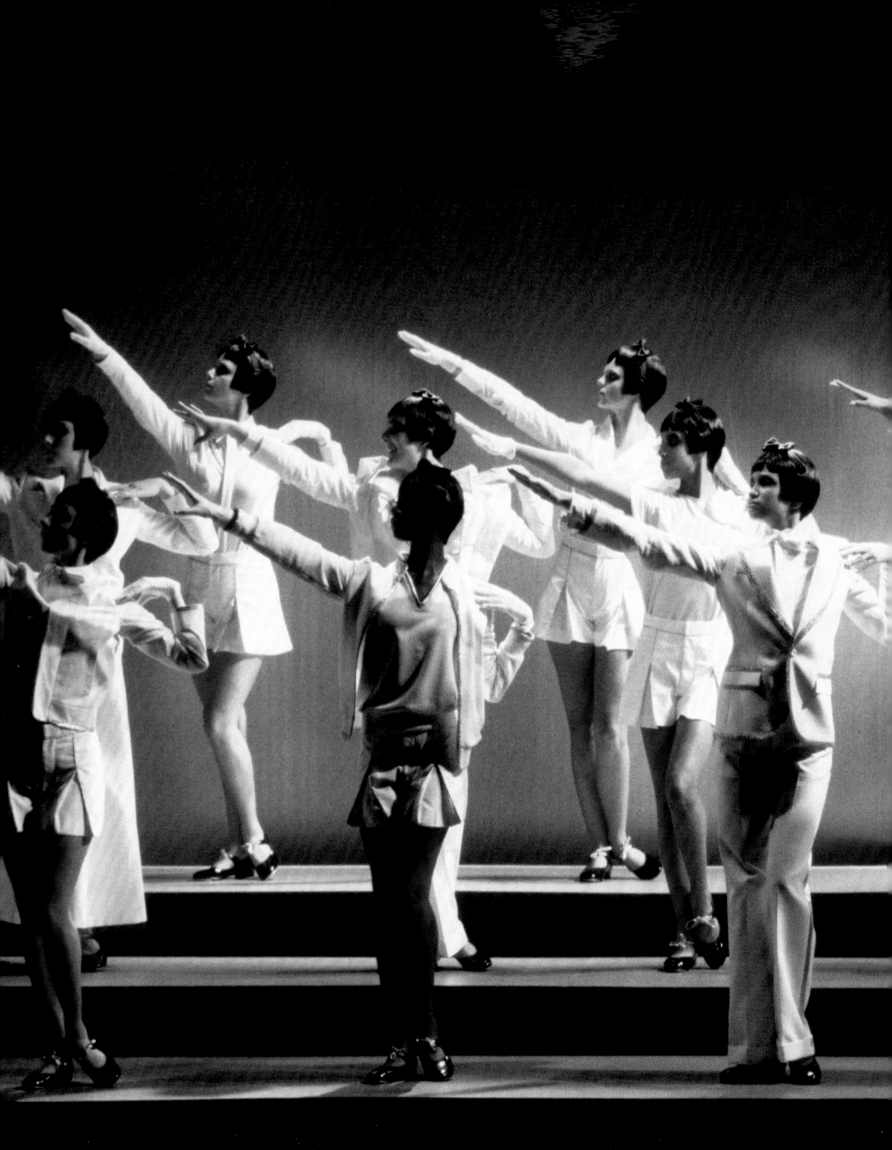

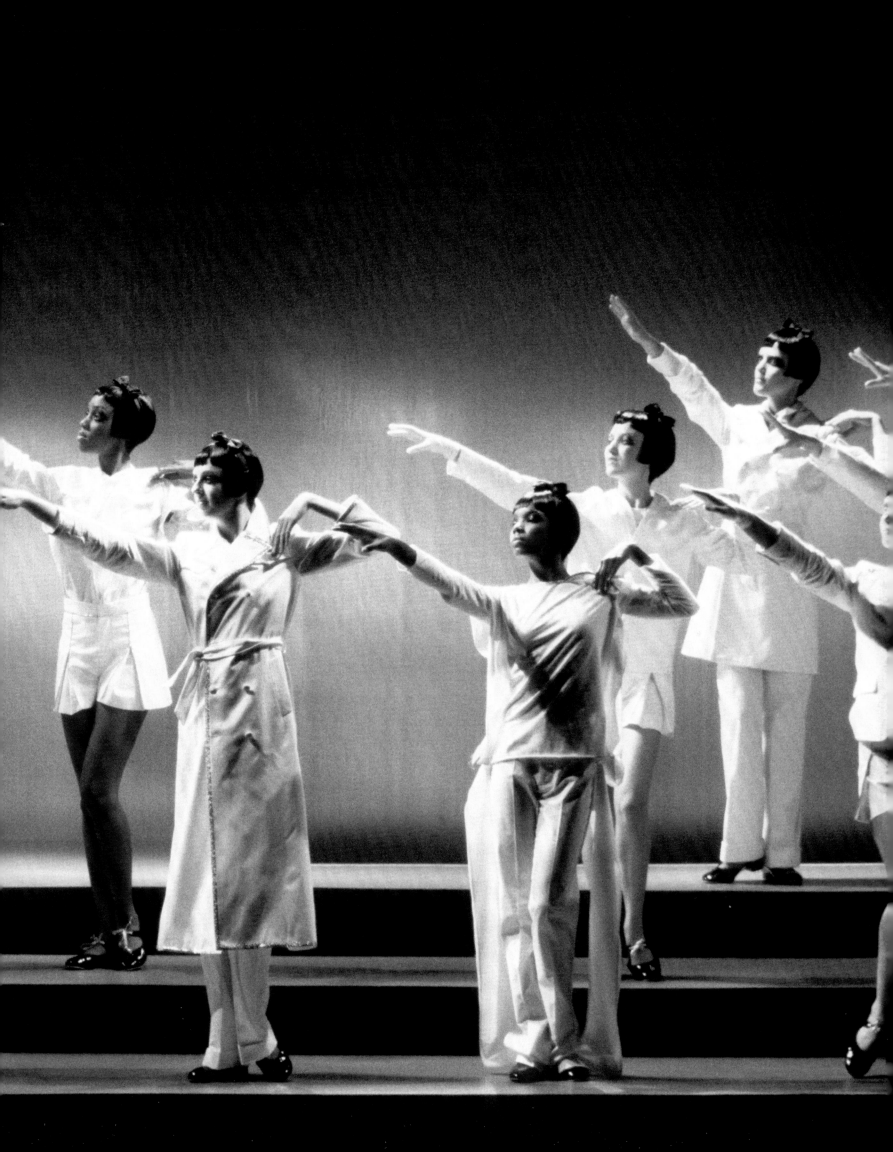

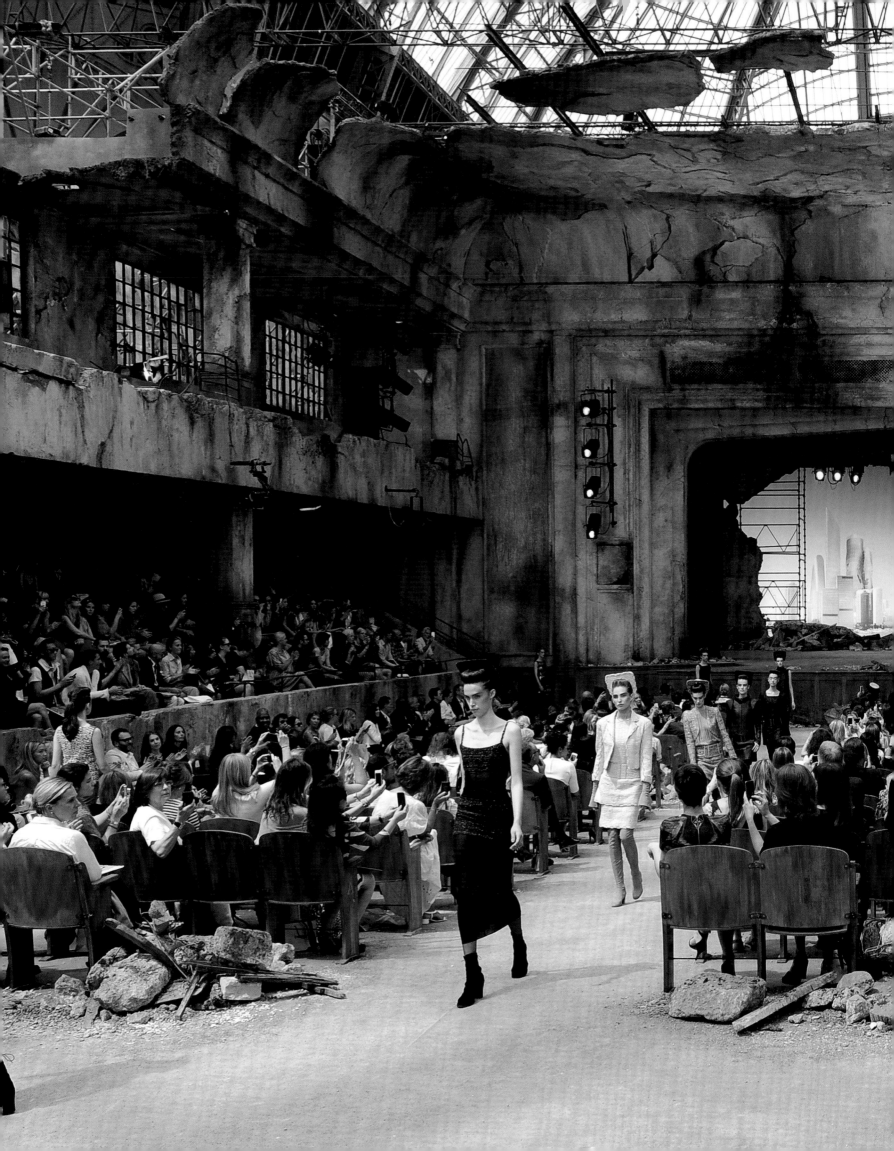

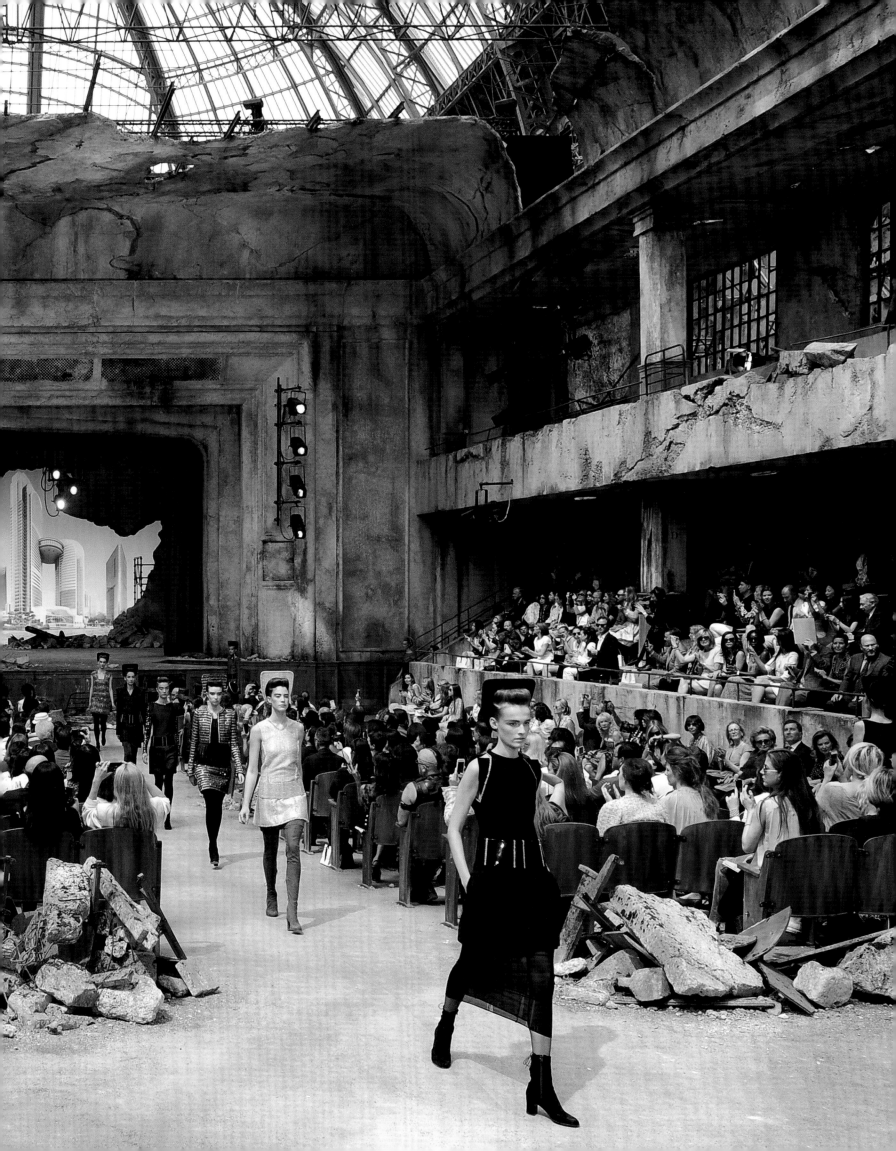

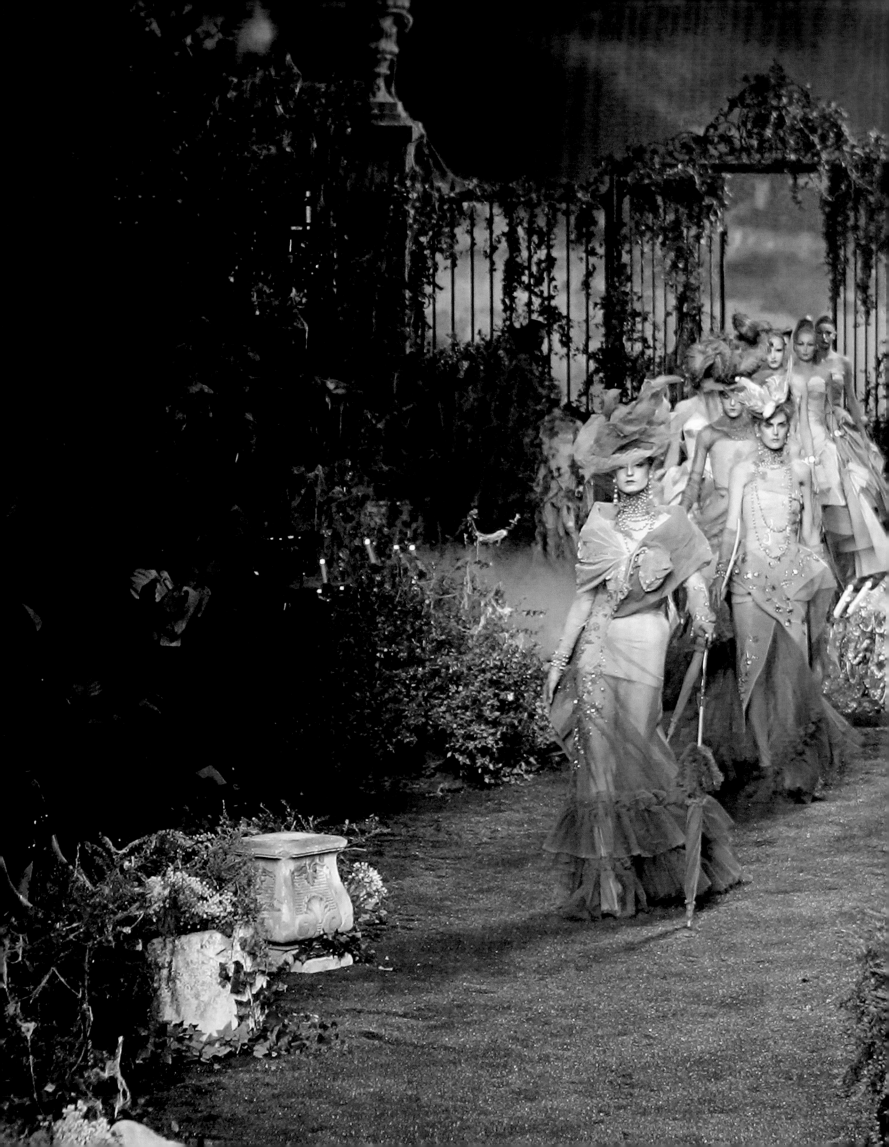

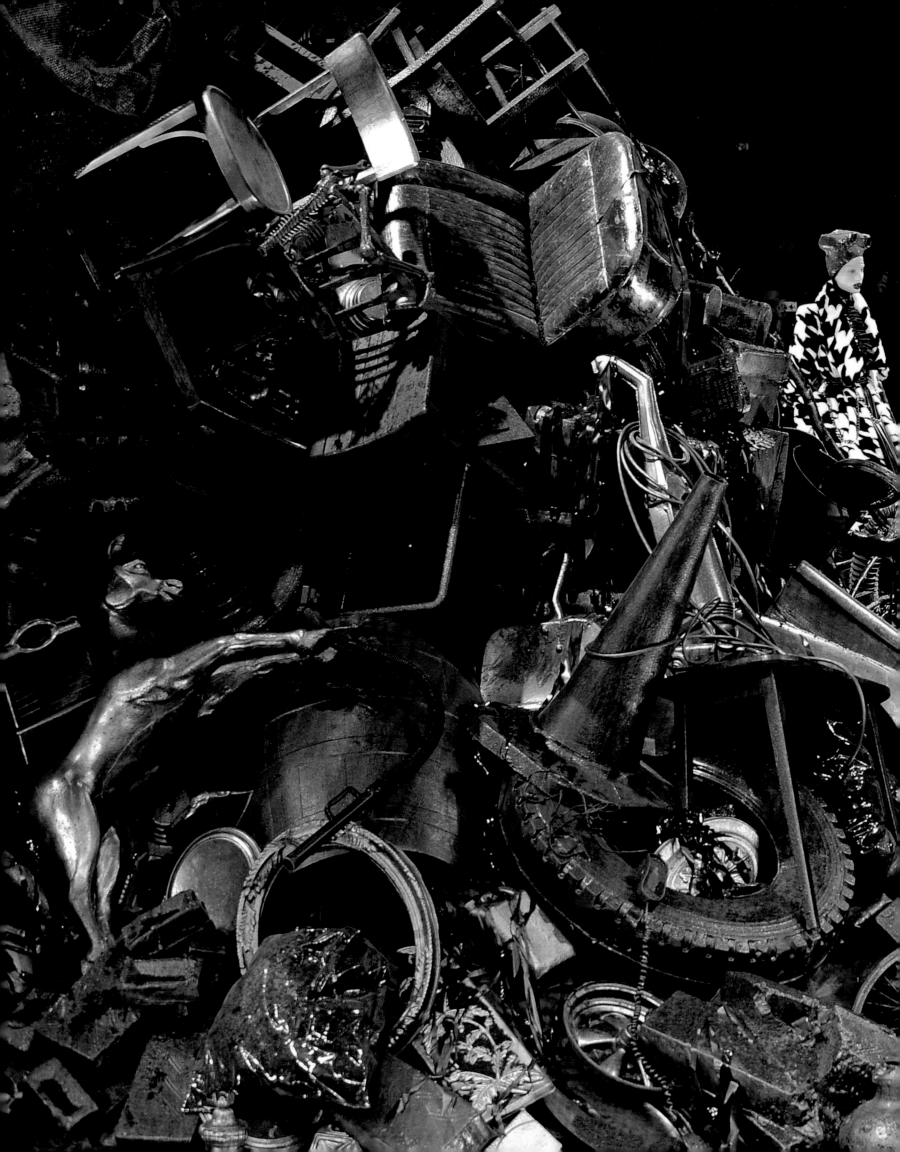

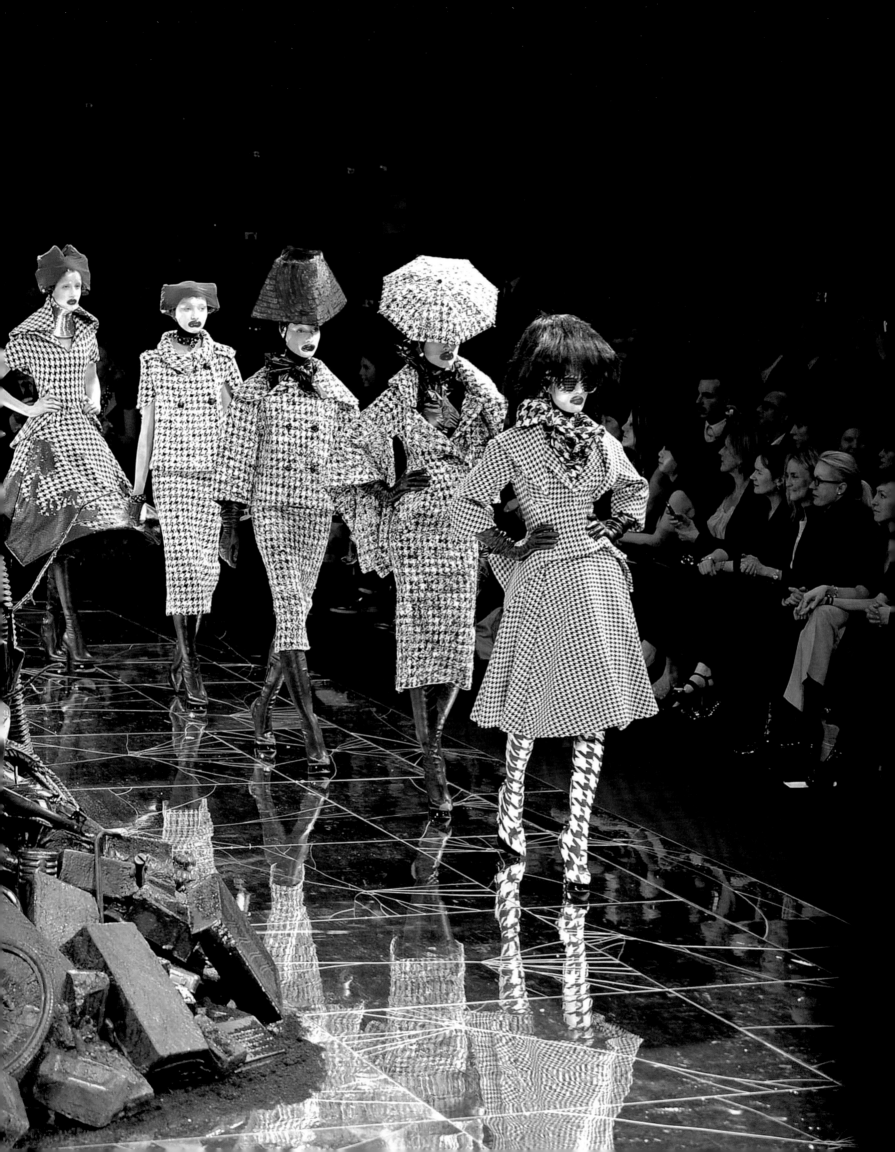

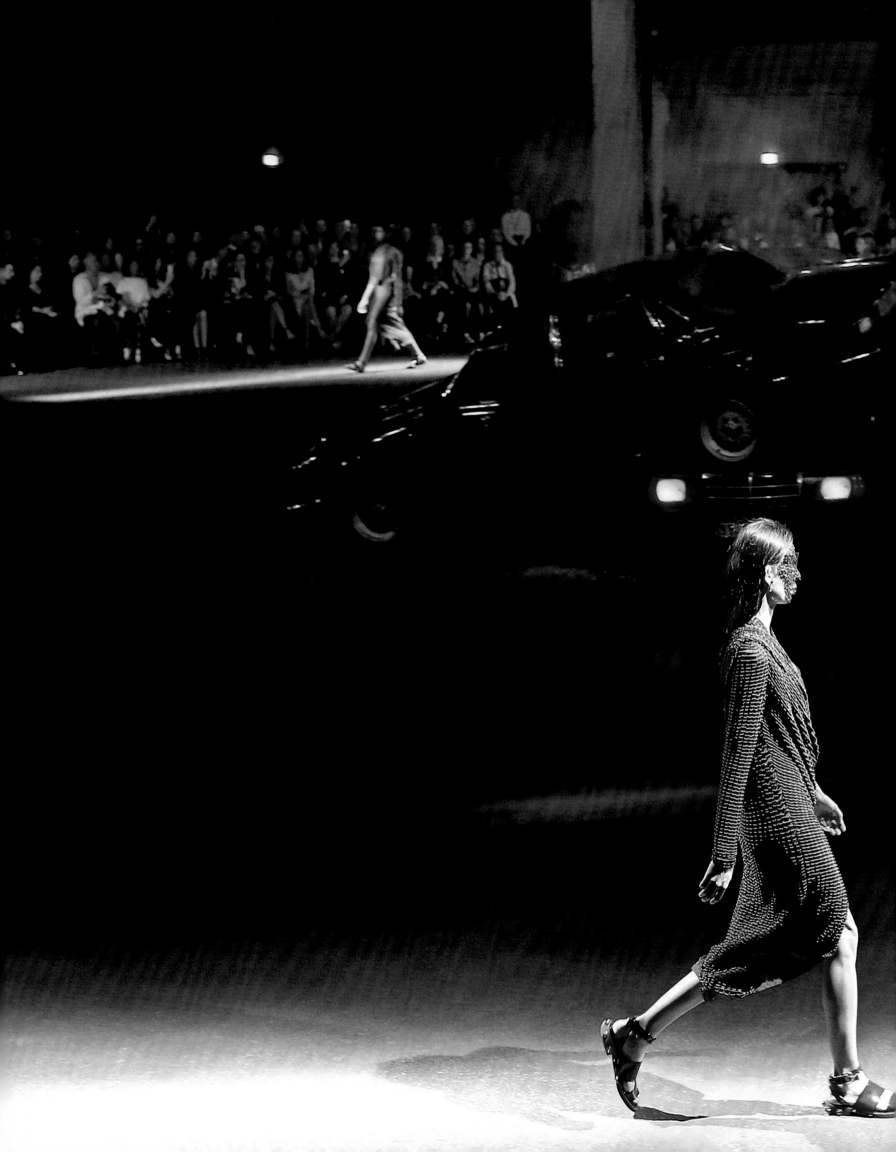

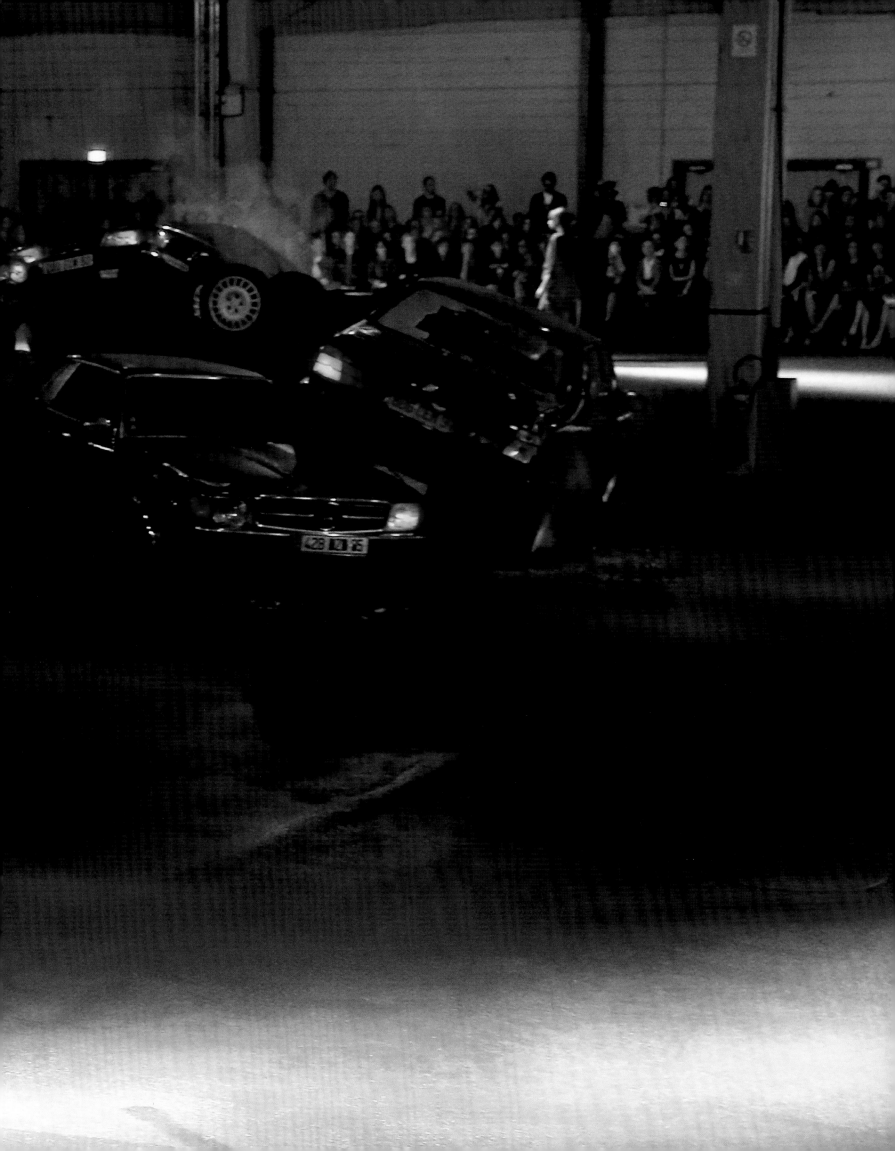

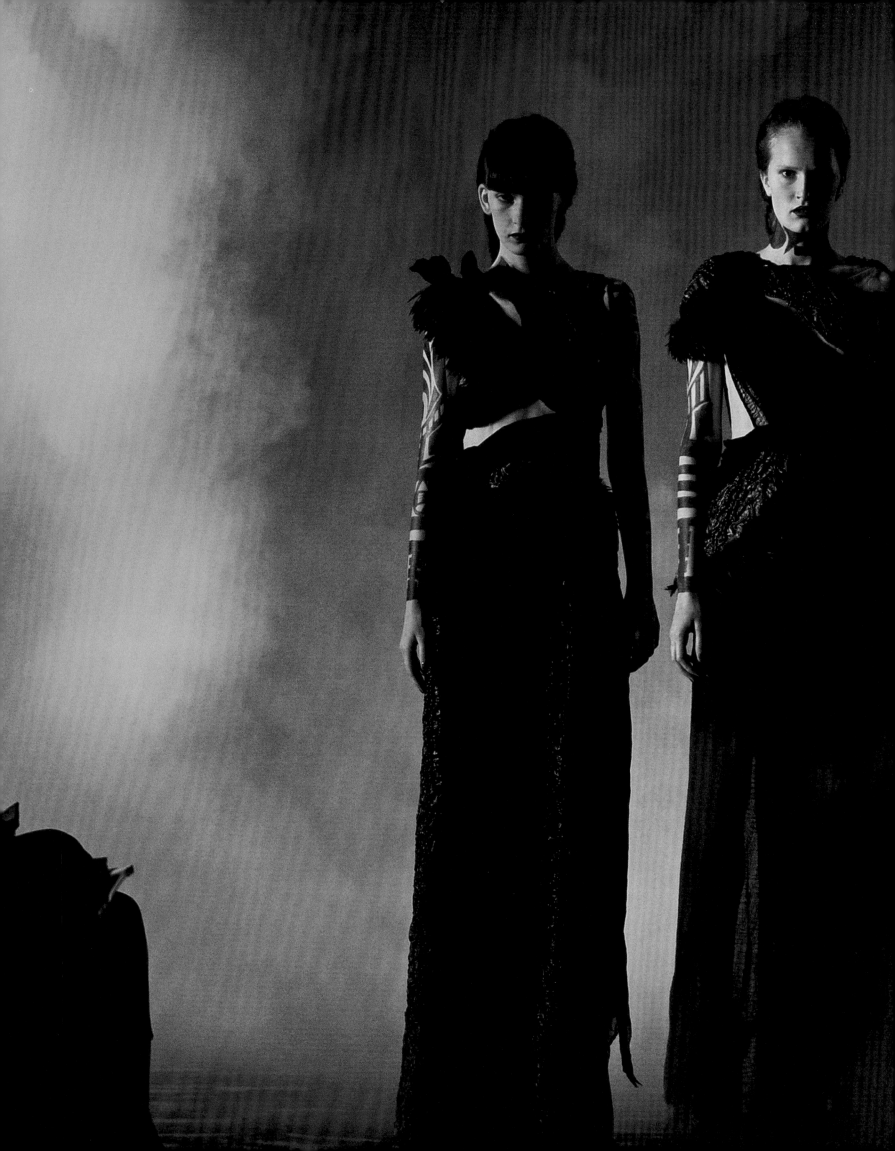

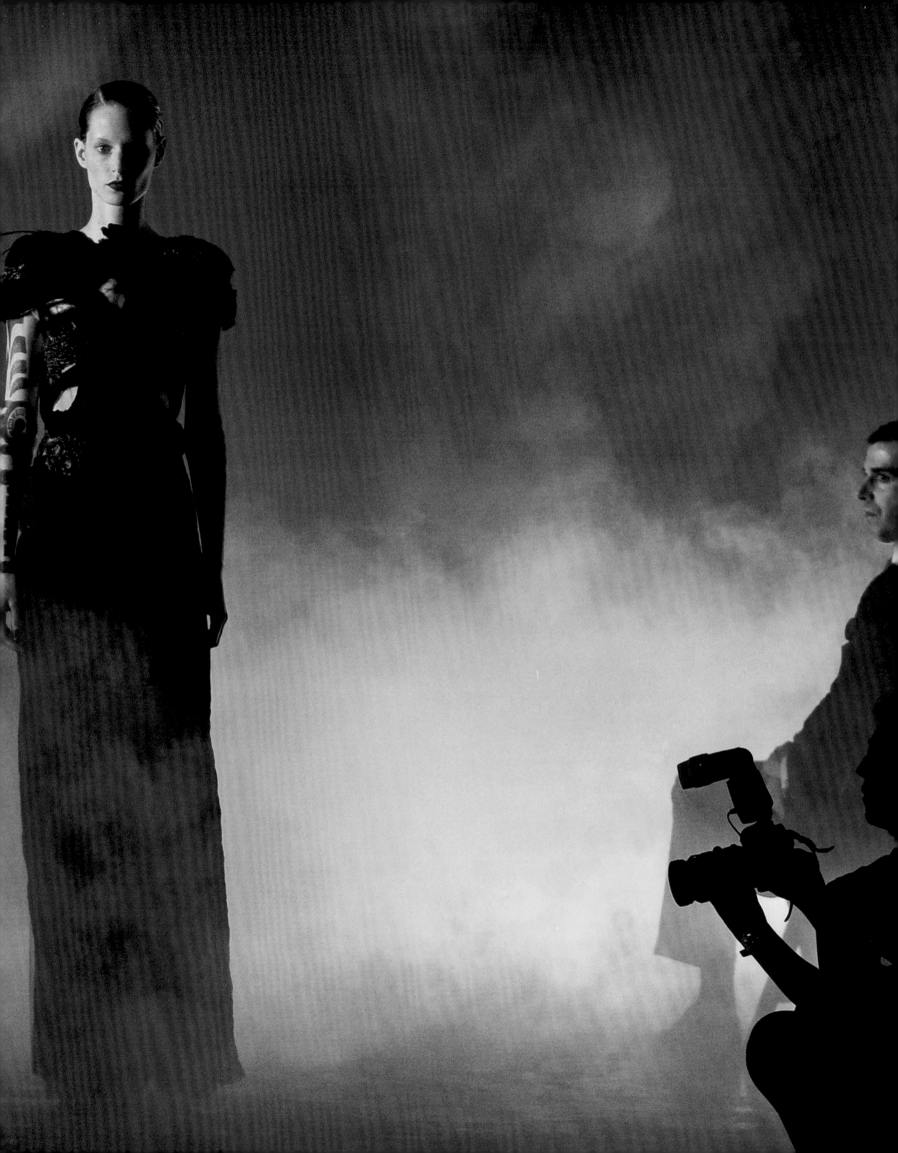

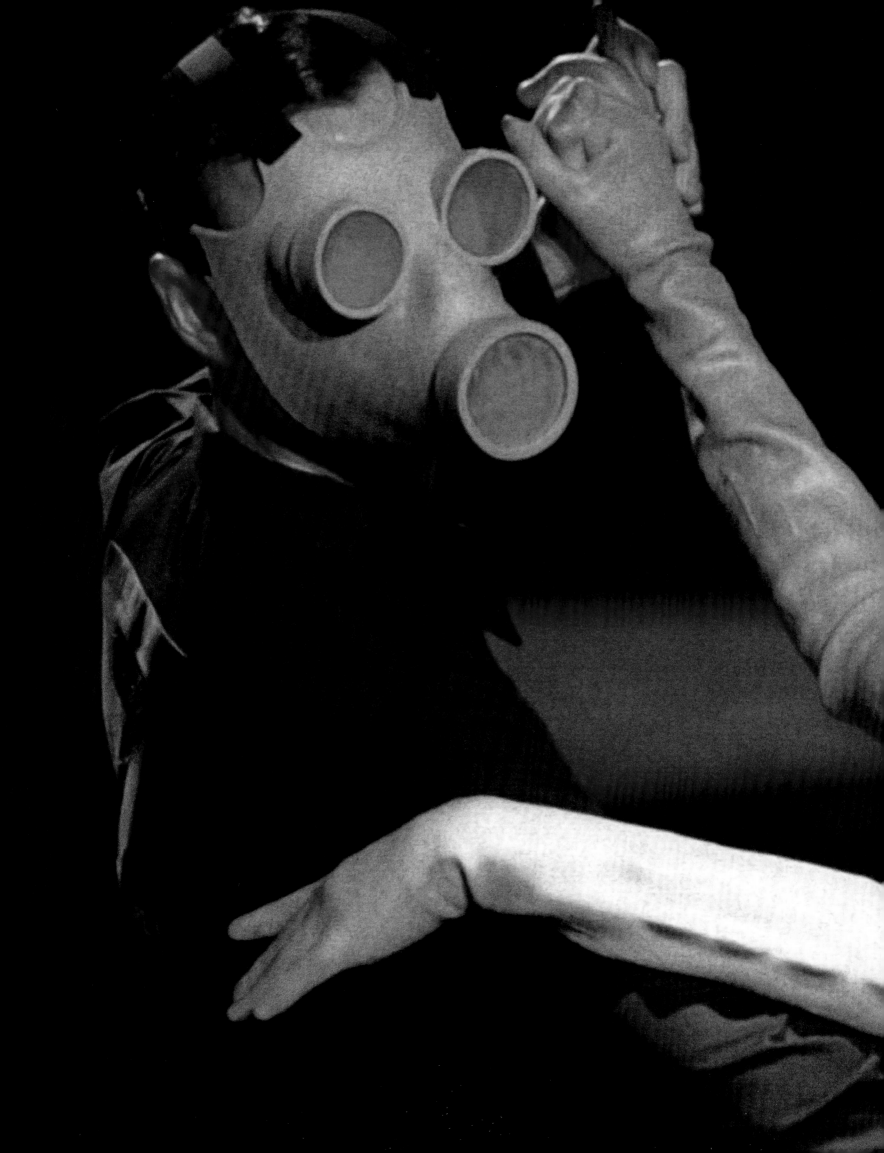

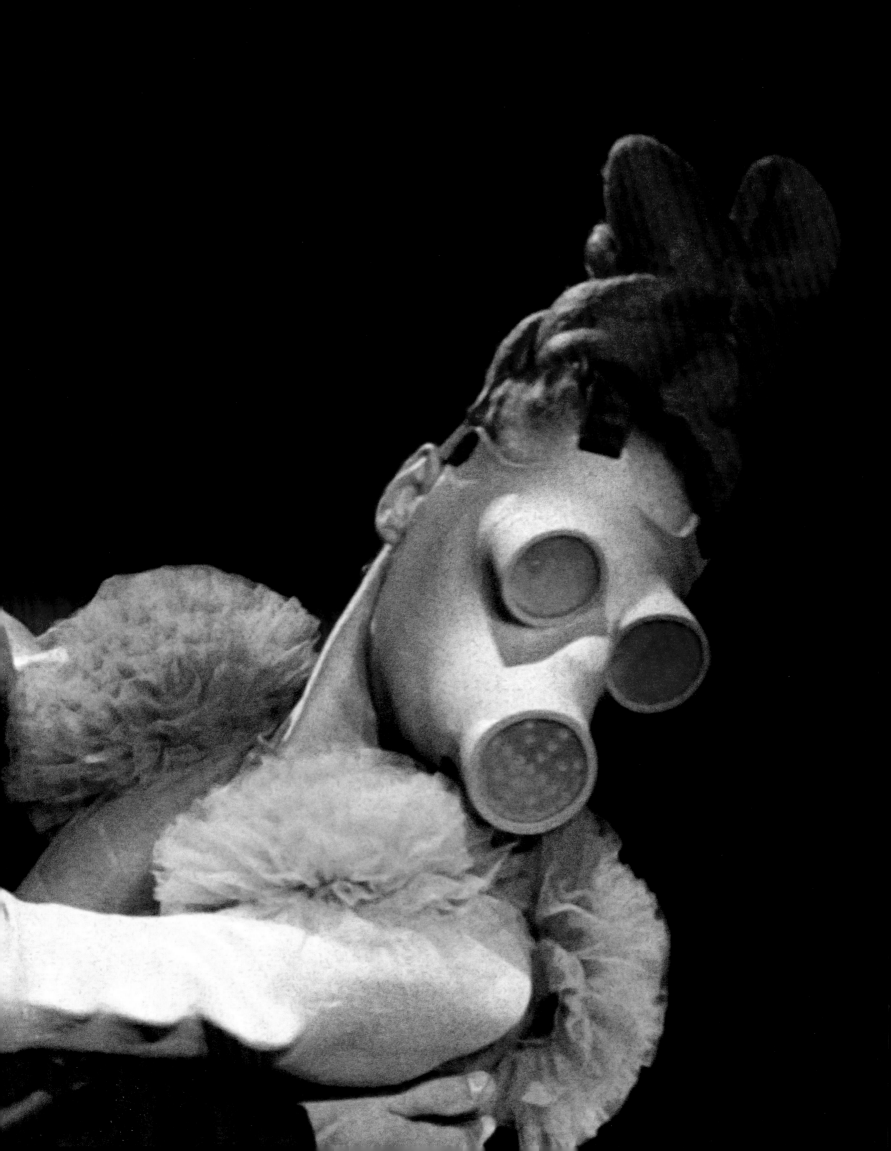

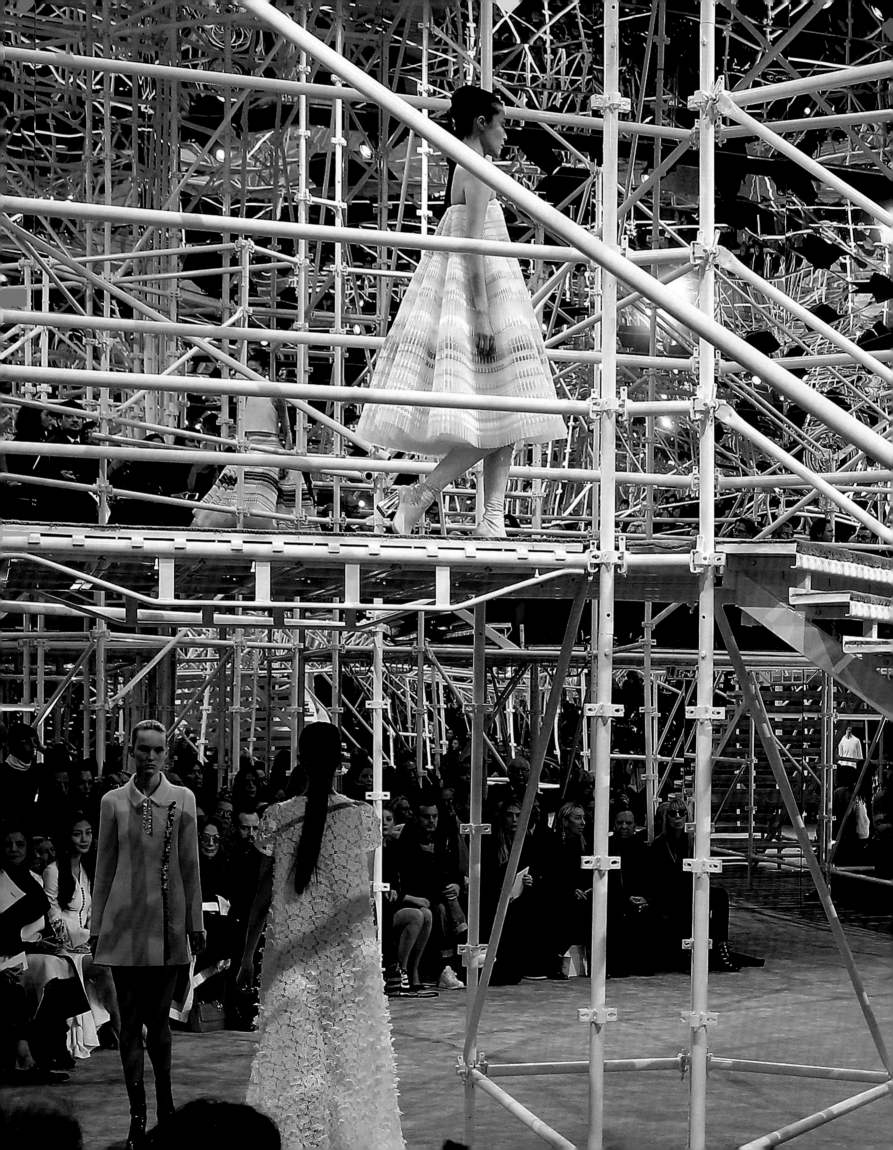

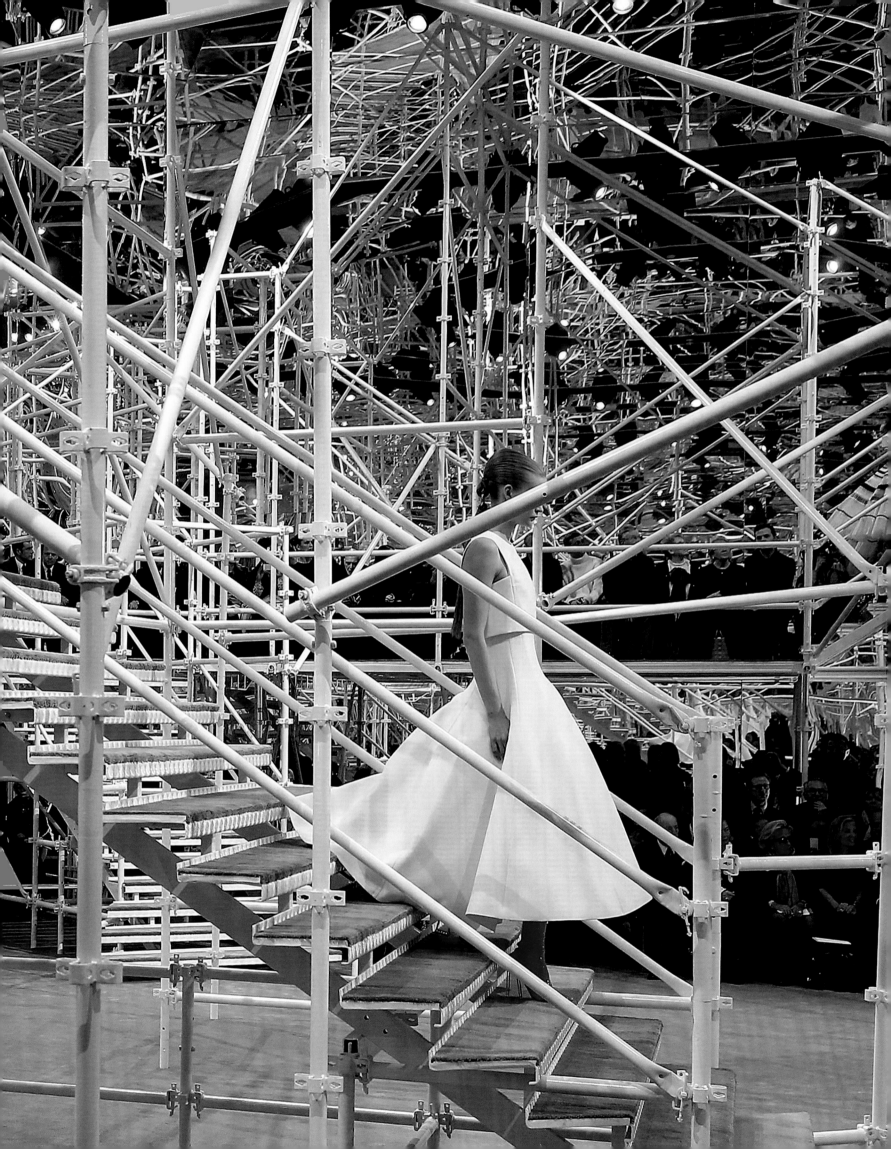

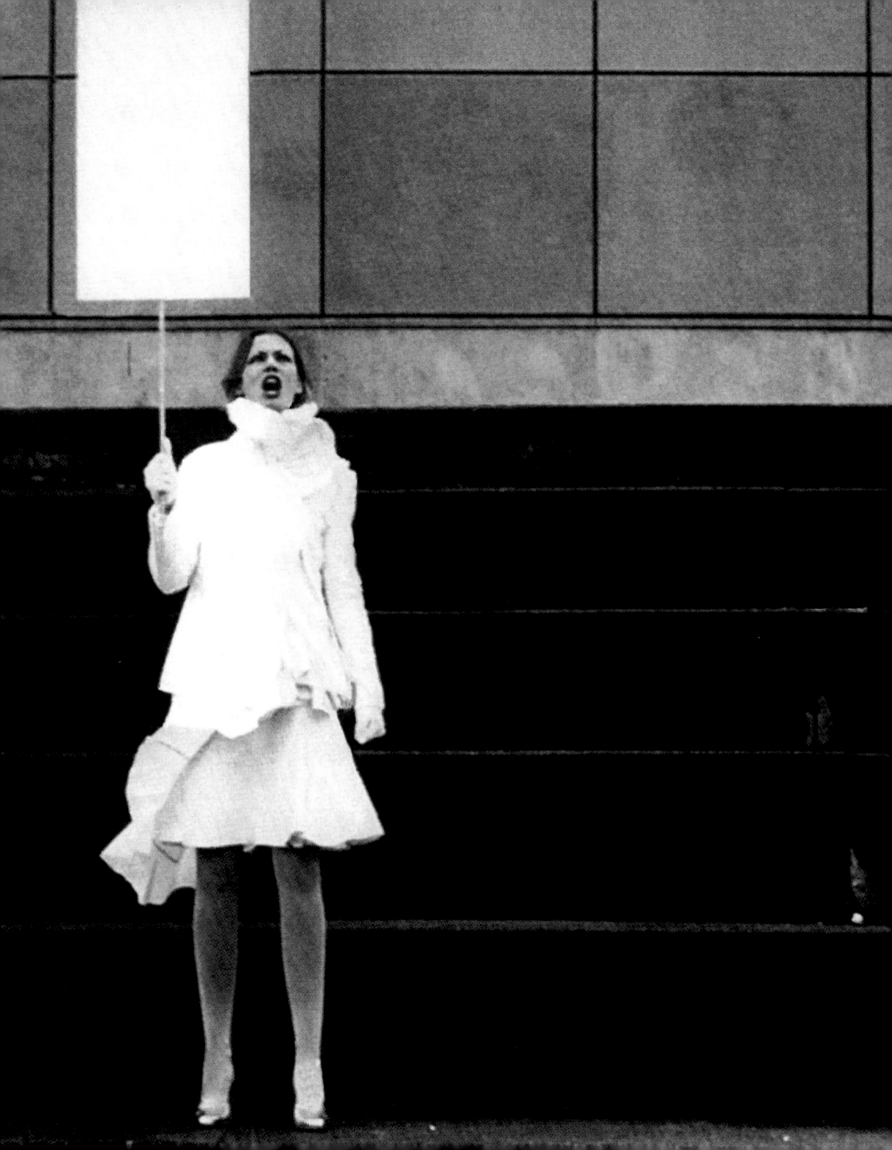

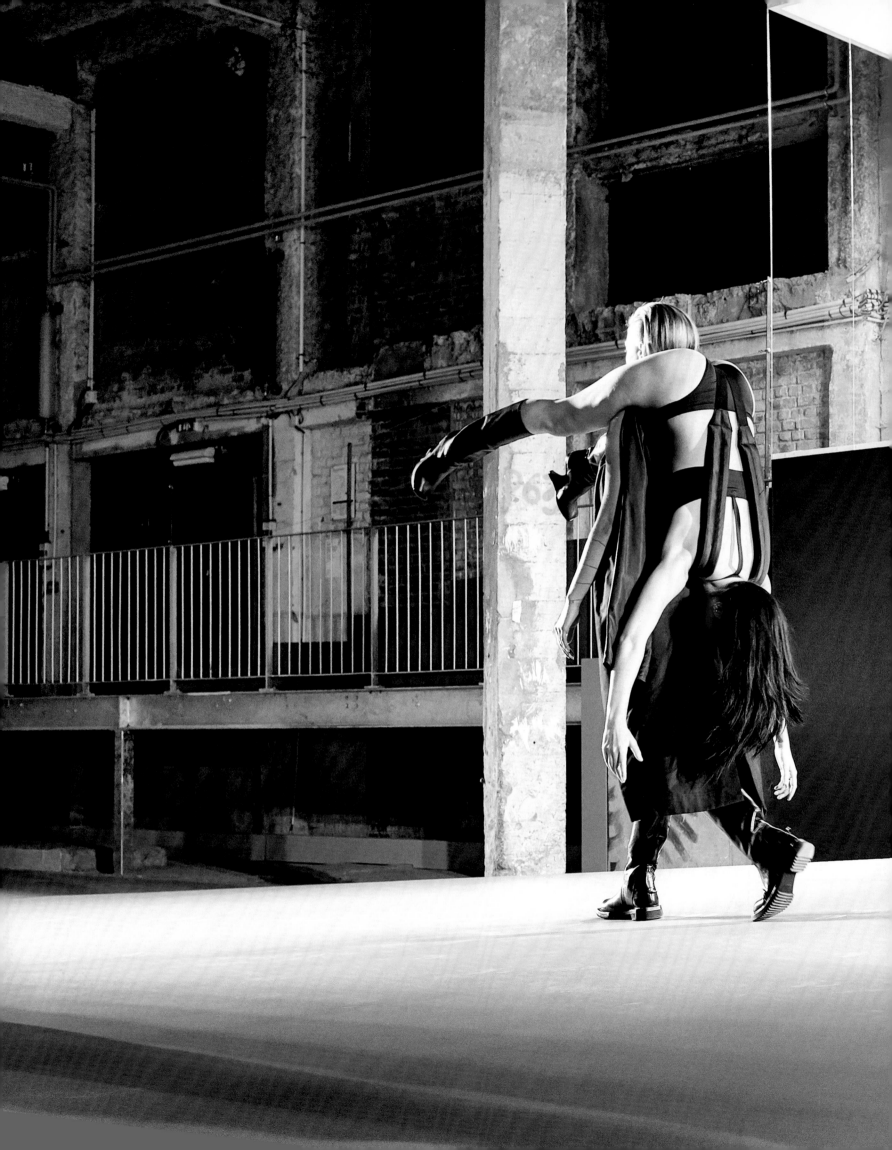

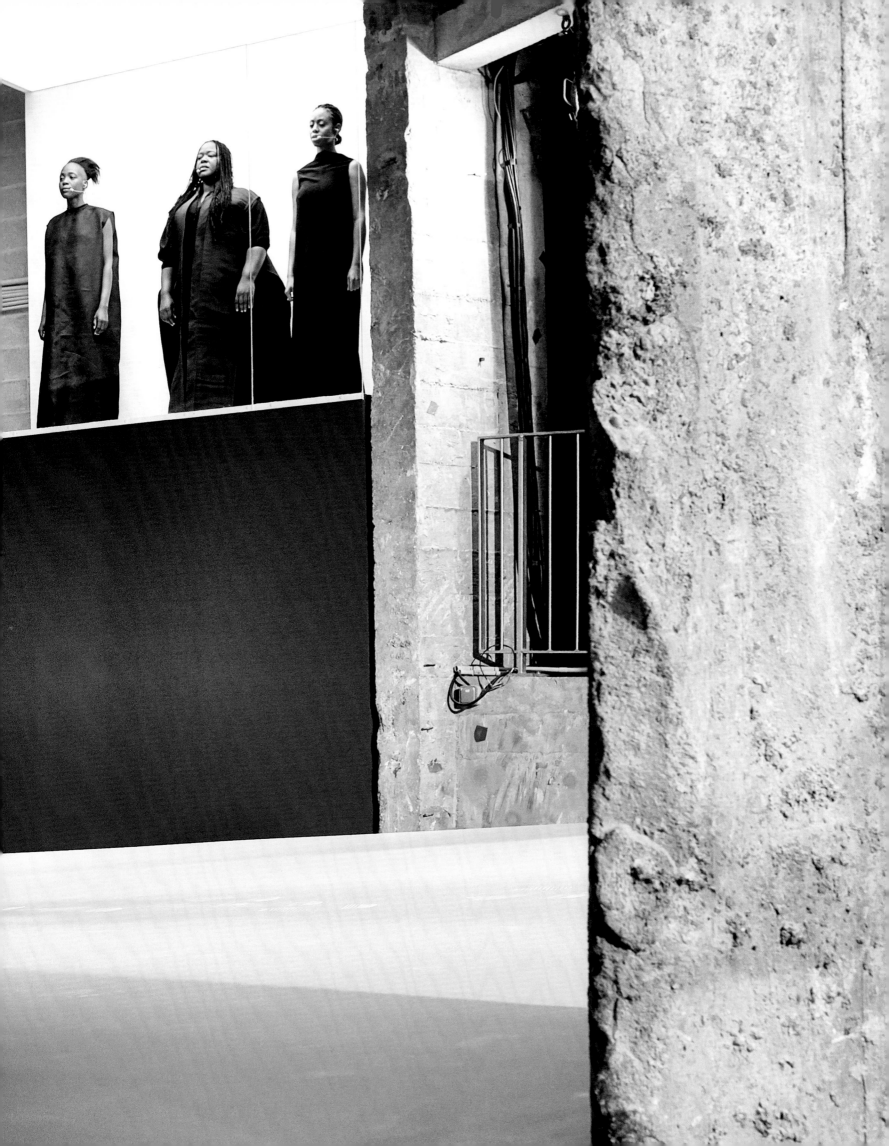

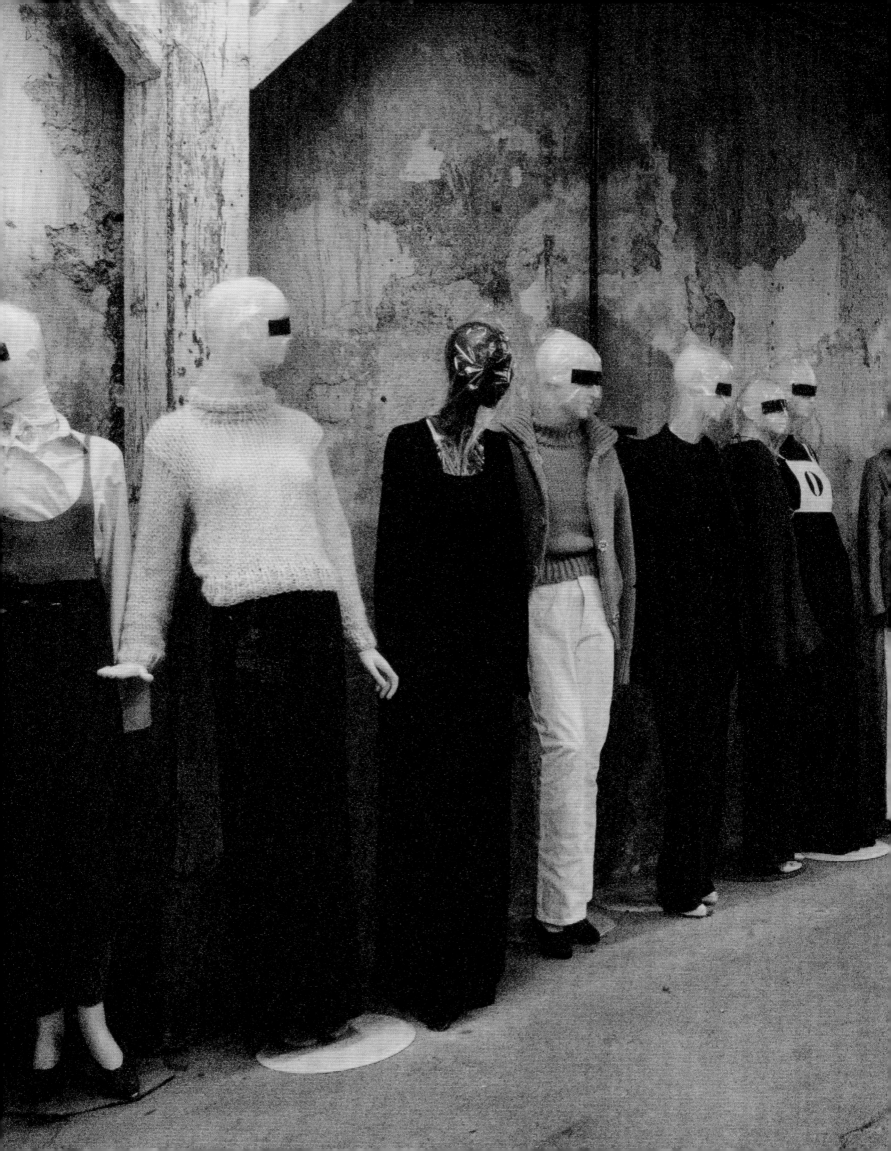

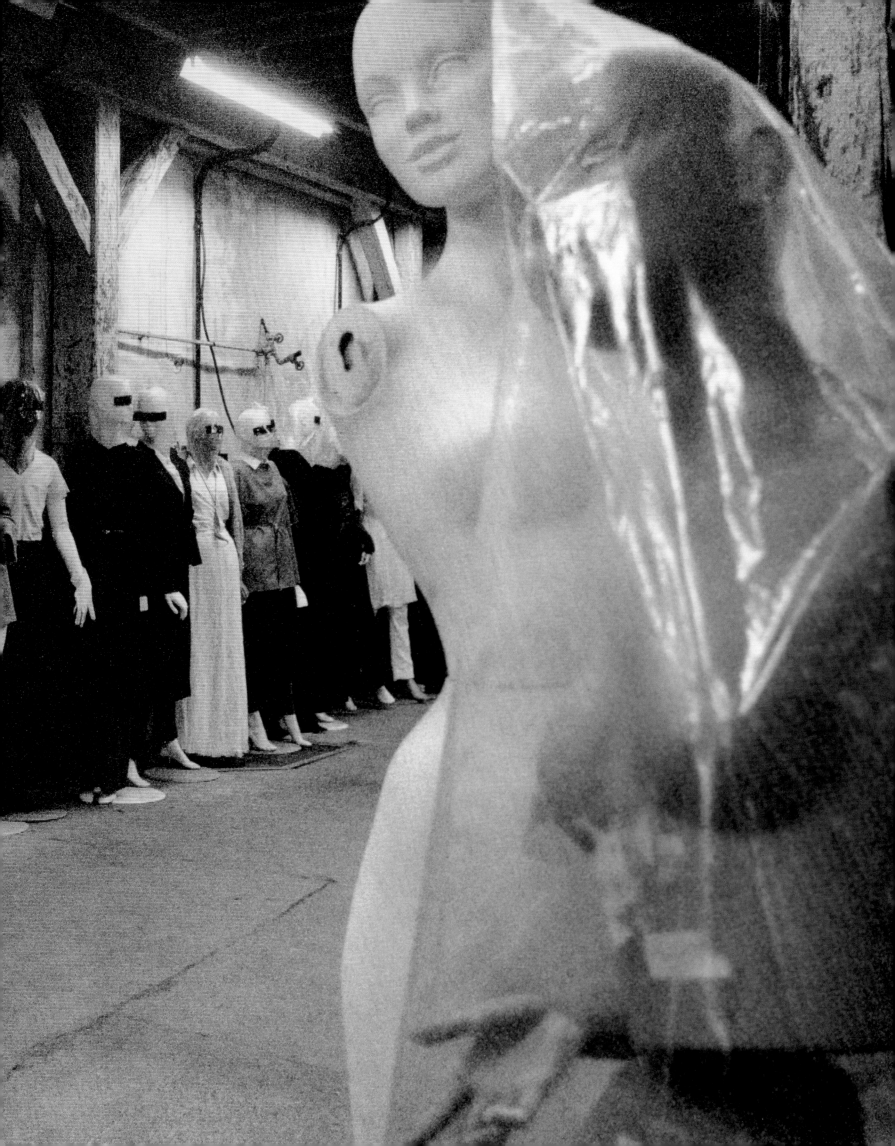

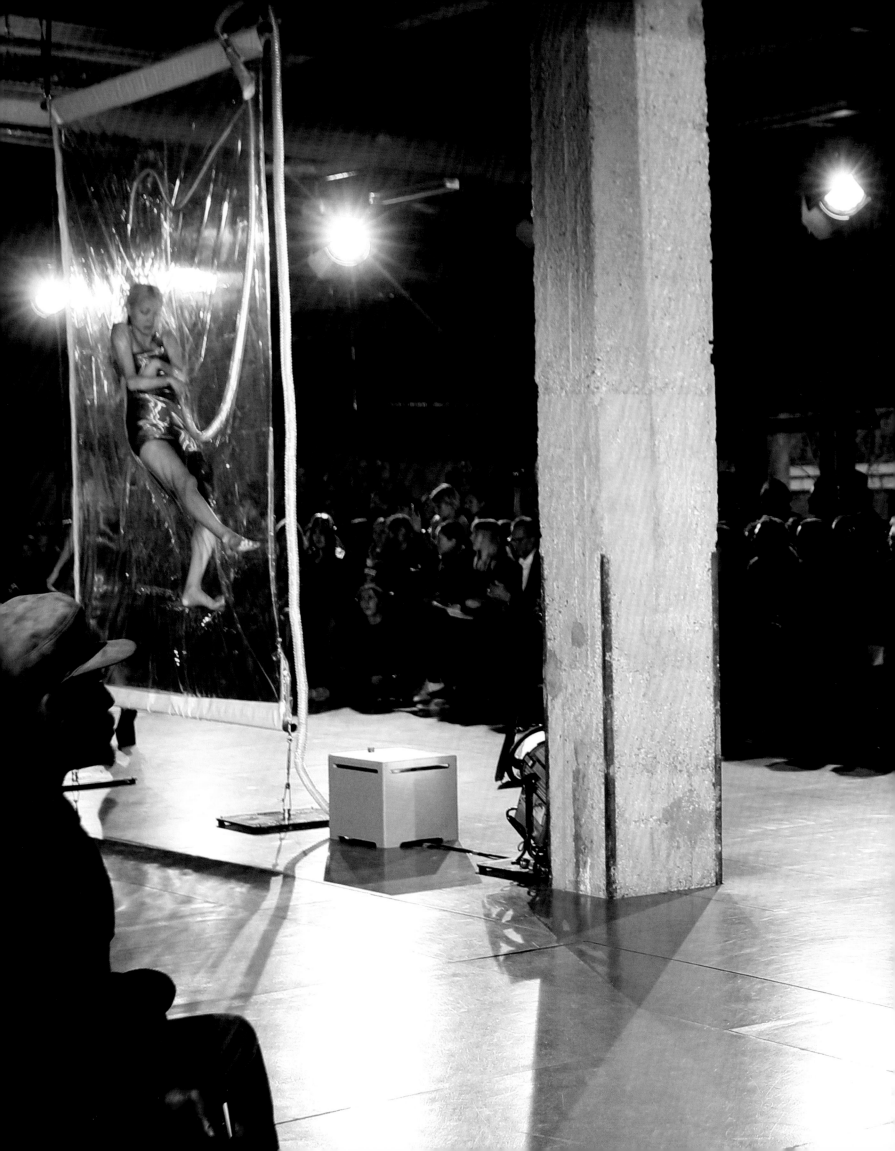

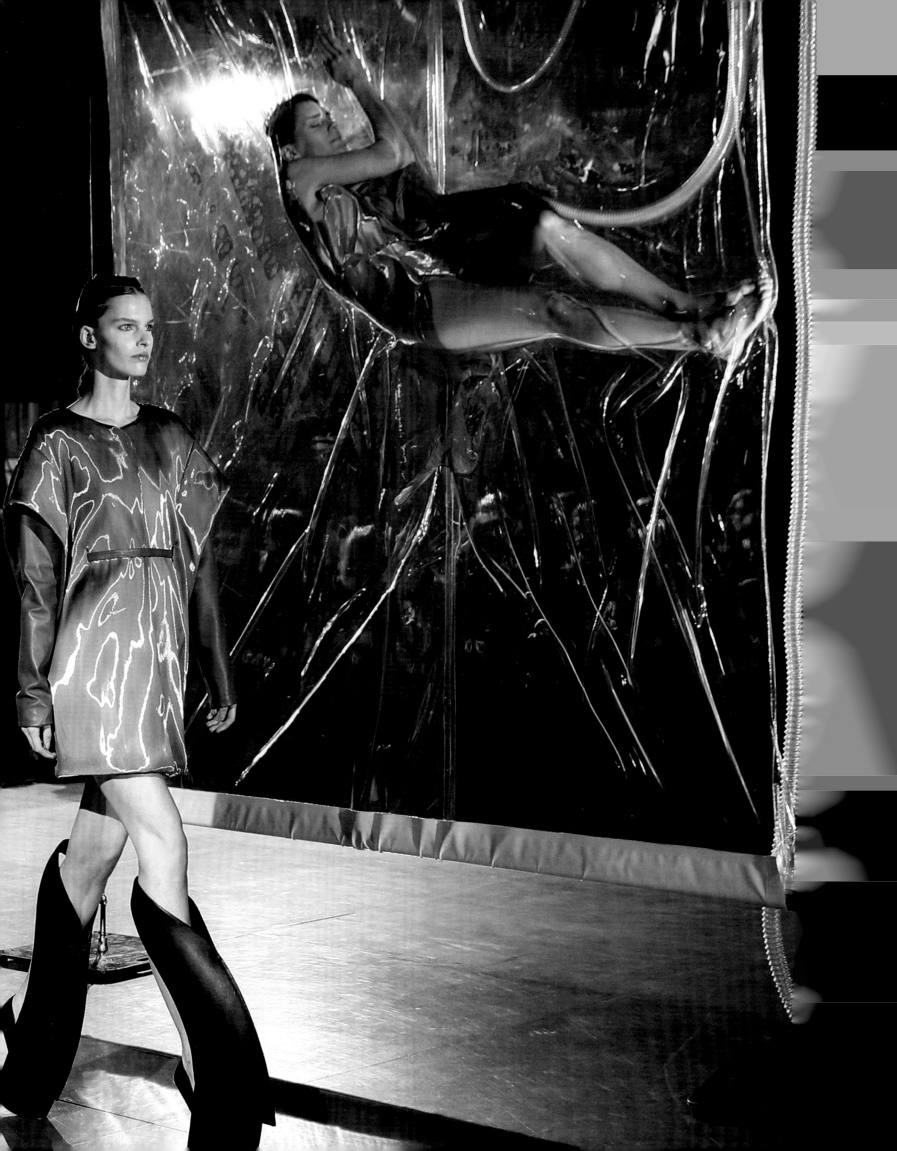

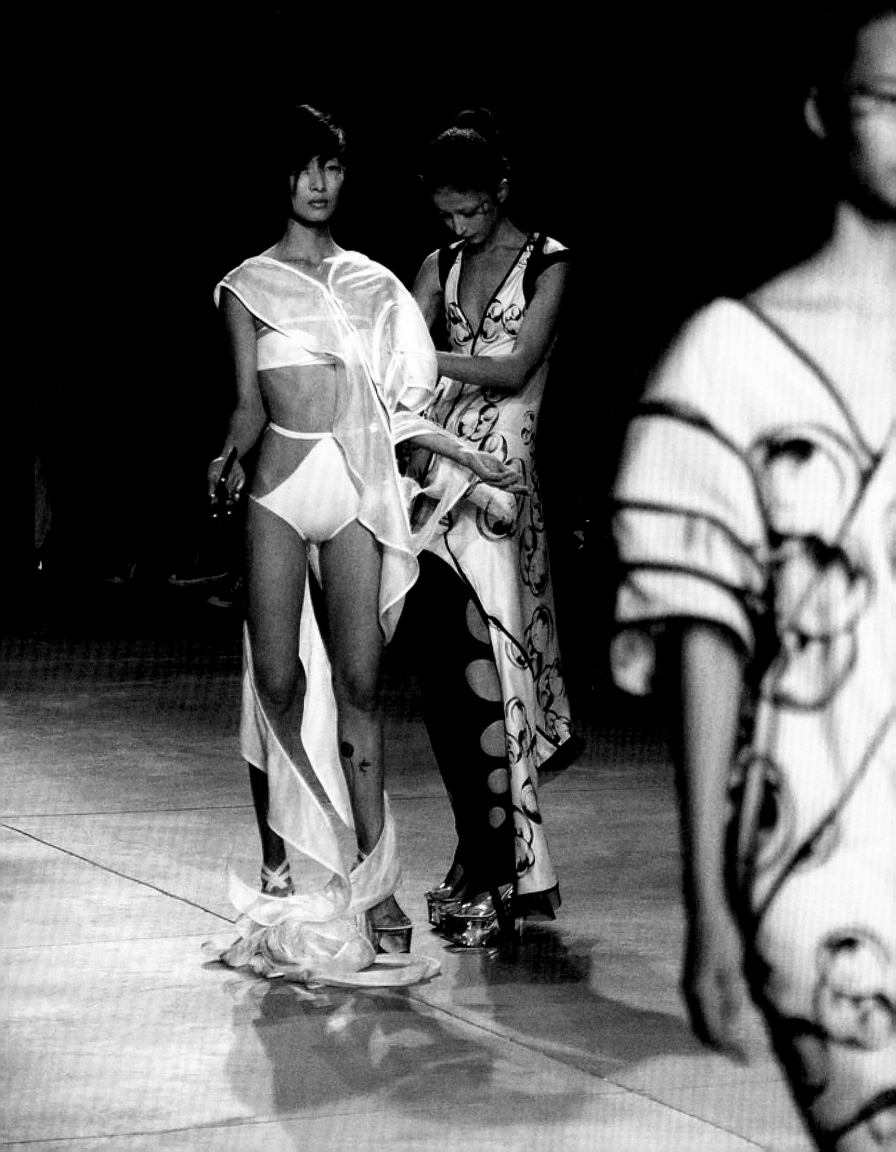

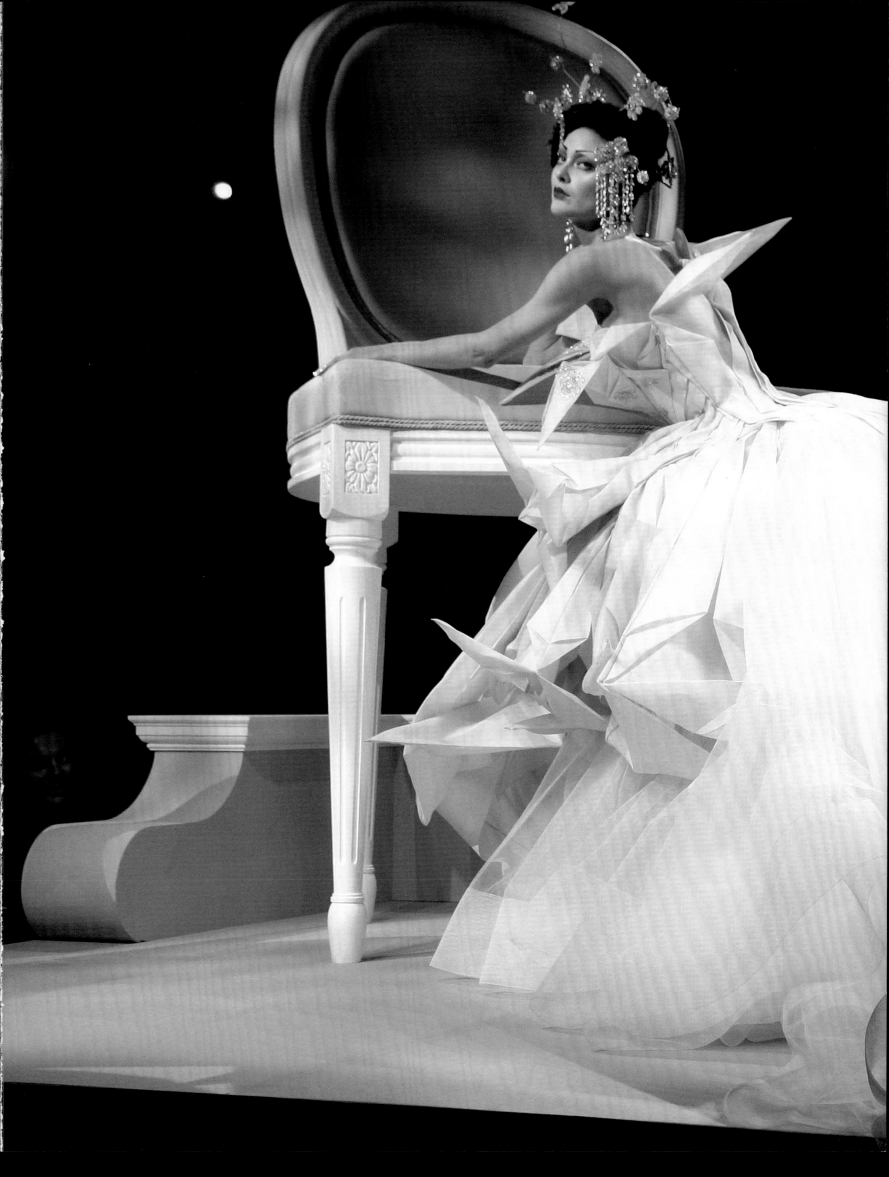

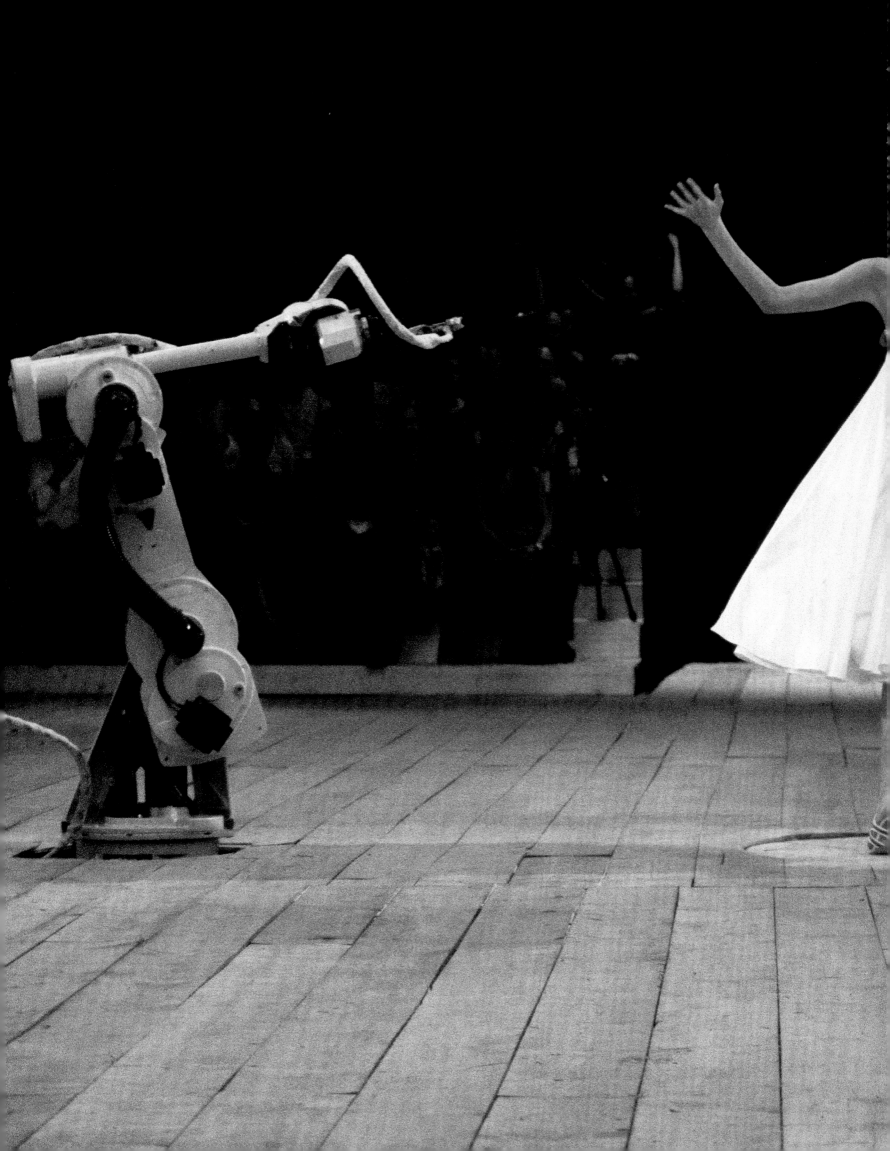

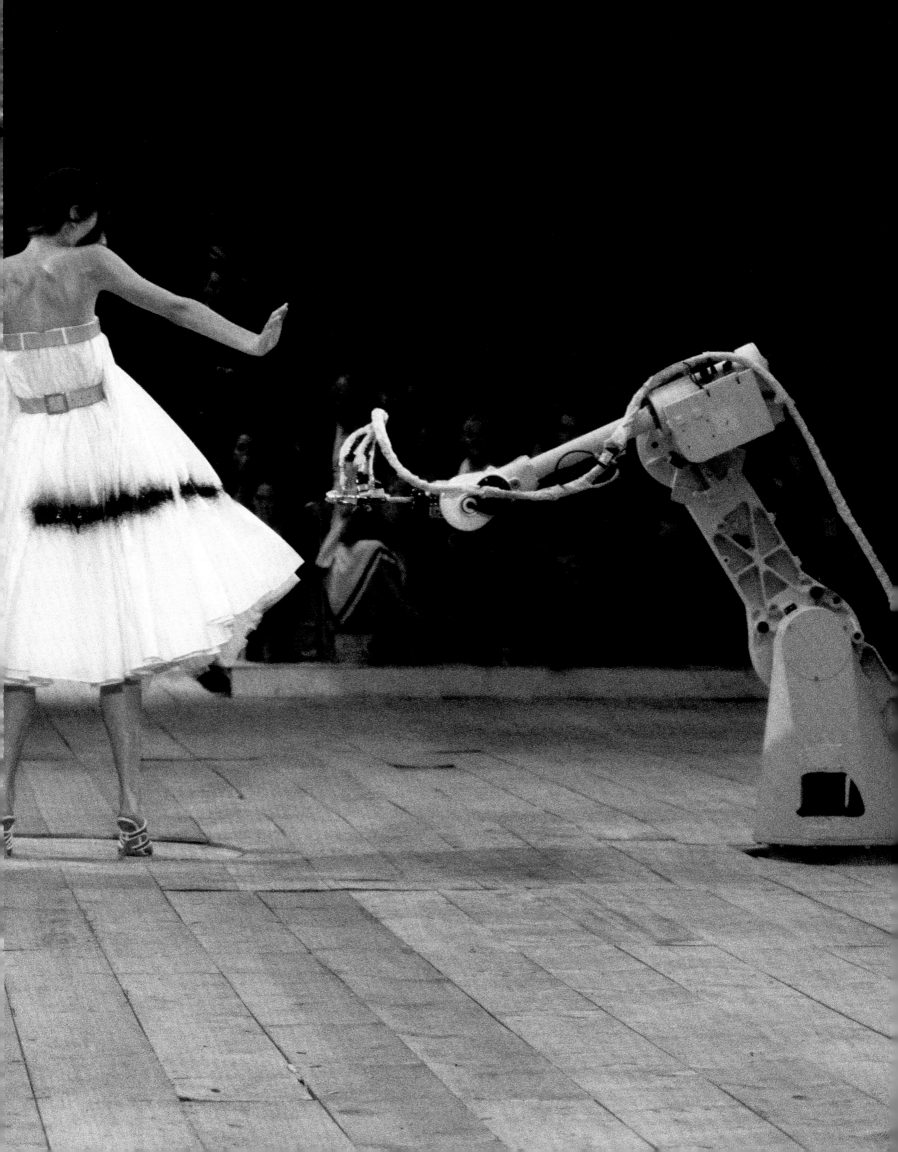

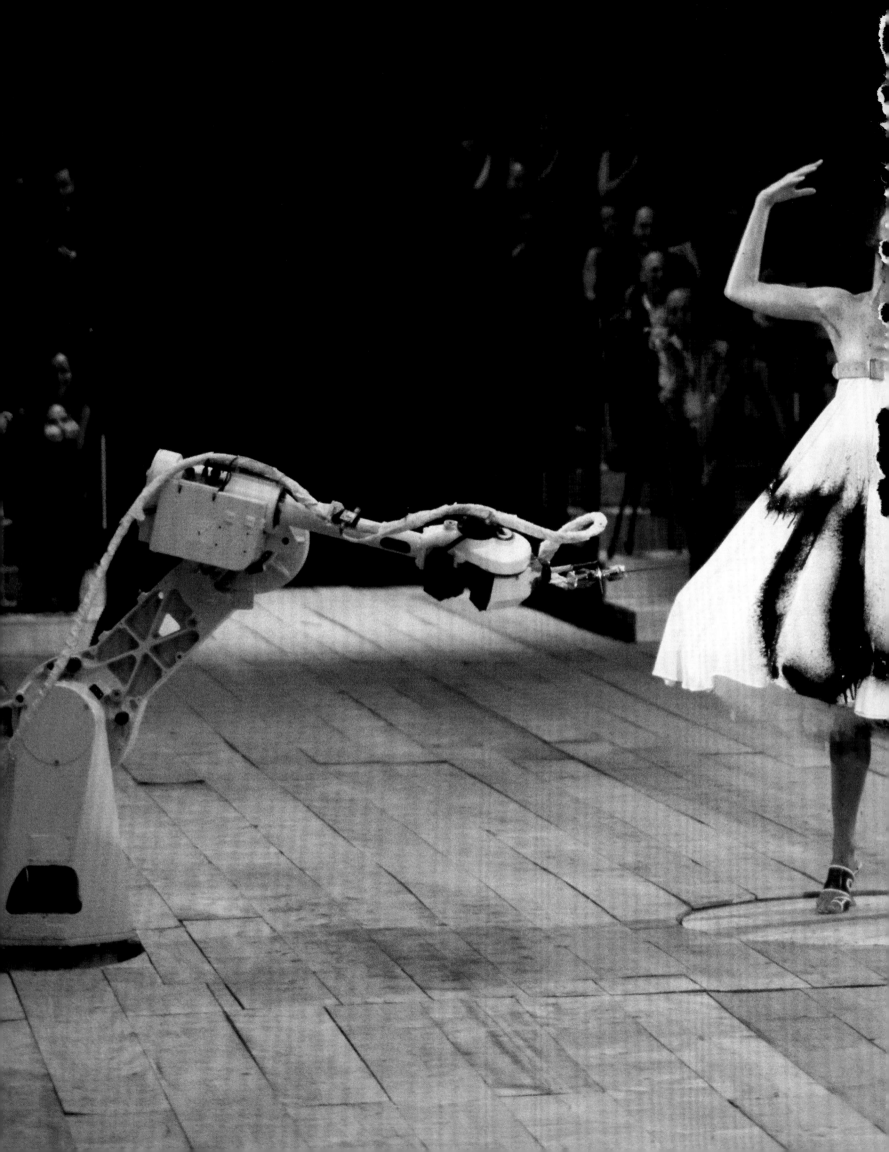

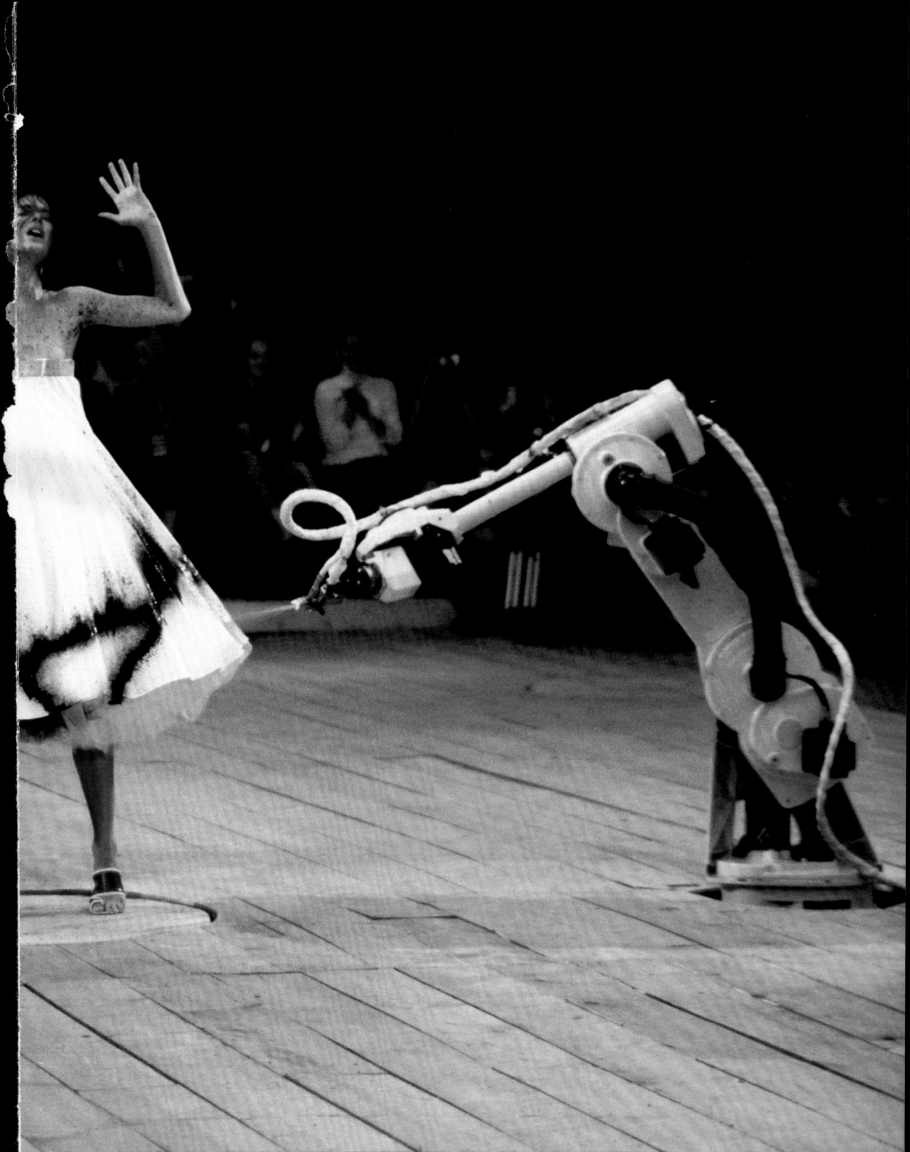

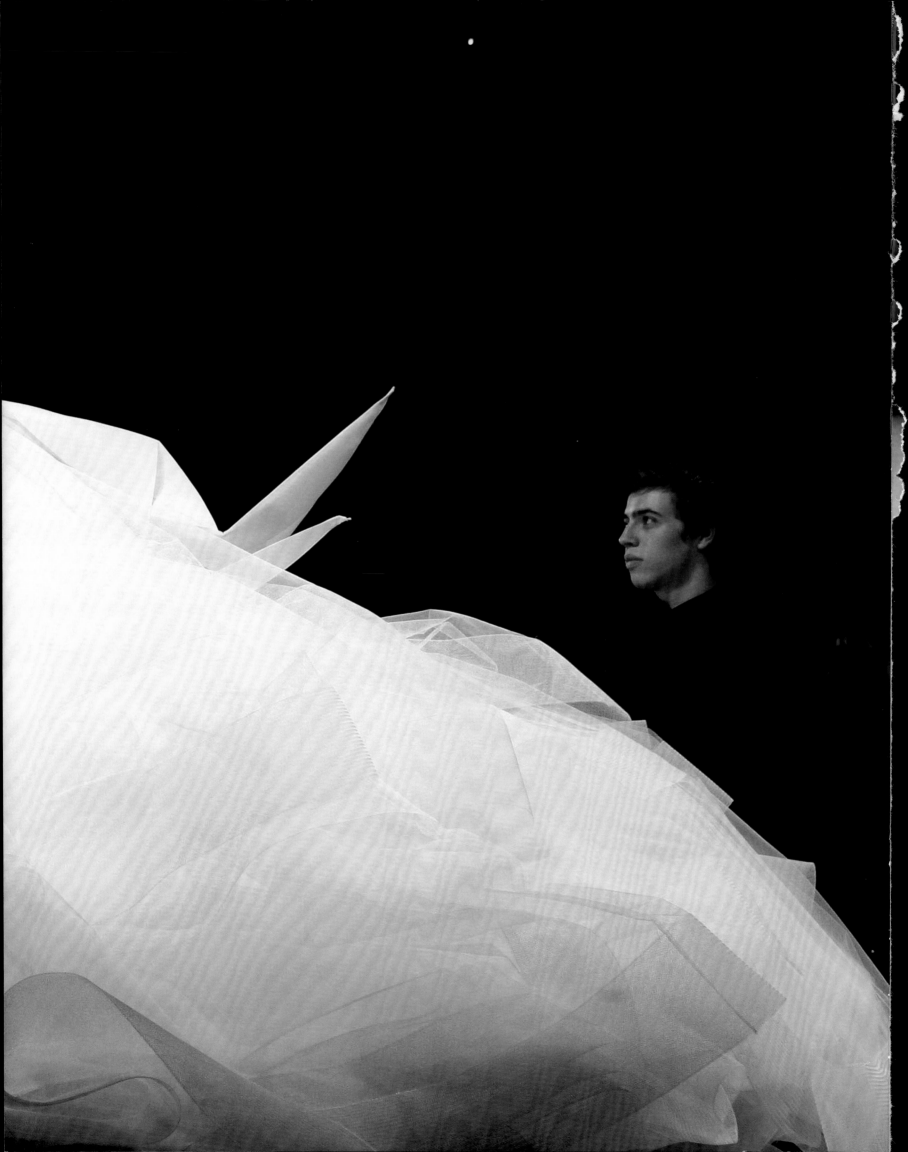

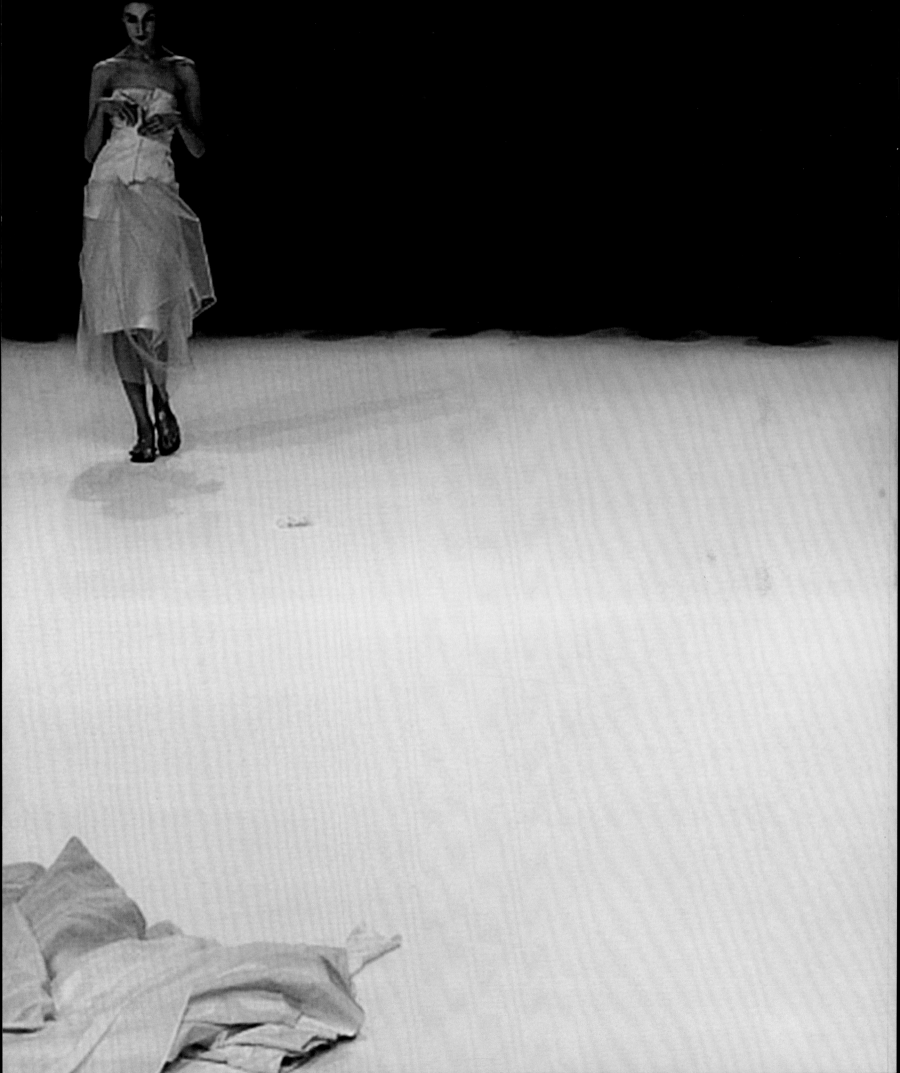

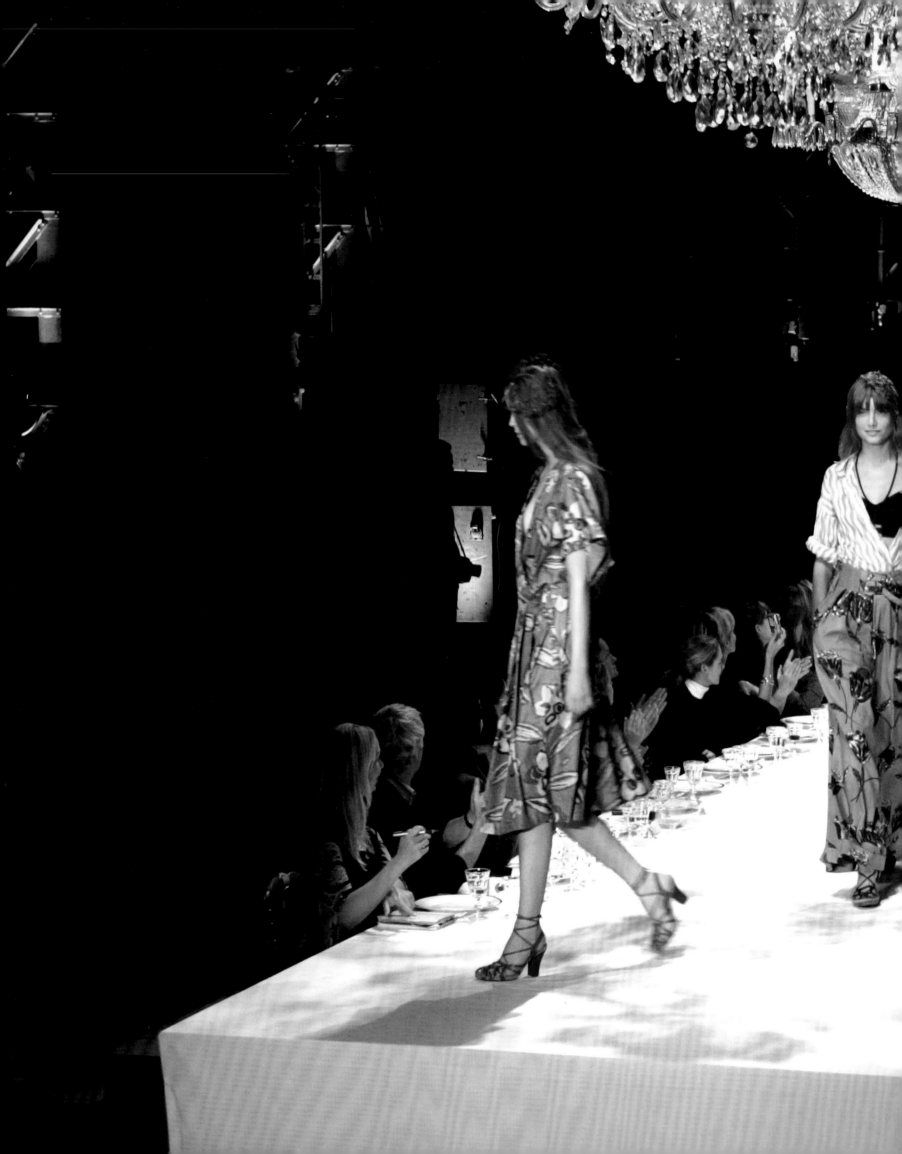

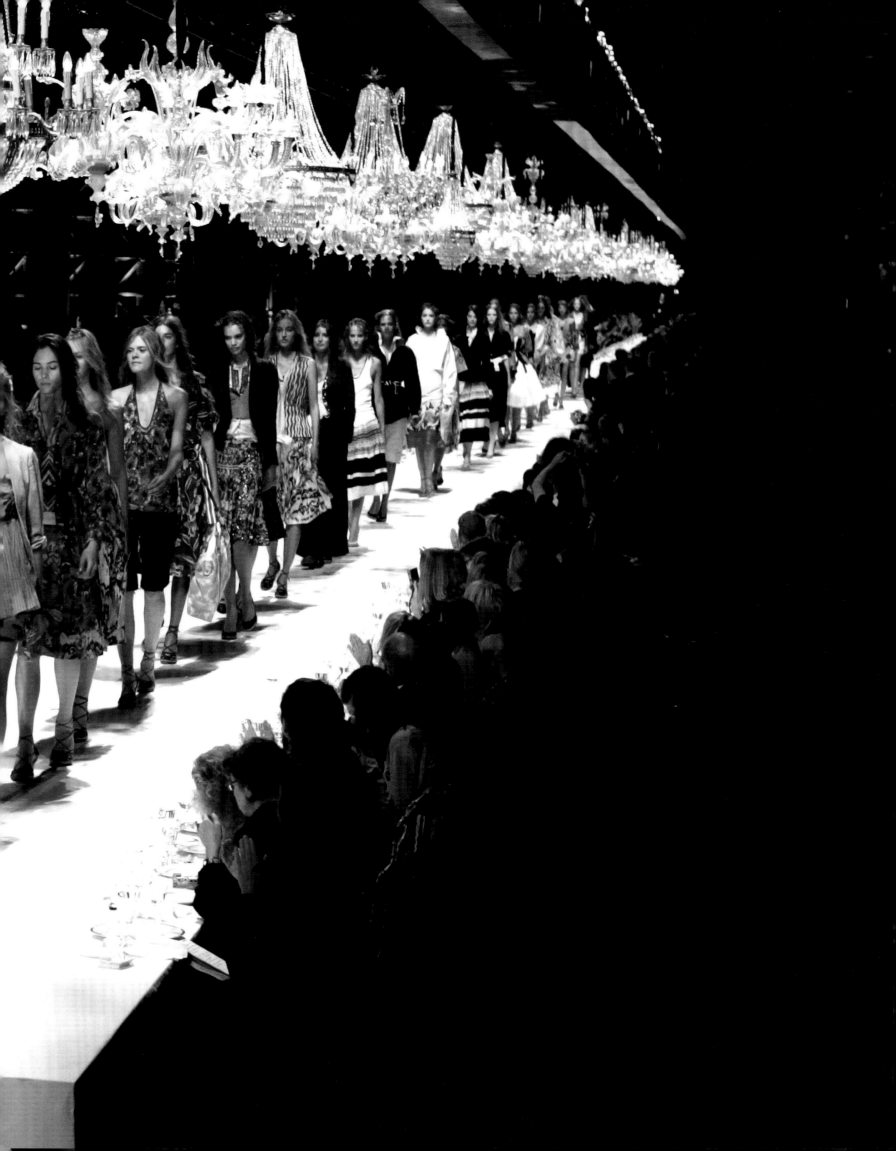

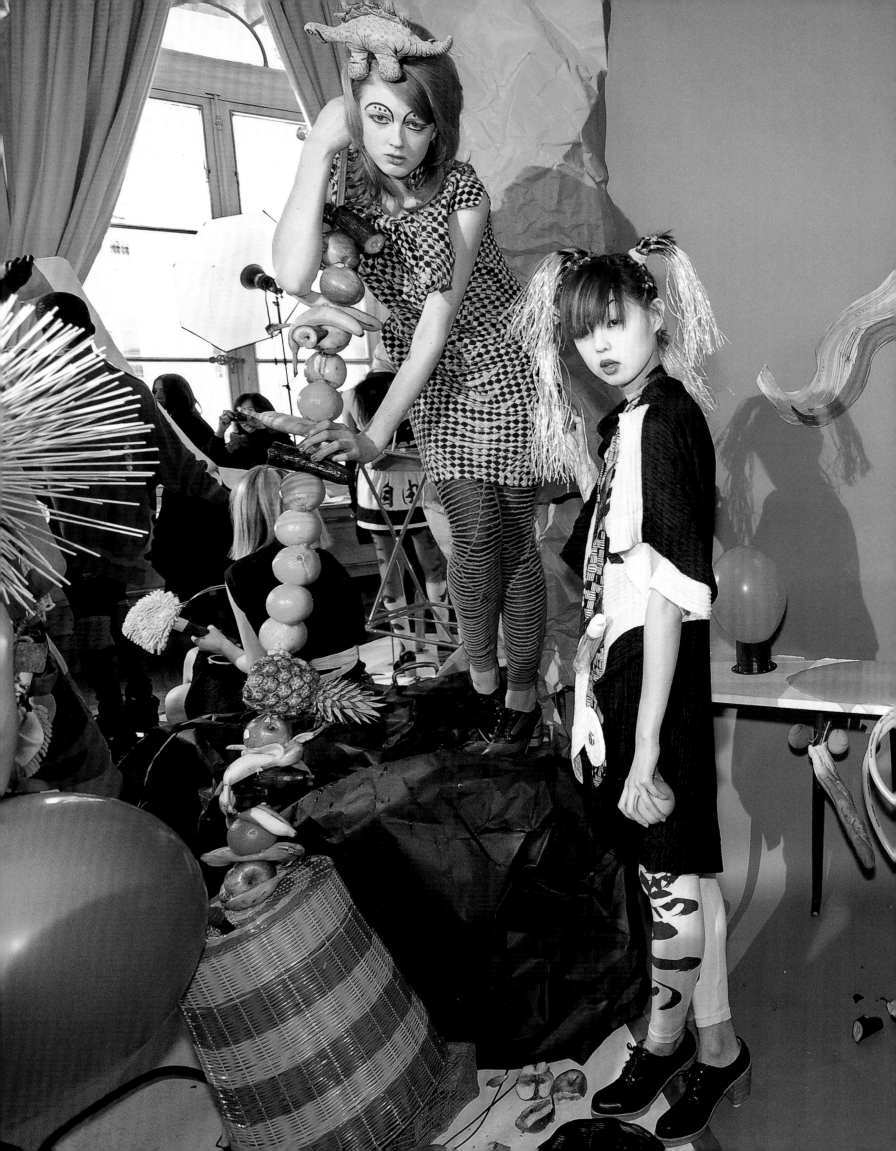

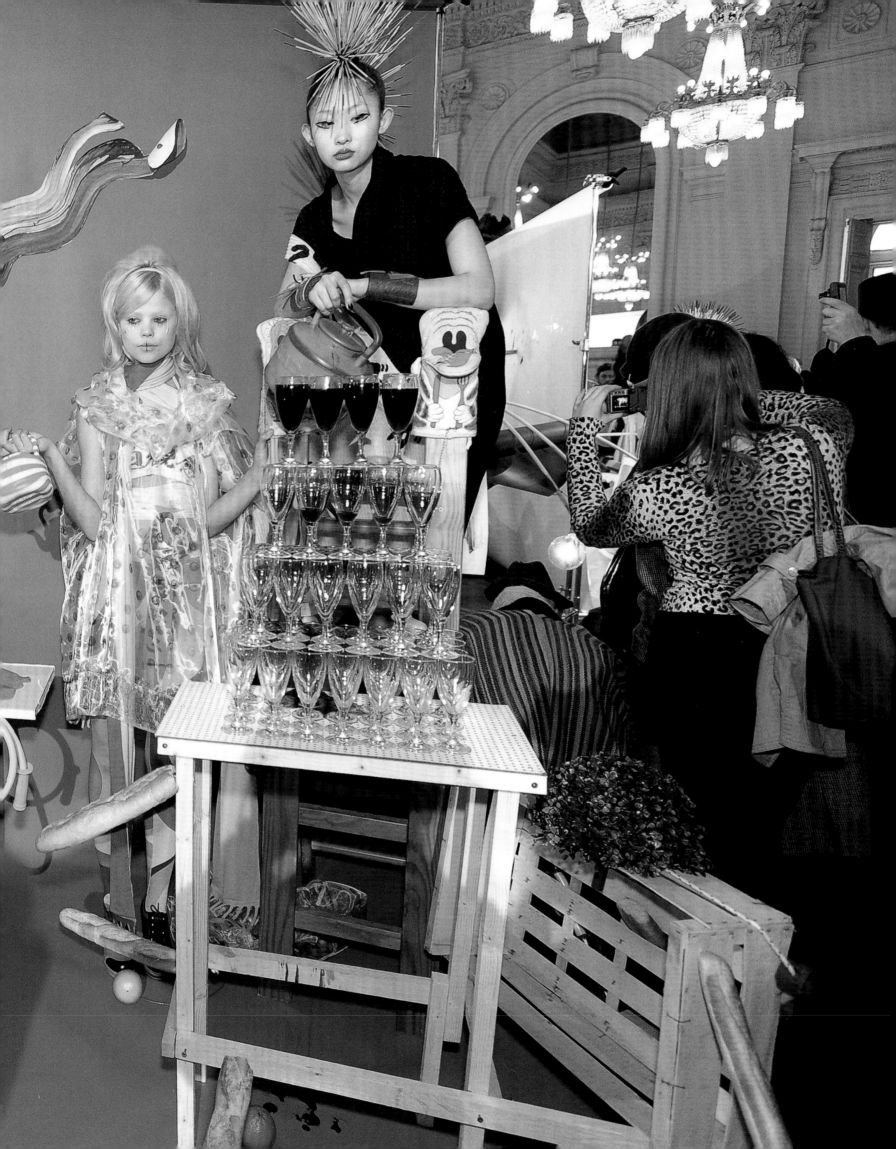

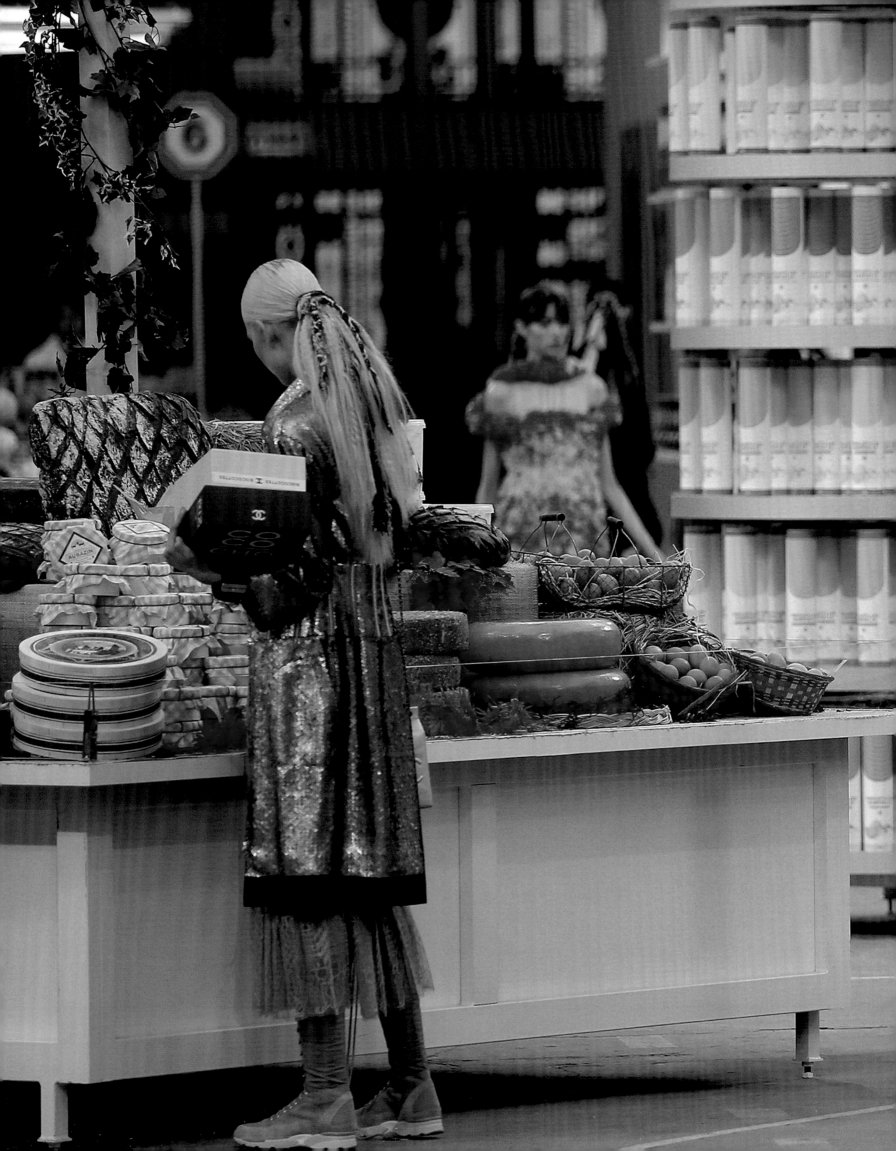

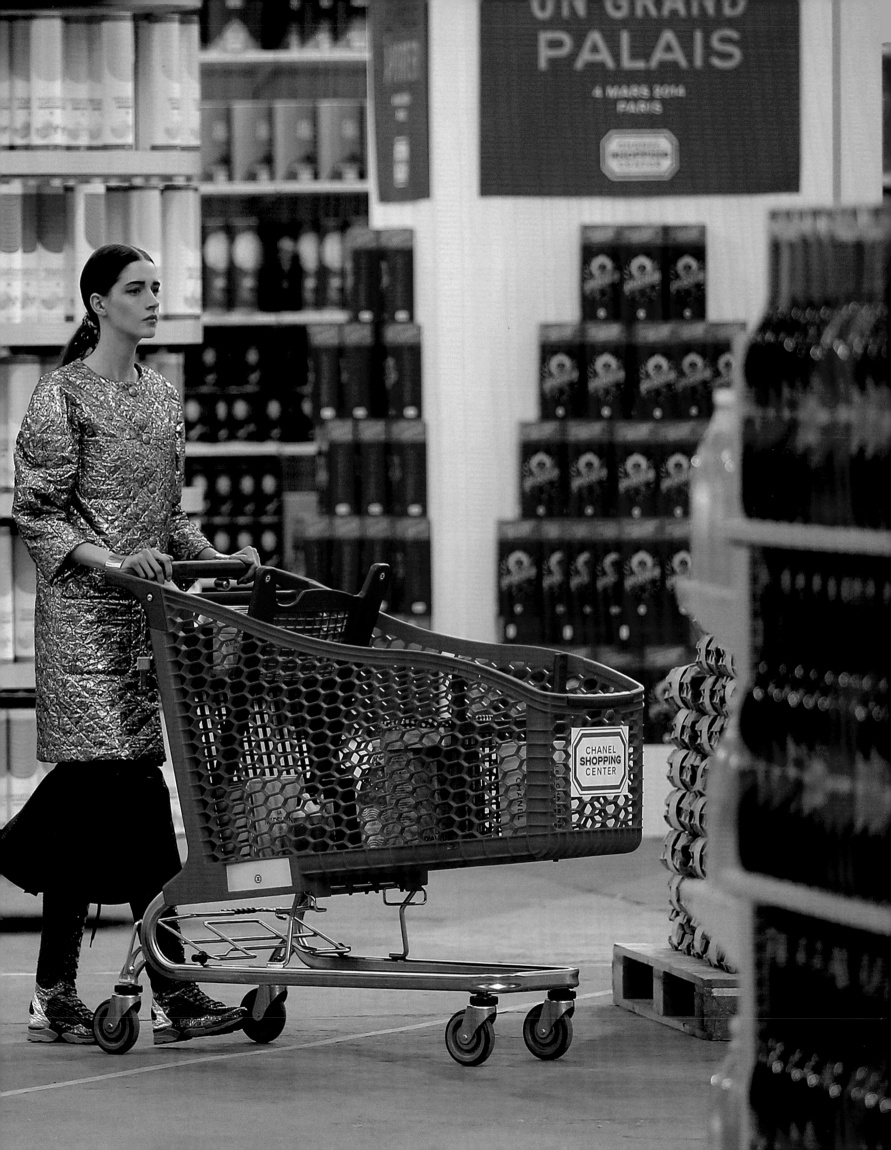

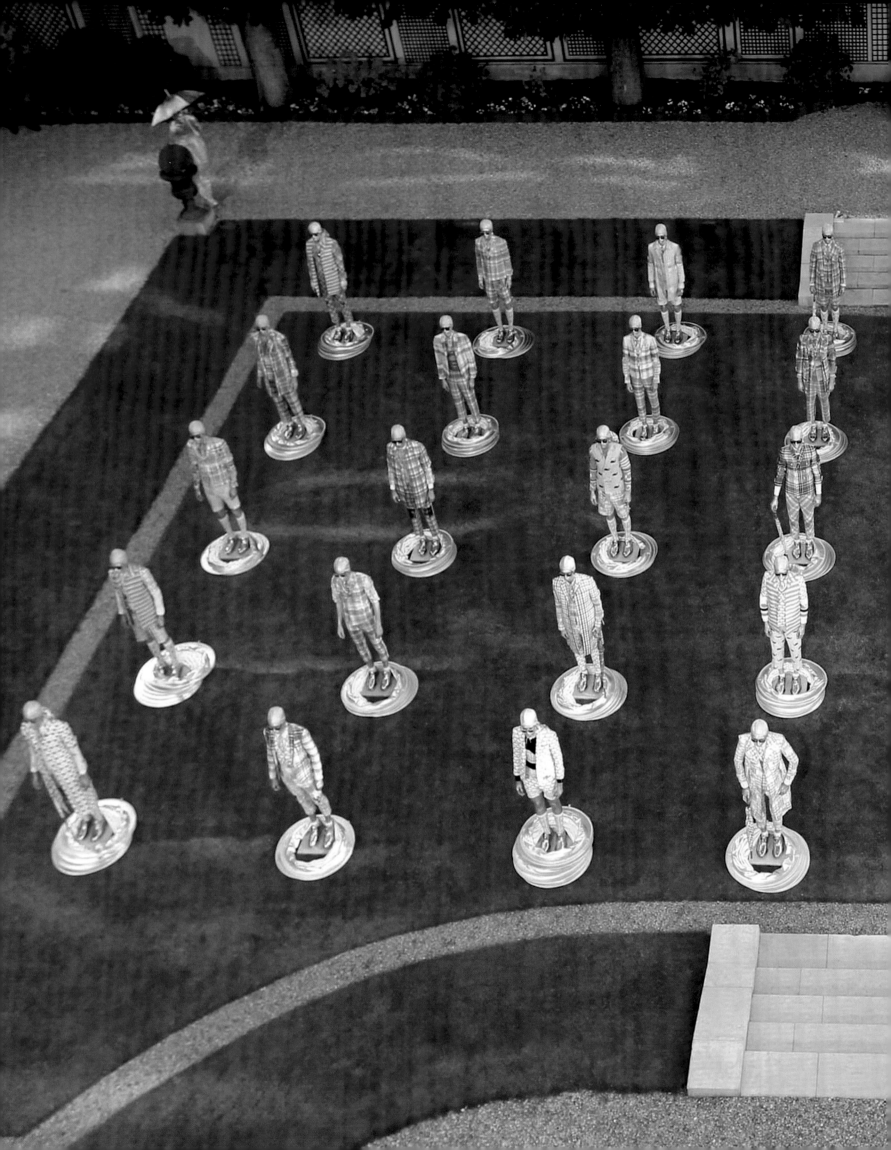

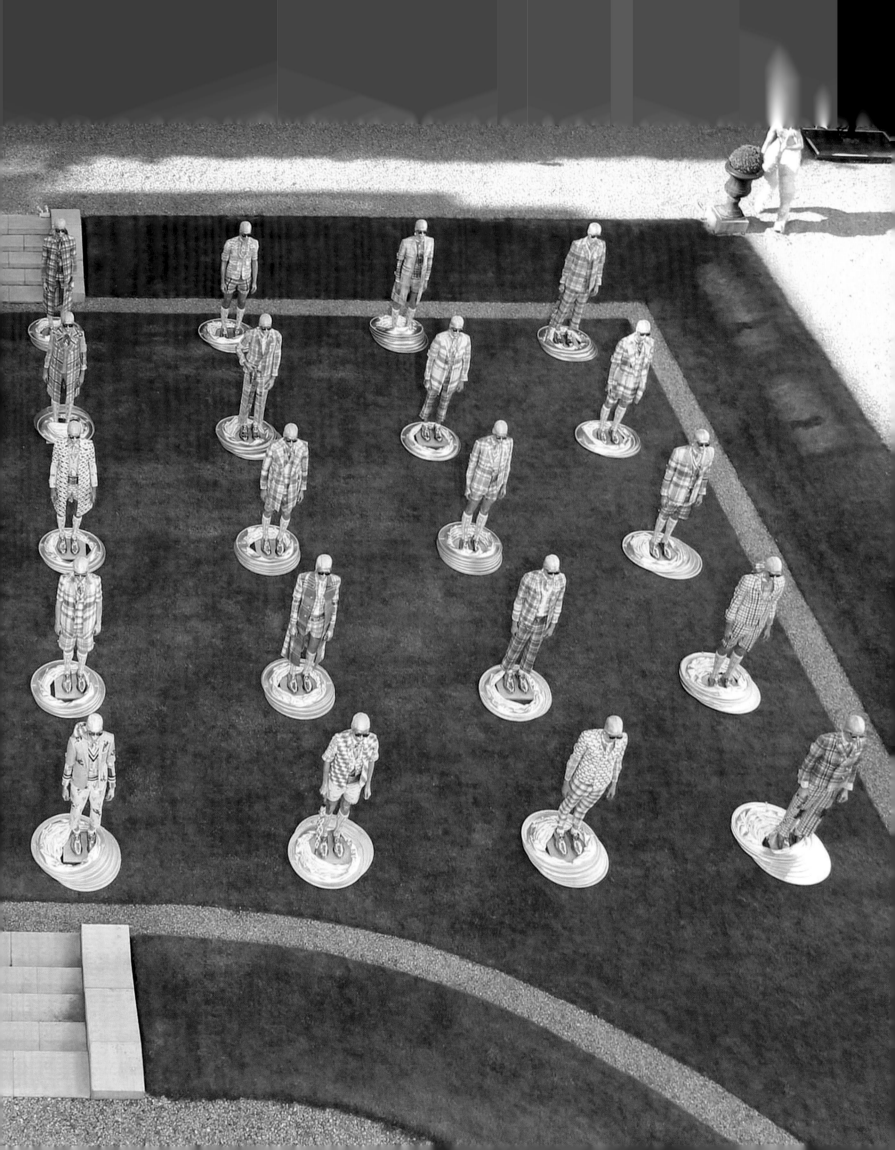

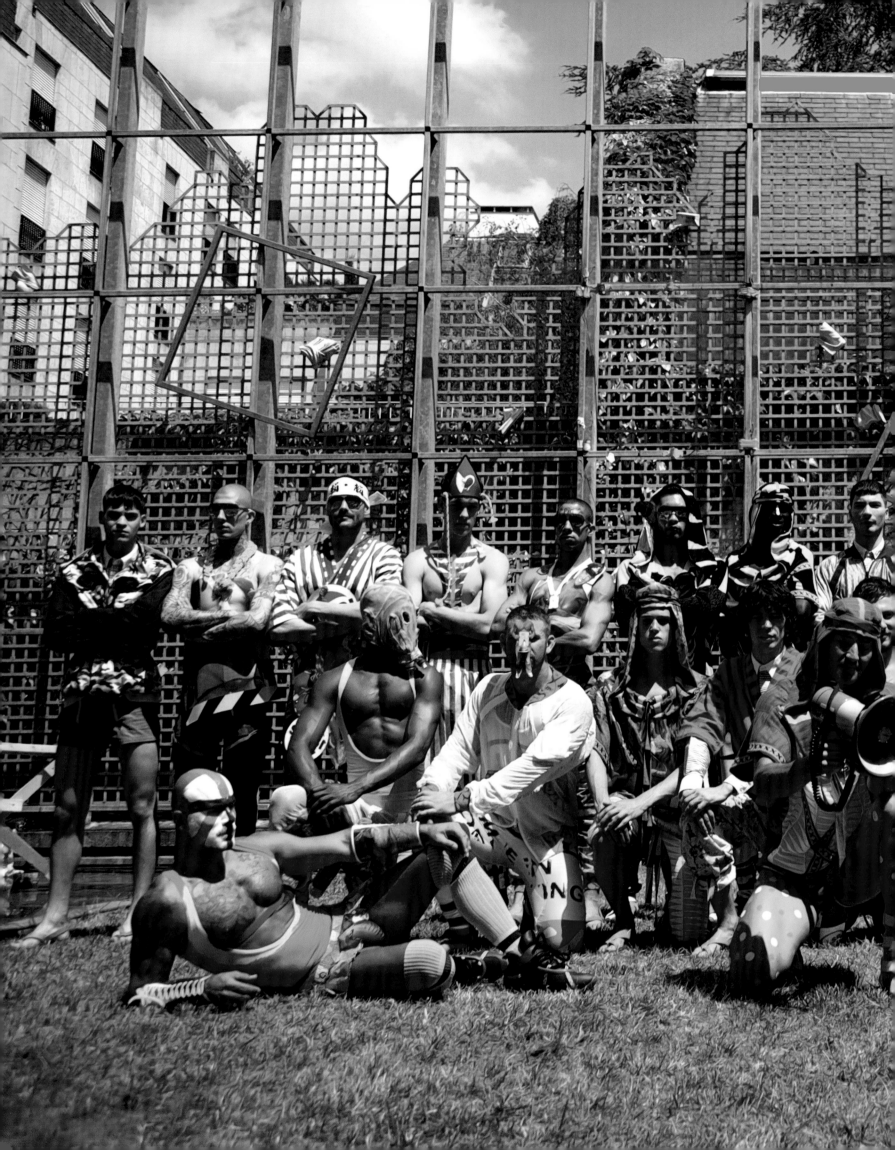

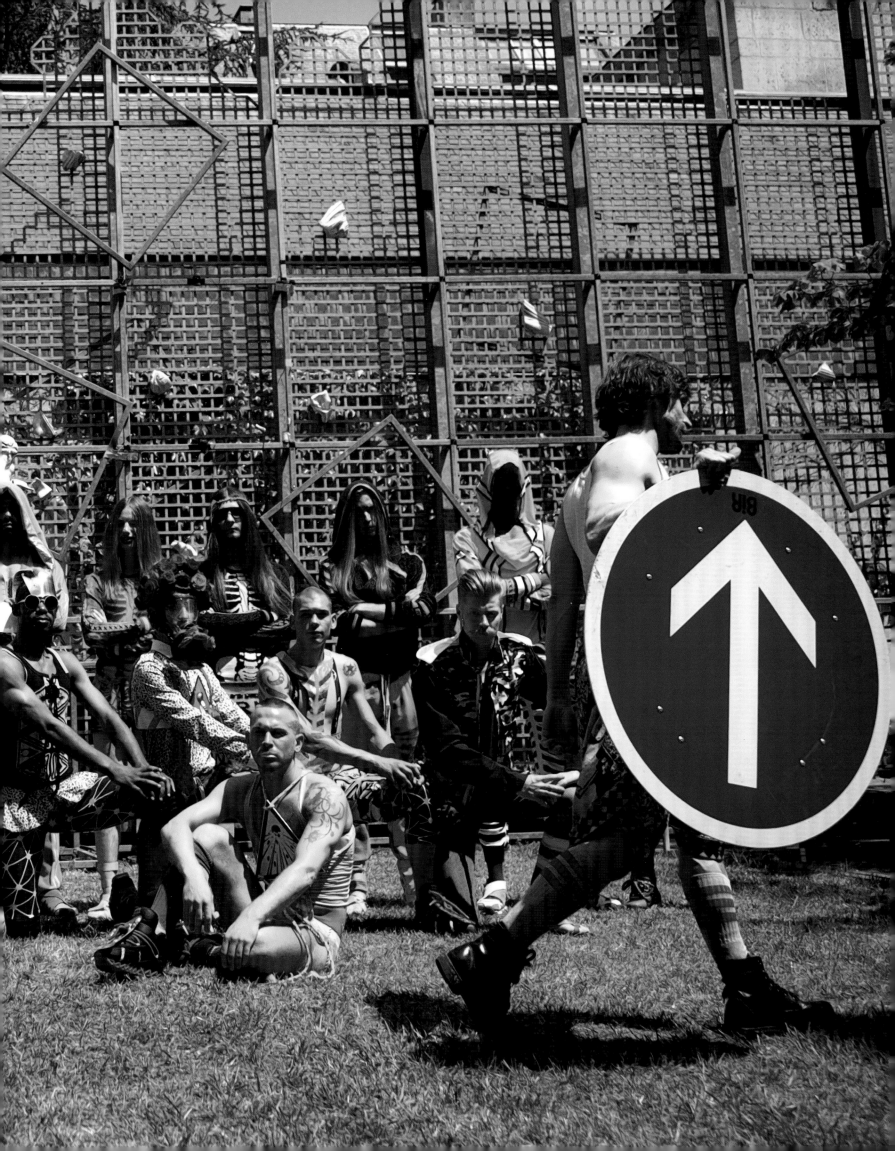

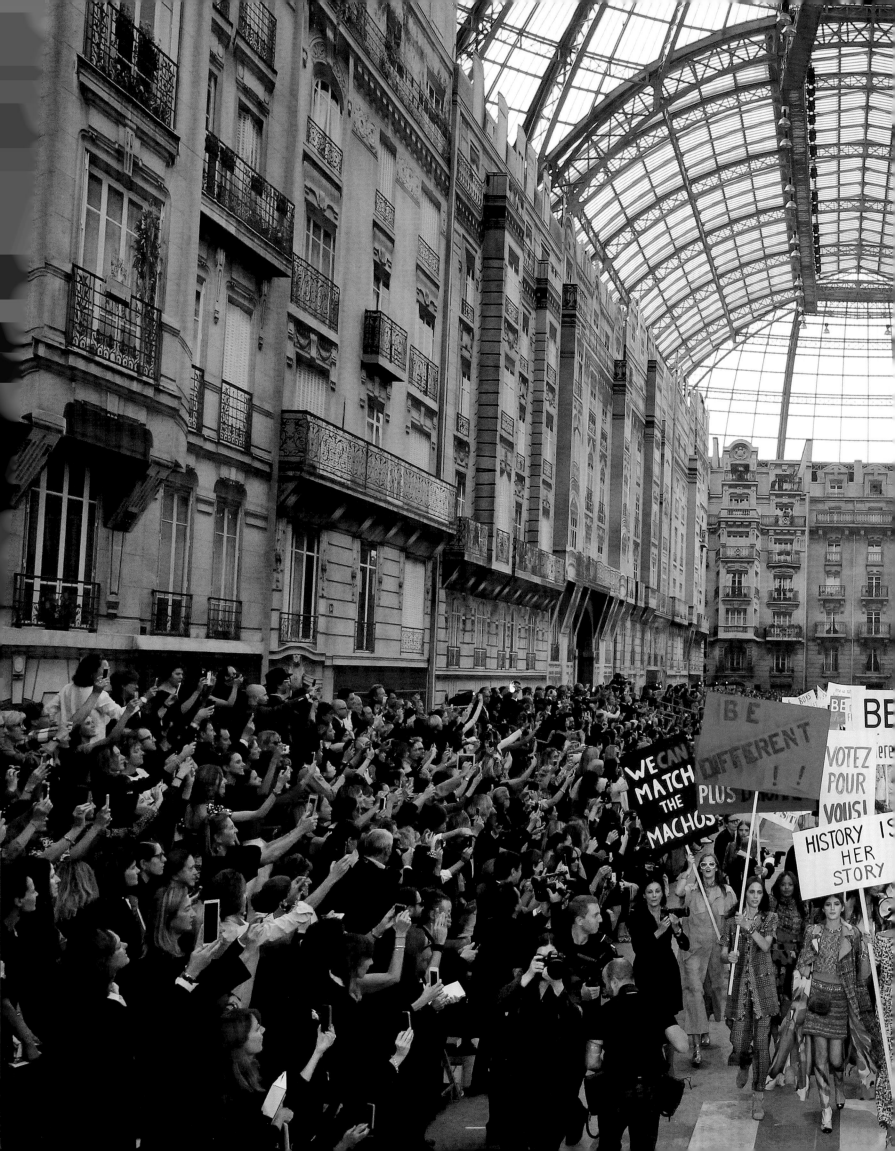

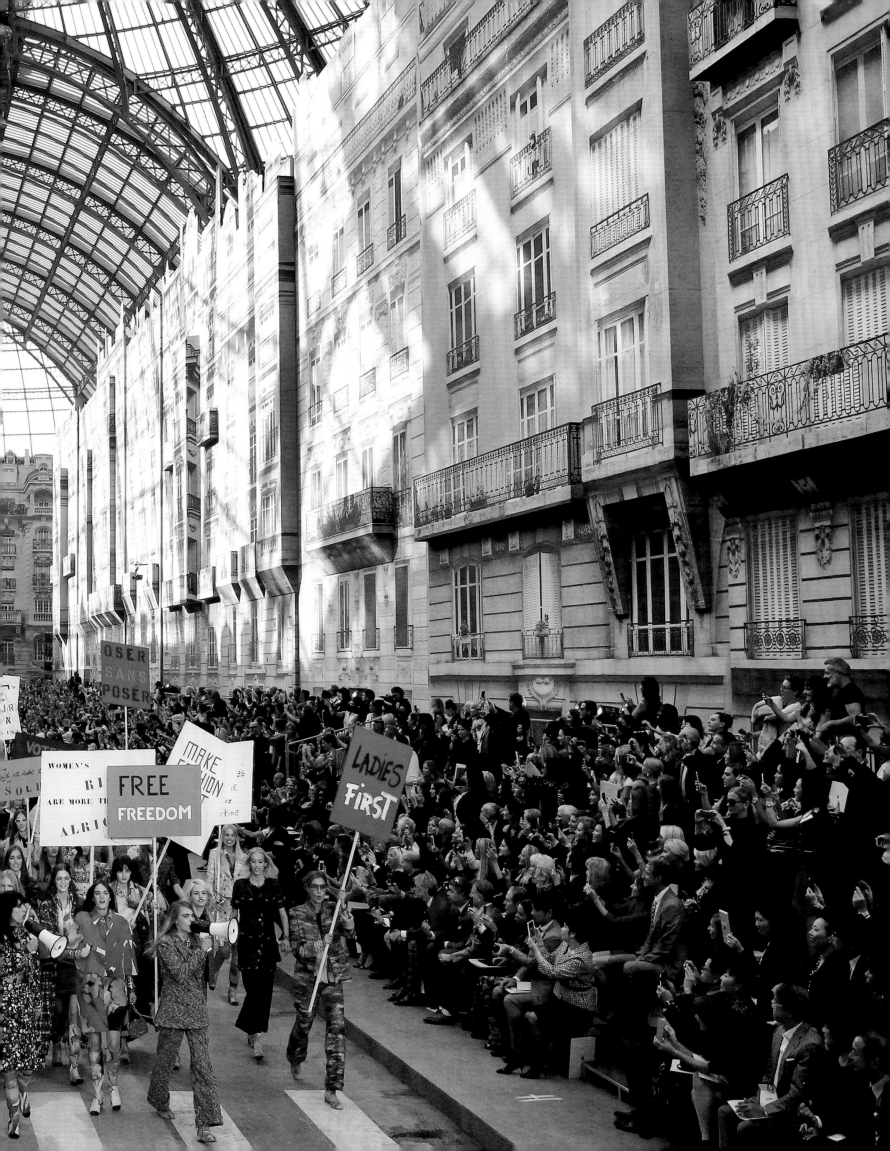

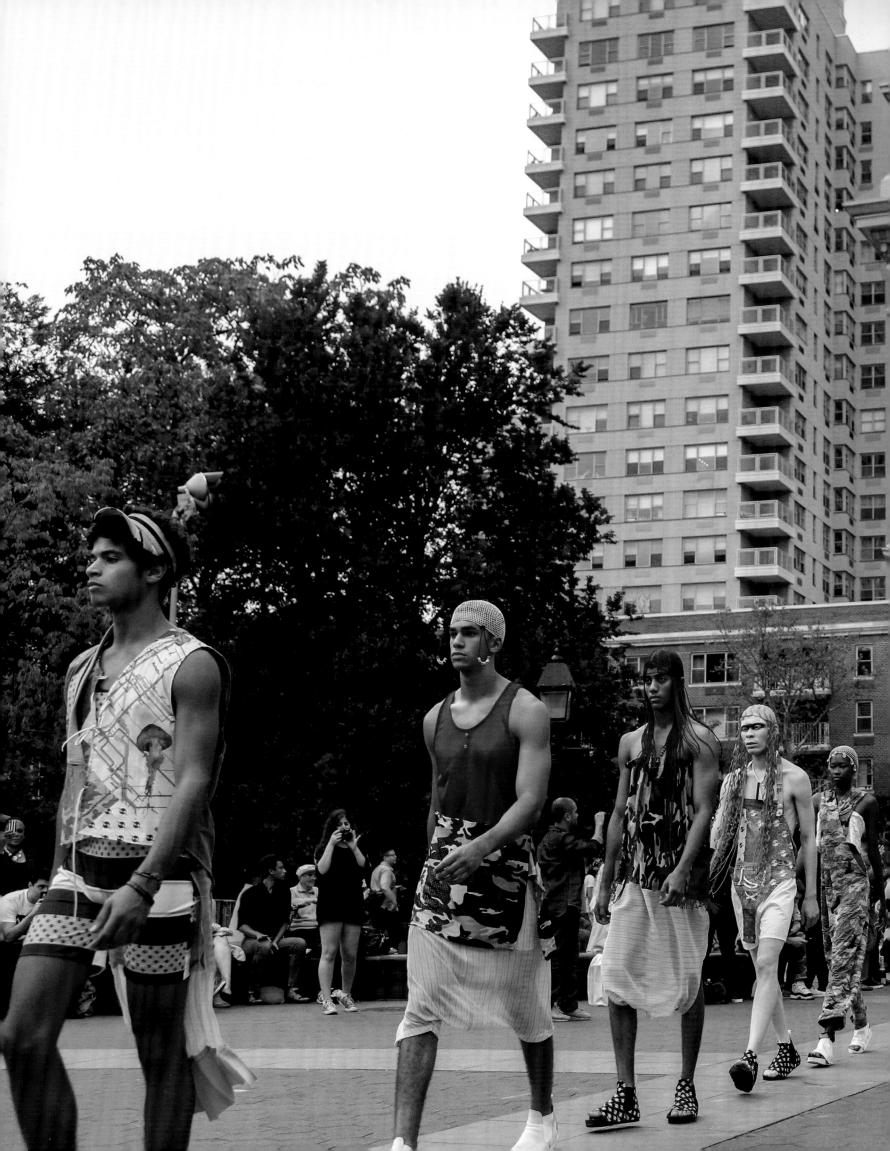

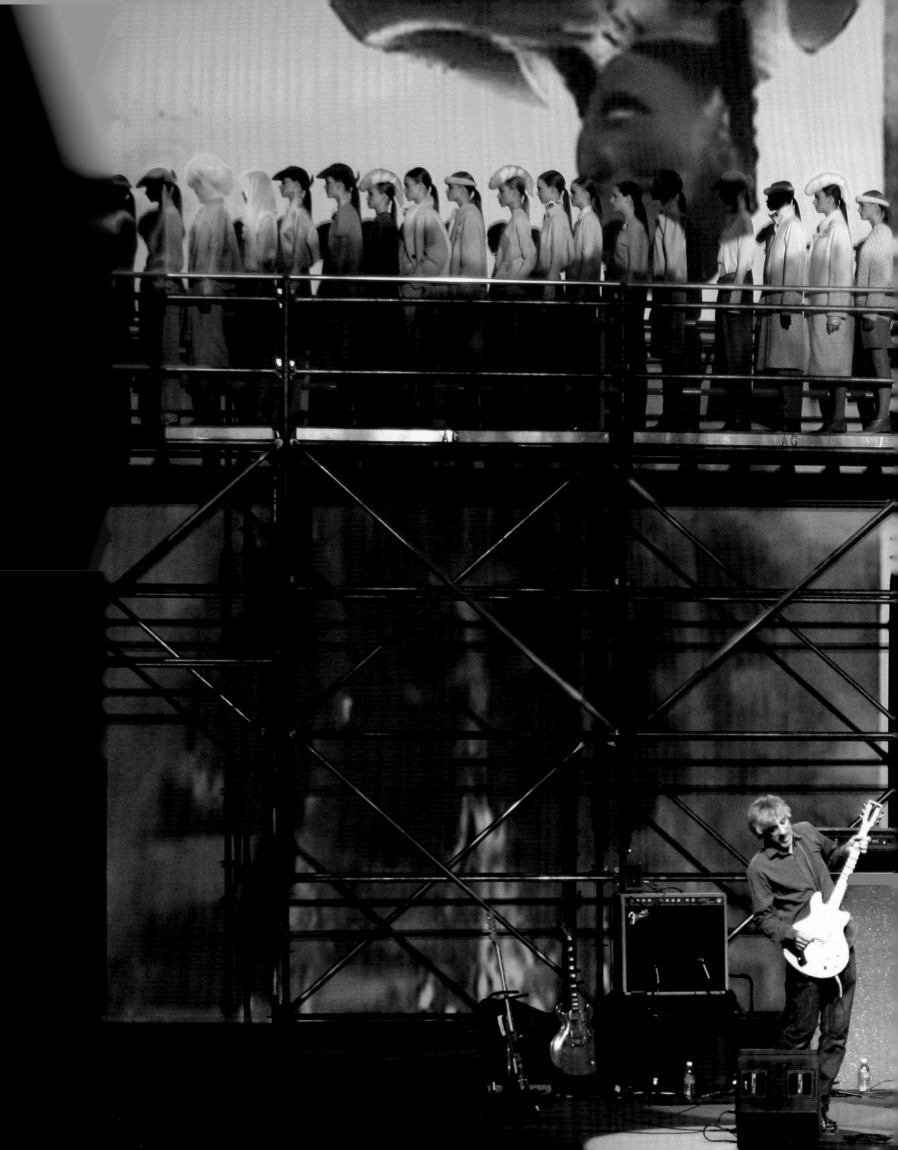

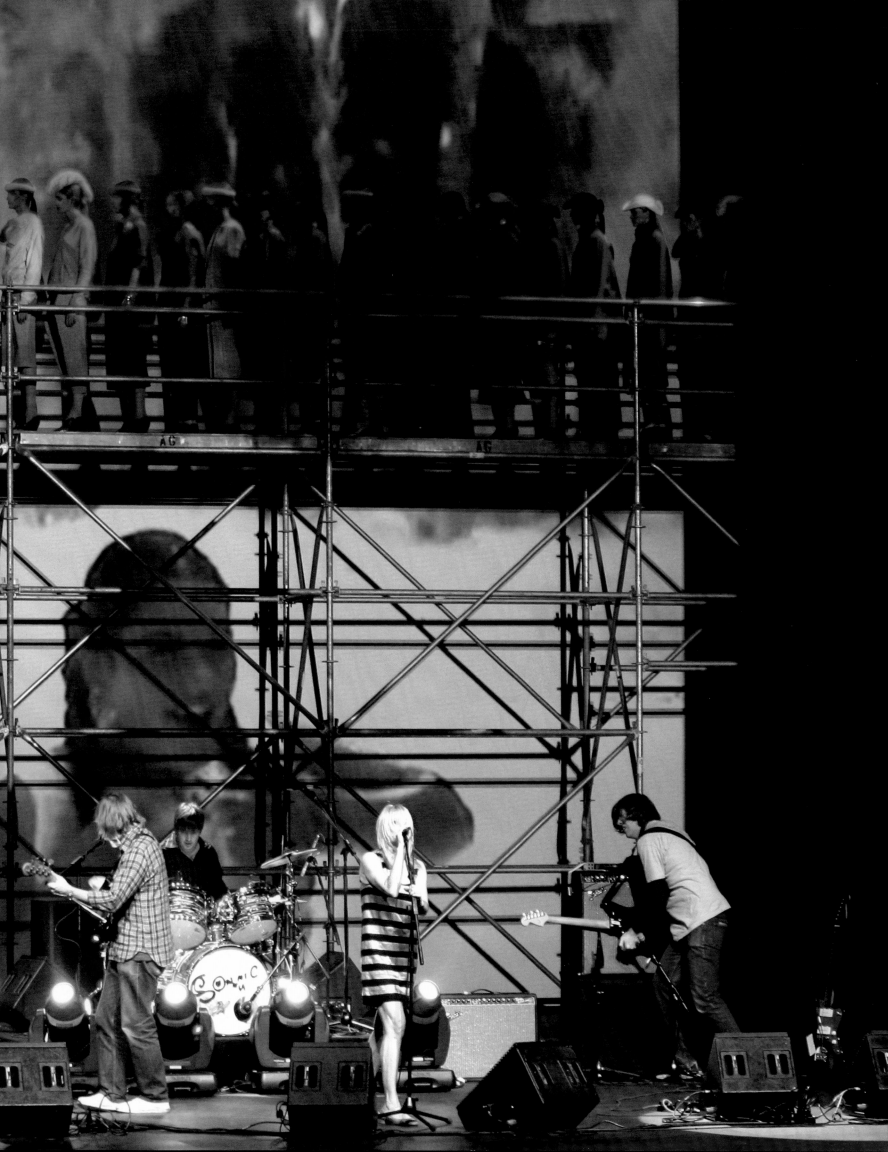

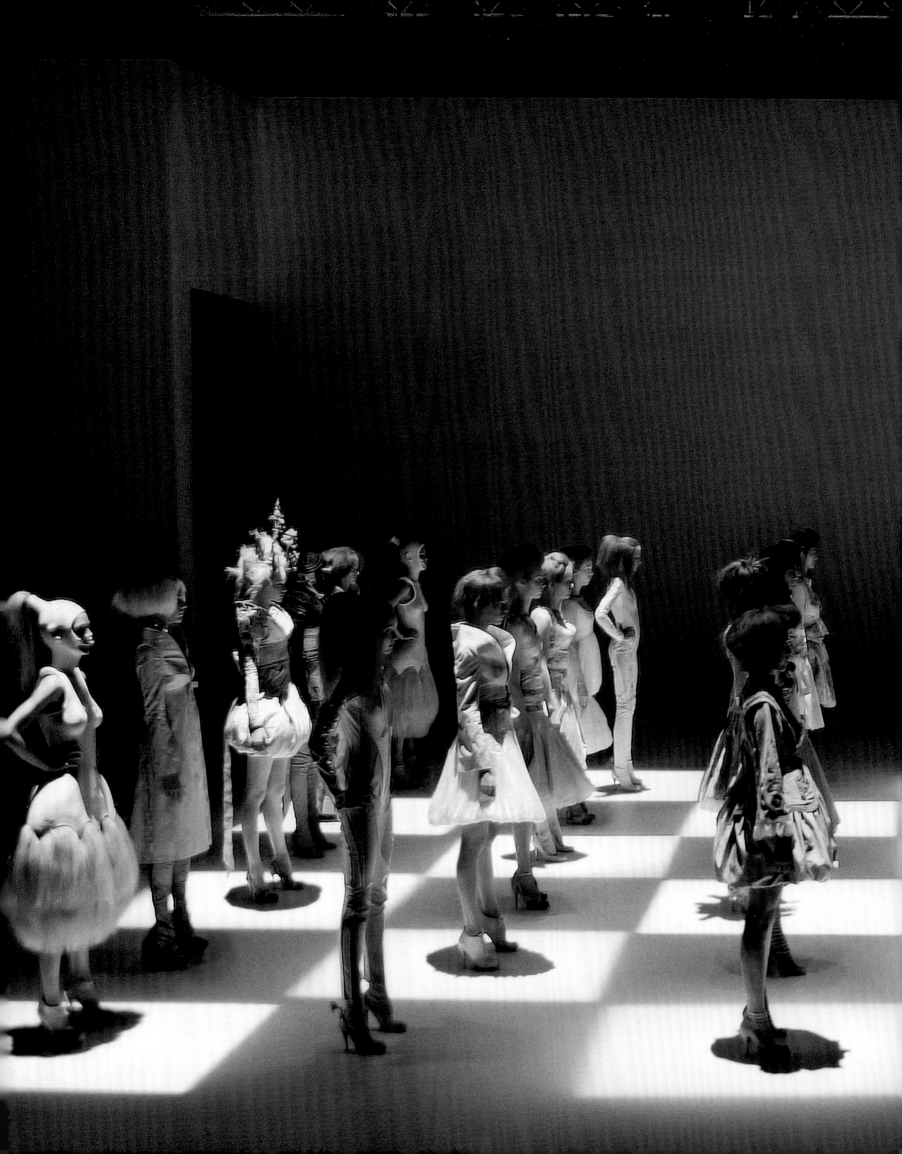

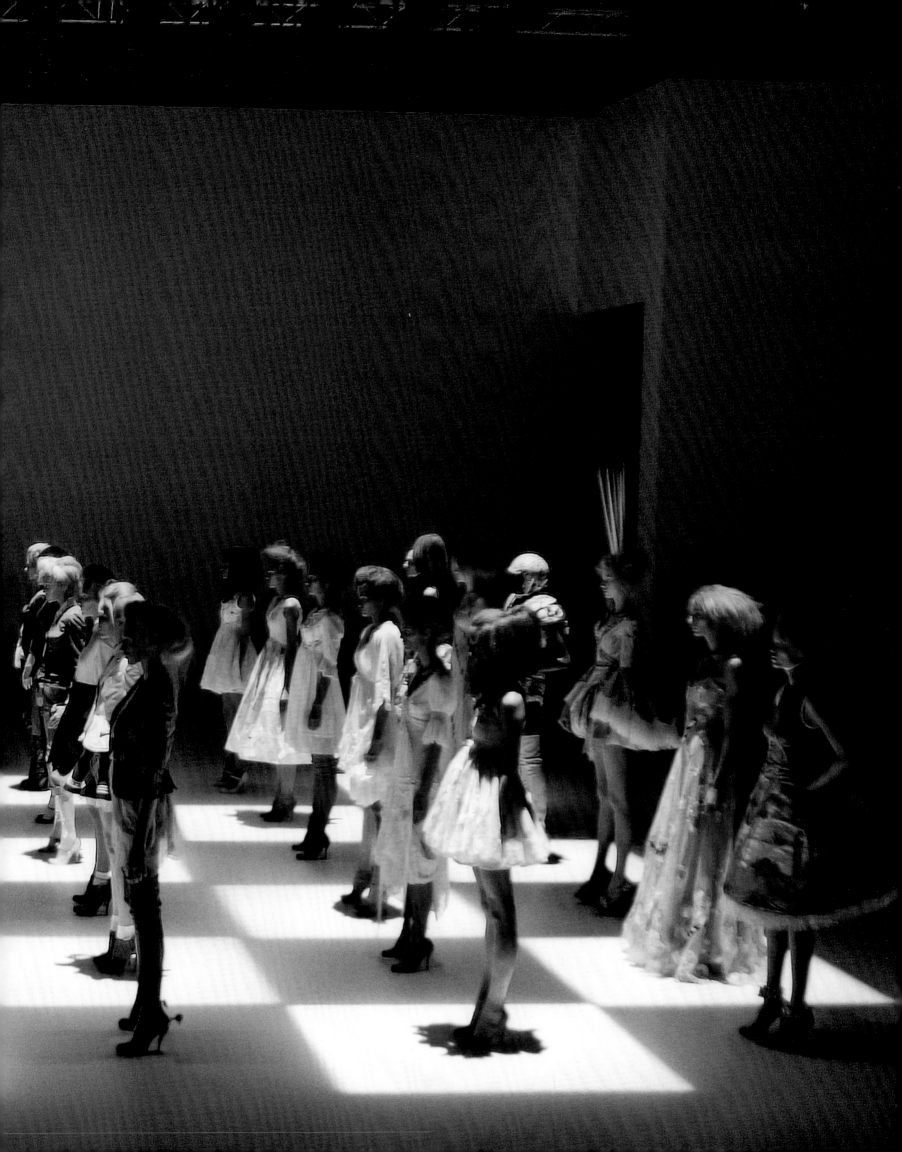

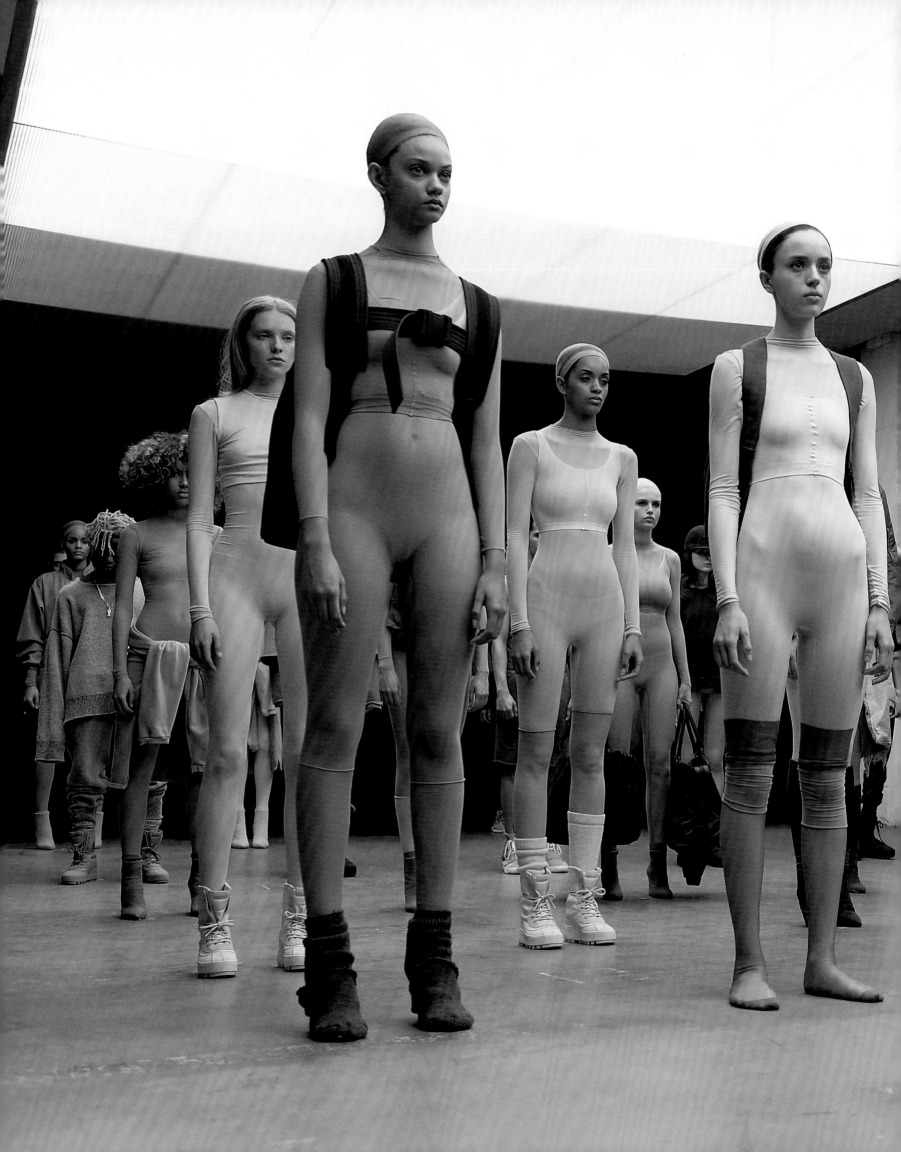

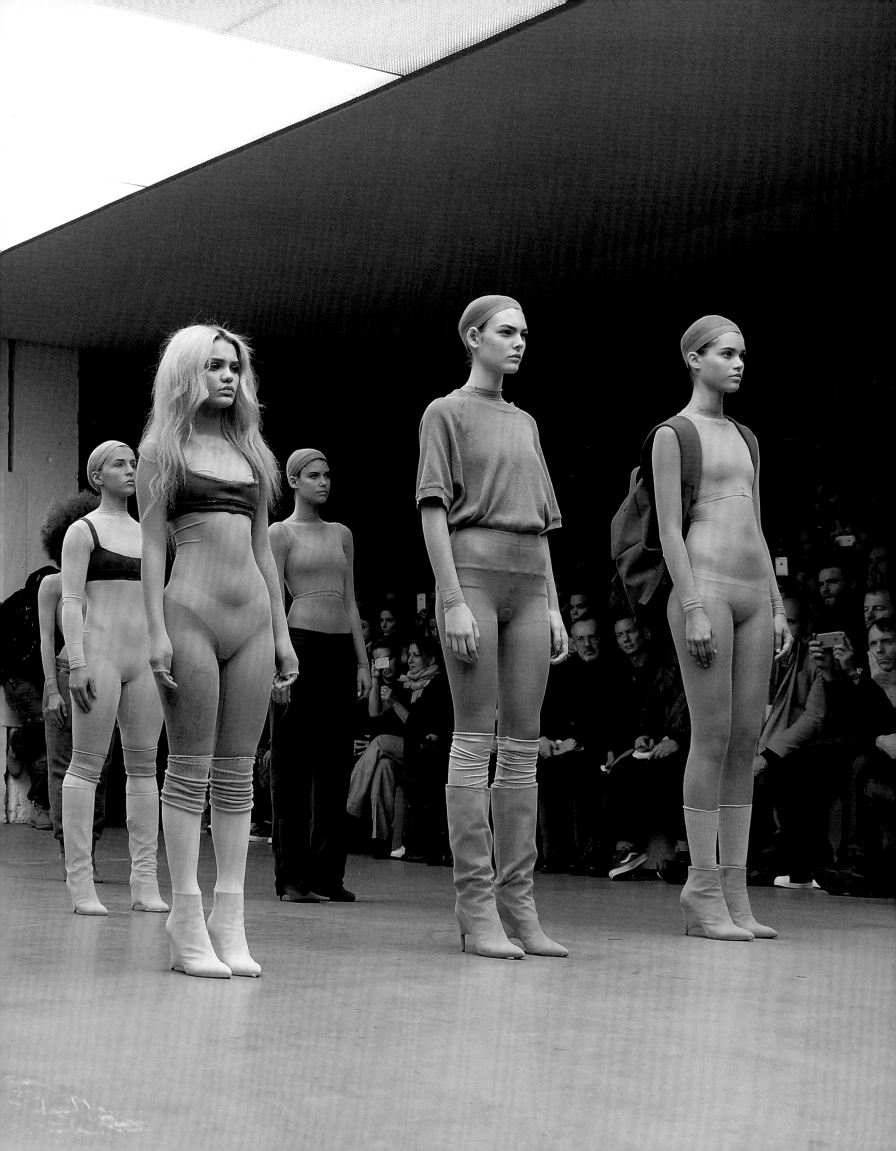

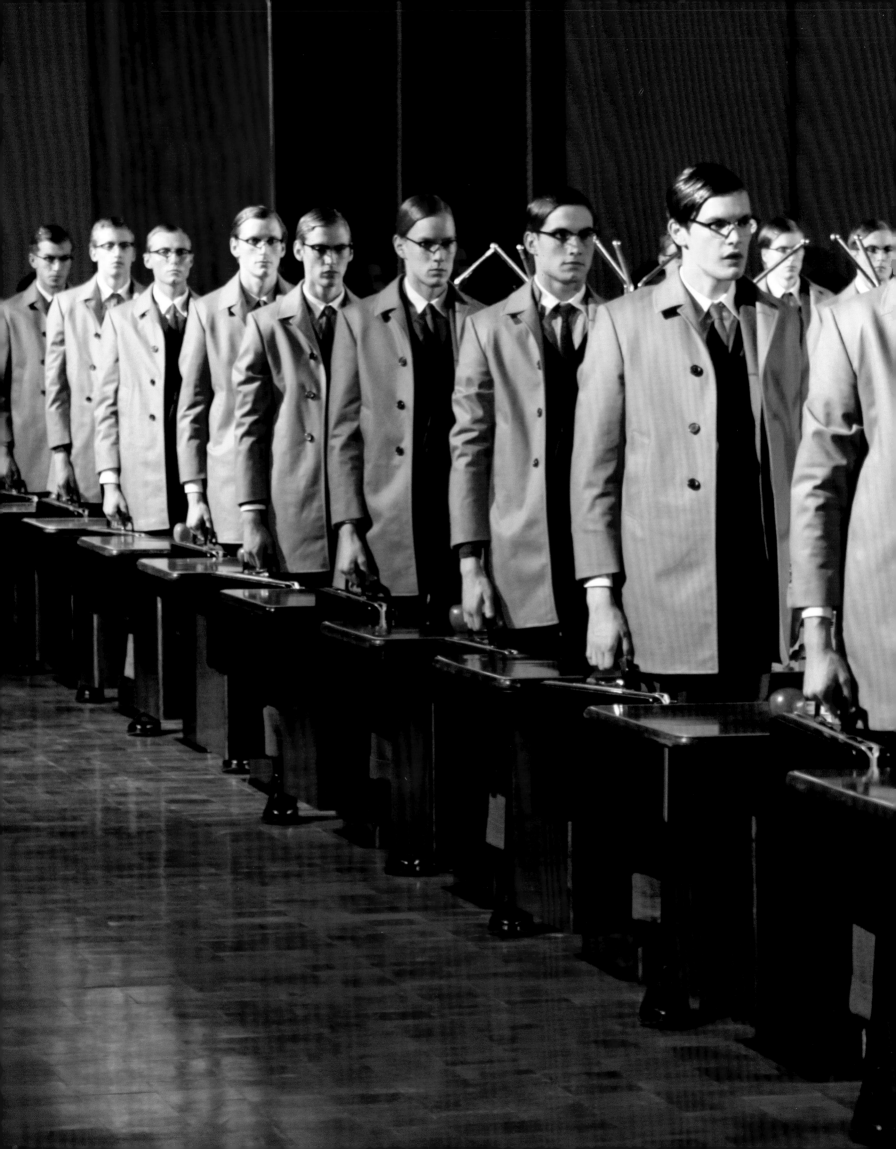

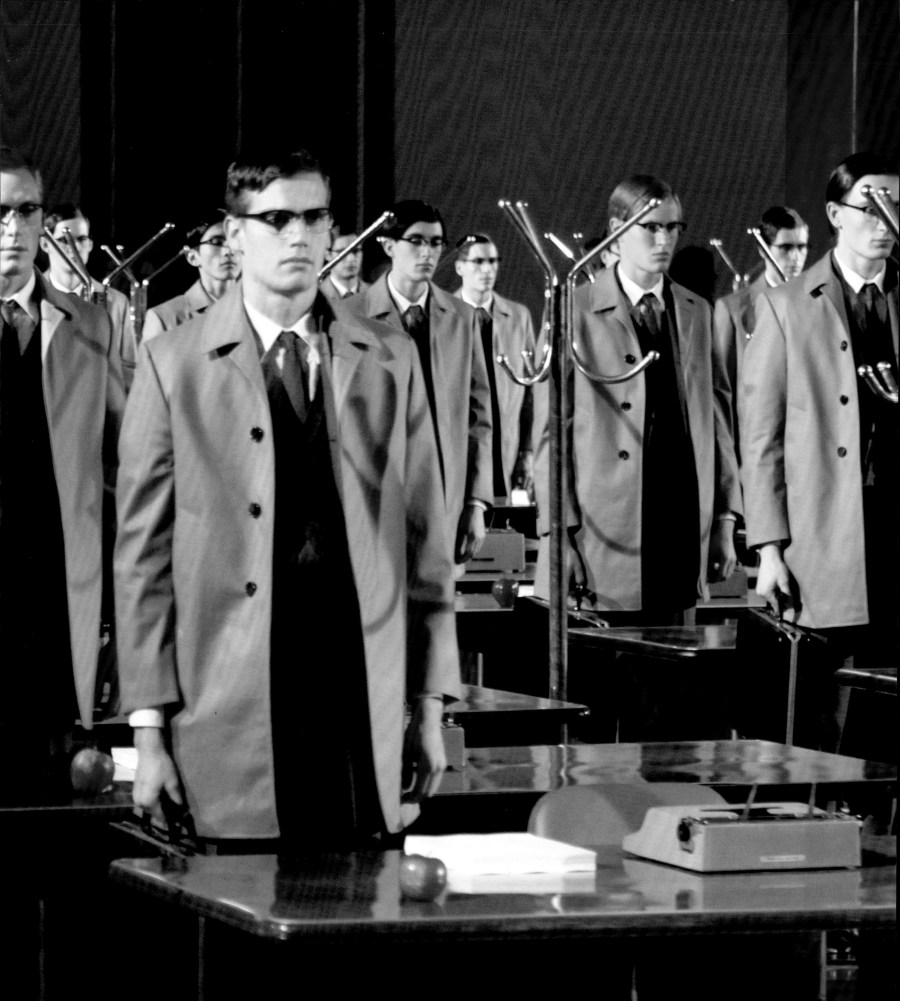

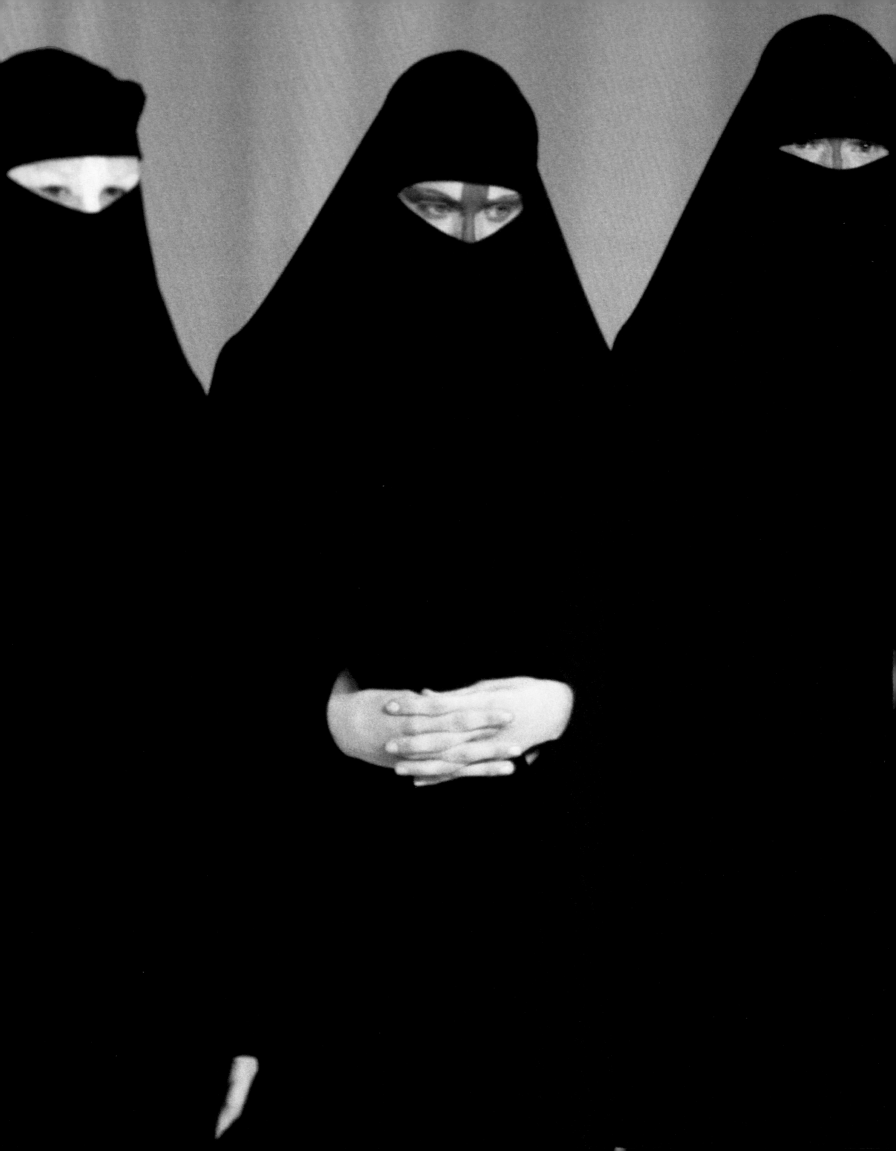

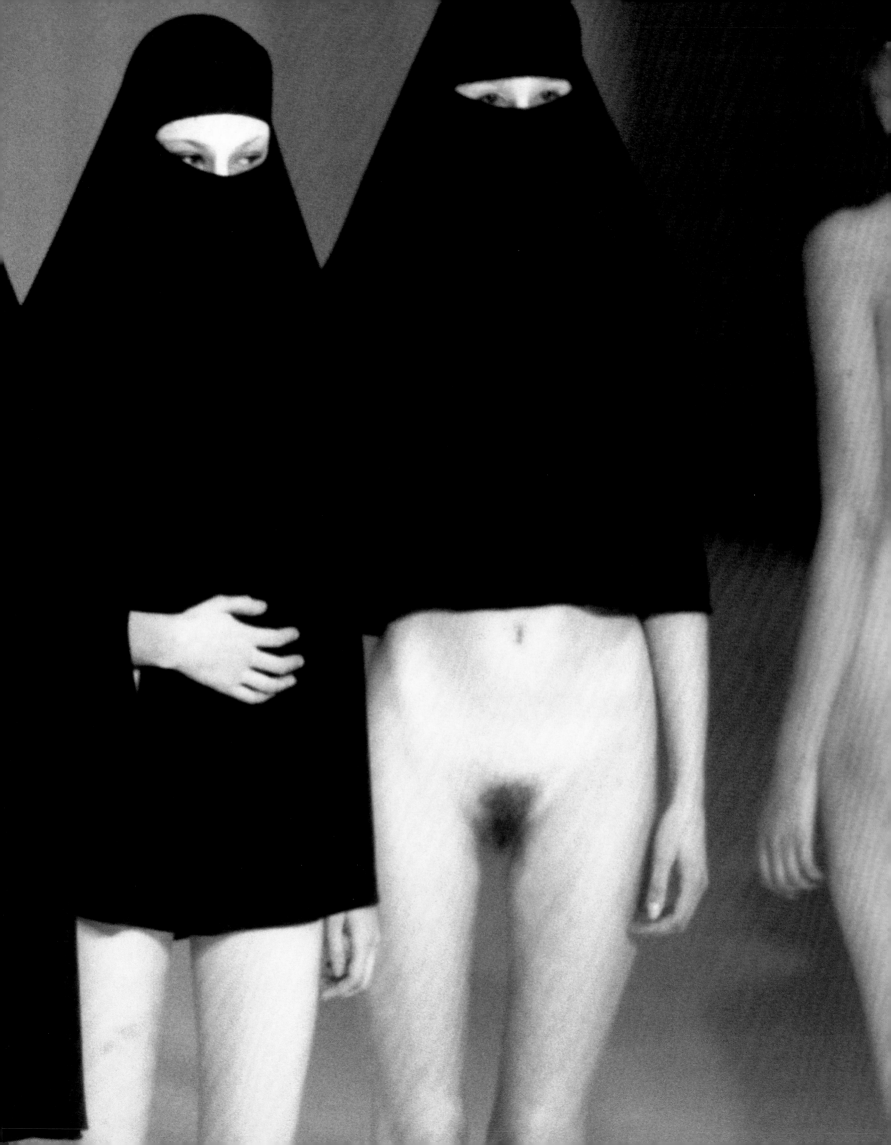

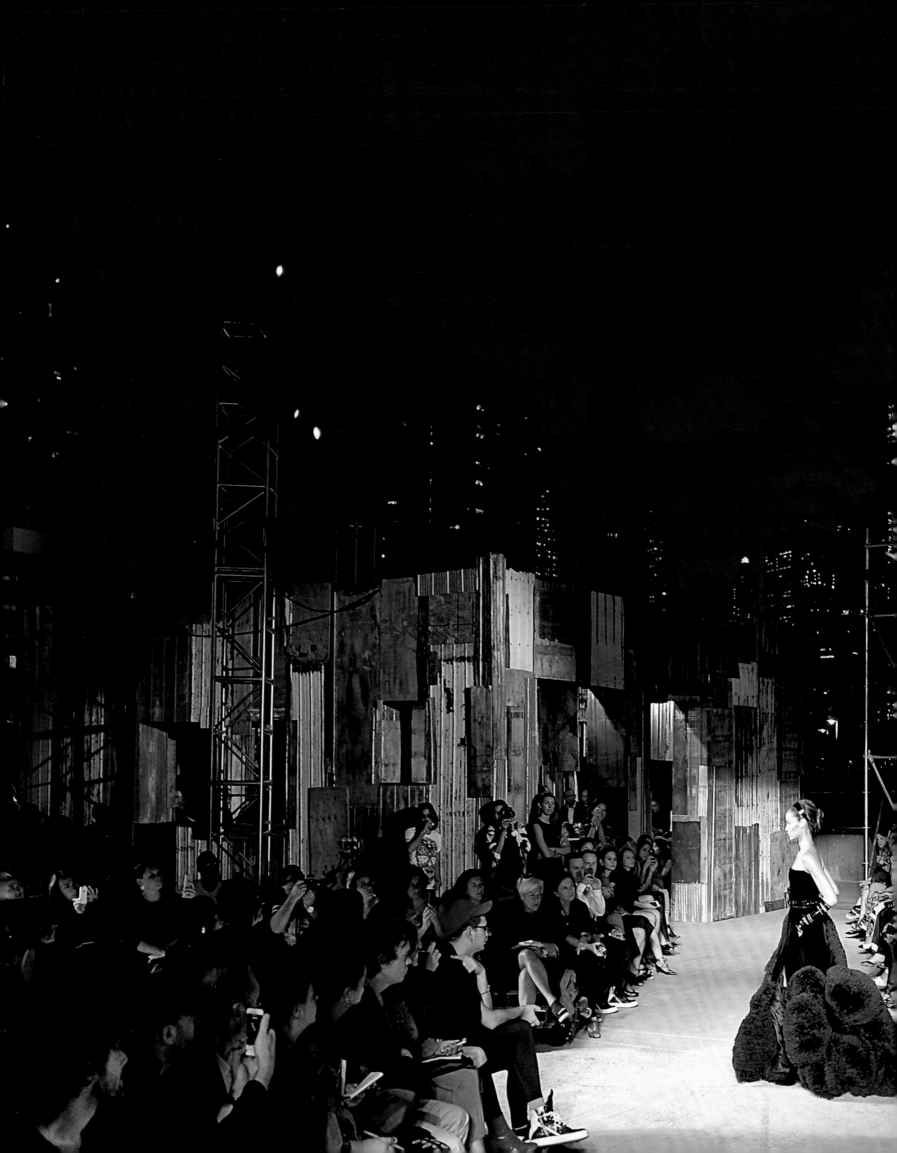

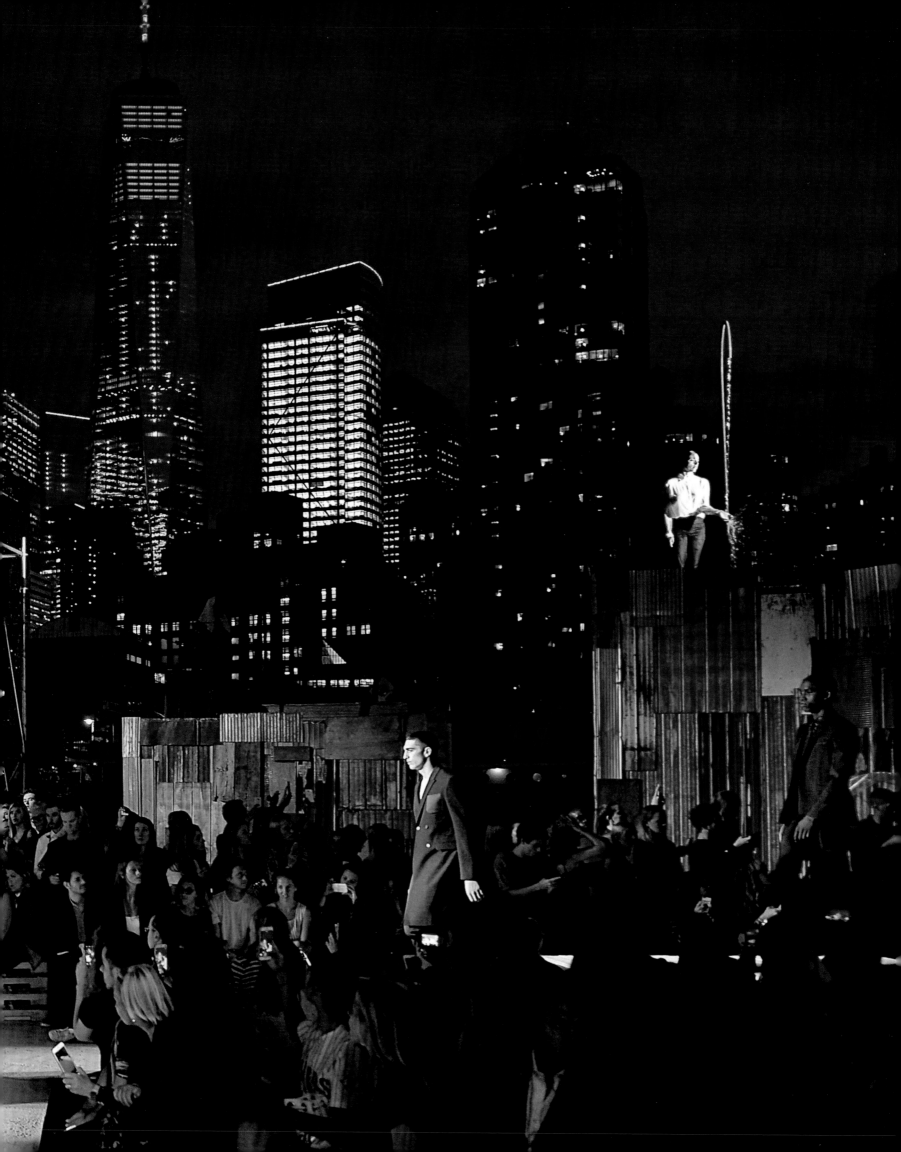

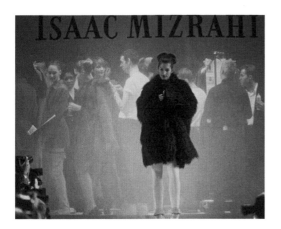

ISAAC MIZRAHI
FALL 1994

The making of Isaac Mizrahi's Fall 1994 collection provided the narrative thread for Douglas Keeve's popular fashion documentary *Unzipped*. But the designer's theatrical runway presentation that season, which brought all of the drama of the backstage to the fore—the frantic retouching of hair and makeup, supermodels in their underwear, and Mizrahi himself in the role of impresario calling the shots—was not, he insists, for the benefit of the film crew. "I was being forced to show in the tents which I was very much against," Mizrahi explained. Like many of his peers, the designer would have preferred to show in, say, a derelict loft space in SoHo. But in the wake of incidents involving a partially collapsed ceiling and a blown generator, which sent editors running for the emergency exits, Fern Mallis, then the executive director of the Council of Fashion Designers of America, corralled the New York shows into two large tents on the grounds of Bryant Park in Midtown. "I felt I had to have a concept that would make the show seem different from all the other shows before and after me," Mizrahi said. "Also, I wanted to show a very glamorous collection in the face of all the grunge and tattoo nonsense that was going on. I felt the audience would need to see this woman in a vulnerable position—I wanted them to see her undressed."

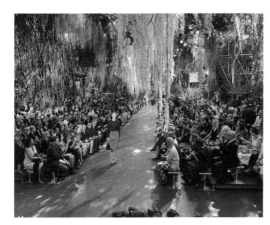

CHRISTIAN DIOR
SPRING 2014

When Raf Simons made his debut at the French house, with his Fall 2012 Haute Couture collection, the venue was a grand, though somewhat down at the heels, hotel particulier on the Avenue d'Iéna. A sequence of rooms had been lined floor to ceiling with fresh flowers, each featuring a different bloom—purple delphiniums, white orchids, yellow mimosa. "Like being inside of a Jeff Koons puppy," is how Simons described it. Indeed, flowers are a classic Dior motif (Christian Dior, himself, had a grand passion for gardening)—one that in his Spring 2014 ready-to-wear presentation Simons would both embrace and subvert. In the Dior tent, in the garden of the Musée Rodin, Alexandre de Betak realized Simons's vision of an upside-down Eden, dripping with flowers both real and fake, and interspersed with plastic tubes and fluorescent lights. The bones of the tent were left mostly exposed, like an industrial trellis for an atomic hothouse, and the sides remained open to the surrounding greenery. While slogans like "Alice Garden" and "Primrose Path" embroidered on the floral dresses might have led viewers down a rabbit hole of references, Simons had something more sinisterly futuristic in his sights: a space ship in the wake of an alien attack, its ceilings ripped open and its guts laid bare.

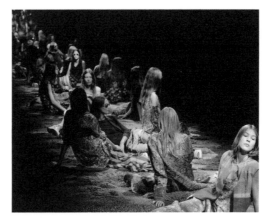

DRIES VAN NOTEN
SPRING 2015

"You want to create a magical moment," said the Belgian designer Dries Van Noten, who has shown in Paris since the early '90s. "Everyone has just come from Milan, everyone is frazzled, and you give them a slow, intense, and visceral experience." With his Spring 2015 collection, inspired in part by Shakespeare's *A Midsummer Night's Dream* and also John Everett Millais's painting of Ophelia drifting through a woodland setting, Van Noten delivered just that. His original concept called for a runway covered in moss, an idea that quickly proved unfeasi-

ble—and incredibly messy—in trial runs. It was replaced, at the zero hour, with a 1,500 square foot carpet, created by the Argentinian artist Alexandra Kehayoglou, who worked night and day to realize the commission in just four weeks. It arrived from Buenos Aires, Van Noten recalled, the day before the show. As he rehearsed the models, one by one, on a sample swatch, the question was not only could they navigate the plush, uneven surface of the woolen glen in their platform shoes but, more to the point, would they be able to gracefully sit or lie down for the show's languorous finale.

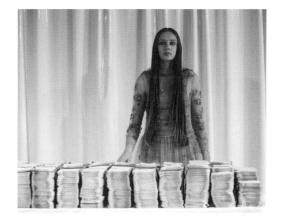

MOLLY GODDARD
SPRING 2016

In presenting her Spring 2016 collection—only her second season on the official London fashion calendar—Molly Goddard made up in charm what she lacked in funds. The set, designed by her mother and assembled with help from her father, was at once quaint and sterile: white curtain, white floors, white tables, white plastic chairs. The models were ordinary girls, cast by her sister from Facebook or the street. In order to distract them from the fact that they were being photographed and ogled by a crowd of buyers and editors, Goddard had them make sandwiches (cheese, tomato and lettuce on white bread with margarine), a banal exercise that stood in stark and deliberate contrast to the clothes themselves which included tulle confections in pink or green, ruffled rompers, and tartan smocks. Goddard assured the girls that it was okay to look bored, and a few of them did, almost too naturally. "We were surprised they didn't make many sandwiches, we really overdid the ingredients," Goddard observed. "But it looked good and we gave everything to a homeless charity afterwards so no waste."

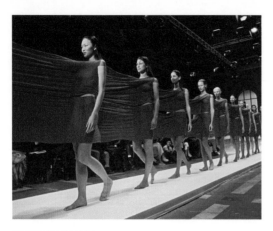

ISSEY MIYAKE
SPRING 1999
Many a designer has closed a fashion show with the image of multiple models wearing identical dresses. But only Issey Miyake has ever orchestrated a finale in which nearly two dozen models came out wearing the same dress. When they walked out single file, connected like so many paper dolls in a shared red garment that extended the entire length of the runway, the stunt was not purely visual. The Japanese designer was introducing the technical innovation that would come to fully occupy his time: A-POC (an acronym for "a piece of cloth"), a radical new manufacturing method that uses computer technology to create clothing from a single piece of thread.

194

COMME DES GARÇONS
SPRING 2011
In Rei Kawakubo's spare runway presentations for Comme des Garçons, the clothes themselves provide the element of performance. Her inventive designs may be steeped in narrative possibility, but the designer, who is famously reticent in interviews, is more inclined to raise questions than make statements. "Multiple personalities; Everything upside down to disturb the status quo," were the crumbs of inspiration tossed out to those attempting to unravel her Spring 2011 collection. The show was held in the Halle Freyssenit, a former train depot

in Paris's 13th arrondissement; inside, a square the size of a boxing ring was framed by narrow wooden benches. The clothes appeared to have been put on upside down, or were somewhat dementedly constructed. A motorcycle jacket with extra sleeves could not help but conjure a straitjacket, which may have been a commentary on the restrictive nature of the fashion system that the Japanese designer constantly challenges in all aspects of her work. The show ended with three sets of twins, conjoined, discomfitingly, by a third, empty garment between them.

MARC JACOBS
FALL 2012
For the set of his Fall 2012 runway show, Marc Jacobs turned to Rachel Feinstein, an artist known for her warped, fairytale-like vision. Feinstein's references ran the gamut from an edifice taken from Giotto, to Rococo follies, to a crumbling staircase in Ireland. It was up to Jacobs's longtime set designer Stefan Beckman to translate Feinstein's paper models into something that could hold its own weight at a much larger scale. While the building material was ultimately rather cheap, the process was labor intensive: "The whole thing was hand-carved over the course of a week," he explained. A series of jagged, precarious arches, some traced with rickety stairs or punctuated with dead trees, gave way to a winding runway that led past a fountain spouting streams of Mylar. If the set—and also the wonderfully batty puritanical collection itself—brought to mind something straight out of Dr. Seuss, Jacobs was quick with those allusions backstage after the show, too: *The Cat in the Hat* and *The Lorax*, but also Jamiroquai, Kurt Cobain, Gloria Vanderbilt and the fashion eccentric Anna Piaggi. The soundtrack that season was from *Oliver!*, variations on the song "Who Will Buy?"

CHANEL
SPRING 2012 HAUTE COUTURE
When it comes to the Chanel runway, the sky really can appear to be the limit. The French luxury house routinely stages the presentations for its Métiers d'Art and Resort collections in far-flung locations (Venice, Dallas, Salzburg, Edinburgh, Seoul, Havana), importing not just models and a full production team but also the audience. If there was ever a possibility of building a runway on the moon, you can be sure that Chanel will be there first. In the meantime, Karl Lagerfeld has presented his ready-to-wear and Haute Couture collections in Paris's Grand Palais, which, having been built for the Universal Exposition of 1900, has seen its share of The-Future-Is-Now installations. For Chanel's Spring 2012 Haute Couture collection, it was the cabin of a space shuttle. The flight simulator was complete with a domed ceiling through which the stars, and a passing glimpse of the earth itself, could be taken in overhead. While some of the more structured silhouettes appeared to reference flight attendant uniforms, the inspiration for the collection came from the heavens: Lagerfeld boasted that the 61-look collection contained 154 different shades of blue.

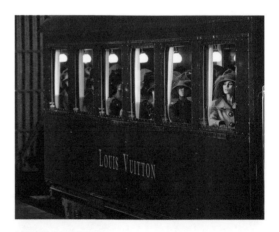

LOUIS VUITTON
FALL 2012
An old-fashioned train car, built from scratch and hooked up to a gleaming period steam engine, pulled into the Louvre's Cour Carrée, which had been decked out for the occasion as a turn-of-the-century railway station. Models,

dressed elegantly if somewhat somberly for their journey back in time, disembarked onto the platform, each followed by a uniformed porter carrying her Louis Vuitton baggage. A clock, glowing like a full moon overhead, had just struck the hour of ten. How civilized it all seemed. More than a decade earlier, when John Galliano's Disorient Express chugged into the Gare d'Austerlitz, Pocahontas clinging to its prow, that train was well over an hour behind schedule. It arrived amidst neocolonial chaos: Was this a Native American pow-wow? An Indian souk? The arrival of the Louis Vuitton train, on the other hand, and Marc Jacobs's Fall 2012 collection, had been precisely timed to the opening of an exhibition later that night, in the museum's Arts Décoratifs wing, exploring the parallel contributions of the designer and the house's founder, Louis Vuitton, in their respective eras of 19th century industrialization and 21st century globalization.

for Comme des Garçons in her usual space in the 3rd arrondissement, Paris's Jewish quarter, on the 50th anniversary of the liberation of Auschwitz. The striped pajamas, some people said, brought the death camps to mind. The theme of that collection was, in fact, simply "Relax."

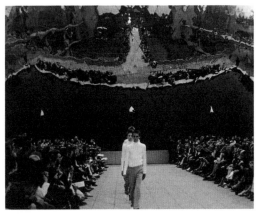

RAF SIMONS
SPRING 1999
As a young designer looking for a unique place to stage a runway show in Paris, Raf Simons could do no better than the Cité des Science et de L'Industrie in La Villette, in the northeast of the city. Adrien Fainsilber's dramatic modernist campus is anchored by the Geode, an enormous mirrored sphere surrounded by water and approached by a network of elevated catwalks, all of which contributed to this otherwise modest show's quiet heroicism. Simons dubbed his Spring 1999 collection "Kinetic Youth," likening its inner logic to the workings of a Rubik's Cube. Models were sent out in coordinated groups, their clothes becoming slowly and incrementally more colorful—and more defiant—as the show progressed, so that what began as a parade of tailored black-and-white culminated in a riot of color. The show came off against certain odds, chief among them the weather forecast, which called for rain. Simons had no contingency plan. "No rain jackets, no umbrellas, nothing," he said. He was already asking people to travel far outside of the city center. If it rained, he genuinely feared that no one would show up, and his fledgling company would go bankrupt. He needn't have worried. The audience watched as themes of conformity and rebellion, and the triumph of the latter over the former, played out to Pink Floyd's "Another Brick in the Wall," under a moody Parisian sky.

195

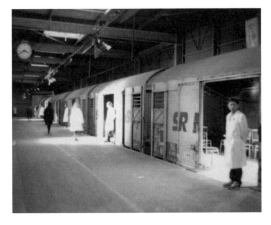

MAISON MARTIN MARGIELA
FALL 2000
A ready-made salon, with a suite of intimately scaled rooms that would allow editors and buyers a close look at the clothes, a train is in many ways an ideal setting for a fashion show. Martin Margiela held his Fall 2000 presentation in a railway depot, where a dozen freight cars were outfitted with disco balls and the spindly gold ballroom chairs one would expect to find in the salons of the Avenue Montaigne. Surplus guests crowded the station platform alongside the photographers, where they could catch glimpses of the models through the open cargo doors as they walked from car to car in their vastly oversized silhouettes, thickets of fringe obscuring their identities. The lights flickered off between the *passages*, making for a disconcerting experience. A few guests became anxious, not sure if the train was going to leave the station or not, and if so, where it might end up. Some in attendance went so far as to venture that the set-up was evocative of the cattle cars headed to the Nazi death camps. While that was clearly not the designer's intent, Rei Kawakubo had suffered similar accusations five years earlier, when she presented her Spring 1995 men's collection

W<
SPRING 1997
Throughout much of the '90s, backed by the German denim company Mustang, the Belgian designer Walter Van Beirendonck was known for his over-the-top runway extravaganzas. "As we invited almost 2,000 people to the shows, it was rather difficult to find venues in the center of Paris," Van Beirendonck recalled of his Spring 1997 presentation. "So I came up with the idea to book two spaces." The double show took place simultaneously at the Elysée Montmartre, a concert hall in the 18th arrondissement, and the Trianon Theater just down the block on the Boulevard de Rochechouart. Each space had its own atmosphere: a floor to ceiling video installation in one and a live concert by the band Agent Provocateur in the other. The collection, "Welcome Little Stranger," had a similarly dual spirit: The title came from a handicraft book that suggested embroidering that slogan on the cushion of a newborn baby's crib. "I also liked the double meaning—a message of aliens and tolerance," the designer said. Certainly there was some of that at play as, to the delight of passersby on the street, the models traveled on foot from one venue to the other, transforming the sidewalk into an impromptu runway. Van Beirendonck, who had not secured permits for this guerilla sideshow, remained backstage the entire time but watched the video footage afterward. "I loved the atmosphere outside, how it was building up," he recalled. "The audience and the traffic stopped, but in the midst of the models, the action on the boulevard (selling food!), carried on."

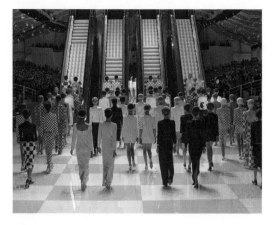

LOUIS VUITTON
SPRING 2013

The French conceptual artist Daniel Buren, whose divisive "Les Deux Plateaux"—a grid of black and white columns of varying height—has become a fixture of Paris's Palais Royal since it was installed there in the mid '80s, brought his sensibility to bear not just on the Louis Vuitton Spring 2013 runway show, but on the collection itself. His graphic set featured two pairs of escalators, their steps intermittently striped yellow and white, via which the models made their entrances and exits in coordinated pairs. The floor was done up in a gleaming yellow and white grid, a Buren signature, but also an allusion to Vuitton's own signature Damier check. This was not Marc Jacobs's first collaboration with an artist for the French house. In previous seasons he'd teamed up with Richard Prince and Takashi Murakami, but this particular show was all the more memorable for its brevity. A punch in the eye, the spectacle lasted a mere six and a half minutes.

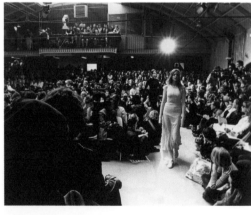

HELMUT LANG
FALL 1993

In the early years of his career, the Austrian designer Helmut Lang showed in Paris at the Espace Commines. The former gallery was decidedly rundown, but for Lang, who was seduced by its rawness and its dramatic glass

ceiling, that was part of the appeal. Even as he moved on to other, more refined spaces in later years, his shows would maintain a distinct, low-fi quality. The runway ran through the audience, delineated by chairs, or in the case of Fall 1993, when he packed about 800 bodies into a room that by all logic should have accommodated far fewer, by people sitting on the floor. Lang habitually gave his models little direction beyond to walk faster than usual, as if in a hurry on the street. Some of them looked at the ground, shoulders slumped, hands in pockets, as they made their way through the crowd; others smiled coyly, perhaps having caught the eye of someone they knew. The clothes, the music, the casting (always a mix of men and women, always a mix of professional models and friends), even the composition of the audience itself, was thoughtfully planned, Lang insisted, down to the last detail. "There was an electrifying energy, which the audience created and also solely owned until the show started," Lang said. "One could literally hear a pin drop. And backstage, one could hear everyone's heart beating, until the music started and the tension broke, merging it all into a single performance."

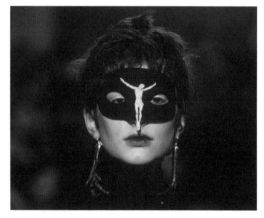

ALEXANDER MCQUEEN
FALL 1996

Some fashion show venues are more loaded than others. For "Dante," the collection that would establish him as a designer with which to be reckoned and not just an *enfant terrible*, Alexander McQueen landed, appropriately, in London's Christ Church Spitalfields, an East End landmark with an imposing gothic spire. It was here, McQueen said, that his ancestors had been christened in the late 18th century. The neighborhood was also the stomping ground of Jack the Ripper, who served as a sort of guiding spirit for the designer's 1992 graduation collection from Central Saint Martins. But McQueen, being McQueen, could not resist further heightening the drama: As the audience filtered into the candlelit nave to take their seats along the cross-shaped runway, they were regaled with embellished tales of the church's haunted catacombs, and the Satanic practices of its architect Nicholas Hawksmoor. Seated

front row, right along with Amy Spindler of *The New York Times* and the *International Herald Tribune*'s Suzy Menkes, was a skeleton. The show opened with Honor Fraser, a model of noble birth, wearing a black mask bedecked with a tiny crucifix, a detail cribbed from a photo by Joel-Peter Witkin. The collection, a commentary on war and religion, was dually inspired by Dante's *Inferno* and the work of the British photojournalist Don McCullin, whose images of Vietnam McQueen had also appropriated, and used throughout the collection as prints.

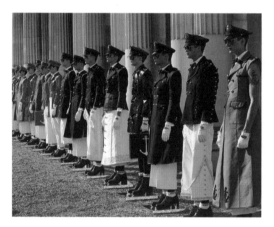

THOM BROWNE
SPRING 2014

A pair of uniformed guards marched through the arcade of the Ecole Militaire, a majestic complex in the 7th arrondissement of Paris (and the alma mater of Napoleon Bonaparte), and assumed their posts in a central courtyard. Their sentry boxes were mirrored, just like the oversized aviator glasses both wore, and lined in a jaunty, though decidedly feminine toile de Jouy wallpaper, making them seem like the dressing rooms of a fancy ladies' department store. The duo were soon joined by an army of models whose outfits—one more flamboyant than the next—brought new meaning to the words "military dress." And with a level of pageantry that would make a fascist dictator blush, the show closed with the appearance of the black-leather-clad general, bearing a white flag. He handed it off to his attending officers who dutifully raised it to full mast, at which time the audience had no choice but to surrender.

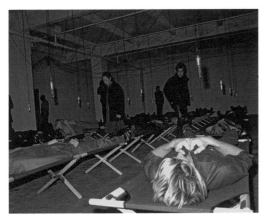

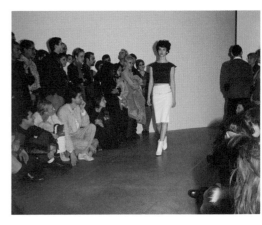

for Opening Ceremony there. Protest was on Sevigny's agenda, too, as a line-up of bands—Lizzi Bougatsos and Sadie Laska of I.U.D.; Shannon Funchess of Light Asylum; the all-girl California surf rock group Bleached; and Kim Gordon, who performed with DNA's Ikue Mori—set up on platforms erected around the nave, played in a round robin. Models dressed in vintage-inspired attire danced freely in the middle of the room. A few stood guard on the perimeter holding placards emblazoned with song titles or scraps of lyrics—Sevigny, her expression stony, standing in solidarity alongside them.

JOHN BARTLETT
FALL 2001

Designing his Fall 2001 collection, John Bartlett found himself drawn to heavy, felted fabrics and drab, military hues. That season he was largely inspired, he said, by the life and work of the German artist Joseph Beuys, and the presentation, less a runway show than a still life installation, was meant to reflect Beuys's predilection for performance art—intimate, politically charged actions he believed held the potential for self-healing and social transformation. The atmosphere was at once peaceful and unsettling: The models were laid out on folding army surplus cots and appeared to be sleeping—young soldiers in a moment of repose. A bare lightbulb dangling above each one dimmed and brightened with the slow, rhythmic breathing of the soundtrack, plunging the room into total darkness at regular intervals. Bartlett remembered people being both enthralled but also frustrated because everything would go pitch black at points, forcing them to stop in their tracks as they tentatively navigated the space. The show was also exceedingly difficult to capture on film. "I wanted something that transcended fashion and moved the audience in a way that mere clothing could not," he said.

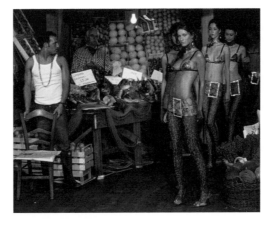

DOLCE & GABBANA
SPRING 2000

In the tented courtyard of the Dolce & Gabbana headquarters, on Milan's via Damiano, the central fountain was festooned with carnival lights. Models entered through a curtain of fringe, into a street market stall overflowing with fruits, vegetables, flowers and freshly caught fish, tended by an older gentleman. A fishmonger, straight out of central casting (sleeveless t-shirt, jeans, rubber boots, thick gold chain around his neck), stood nearby, his sole purpose, apparently, to give each girl a wolfish once over as she paused for the cameras in front of a dismembered swordfish. It could have been a scene from Italian cinema, or just one from everyday life in Italy. These women, in their sheer blouses unbuttoned to expose crystal encrusted bras, skimpy mini skirts, and leopard tights, were clearly not in the market for melons, but were perhaps just passing through at the opening of business in the wee hours of the morning, on their way home from a night at the club.

SUSAN CIANCIOLO
RUN COLLECTION, 1995

Susan Cianciolo has always operated on fashion's fringes, less of a designer *per se* than an artist whose medium happens to be, on occasion, clothing. Her first runway presentation was, in fact, in an art gallery—Andrea Rosen on Prince Street in SoHo, where she would later show her film *Pro-Abortion; Anti Pink*. As Cianciolo has never abided by seasons, when asked, she could not recall which one this collection was. "Possibly Fall/Winter, not certain," she said. The clothes themselves offer up little clue. "There was never a particular theme," she added. "I didn't believe in themed shows and collections." Neither was there anything like a seating chart—or chairs, for that matter: People either stood in the scrum or sat on the floor. An informal runway was marked out in strips of red tape, which bisected the space on a diagonal. "At the time it seemed different," Cianciolo said, "but it was all I had to offer." The first model emerged, flipping a switchblade as she traversed the room, an action that telegraphed the collection's awkward, new wave aesthetic and sliced, off-the-shoulder attitude.

197

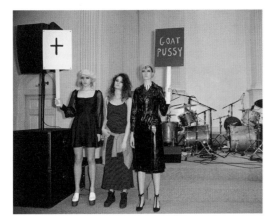

CHLOE SEVIGNY FOR OPENING CEREMONY
FALL 2013

The historic Saint Mark's Church-In-The-Bowery has long stood for political and artistic protest: Martha Graham danced there, Allen Ginsberg read poetry there. And Chloë Sevigny held the show for her Fall 2013 collection

LOUIS VUITTON
FALL 2011

Guests arriving at the Louis Vuitton show that season were greeted by uniformed maids animatedly wielding feather dusters, and, even though it was not yet 10 o'clock in the morning, proffering trays of champagne and vodka shots.

Inside, they were confronted by a pair of ornate, old-fashioned cage elevators—perhaps a reference to Claridge's in London where Kate Moss had infamously celebrated her 30th birthday with a *Beautiful and the Damned*-themed party. Or, it seemed more likely as the looks began to roll out—accessorized variously with black rubber boots, military caps topped with miniature masks, handcuffs—the Viennese hotel where the former Nazi officer Maximilian Theo Aldorfer (Dirk Bogarde) is employed in Liliana Cavani's 1974 psychodrama *The Night Porter*. Jacobs's own psycho-sexual romp—"Fetish 101" as he referred to it, and an exploration of women's inexplicable obsessions with certain Vuitton handbags—came to a climax with the vision of Moss, striding alone across the gleaming black-and-white checkerboard floor, a trail of cigarette smoke wafting behind her. Even in light of John Galliano's dismissal from Christian Dior a little more than a week before, Jacobs's references raised surprisingly few eyebrows. However, according to the designer, the house received a stiff fine for permitting Moss to smoke on the runway on what turned out to be No Smoking Day in the UK.

and sizes (tall and lanky, short and stocky) and a range of ages (8 to 70), their diversity echoed by the variety of the vintage mirrors themselves. Throughout the performance, they dressed and undressed, picking up and discarding garments from crumpled piles at their feet, oblivious to the audience observing them at close range. One woman, in a roomy white dress and high heels, manically peddled a stationary bike, a desperate attempt, it would seem, to sweat herself down to a smaller size. Meanwhile, a video by the artist Vanessa Beecroft, exploring themes of beauty and self-esteem, played in a back room, where a troupe of naked women, holding up clear, glass masks that had been marked in red and black pen by the hand of a plastic surgeon, were being subjected to a rapid fire projection of images culled from mainstream fashion media.

industry bias against synthetic fur as not being luxury material. Lagerfeld, meanwhile, was quick to deflect any accusations of social or environmental insensitivity. "That was the challenge of the show. There have been in fact no animals hunted in the arctic for ages," he said. "There is no real fur coming from there, but people think fur when they see an iceberg. I never think in terms of political correctness or social issues. Publicly, that is not my job."

198

MAISON MARTIN MARGIELA
FALL 1997
The invitation to the Martin Margiela Fall 1997 show came in the form of a folded tourist map, and like many Margiela invitations—which have come disguised variously as a telegram, a classified ad ripped from the pages of a free Paris weekly, and a wine label—it could have easily been mistaken for junk mail. The Belgian designer staged three separate shows that season—hence the need for a map. Models in pelt-like wigs made from old fur coats and Stockman dress form vests were shuttled by bus from an abandoned covered market, to a nightclub, and then to a dance school. At the third and final stop, they casually made their way through the standing crowd, as a brass band, brought in from Belgium for the occasion, played "Brother Can You Spare A Dime." This was yet another variation on the theme of the traveling fashion show. For his Spring 1993 women's collection, Margiela staged two simultaneous shows on opposite ends of the Montmartre cemetery—one, in a defunct hospital where the silhouettes were all white, the other in a garage where the clothes were all black. Guests were invited to only one or the other; there was no way to see them both.

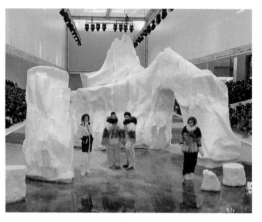

CHANEL
FALL 2010
While all of the fur in Karl Lagerfeld's *Nanook of the North*-themed collection for Chanel was fake, the gigantic iceberg at the center of the runway in Paris's Grand Palais was definitely real—a reported 265 tons and 28 feet high at its apex, imported from Scandinavia, and carved by a team of ice sculptors over the course of nearly a week. Chanel was granted permission to bring the iceberg into the country on the condition that it be sent back afterwards—or what was left of it anyway. The models strode through a sea of ice water in their high-heeled Mukluk boots, further sounding the alarm of global warming. It is easy to become seduced—or distracted—by the monumental runway settings at Chanel, which are unparalleled in the fashion world. But this collection was also widely recognized as a technical tour de force for the French house in that it succeeded in overturning an

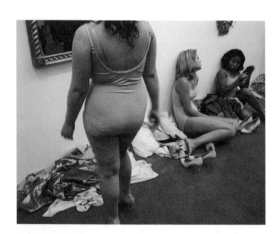

IMITATION OF CHRIST
SPRING 2013
Tara Subkoff titled her Spring 2013 presentation for Imitation of Christ "This is Not a Fashion Show." True, this latest installment in her series of so-called situational experiments, staged at Bortolami Gallery in Chelsea, did not involve an actual runway, but fashion was at the center of the conversation. As a girls' choir belted out an *a cappella* rendition of "Carol of the Bells," a cast of women, dressed in flesh-toned leotards, obsessed over their reflections in mirrors on the walls. The women came in all shapes

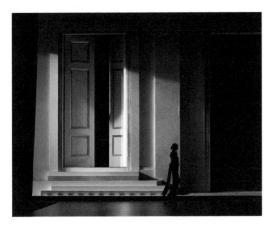

MARC JACOBS
FALL 2007
The velvet curtain parted, and the audience let out a collective gasp. More than 50 models were arranged on the stage in a tableau vivant—like tiny figures in a gigantic doll-house—in front of a pair of grand doors, some 30 feet high and finished in silver leaf. According to Stefan Beckman, the man responsible for the dramatic and surreal set, the inspiration was one of Marc Jacobs's favorite films, *Last Year at Marienbad*. "Marc," he noted, "is an incredible director." Jacobs often puts off the design of the set until quite late in the creative process, when the collection has already started to come together. In some instances, the set serves to underscore themes already present in the clothes, and in others, it can take the collection to a completely different place all together. "Ultimately it's always about the clothes," said Beckman, "the set is like the icing on the cake."

VIKTOR & ROLF
FALL 2002
"Long Live the Immaterial" was the third in a trilogy of collections from the Dutch design duo Viktor Horsting and Rolf Snoeren, each dedicated to a single color. Fall 2001 and Spring 2002 were all-black and all-white

respectively; Fall 2002 revolved around a bright sky blue. Accordingly, the show, at a Paris television studio, incorporated a blue screen technique commonly used in the film world but rarely in fashion. The models made their way down an unremarkable catwalk in the darkened space, but in live footage projected on a pair of screens behind them, anything blue they were wearing—from a belt or a pair of gloves to a full pantsuit—dissolved into a waterfall or a freeway at rush hour. One model was visibly startled, as she made her turn at the end of the runway, to encounter herself entirely engulfed in flames. ("I think she almost had a heart attack," said Alexandre de Betak, the mastermind behind the production.) For the designers, it was pure poetry. "It was a collection made out of the sky, the stars, the trees, clouds... a very romantic desire that became a reality in that one fleeting moment of the show," they said. "We still love that power that a great fashion show can transmit, when all the elements together add up to more than the sum of the parts."

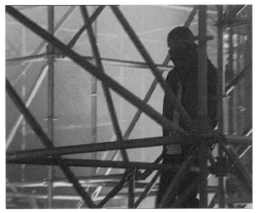

RAF SIMONS
FALL 2001
In retrospect, Raf Simons would describe his Fall 2001 show as being the most horrible of his life. Certainly it was one of the more challenging. The season before, Simons had been convinced he was finished with fashion for good. He ultimately returned, determined, he said, to do things on his own terms. "Riot Riot Riot," as his comeback collection was called, expressed his mixed feelings of anger and vulnerability and his revolt against the fashion system. "I didn't care if it would be commercial or not," Simons said. Richey Edwards, the guitarist for the Manic Street Preachers who had gone missing in 1995, served as a sort of poster boy for the collection—a choice that would seem oddly prophetic after guests on a bus chartered to take them to the remote warehouse on the outskirts of Paris, got stuck in Chinese New Year traffic, and missed the show all together. Those who did make it were

confronted by a raw Escher-like space within a space, anchored by a tall scaffold structure that the models, menacingly cloaked in oversized hoodies and Keffiyeh, navigated via steep stairways through a cover of smoke and colored light. "Show spaces were supposed to be beautiful and I wanted the opposite," Simons said.

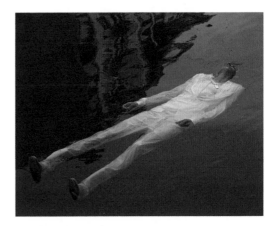

CAROL CHRISTIAN POELL
SPRING 2004
An Austrian designer who works in Milan, Carol Christian Poell presented his Spring 2004 collection in the Naviglio Grande, the city's main canal. The title was "Mainstream-Downstream," and indeed, a steady stream of models, and the occasional disembodied shirt and pants, traveled the approximately 400 meters from a small pedestrian footbridge to a large, congested overpass—a fashion journey that took about 40 minutes from start to finish. The invitation was vague regarding the details (the address was stated to be near an empty tank on a particular side of the channel) an attempt to avoid drawing undue attention to the spectacle, which could have easily caused a traffic jam or worse yet a panic had it been misconstrued as a parade of corpses. For the designer, this show represented a rupture with a fashion system that no longer made sense. Indeed, at a time when the term "fast fashion" seems to apply even to luxury brands that show a minimum of 4 collections a year (6 for those also presenting Haute Couture), the pace of this particular fashion event was startling slow—wholly dictated, as it was, by the current. "Everything," the designer said, "was out of our control."

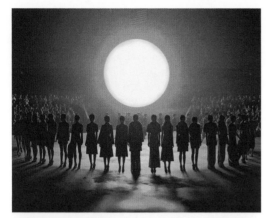

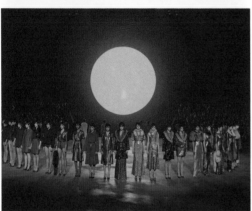

MARC JACOBS
FALL 2013

An enormous sun had been suspended over the vast drill hall of the 69th Regiment Armory, where Marc Jacobs regularly staged his shows. Inspired by the *Weather Project*, the Icelandic artist Olafur Eliasson's mesmerizing, monofrequency installation at the Turbine Hall of the Tate Modern in London, Jacobs's malevolent burning star was created using rear projection material and, according to his production designer Stefan Beckman, "nearly every available sodium bulb in the country." It sucked the light, if not the life, from the room, emitting a stifling heat and casting the space in a sickly pallor. Seating was in the round, lining the perimeter of a custom-poured concrete floor. In that atmosphere, it was nearly impossible to read the clothes Jacobs sent out. Models made their way around the space as blackened silhouettes or mere shadows as the audience struggled to discern the message in this hazy presentation. And then, just when the show appeared to be over, the lights came up, and the 55 models were sent back out to retrace their steps. The soundtrack? "Somewhere Over the Rainbow." The mood remained resolutely melancholy (Jacobs, it seemed, was working through the after-effects of Hurricane Sandy, which submerged much of downtown Manhattan in water and, for nearly a week, total darkness). But on second view, the silvery pajamas and sequined coats and gowns that had at first seemed so bleak, very nearly dazzled.

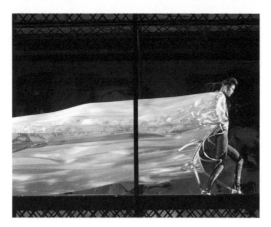

ALEXANDER MCQUEEN
FALL 2003

The setting of Alexander McQueen's Fall 2003 runway show was a desolate winter landscape bridged by an elevated glassed-in catwalk—all the better for focusing on the clothes. McQueen titled the collection "Scanners," and the invitation bore an image of his own brain, a reminder perhaps that the Romantic mind seeks affirmation in the beauty and the power of the natural world. The catwalk turned out to be a wind tunnel, and throughout the show models were sent across it. One had a billowing silk parachute strapped to her body; another struggled against gale force winds and driving snow while dragging a 20-foot kimono. McQueen was prone to theatricality in his runway presentations, but here he was not just offering a distraction but also a metaphor for the creative process—the emptiness at the end of a season when all of the creative energy had been exhausted, and the sheer physical effort it takes to face the next one.

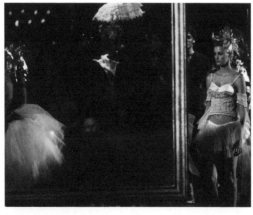

JOHN GALLIANO
SPRING 1996

The fantastical narratives that inform John Galliano's collections play out on the runway to dizzying effect. For Spring 1996, the Théâtre des Champs-Elysées, where Diaghilev's Ballet Russes first performed Stravinsky's

"The Rite of Spring" in 1913, set the mood for "Le Papillon et Le Fleur," a tale involving Nijinski, a child dancer discovered by missionaries in Africa, Beryl Markham, and Marchesa Casati. The stage was a jumble of overlapping vignettes, including a rehearsal studio with young dancers moving through their pliés at the barre, a backstage with cluttered makeup tables and baskets spouting clouds of tulle, and an artist's aerie where a painter, reminiscent of Edgar Degas, stood contemplating a canvas in progress. When the curtain came up, VIP guests who had been ushered to their seats through a labyrinth of corridors, discovered that they too were part of the spectacle. The model Shalom Harlow, a trained ballerina, pirouetted through the scene and out into the aisles of the orchestra.

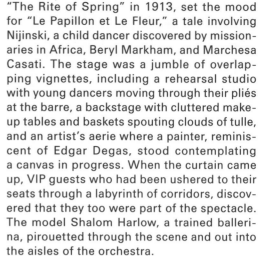

BERNADETTE CORPORATION
SPRING 1997

For a mere handful of memorable seasons, Bernadette Corporation, a downtown New York artist collective made up of Bernadette van Huy, Thuy Pham, and Antek Walczac among others, assumed the guise of an underground fashion brand, adopting the conventions of high fashion while simultaneously thwarting them. Their references were lowbrow (street wear, or as some called it, "ghetto" style) and in shows staged in unlovely venues, models, cast from the yellow pages, smoked, chewed gum, or wore headphones as they walked the runway. "We were being virtuosic," van Huy said. "Working with nothing. We didn't need large staffs or high production costs for rare feathers or beads, because playing with class distinctions can create bigger effects." For Spring 1997, a squad of cheerleaders took the stage, without irony, at the Roxy, a former nightclub. In today's lingo, Bernadette Corp. might be described as fashion disrupters. "Whatever offends people, you can say it possesses a raw potential or energy," van Huy said. "Like a diamond in the rough. You can harness that offensive potential. If you set it in the right framework, it can give off beauty and pleasure."

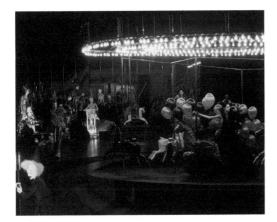

ALEXANDER MCQUEEN
FALL 2001

The fashion show circuit can seem like a traveling circus to those who follow it—a sentiment not lost on the designers themselves. When Alexander McQueen presented his Fall 2001 collection, he had just ended a fraught stint at Givenchy, the LVMH-owned luxury brand, and his signature label was now operating under the auspices of its rival conglomerate, the Gucci Group. The show, appropriately titled "What a Merry-Go-Round," was staged in London, in front of a Victorian toyshop, its nightmarish set decorated with warped funhouse mirrors, an array of creepy discarded carnival props, and an antique carousel, its horses shrouded in what looked to be latex slipcovers. The soundtrack sampled variously from *Rosemary's Baby*, the voice of the Child Catcher from *Chitty Chitty Bang Bang* tempting children with free candy and ice cream, and Mary Poppins singing, "a spoonful of sugar helps the medicine go down." The models circled the stanchions of the carousel gesturing lewdly like pole dancers, many of them sporting garish grease paint makeup and tricorn wigs. Some in the audience that day might have recognized the skeleton that had sat front row at McQueen's "Dante" show so many seasons back, clutching the ankle of a model in a funereal black dress as she dragged it mercilessly across the stage.

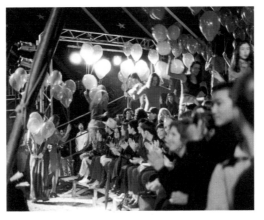

MAISON MARTIN MARGIELA
FALL 1995

The venue for the Maison Martin Margiela Fall 1995 runway show was a circus tent pitched in Paris's Bois de Boulogne and outfitted, authentically, with metal bleachers and a sawdust-covered floor. An amusing choice, perhaps, for a designer who, throughout his career, refused to assume the public role of ringmaster. Margiela never gave interviews or sat for photographs, his anonymity underscored by his signature of four white stitches. But a circus is a highly democratic form of entertainment, an escape from the dreariness of urban life, and in that regard, for Margiela, it seemed rather fitting. The show got off to a somber start, but workaday gray and brown wool ensembles were slowly supplanted by long gowns in crushed velvet and satin in brilliant lipstick shades. The models, their faces obscured by their color-coordinated stocking masks, walked the aisles to a soundtrack of scratchy waltz music and the sound of the rain falling steadily upon the tent. The finale was joyful, almost childlike—this was a circus after all—as the models returned to parade through the audience, their faces uncovered, bearing bouquets of fuchsia balloons.

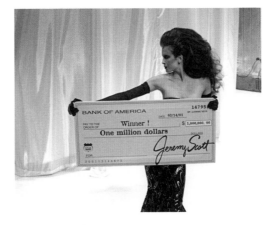

JEREMY SCOTT
FALL 2001

At Paris's Cirque D'Hiver, Jeremy Scott offered up another type of circus all together. He called his Fall 2001 collection "American Excess," and the presentation took its cues from classic television game shows like "The Price is Right" and "Let's Make a Deal," in which showroom models, done up as if for a beauty pageant, would "tease" the prize items—in this case a La-Z-Boy recliner, a set of matching luggage, a refrigerator stocked with gold bricks, a gilded shopping cart overflowing with cash, and a check made out for one million dollars. The show lasted only 3 minutes and ten seconds—the time it took for the rotating stage to complete a single revolution—after which a curtain dropped to reveal the designer, accompanied by Devon Aioki and two other models in evening gowns and platinum blonde wigs, perched on a fake cloud as chocolate gold coins and bills emblazoned with Scott's image rained down from above. A showman from day one, Scott has variously transformed the runway into a red carpet, a peep show, and a pep rally. "I don't think that I have ever thought of fashion or my show as anything but entertainment," he said.

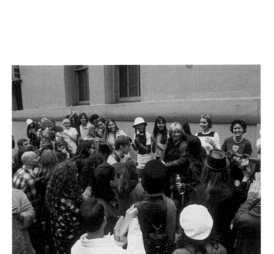

X-GIRL
SPRING 1994

Taking advantage of the crowd exiting the Marc Jacobs show, which was held that season in a loft in SoHo, Daisy von Furth and Kim Gordon staged a guerilla presentation for their street brand X-Girl on the sidewalk outside. There was no invitation, no runway, no seating, and, naturally, no permit. A banner affixed to a side of a building read, "X-Girl is #1." "We were street fashion and had nothing to do with the official fashion world and the way it worked. But we also had lots of cool friends with lots of good taste and connections," von Furth said. The Ford agency sent over a bunch of models (including Padma Lakshmi), Sofia Coppola rounded up her posse (Zoe Cassevetes, Ione Skye), and because of Gordon (a member of the band Sonic Youth), and the Beastie Boys connection (Skye was then married to Ad-Rock), MTV's *House of Style* ate it all up. The event, von Furth recalled, was in fact Coppola and Spike Jonze's idea. "I think they needed an excuse to hang out together and since they were both directors this was their idea of fun. Plus Spike was very much into the skaterish hijinx—he would go on to direct seasons of *Jackass*—so the idea of going out on the street and making a spectacle was second nature to him."

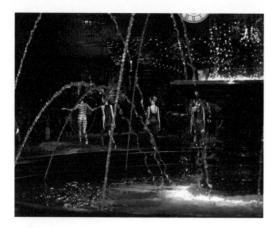

LOUIS VUITTON
SPRING 2014

A carnival? A funeral? A retrospective? Marc Jacobs's final runway presentation for Louis Vuitton brought all of these things to mind. The set, a glamorous but ultimately sinister shadow world, reprised some of Jacobs's greatest hits from his 16-year tenure as chief designer for the French luxury brand. There was the gleaming white carousel from Spring 2012, the gold cage elevators from his Fall 2011 fetish collection, a pair of canary yellow escalators from his Spring 2013 collaboration with the artist Daniel Buren—all reimagined in fashion's shade of choice, black. As the audience sat in the darkened space waiting for the show to begin, the clock, which only a few seasons before had announced the arrival of the Louis Vuitton Express, ominously ticked down the remaining seconds before Jacobs's departure.

202

with hand-sewn details. (Exhibit A: an Yves Saint Laurent shirt emblazoned with the words "Bring Me the Head of Tom Ford.") The clothes were mostly black that season, as befitting the solemnity of the occasion, though some of the dresses were perhaps more suited to a cocktail party or a high school prom.

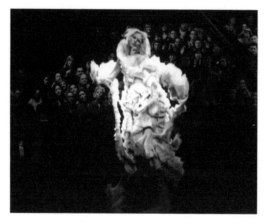

ALEXANDER MCQUEEN
FALL 2006

Grief also cast a shadow upon Alexander McQueen's Fall 2006 runway show. A return to his Scottish roots, "The Widows of Culloden" reprised the themes, both aesthetic and narrative, of his by then infamous "Highland Rape" collection. But where that show, staged in the early days of his career, had been brutal and aggressive, this one was decidedly romantic and wistful. After the last model made her passage across the rough-hewn wooden floor, what appeared at first to be a plume of smoke materialized into a holographic image of Kate Moss, her gown a cascade of white ruffles. The ghostlike apparition floated there mesmerizingly for several minutes, twisting in a virtual breeze, and then vanished, prophetically, into a point of light.

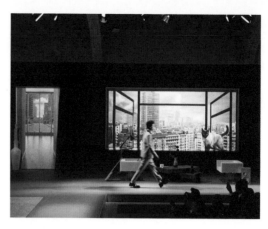

PRADA
FALL 2013

AMO, the design arm of the Rem Koolhaas-led architecture firm OMA, has for many years conceived the quirky sets for Miuccia Prada's men's and women's runway shows. This particular season, there were two collections on view: the Prada men's Fall 2013, and the furniture collection that the Dutch architect had designed for Knoll. When Koolhaas explained that he wanted to create a range of pieces that performed in precise and completely unpredictable ways, and that would not only contribute to the décor of a room but also animate it, he could have very well been describing the set itself. The theme was "Ideal Home," and the models strolled through various domestic tableaux, furnished with Koolhaas's hydraulic chairs and shape shifting cantilevered tables, while projections of windows offered disorienting views of the cityscapes beyond, and, on occasion, an enormous house cat.

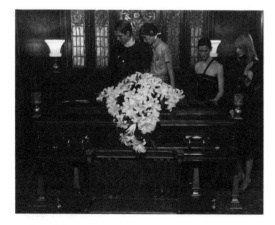

IMITATION OF CHRIST
SPRING 2001

For the Spring 2001 show for their fledgling label Imitation of Christ, Tara Subkoff and Matt Damhave staged a wake at a funeral home in New York's East Village. An extended model family—siblings, army buddies, a grieving widow, orphaned offspring, and more than a few mistresses—gathered to pay their respects around a glossy, mahogany casket blanketed in white lilies. It was an effective New York debut for a label whose *m.o.* was to resurrect Salvation Army and Goodwill castoffs and give them new life as covetable, one-of-a-kind items

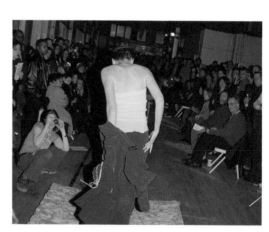

SUSAN CIANCIOLO
RUN COLLECTION, 1997

For the presentation of her fourth RUN Collection, Susan Cianciolo took over an empty storefront on lower Broadway in New York, its peeling signage indicating that the space was the former home of a certain Glamour Furniture. RUN was a tag Cianciolo had given herself in the early '90s when her medium was not fashion but performance art; the addition of the word Collection was a reference to the clothing, yes, but also to the many people she gathered around her as collaborators—the artists Bernadette van Huy and Rita Ackermann,

and even her own mother, who participated in Cianciolo's old-fashioned sewing circles. Her shows were similarly a group effort—this one in particular was a collaboration with the writer Judy Elkan. In the packed, airless space, the artist Jillian McDonald lay on the ground reciting poetry, while models pulled misshapen garments from tiny handbags and dressed themselves before the audience or peeled off odd layers as they made their way down a makeshift runway. Messages were distributed, in the tradition of teen-agers passing notes in class. One featured a quote from Marcel Duchamp, another from David Lee Roth. Programs were piled up by the front door, each one hand-decorated by the artist and skateboarder Mark Gonzales with jokes and drawings and the words RUN Collection misspelled.

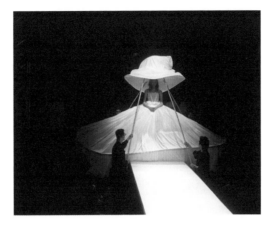

YOHJI YAMAMOTO
FALL 1998

In an interview with Frances Corner, from the London College of Fashion, on the occasion of a retrospective of his work at the V&A museum in London, Yohji Yamamoto voiced his preference for hiding the body, rather than exposing it—ultimately, he said, making a house for it. This was sexier to him, he explained, because he could then imagine what was inside. There is perhaps no better example of that in the Japanese designer's work than the finale of his Fall 1998 runway show, in which the model Jodie Kidd was required to navigate the runway, with the help of four attendees wielding bamboo poles, wearing a silk hoop wedding dress (complete with matching hat) that was in fact the size of a modest wedding tent.

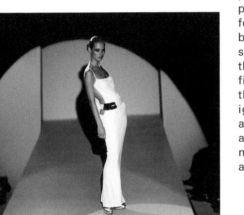

GUCCI
FALL 1996

In Tom Ford's presentations for Gucci, the suspension of reality was total. The show's location didn't much matter—it could have been an old bank building or, for that matter, a white tent—the slick formula obliterated any sense of time or place. There was no set to speak of, just a runway against a white backdrop. The room was pitch black—one could scarcely see the person sitting across from them—with the spotlight fixed on the clothes, while the soundtrack conjured the era of hedonism to which Ford aspired. (It's not taking things too far to say that the rush he was going for was that delivered by a line of coke.) Fall 1996 was only Ford's third collection as the creative director of the Italian house, but his aesthetic was by then already well established. As Kate Moss stepped out onto the runway in a Halston-esque column for the finale, and singer Glodean White proclaimed, "I'm under the influence of love," the message was that nothing else, least of all the world outside, mattered. And for those 20 minutes, nothing else did.

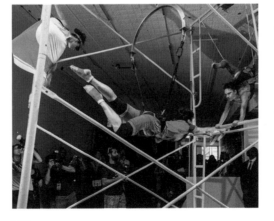

VPL
SPRING 2015

In her shows for VPL, Victoria Bartlett has sent models walking down a conventional runway, but more than once she made them endure a training circuit in an actual gym, an approach that put her commitment—both

aesthetic and technological—to athletic wear to the physical test. For her Spring 2015 collection, she worked with the aerial artist Amanda Topaz on "Fundipendulous," a video in which a dancer, a contortionist and an aerialist—the latter suspended alternatively from a bridge over the Delaware River, the rafters of a barn, and a enormous piece of earthmoving equipment—assume astonishing shapes against the dramatic natural landscape of upstate New York. The piece was adapted as a live performance, staged during the presentation of the collection, on scaffolding erected in the back of the VPL store in SoHo.

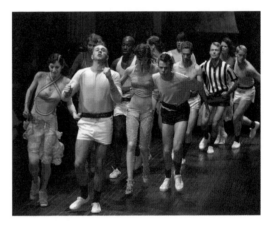

ALEXANDER MCQUEEN
SPRING 2004

A show in three acts, Alexander McQueen's dramatic Spring 2014 runway presentation took its cues from Sydney Pollack's depression-era film *They Shoot Horses, Don't They*, the story of a grueling boardwalk dance marathon. At Paris's Salle Wagram, an emcee announced the competition—"around and around and around we go and we're only beginning folks," he intoned, as models, the flame-haired Karen Elson in a silver sequined gown chief among them, and professional dancers took the floor, each isolated in his or her own individual spotlight. Michael Clark's deft choreography was in sync with music that ranged from Duke Ellington to disco. For the heart-in-your-throat second act, the dance floor was transformed into a running track, and the dancers, now wearing variations on period athletic wear, circled the room at exaggerated, breakneck speed. By act three, the finalists appeared desperate and delirious. They were carried off the stage one by one, until the last woman standing, a dead ringer for Elson, collapsed to the floor, her silver sequined dress tarnished and in tatters.

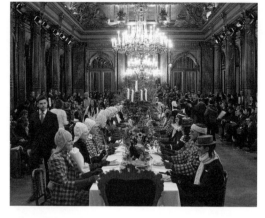

THOM BROWNE
FALL 2011
Between the leg-of-mutton sleeves, the pork-pie hats, the school uniform-gray flannels, the Aran-knit wigs, the pilgrim buckles, and the John Lennon sunglasses, Thom Browne's Fall 2011 men's collection offered up a menu rich in allusions even as the models, who were seated at a lavish banquet, nibbled daintily on corn and peas. In Browne's highly choreographed piece of dinner theater, staged in the grand Salon Impériale of the Westin Hotel in Paris, all 44 men stood up from the table in unison, each of them peeling away one by one to make an excrutiatingly slow tour around the room, as if walking in a fog of tryptophan. The presentation reached a crescendo when several roasted turkeys were brought into the hall on silver platters with extreme pomp and circumstance and placed on the table, where they remained untouched for the duration of the show.

to the models' feet with packing tape. The presentation, held in a school auditorium, was a similarly ersatz affair that imbued the clichés of the fashion show—the spindly ballroom chairs, the flutes of Champagne passed on silver trays, the elevated catwalk—with a certain working class charm. Rough wooden tables, flanked by a mongrel assortment of chairs, snaked through the space, and as the guests arrived, they were offered cheap red wine in plastic cups. Somewhat inexplicably, a pep squad, wielding megaphones and white pompoms, had commandeered the stage. When the show started, the tables turned out to be an elevated catwalk, as models strode through the detritus of empty cups and bottles, which no one had bothered to clear.

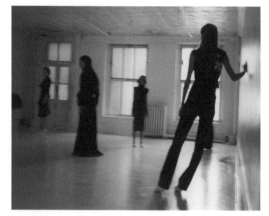

BRUCE
FALL 1998
"As young designers in New York we had to fight a bit harder to be taken seriously and for people to understand that we could produce quality clothing," said Nicole Noselli, who with Daphne Guiterez launched the label Bruce in the late '90s. For their second show, Fall 1998, they opted for a static presentation in a downtown loft painted white like a box, the idea being that the details and the workmanship of the clothes could be better appreciated up close. Several pairs of shoes with heels of various heights, which the designers had spray-painted white, were nailed to the floor at points around the room. The models made their circuit in bare feet, stepping into a different pair of shoes at each stop and standing still, as directed, for as long as they possibly could. It was an occasionally awkward set-up for the audience and the models alike—one pair of shoes was positioned so that its wearer would be forced to prop herself against the wall. "Presentations that require the models to stand still while an audience views at close range already create a strange dynamic between the viewer and the 'live mannequin,'" Guiterez observed. "Having them fixed to the floor only magnified that tension."

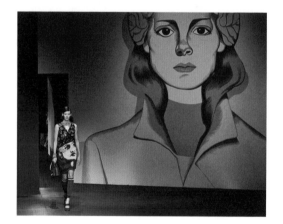

PRADA
SPRING 2014
Miuccia Prada is not a designer who thinks literally, and like the Prada collections themselves, the runway sets offer only a sideways glance at anything that might be construed as an actual reference. For the Spring 2014 women's show, the space in Milan evoked an urban streetscape, its inverted runway surfaced in industrial rubber. A specially-commissioned mural by the artists Miles "El Mac" MacGregor, Mesa, Gabriel Specter, Stinkfish, Jeanne Detallante and Pierre Mornet lined the walls from floor to ceiling, and their perspectives on womanhood echoed throughout the collection on a more portable scale in the clothes and handbags. "In the Heart of the Multitude," as the project was called, activated the season's themes of power, femininity, and representation, and Prada's intent to inspire women to fight—all of which was further amplified by the soundtrack of Britney Spears singing "Work Bitch."

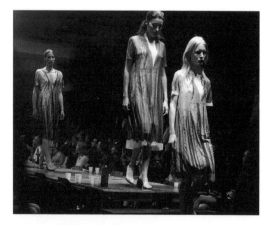

MAISON MARTIN MARGIELA
SPRING 1996
For Spring 1996, Martin Margiela presented a facsimile of a collection, silk screening sequined gowns, floral dresses, and chunky knits onto simple white garments. In place of actual footwear, the soles of shoes had been affixed

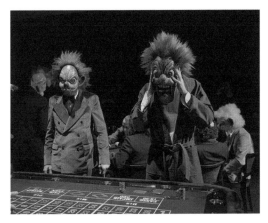

ADAM KIMMEL
FALL 2010

The menswear designer Adam Kimmel, who withdrew from fashion in 2012, was known as much for his seasonal artist collaborations as for his clothes. For Fall 2009, he commissioned a series of Warholian screen tests from the poet, filmmaker and Factory denizen Gerard Malanga. For Spring 2010, he worked with the photographer Jim Krantz, whose Marlboro Man ads were famously appropriated by the artist Richard Prince in the 1980s. And for Fall 2010, he teamed up with the artist George Condo, an American painter and, it would seem, a gambling man. Condo, whom the designer described as equal parts stylish and bad-ass, was not just a partner in crime that season but a muse for the collection. For the lively presentation, Paris's Yvon Lambert gallery was decked out as a swank Monte Carlo casino; the models in elegant velvet smoking jackets and cashmere sweaters—topped with Condo's maniacal, almost cubist heads, produced with the Hollywood special effects prosthetics artist Gabe Bartalos—tried not to lose their shirts.

was adapted from traditional routines, including gritting, kabuki-like scowls that lend stepping such great theatricality," Owens said of the display of raw power and fierce solidarity. Significantly, Owens also adapted his own aesthetic that season, designing what amounted to dozens of one-of-a-kind pieces for the women whose bodies were very obviously not sample-sized. "The finale, when the dancers linked closely together to exit the stage, has its origins in the '60s when students had to link arms in order to pass through throngs of angry protesters and enter the doors of the newly desegregated universities," Owens explained. "But I think everyone can relate to the poignancy of clinging together in the face of adversity."

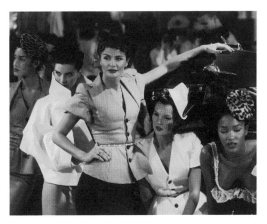

JOHN GALLIANO
SPRING 1995

In John Galliano's runway shows the models didn't just walk, they performed—each individual look in the collection conjured by its own character. His Spring 1995 presentation, at Studio Pin-Up in Paris, unspooled a narrative befitting Tennessee Williams: The set brought to mind *A Streetcar Named Desire* and the soundtrack was shot through with the voice of Marlon Brando in *On the Waterfront*—"I coulda' had class; I coulda' been a contender." The program notes described a certain Misia Diva (a fictionalization of Misia Sert, a friend of Chanel, and muse to everyone from Proust to Picasso). Kate Moss wore a white skirt suit with an hourglass silhouette, Shalom Harlow a black strapless gown, its skirt slicing across her thighs like a pair of open scissors, and Nadja Auermann spilled out of a powder puff of tulle. They navigated a claw-foot bathtub strewn with rose petals and a vintage kitchen festooned with lingerie hung up to dry; posed like hood ornaments against the nose of a gleaming vintage Oldsmobile; and lay down on a cast iron bed, a shirtless hunk on top, empty liquor bottles strewn beneath, preening and posturing and never breaking character.

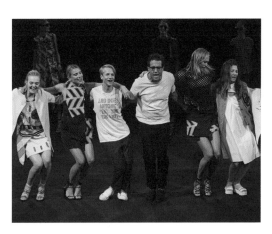

OPENING CEREMONY
SPRING 2015

As soon as an independent label reaches a certain level of success, it begins to feel the pressure to start acting like an established one. This was the issue that Opening Ceremony's Humberto Leon and Carol Lim were grappling with as they went into their Spring 2015 collection—how to go back to a simpler, naive time, before their business got so big, when they were able to do things just for fun with their friends. They summoned that "Hey, let's put on a show!" spirit that season, breaking with the runway format and presenting their collection as a play in one act. "100% Lost Cotton" was written by Jonah Hill, a veteran of bawdy Judd Apatow comedies who had graduated to more serious roles, and Spike Jonze, a creator of the MTV series *Jackass* who in recent years had begun to rack up Oscar nominations, winning the award for best original screenplay for his feature film *Her*. The play, which was directed by Jonze and starred John Cameron Mitchell in the role of Leon and Catherine Keener as Lim, was performed not in a local playhouse or high school auditorium, but rather on the stage of the Metropolitan Opera House in New York.

205

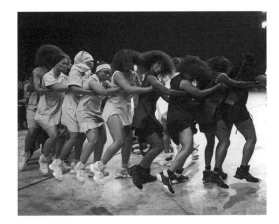

RICK OWENS
SPRING 2014

For his dynamic Spring 2014 runway show, Rick Owens tapped into a culture that is well known throughout NPHC fraternities and sororities, but relatively foreign to the fashion world: stepping. "The choreography and style

JEAN COLONNA
SPRING 1996

The men and women in Jean Colonna's runway shows often looked like they could have stepped out of a Nan Goldin photograph—but for Spring 1996 they in fact stepped into one. The models entered through a door veiled by

a beaded curtain into the set of a seedy hotel room or perhaps an SRO, with faded wallpaper, shabby furniture, and a half-made bed. (Goldin, in Paris for an exhibition of her work, was seated front row, camera in hand.) In Colonna's eyes, as in Goldin's, such a *demimonde* has its own particular glamour, however seamy. The designer was well known by then for his outlaw, anti-fashion stance, which did not stop at his preference for cheap fabrics like PVC and nylon. In one of his early shows, he had a model fire a gun loaded with blanks into the crowd of photographers at the end of the runway.

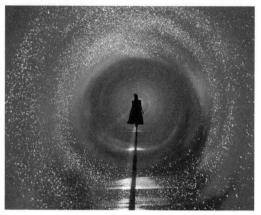

JOHN GALLIANO
FALL 2009

For a production designer, the challenge is often to interpret a designer's obscure or vague references into three-dimensional reality. If there is little budget to work with, he or she has to be all the more creative. Alexandre de Betak had worked with John Galliano for many years, on runway shows both for his own label and for Christian Dior. For Fall 2009, the brief was merely: "Ukrainian Virgin Brides." The venue, in Paris's 13th arrondissement, was appropriately cold and bleak—in Betak's words, "a gigantic, ugly raw space with cheap benches"—which made the final effect all the more magical. Models, appearing like ice maidens with silvery lashes, voluminous skirts, and towering shoes seemingly propped up on the runners of an old-fashioned sleigh, made their way through a sparkling winter wonderland. Betak had conjured a snow tunnel from the simplest ingredients: soap bubbles, lasers, a few spotlights and a wind machine—a technical sleight of hand that the audience fell for quite willingly.

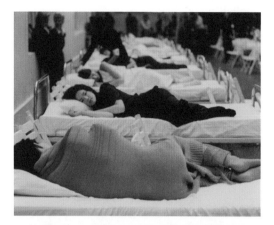

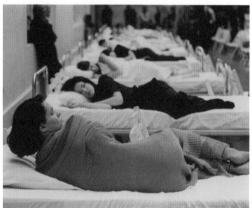

A.F. VANDEVORST
SPRING 1999

The Belgian designers Filip Arickx and An Vandevorst, partners in work and in life, discovered early on that they shared a weird mutual interest in hospital design. Arickx once found a complete set of hospital furniture on the street and brought it home; Vandevorst presented her graduation collection from the Antwerp Fashion Academy on hospital beds. "Without a doubt it became the DNA of our brand," she said. (Their logo is a red cross.) Their second collection, Spring 1999, was inspired, they said, by "a woman lying in her bed," and the resulting clothes, many of them pajama-like or even sheet-like in design, bore the permanent creases and wrinkles of a night's sleep. Etienne Russo, whose company Villa Eugénie would go on to stage some of Chanel's more over-the-top runway productions, procured 32 beds from an old French hospital, transforming the courtyard of a school in the Marais into a sort of sanatorium. "At first nobody dared to enter, it was so serene," Vandevorst recalled. "But once they came in, they could sit next to the beds as if visiting a loved one." And then one by one, the models rose from their slumber and walked.

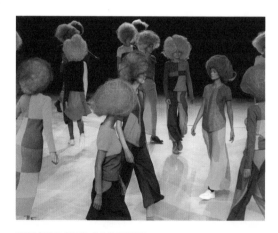

COMME DES GARÇONS
SPRING 1996

If Rei Kawakubo had a reputation for being dour, and occasionally humorless, she quite literally shattered it with her kaleidoscopic Spring 1996 collection for Comme des Garçons. The audience was seated in the round, a set-up that

LOUIS VUITTON
FALL 2013

The set of Marc Jacobs's Fall 2013 collection for Louis Vuitton was the corridor of a once-grand hotel, where the guests, while maintaining a sense of propriety, had also seen better days. It was a sight all too familiar to the travel-weary editors and buyers in the final stretch of their semi-annual fashion tour. The runway was a continuous loop, the audience seated at its center. As each door opened, models in various states of dress or undress emerged, performed their lap wearing the distant look of sleepwalkers, and returned to their rooms. Some wore old-fashioned dressing gowns, others fur jackets over their satiny lingerie. The dim light and the faded colors heightened the cinematic quality of their surroundings, which were at once anonymous and all too intimate. Open doors offered tantalizing glimpses of the goings on inside the rooms, forcing the viewer into the role of voyeur (there were Vuitton steamer trunks propped up conspicuously just over every threshold to be sure). Kate Moss closed the show, and with a feint slam, the door to her suite, and Jacobs, appropriately, took his bow in silk pajamas.

subtly alluded to a kaleidoscope's lens, but one that also provided a near seamless black backdrop for the colorful clothes that would emerge. Patterns shifted, broke and refracted as the models whirled through the space. And there was something wonderfully perverse in the designer's casting of big names like Nadja Auermann, Carolyn Murphy, Linda Evangelista, Kate Moss, Amber Valletta, and Stella Tenant (the super gang was all there) only to disguise them beneath voluminous cotton candy wigs.

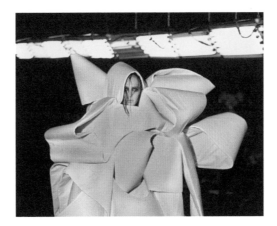

OLIVIER THEYSKENS
FALL 1999

For the second season in a row, Olivier Theyskens had chosen to show in a raw space on Paris's Quai d'Austerlitz. "It looked like an abandoned parking garage," he said, "which was in fact what I was looking for." A low, polished black catwalk wended its way through the concrete columns and banks of glaring overhead lights flickered on and off, like malfunctioning strobes. The industrial electronic soundtrack to the show was equally migraine-inducing. Theyskens is a designer with a penchant for drama—the potential, as he described it, for an explosion of emotion—but also for fragility and vulnerability. Least inspiring to him is the girl who is oblivious to the danger in her path. The first model out couldn't see the runway in the darkness; another looked like she might crumple under the sheer burden of her ensemble. "It was a dangerous outfit—a giant ball of fabric," Theyskens said, still seemingly in awe of her strength and composure. "Had she fallen, she would not have been able to get back up."

apex with their feel-good Spring 2001 show, a highly choreographed old-time Hollywood production, in a theater on the Avenue Wagram in Paris. The cast of dancers, recruited from a school in Holland and outfitted with matching Louise Brooks-style wigs, tapped and twirled their way through the 20 minute revue, which was set to classic musical numbers like "Singing in the Rain" and "Zing! Went the Strings of My Heart." The designers, dressed in matching suits trimmed in silver lamé, joined in for the all-white finale. "We had intended to dance the whole way through," they said. "But little did we know how difficult tap dancing actually is."

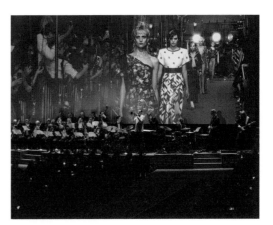

MARC JACOBS
SPRING 2016

Marc Jacobs's Spring 2016 runway show took the form of a Hollywood movie premiere. The marquee of the Ziegfeld, New York City's largest standing single-screen venue, read ONE NIGHT ONLY MARC JACOBS (and, for good measure, #marcjacobspremiere). The designer didn't just take over the theater, including the lobby, the concession stand, and the big screen, but also the scene on the street. Models walked a red carpet and posed in front of a step-and-repeat before entering the auditorium through the lobby, where hundreds of seats had been cleared to make way for a pair of runways. There was free popcorn and soda; old-fashioned cigarette girls distributed candy and uniformed ushers handed out a custom Playbill. The show was accompanied by a full orchestra, led by the jazz musician Brian Newman on the trumpet, and Jacobs's bull terrier, Neville, a media star in his own right, stood in as the MGM lion. Now that is entertainment.

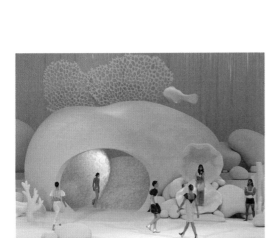

CHANEL
SPRING 2012

In the under-the-sea wonderland the producer Etienne Russo created for Chanel that season, enormous shells, fans of coral, sand dollars, seahorses and a mountain of bubbles that might have very well been caviar, dwarfed the models as they drifted through the pristine white space. The singer Florence Welch, posed Botticelli-like in an oyster shell, performed her newly released song "What the Water Gave Me," an ode to nature's great power. Indeed, the subtext of Karl Lagerfeld's Spring 2012 runway show seemed to be that these dramatic silhouettes, shaped by natural forces, were as breathtakingly modern as anything made by the hand of man. Pearls, a Chanel signature, dotted the models' hair and faces and provided the overall motif for the shimmering collection. "Chanel is about pearls indeed, but not only," Lagerfeld said regarding this utopian vision. "That was a poetic set but as the oceans become increasingly polluted, it was great to show an under-the-sea place clean and fresh. The way things should be..."

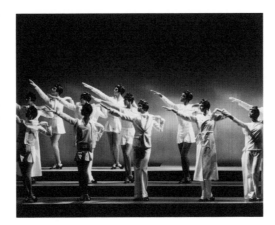

VIKTOR & ROLF
SPRING 2001

While most designers are content to pull the strings from backstage, Viktor Horsting and Rolf Snoeren regularly appear on the runway, the stars of their own shows. That commitment to performance perhaps reached an

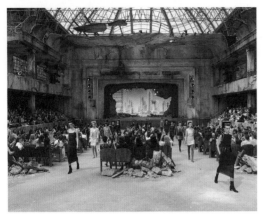

CHANEL
FALL 2013 HAUTE COUTURE

Guests entered through heavy curtains into the wreckage of a theater. The vintage wooden seats were numbered with tarnished brass plates, and the aisles were strewn with broken concrete and tangled rebar from the collapsed ceiling—the aftermath of a bomb, or a fire, or perhaps, sheer neglect. A jagged hole in the far wall, just beyond the stage, offered a futuristic view of gleaming skyscrapers from new world capitals all corralled into a single cityscape. One by one, Chanel had been acquiring Paris's highly specialized ateliers (Maison Lemarié for feathers, Desrues for buttons, Maison Lesage for embroidery, and so on) and this particular couture collection employed such timeworn techniques to startlingly modern effect, providing the bridge between the past, the present, and the future. "A certain kind of drama is old-fashioned," Lagerfeld said. "A new world starts to change all of our old, classic ideas. This world is not better, and not worse. It is just different from the perception of the one that came before it—and the newer generation wants nothing else."

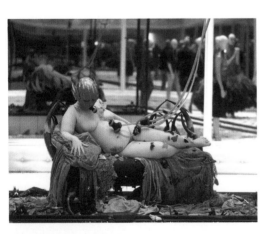

ALEXANDER MCQUEEN
SPRING 2001

Alexander McQueen's runway presentations routinely started late, but that season, the audience was forced to sit and confront its own image, reflected in the walls of a mirrored box, for an uncomfortable period of time,

creating a level of self-consciousness bordering on paranoia—which turned out to be the intent. When the show finally started, it became apparent that the mirror was two-way; models, with their heads bandaged as if recovering from a lobotomy, walked the perimeter of a padded cell, reveling in their own reflections, seemingly oblivious to the fact that they were being watched. The clothes became increasingly fanciful—one gown was covered in razor clam shells, another wrapped its wearer in a sinister embrace of claw-like silver branches—and the models increasingly disturbed. As the last one left the confines of the cell, panes of glass crashed to the ground to reveal an image straight out of Joel-Peter Witkin: The fetish writer Michelle Olley, reclining on a lounge draped in rotting lace, naked, save for the porcine hood shrouding her face, and hooked up to a breathing apparatus as moths flittered around her.

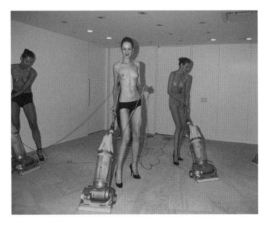

IMITATION OF CHRIST
SPRING 2003

In Tara Subkoff and Matt Damhave's shows for Imitation of Christ, the theatrics increasingly upstaged the clothes. After only a handful of seasons, their antics were starting to wear a bit thin, becoming less of a disruption of the fashion establishment than a diversion from it. If there was a message in their Spring 2003 show, which was billed as a retrospective and staged at a furniture showroom in midtown Manhattan, it was obscured by the chaos of the event itself. The overlapping vignettes featured dancers in pointe shoes with scraps of clothes trailing from their leotards, and models in hand-illustrated—or hand-shredded—frocks. A band played live, providing a soundtrack to art videos and footage from previous Imitation of Christ productions. A gaggle of topless models accessorized with black stilettos and shiny yellow Dyson vacuum cleaners begged the question, when you have fashion, who really needs clothes anyway?

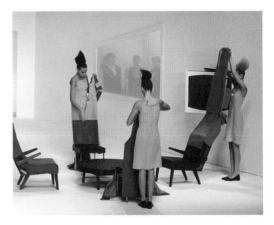

HUSSEIN CHALAYAN
FALL 2000

There are fashion designers who offer an escape from the outside world—and then there are those who face it head-on. Hussein Chalayan stands firmly in the latter camp. Informed by news reports of refugees fleeing Kosovo, which Chalayan connected to his own experiences as a child growing up in Cyprus, "After Words," his Fall 2000 collection, was an exploration of dislocation and rootlessness, of having to leave your home in a time of war and the things you take with you. The stage was minimally set with the accouterments of a modest living room: a low wooden table surrounded by four chairs, a shelf, and a television mounted on the wall. About halfway through the show, models began to clear the room, removing the objects from the shelf and stashing them in the folds of their clothes or in specially designed pockets. A group of them then pulled the slipcovers off the chairs and, with only a few minor adjustments, put them on as dresses. In the moving finale, even the table, which telescoped into a skirt, turned out to be portable, so that not a single thing was left behind.

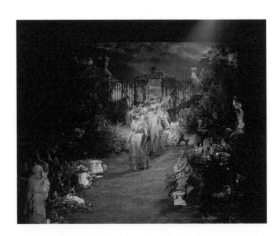

CHRISTIAN DIOR
FALL 2005 HAUTE COUTURE

The lavish presentation for John Galliano's Fall 2005 Christian Dior Haute Couture collection began with the arrival of a horse-drawn carriage, draped in black as if for a funeral. A young boy, dressed in a sailor suit, and his mother, dressed in Edwardian finery, stepped out and onto the runway—a misty garden path strewn with broken statuary and fallen chandeliers swathed in cobwebs under a turbulent sky. The show marked the birthday of Christian Dior, who would have been 100 that year, and the collection was a stroll through the storied history of the fashion house he built, and an ode to the women who both inspired his clothes and were known for wearing them. Shining a spotlight on the artistry of haute couture, Galliano constructed the 43-piece collection on the foundation of a barely concealed Stockman-like corset. In one particularly revealing section, a fin de siècle silhouette was transformed, over the course of four dresses, into a New Look.

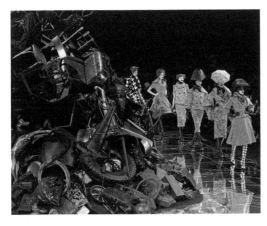

ALEXANDER MCQUEEN
FALL 2009

The message of Alexander McQueen's deeply cynical Fall 2009 collection was *it has all been done before*. Chafing against the forced march of creativity that required him to reinvent himself every six months, McQueen quite literally trashed the notion that fashion designers did anything more than recycle ideas from the past. The show was titled "The Horn of Plenty": The centerpiece of the fractured-mirror runway was a heap of charred refuse made up of all manner of obsolete junk—furniture, electronics, a wagon wheel, and, most notably, disused props from previous McQueen runway productions. The throwaway nature of luxury in the 21st century was echoed in the clothes themselves. McQueen cribbed from his own collections but also from those of fashion greats like Yves Saint Laurent, Christian Dior, and Paul Poiret, rendering many of the silhouettes in expensive fabrics designed to resemble garbage bags, and topping them off with hats by Philip Treacy created from tin cans, lampshades and umbrellas.

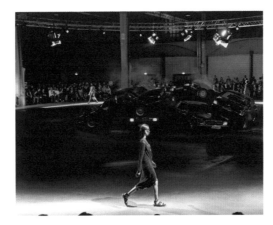

GIVENCHY
SPRING 2014

The Givenchy Spring 2014 runway also had a massive pile-up at its center, but instead of discarded junk, this one was a decadent heap of vintage luxury cars—a Mercedes, a Jaguar, and a BMW, its windshield smashed, among them. Smoke continued to rise from the smoldering wreckage throughout the show, the still-functioning taillights glowing menacingly through the darkness, as the models walked a path picked out in lights around the perimeter. A live drum performance by the Senegalese troupe Sing Sing Rhythms punctuated the haunting Ludovico Einaudi soundtrack with a booming, rapid-fire staccato, further undercutting any serenity the clothes themselves may have offered that season. Givenchy's Riccardo Tisci described the collection as a mash-up between the cultures of Japan and Africa, for which the actual car crash would have been a rather heavy-handed metaphor, had it not also insinuated a certain uneasiness with the idea of creating anything that might be construed simply as beautiful.

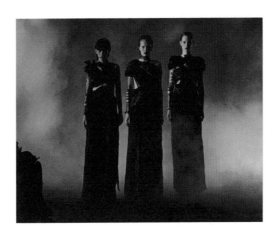

RODARTE
SPRING 2010

Kate and Laura Mulleavy have long collaborated with Alexandre de Betak on their runway presentations for Rodarte, starting their conversations early in the creative process so that the set and the collection evolve hand in hand. Among the inspirations they posited for Spring 2010 were Death Valley and the California condor. "Condors are really, really ugly," de Betak observed. "The challenge was to keep the inspiration, but make it beautiful." Over the seasons, de Betak has employed the same basic tools—mainly, fluorescent tube lights and wooden folding chairs—to miraculous effect, augmenting them that particular season with black sand and colored smoke. "The sand was evocative of the desert," the designers said. "We also burned many of the textiles, and the smoke was an abstraction of that technique." Yellow gel lights provided the toxic mood the Mulleavy sisters were striving for without actually poisoning all of the guests, who were left to sit in complete darkness and endure a low wave frequency hum while the room filled up with smoke. When the lights came on and the music started, it was apparent that a few people in the audience had fallen asleep, de Betak recalled. Then the first model came out and kicked the path through the smoke and the show began.

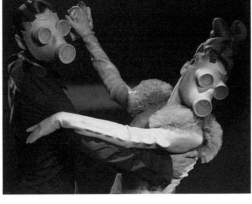

W<
SPRING 1998

"I am a story teller," Walter Van Beirendonck has said. "Every collection tells a story based on very clear research, ideas, and visions. I see fashion as communication." Inspired by David Lynch's neo-noir *Lost Highway*, which takes an inexplicable detour mid-film, Van Beirendonck presented his Spring 1998 collection, "A Fetish for Beauty," via a quartet of disparate tribes—Whizzkids, Black Beauty, White Trash, and Birds from Outerspace—each with its own story, look and choreography. The show opened with a performance of line dancers ("If you

could dance you were in!" Van Beirendonck said regarding the casting. "No physical selection.") followed by a group of Goths fronted by the model and musician Jamie Del Moon, stilt walkers in white pantsuits and sculpted red wigs, and culminated in a splashy ballroom dance number. "While working on the collection I saw a fantastic image in the Imperial War Museum in London," Van Beirendonck said. "It was a picture of a group of people wearing evening dresses and tuxedos but with gas masks on. It conveyed such a sense of alienation."

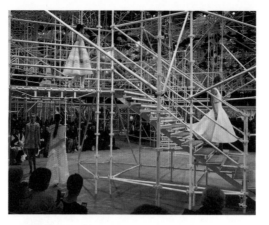

CHRISTIAN DIOR
SPRING 2015 HAUTE COUTURE
In his Spring 2015 collection for Dior, Raf Simons conjured a state of trippiness not often associated with Haute Couture. "Like being on acid," the designer said point-blank. Simons is invariably influenced by music, and taking David Bowie as a muse and spiritual guide, he dropped the romanticism of the '50s, the experimentation of the '60s, and the freedom of the '70s into a singular collection that had as much to say about the material culture of those decades as about the trajectory of female sexuality they charted. The set, a maze of white scaffolding, dusty rose carpeting (the only reference to flowers that season), and mirrored walls, multiplied the effect exponentially. The scene was reminiscent of the show from William Klein's 1966 satire on the fashion world *Qui êtes-vous Polly Maggoo* but also harkened back to Simons's own set from his Fall 2001 show "Riot Riot Riot," staged at a time when he felt burdened by the fashion system and was looking for a way to set himself free.

an epiphany and decided to make this uneasiness the subject of the season." They staged a photo shoot of a model, dressed in the cut-up toiles, holding a blank placard. "The sign she is holding is empty; there is no collection that season, and no fashion message." The designers then posted the image around Paris, and delivered it personally (there was no money back then for couriers) to editors, in town for the shows, at their hotels. "At the time," they recalled, "the action generated zero reaction, because nobody knew who we were so nobody cared. We were frustrated. We wanted to be fashion designers but were mainly operating in the art world. We did not fit in and we had no clue how to enter the fashion system. When we think about it now we would say it was less a cry of protest, and more a cry for attention."

210

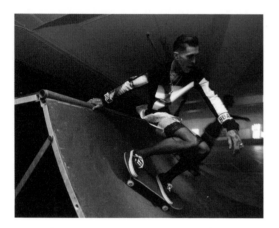

HOOD BY AIR
SPRING 2014
Hood by Air's Shayne Oliver knows very few boundaries—constructs of gender or race have little traction in his world. His audacious, streetwear-inflected collections are intentionally hard to classify: Straps and zippers are not utilitarian devices but transformative ones that deny a garment—or its wearer—a fixed identity. Pants or a skirt? Girl or boy? Neither? Both? His runway shows have occasionally assuaged the audience's natural fear of the unknown, offering insight into his perspective—in one, performers from the underground ballroom scene vogued on the runway. But, more often than not, his presentations have served to increase its angst and consternation, as in the show when models fled the runway and ran into the aisles. For this presentation during men's fashion week in London, Oliver was in a party mood: The parking garage of Selfridges department store was decked out like an underground nightclub, complete with a half-pipe, which the model Jimmy Q navigated on his skateboard alongside a crew of similarly dressed kids, cast from a local mall, on old-school roller skates.

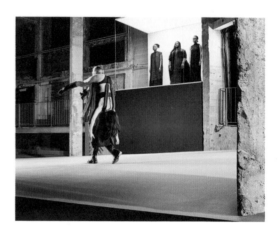

RICK OWENS
SPRING 2016
"There is a wonderful Annie Leibovitz image of the performance artist Leigh Bowery carrying his wife Nicola Bateman in a harness they would use for a birthing performance that I always loved," said Rick Owens, of the inspiration for his Spring 2016 runway show. About every third model walked the runway with another model strapped to her like a human backpack. Some looked as though they were shouldering the dead; others like they were on the verge of giving birth. Indeed, the show was an expression of the primal urge to carry on. Owens has said that it's only since 2011 that he felt comfortable enough with the runway format to stretch it. Now that the digital age has made showing clothes that won't be available for six months somewhat old-fashioned, the show for him has become an opportunity to reaffirm the aesthetic and even moral values he stands for. "It's a basic human need to gather together and celebrate beauty, and I'd like to cover as many ideas of beauty as I can," he said. "This seems the most logical and positive contribution I can make within my human means."

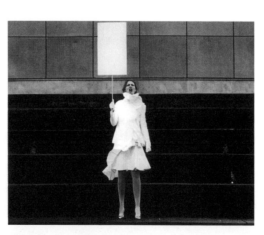

VIKTOR & ROLF
SPRING 1996
Viktor Horsting and Rolf Snoeren set out to create a Spring 1996 collection, but then realized they just weren't feeling it. "We kept trying and ended up cutting up most of the toiles in the process," the designers recalled. "Then we had

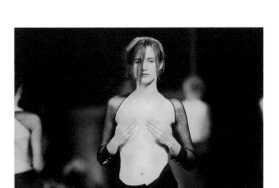

ANN DEMEULEMEESTER
SPRING 1995

"Every collection was a different step in a larger life work," said Ann Demeulemeester. "The soul stayed the same and evolved through time." She applied the same measured approach to her runway shows, which in their quiet strength and vulnerability, and their moments of true poetry, evolved very subtly from season to season. The casting was always a familiar mix of women and men; one year, her son walked the runway. "It was great to compose a kind of family and it was only natural that the friends of my gang were back in the next shows combined with new discoveries," she said. "The locations didn't change often since I liked to have a home that suited me and my family." Among her favored Paris venues was the Académie des Beaux Arts, where her Spring 1995 presentation took place. The soundtrack was often the music she had been listening to as she designed the collection. For Demeulemeester, the show was never a performance, but simply the last step in giving a child to the world. "The next day was always a bit sad," she said. "But it always let me create a new one."

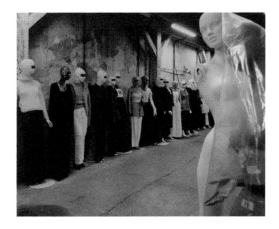

MAISON MARTIN MARGIELA
FALL 1994

Barbie, Ken and G.I. Joe were the de facto muses for the Maison Martin Margiela Fall 1994 collection. Garments originally produced for a doll's wardrobe were enlarged to human scale—exposing all manner of distortions. Amplified 5.2 times, zippers and buttons, overly large to begin with to accommodate the manipulations of small fingers, not to mention toy manufacturers' budgets, looked almost absurdly so. Other cost cutting design measures (unfinished seams, stray threads) also become glaringly obvious. Margiela did not hold a formal runway show that season, but under the circumstances, a showroom presentation on mannequins seemed appropriate—for what are department store mannequins if not human-sized Barbie dolls, designed to conform to some ideal and totally unrealistic body type? Like Margiela's previous experiments in proportion, this one subverted the long held notion that fashion designers could only create for a size zero, and that a runway model was little more than a clothes hanger. He even went so far as to obscure the mannequins' faces, as he was wont to do in his live shows.

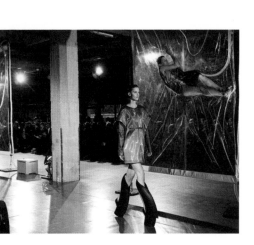

IRIS VAN HERPEN
FALL 2014

"In my work, I combine tradition with new techniques and materials," said the Dutch designer Iris Van Herpen. "That is also the blend in my choice of presentation." She has choreographed abstract performances like "Embossed Sounds," where the models became musicians, playing their clothes as if they were instruments, and produced a dress live on the runway using laser-cutting, 3-D printing, and hand weaving. For "Biopiracy," her Fall 2014 collection, Van Herpen was inspired by the fact that human genes have been patented—meaning, she said, that your body is ultimately not your own. At the center of the runway was an installation by the Belgian artist Lawrence Malstaf, whose work explores the psychological aftermath of extreme physical experience. The models Hannelore Knuts, Iekeliene Stange and Soo Joo Park were vacuum-packed, suspended from the ceiling, and appeared to be slowly suffocating. A soundtrack of slow and regular breathing was intended to make the audience feel as though it was inside the industrial packaging along with them. Unsettling as it seemed, Van Herpen was not merely offering a commentary on brave-new-world consumerism, but also an escape from it. "It feels like you are floating in the air, embryonic and weightless," said the designer, who went through the experience herself as part of her research for the collection. "It creates a meditative state where something as abstract as ownership does not even exist."

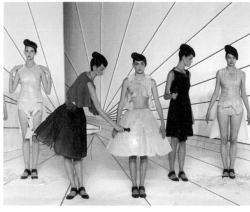

HUSSEIN CHALAYAN
SPRING 2001

"Ventriloquy," Hussein Chalayan's Spring 2001 runway show, opened with a short animated video, in which 3-D wireframe models, dressed in clothes from the collection, underwent a series of cryptic ego/alter ego interactions—and then shattered into tiny pieces. While the technology appeared primitive, Chalayan was already pointing to a culture in which the replica is privileged over the original, the digital image over reality. This sentiment was underscored in the finale of the live runway show that followed, when three models proceeded to smash the dresses of those standing next to them. The models wielding the hammers were wearing actual garments from the collection; the others wore rigid copies, fabricated from sugar glass.

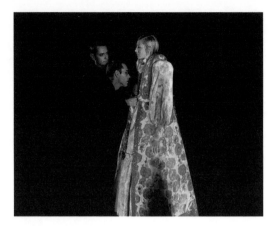

VIKTOR & ROLF
FALL 1999 HAUTE COUTURE
Viktor Horsting and Rolf Snoeren's "Russian Doll" collection cast the model Maggie Rizer in the role of a human *matryoshka*. Dressed in a modest frayed jute sheath, she assumed her position on a spotlit pedestal in the middle of the otherwise darkened salon of the Hotel Plaza Athenée in Paris, and remained stock still and almost unblinking as the designers proceeded to dress her, layer by layer. As the show progressed, the clothes increased in grandeur—from a simple, monk-like frock encrusted in Swarovski crystals, to a magnificent coat in antique floral silk jacquard, and culminating in a monolithic cape festooned with a rose the size of Rizer's own head, which by the finale stuck out from her mountain of ensembles like a tiny pea. "The idea," the designers said, "was to mix extreme poverty with extreme *richesse*." Horsting and Snoeren regarded the show as a ritual to celebrate and honor beauty and exclusivity. "It sounds high falutin'," they said, "but we were very serious in our endeavor to escape the idea of commercialism. Beauty for beauty's sake, not the aim of necessarily possessing it."

212

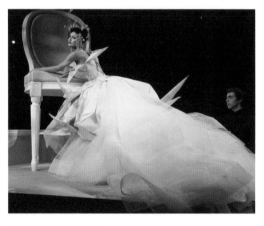

CHRISTIAN DIOR
SPRING 2007 HAUTE COUTURE
John Galliano's Spring 2007 Haute Couture collection for Dior provided an almost linear narrative—the story of Madame Butterfly, had she been a client of the French couture house. The set was a Dior Couture Salon, elegantly stripped down to its essentials and then blown up to almost surreal proportions. Models entered via a rotating stage and proceeded to navigate, with the occasional assistance of strategically placed attendants, a meandering runway. The scale of the props aside, the set mimicked the labyrinth of rooms inside the Dior headquarters, which had started modestly enough as a single townhouse at 30 Avenue Montaigne and expanded over the years, eventually occupying several buildings down the block and around the corner and up the rue François Premier. The final dress of the collection, a deluge of tulle barely contained within its origami-like folds, was not in the least dwarfed by the enormous medallion chair.

a pair of scissors, snip a small piece of her clothing to take as a souvenir. Ono repeated the work in 1965 at Carnegie Hall in New York, where it was filmed by Albert and David Maysles. For their 2010 collection, threeAS-FOUR's Gabriel Asfour, Angela Donhauser and Adi Gil collaborated with Ono on a series of prints based on her little-seen dot drawings, and used *Cut Piece* as the conceit for the presentation. A lone model, wearing a loosely spiraling white dress and holding a pair of shears in each hand, stood in the middle of the runway while one by one the other models made their circuit and then paused to take a swipe at her dress. By the end of the show the frock lay in tatters at her feet.

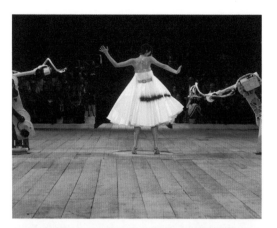

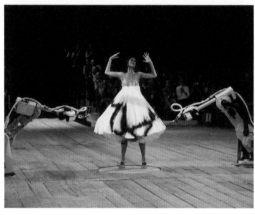

ALEXANDER MCQUEEN
SPRING 1999
Alexander McQueen's thirteenth collection, "No. 13," was a celebration of William Morris and the Arts and Crafts movement, as epitomized by the opening look: Aimee Mullins, an athlete and a double amputee, walked out onto the raw plank floor atop a pair of exquisitely carved wooden prosthetic legs. Amidst all of the handiwork that season, a pair of industrial robots, stationed in the middle of the runway throughout the show, seemed glaringly out of place, until the model Shalom Harlow assumed her position between them on a rotating platform wearing a strapless white muslin dress, bolstered by layers of tulle and secured at the chest with a leather strap. Seemingly aroused by her presence, the dual sentries came to life, limbering up for an attack, and as if suddenly sensing their prey, opened fire on Harlow in a spray of yellow and black paint. The tableau was inspired by the German artist Rebecca Horn's work *High Moon*, in which two shotguns fire pink paint at one another. It stands among the most memorable moments in modern fashion history. It was also reportedly McQueen's favorite show, and the only one that brought him to tears.

THREEASFOUR
SPRING 2010
In Yoko Ono's feminist performance *Cut Piece*, which she first enacted in 1964 at the Yamaichi Concert Hall in Kyoto, Japan, the artist sits passively in the center of the stage, as audience members are invited to come up and, using

YOHJI YAMAMOTO
SPRING 1999

Yohji Yamamoto's enchanting Spring 1999 collection was ostensibly about weddings, and as at any real wedding ceremony tears of joy were shed. However, Yamamoto not only tipped his hat to western nuptial tradition, but in his thoughtful way, gently subverted it too. "Behind the wedding dress there must be many stories," the designer ventured. Myriad social issues—feminism and femininity, interracial and same sex marriage—were thinly veiled. To the tune of Wagner's "Bridal Chorus," and also, cheekily, the Jane Birkin and Serge Gainsbourg duet, "Je t'aime moi non plus," the models walked out into the unadorned space singly or in pairs—two women, both in tuxedo-like black dresses and holding immense white bouquets; a boy and a girl, she in pants, he in a long printed skirt. Angela Lindvall walked out arm-in-arm with *Vogue*'s André Leon Talley. Each look was a performance unto itself, a rite of passage. Malgosia Bela unzipped several pockets concealed within her giant hoop skirt to assemble a complete bridal kit: hat, gloves, overdress, a pair of shoes, and a bouquet. Trish Goff disencumbered herself from an inflatable skirt the size of a life raft. And Erin O'Connor emerged in a voluminous white dress and, to the delight of the audience, proceeded to liberate herself of it, layer by layer.

DRIES VAN NOTEN
SPRING 2005

In the mind of Dries Van Noten, the ultimate party is one where everyone ends up dancing on the table. And in that regard, his Spring 2005 runway show, a celebration of his 50th collection, did not disappoint. In a former factory on the edge of Paris, a banquet was set for 500 guests. More than 100 Venetian chandeliers were hung low over the table so that it was nearly impossible to see who was seated across the way. The table was not just for show. An elegant dinner of *poisson en papillote* was served, with great aplomb, by a staff of 250 uniformed waiters (the photographers, hidden behind a curtain, were offered their own buffet). Once the plates (though not the copious wine goblets) were cleared, the chandeliers were drawn up, the curtain dropped, and the show began—with the table as runway. For a parting gift, everyone received a scrapbook documenting the previous 49 collections, with the current one represented by a Polaroid of the chandelier under which they had been seated. The designer views the presentation of every collection he does as a momentous occasion. "The runway show is always an important thing for me," Van Noten said. "It's a celebration of the creativity of the last six months. It's not only putting clothes on a girl or boy, it's a piece a theater for me."

under normal conditions would have been *their* reserved seats, pens and notepads in hand. The models pointed, whispered amongst one another, and rudely chattered away on their cellphones—mimicking the typical front row behavior at most fashion shows. Tara Subkoff and Matt Damhave called the production "Reverse Runway," delivering their lesson about how it feels to walk in a model's tortuous high-heeled shoes to a soundtrack of RuPaul's "Supermodel (You Better Work!)."

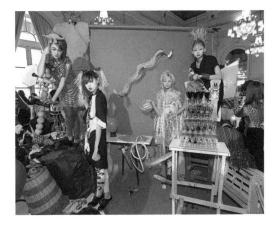

BERNHARD WILLHELM
FALL 2010

"There are no rules for how to operate in fashion," said Bernhard Willhelm, "and this counts for the form of the presentation. I'm maybe at the stage that a fashion show isn't necessary at all." Indeed, his Fall 2010 presentation had the makings of a free-for-all. Staged at the former Paris Stock Exchange, a neoclassical building which appealed to Willhelm in its likeness to a Roman temple, the Dionysian installation proposed a sort of demented workout circuit (he called it "a sporty workout decadence") centered around a DJ station and composed of baguettes, mops, fruits, exercise balls, laundry baskets, tennis racquets, teapots and models wearing the clothes from the collection. "As you know," Willhelm said, "when we look at the Greeks and the Romans, our morals don't apply."

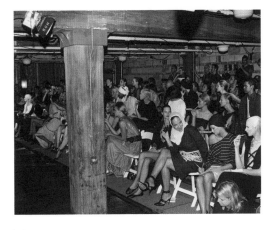

IMITATION OF CHRIST
SPRING 2002

The line-up of talent for the Imitation of Christ Spring 2002 runway show was stellar: It included both seasoned fashion vets like Rachel Williams and Carmen Dell'Orefice and girls of the moment like Sophie Dahl, Audrey Marnay, Mariacarla Boscono, Bridget Hall, Erin O'Connor, Karen Elson, and Guinevere Van Seenus. None of them, however, would actually walk the runway. When the magazine editors and store buyers were ushered single file into the show space, they encountered the models dressed to the nines, sitting front row in what

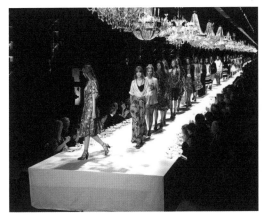

CHANEL
FALL 2014

In the digital age, the concept of the shoppable runway is fast becoming a reality, as brands like Burberry strive to make clothes available for purchase not six months later but the very next day. Indeed, now that fashion shows are accessible to a general public, virtually at least, their *raison d'être* seems less to provide entertainment than to spark the impulse to buy. Perhaps no designer has made that argument more forcefully than Karl Lagerfeld in his Fall 2014 collection for Chanel. The set was a gigantic supermarket, its shelves stocked with all manner of cheeky Chanel-branded products—from pain grillé and bottled water to "Jambon Cambon," "Le 9 de Chanel eggs," and "Tweed Tea." The models perused the merchandise at their leisure, some carrying baskets realized in Chanel's signature chain, others pushing the types of enormous carts one usually finds at big box stores like Costco. "Supermarkets are a part of life today," Lagerfeld said. "La Grande Epicerie is a chic place where everyone goes. Not me. I never cooked and never bought food in my life. Chanel is about life, a privileged life, but life. People wear the clothes and the set is where they come and go. We need fashion as we need food—and nobody wants to eat the same food all the time."

THOM BROWNE
SPRING 2013

In his menswear designs, Thom Browne regularly transforms the straight-laced into the subversive, so that something as conformist as a gray flannel suit suddenly comes across as the most extreme of fashion statements. In a similar spirit, his Spring 2013 men's presentation began as a regimented affair and then quickly devolved into something extremely twisted. The setting was a Parisian garden, a perfectly manicured patch of grass upon which several pairs of silver brogues had been placed in orderly lines. First to enter the garden was a quartet of satyrs, painted silver from head to toe, two carrying umbrellas and the others carrying flutes. They were soon followed by a procession of bizarre creatures, wearing what looked like armor made from a Slinky, who shuffled around the space before each assumed a place at one of the pairs of shoes. All at once, the armor dropped to the ground, revealing models dressed in Browne's Spring 2013 collection, which presented a twisted take on American preppy. The models remained standing there like statues while the crowd moved in for a closer look.

against a backdrop of colored smoke bombs. The music, if one could call it that, was a cacophony of air raid sirens. "It all went together with the idea of danger and toxic and sexy," he said, "which were the main topics of the show."

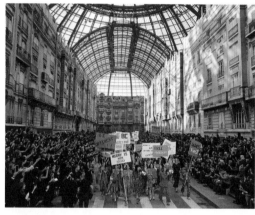

CHANEL
SPRING 2015

Karl Lagerfeld took to the streets for his Spring 2015 collection for Chanel. And while no doubt the French house has the power to stop traffic in Paris any day of the week, it nevertheless commissioned a full-scale set. Were it not for the glass dome of the Grand Palais looming overhead, the set could have easily passed for any one of the city's Hausmannian boulevards. On the Boulevard Chanel, models walked deliberately, often in pairs and groups, in a show of fashion solidarity. They came out *en masse* for the finale bearing placards ("Feministe mais Feminine"; "History is Her Story"; "Make Fashion Not War"), joined by Lagerfeld who marched with them to the soundtrack of Chaka Khan's "I'm Every Woman." "Seeing the job I did all my life I have to be a feminist," said Lagerfeld, who was not just tapping into the plight of women around the world and the Occupy spirit, but the formative 1969 student riots in Paris. "Chanel was not a feminist in the way they are today, or a 'suffragette.' She thought women should have the same freedom as men but she wanted women feminine and free, not feminist and aggressive."

BERNHARD WILLHELM
SPRING 2011

Bernhard Willhelm cultivates mayhem. It's in his clothes, and it's in his fashion shows. And ultimately it suits him. The presentation for his Spring 2011 collection, staged in a garden in the Marais neighborhood of Paris, was a visual extravaganza but done on the cheap, a fashion show as merry prank, deliberately thumbing its nose at the blockbuster productions that have become the industry norm. If Willhelm had unlimited resources to produce his shows, he insisted, he would prefer to give the money to the poor or buy a new houseplant. "Did you say 'runaway' productions?" he countered. This particular show opened with a crew of "sexy guys" who used traffic signs to clear away chest-high piles of soap bubbles, all the while flashing expressions described by the designer as "warning sign looks." The runway portion of the program began as models walked out and posed

GYPSY SPORT
SPRING 2015
"Over all it's about outsiders being outsiders, and never trying to conform or fit in," said the designer Rio Uribe, of his downtown New York label Gypsy Sport. "Fashion can be a very cold and elite environment, so instead we wanted to express fun and inclusivity." Washington Square Park, where Uribe staged his Spring 2015 collection, provided the ideal venue for this populist mission, not only because the iconic arch stood as the ultimate ready-made set, but, as Uribe pointed out, "the park is known for non-conformity and for bringing people of all walks of life together." As spontaneous as the guerilla show might have seemed, it was the result of no small amount of tactical consideration: Uribe rented a small hotel room across the street for hair and makeup, and spent several weeks recruiting local musicians and artists to perform for the duration of the show. "We asked them to invite their friends and family, too, so I knew that people would be there." The models, about half of them professional and half cast from the street, marched over to the park, like an army. "We did not have permits, and the police actually watched the show and took photos," Uribe observed. "It was funny."

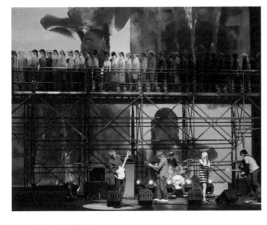

MARC JACOBS
FALL 2008
The Lexington Avenue Armory was set up like an East Village nightclub, with a stage, framed by scaffolding, for a runway and the front row seated in VIP banquettes complete with bottle service. The New York band Sonic Youth, fronted by Kim Gordon in a striped Marc Jacobs shift, performed live, creating a wall of sound, while random video footage—ocean waves, a giant eyeball—was projected on a screen behind them. In director Nick Egan's music video for the Sonic Youth single "Sugar Kane," the band performs in the midst of a fashion show featuring models wearing looks from Jacobs's infamous Spring 1993 Grunge collection for Perry Ellis. In this runway show as rock concert, however, Jacobs's Fall 2008 collection came across as buttoned up and relatively conservative, even if the vibe was distinctly '80s. Still, if there was a message in the music, it was that there is often more intrigue in dissonance than in harmony.

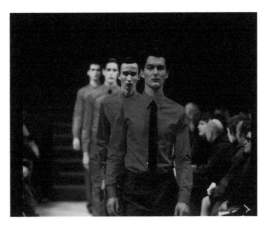

RAF SIMONS
FALL 1998
"Radioactivity," the title of Raf Simons's Fall 1998 collection, alludes to the musical styles that informed it—Punk and New Wave among them. But it is more often referred to as the "Kraftwerk Collection" for the bright red shirts and skinny black ties Simons showed in homage to the uniform of the German electronic music band, and which stood out amongst the otherwise all-black collection. The presentation was held at the Moulin Rouge in Paris, a venue the designer at first resisted as being too defined by its flamboyant décor and its prominent stage. "Then I thought we might as well use it," said Simons, who ended up building four additional platforms where the different runway tribes, distinguished by look, convened and remained overlooking the audience throughout the show. The tight choreography and the sensation of simultaneously watching and being watched, created an intensity that was palpable. "I've become much more relaxed with regard to my own shows," Simons observed in retrospect. "The things that go wrong can also be beautiful."

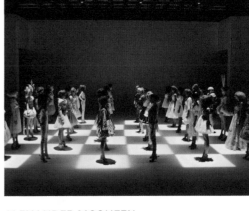

215

ALEXANDER MCQUEEN
SPRING 2005
In shows like Fall 2009's "The Horn of Plenty" and Fall 2001's "What A Merry Go Round," Alexander McQueen projected his growing cynicism toward the fashion system in which he felt like a mere pawn. His Spring 2005 runway presentation was no less critical but decidedly more playful. "It's Only A Game" began as a more or less typical runway show: The models each made a tour of the stage and then assumed their places in a grid formation, at which point a computerized voice announced, "Now we start the game." The floor lit up like a chessboard, with each of the 36 looks in the collection corresponding to a different piece, and highlighting a different McQueen signature motif. The computer called the moves, "F4 to E3, A6 to B4," and so on, resulting in a standoff between bishops, much posturing by the knights, and a series of increasingly intense sacrificial moves, until the game ended, just minutes later, in a checkmate.

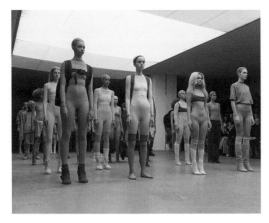

YEEZY
FALL 2015

When Kanye West debuted Yeezy, his shoe and clothing collaboration with Adidas, the musician, who is prone to grandiose statements (for example, his intention to run for president, and his desire to be hired as the designer for Hermès) made the extent of his ambition clear in a voiceover that opened the show: "I'm here to crack the pavement," he boomed. So it was perhaps surprising that the production itself was a relatively modest one. In the empty, industrial space, fifty models were lined up in quasi-military formation, per the directive of the artist Vanessa Beecroft who choreographed the presentation—a bedraggled army in flesh-toned body stockings and distressed sweatshirts. Some of them appeared to be just barely standing. As in Beecroft's art performances, which have featured women in matching wigs and Gucci bikinis or Navy SEALS in their dress whites, this exercise in repetition forced even the smallest dissimilarities into sharp focus, in this case the diversity of the casting—a mix of street-cast models and professionals. This, more than anything else about the show, fulfilled West's intent to make people feel "like it's okay to create and follow what their dreams are and not feel boxed in."

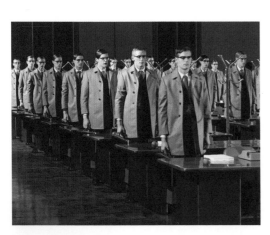

THOM BROWNE
FALL 2009

The Scene: L'Istituto di scienze militari aeronautiche in Florence. A man in a gray suit and a white shirt enters the room. He removes his jacket, hangs it on a coat tree, and dons, in its place, a gray cardigan with four white stripes on the left-hand sleeve. He sits down at a desk, upon which have been placed an old-fashioned Olivetti typewriter, a sheaf of white paper, and a bell. In front of him stretch four rows of ten identical desks, each with its own typewriter, its own sheaf of paper, its own coat tree, from which hangs a gray cardigan with four white stripes on the left-hand sleeve. The man rings the bell. In file forty more men, uniformly dressed in identical gray suits and khaki raincoats, and carrying identical black briefcases. The bell chimes again and the men remove their coats and their jackets, don their cardigans, and, on cue, take their seats at their respective desks. They begin to type. The room echoes with the sound of keys striking like rain. Their papers are collected and brought up to the front of the room where they are placed in four neat piles. The men continue typing. The bell rings. Lunch break. Forty red apples. Forty sandwiches on white bread. The bell rings. Lunch break over. More typing. More papers collected. At the final ring of the bell, the men rise in unison, don their jackets and coats, and exit the room as they came, single file, each one depositing his uneaten red apple on the boss's desk. From start to finish, the whole thing takes about 15 minutes.

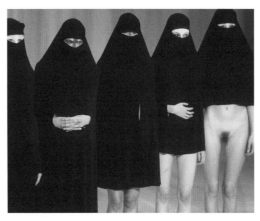

HUSSEIN CHALAYAN
SPRING 1998

With "Between," his Spring 1998 collection, Hussein Chalayan and his producer Alexandre de Betak began to develop the specific language of a Chalayan show—with a stage instead of a runway, live music, and choreography inspired by pattern cuts. "It was the opposite of a fashion show, which was supposed to be upbeat and fast paced," de Betak said. At one point during the presentation, a lone model stood on the stage, unmoving for a full five minutes, her directive to make eye contact with every single member of the audience. The finale that season yielded an image that remains unsurpassed in its intensity and quiet defiance: A handful of models dressed in Burqa-style garments, ranging in length from mid-calf to mid-torso, lined up side by side; a sixth model was entirely naked, save for the mask covering her face. Chalayan, who is not a religious person, was quite literally turning cultural mores on their head: In the West, women don't cover their heads, and yet they often rely on clothing to proclaim their individuality. A dress can in fact strip a woman of her identity altogether. Ironically, it was a debate, like so many in fashion, that played out in hemlines.

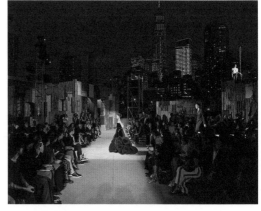

GIVENCHY
SPRING 2016

Riccardo Tisci may not have had much of a choice when it came to the date of his Spring 2016 runway show for Givenchy, which was scheduled to take place in New York City on September 11th. But to his credit, he didn't wear the predicament lightly. The show was staged on Pier 26 in lower Manhattan, in full view of the Freedom Tower and, as the sun set over the Hudson River, the soaring, ghost-like apparition of the fallen twin towers provided by the *Tribute in Light*. Tisci collaborated on the production with the artist Marina Abramovic, who spelled out in the program notes her intent to create something respectful and humble, to which the public would also be invited. The set was fabricated from recycled materials, the music culled from six different cultures and religions. Performers stationed on elevated platforms enacted simple ritual-like gestures: A woman climbed a ladder leading to nowhere, another stood under a stream of water; a couple embraced. The clothes were a mix of black and white. "This event that we are creating together is about forgiveness, inclusivity, new life, hope, and above all, love," she said.

Photography Credits

12–13, 193
ISAAC MIZRAHI
Fall 1994
The Kobal
collection at Art
Resource NY

14–15, 193
CHRISTIAN DIOR
Spring 2014
Anthea Simms

16–17, 193
DRIES VAN NOTEN
Spring 2015
Catwalking/
Getty Images

18–19, 193
MOLLY GODDARD
Spring 2016
Jack Taylor/Getty
Images

20–21, 194
ISSEY MIYAKE
Spring 1999
Yasuaki
Yoshinaga/
Courtesy of
Issey Miyake
and Dai Fujiwara

22–23, 194
COMME DES
GARÇONS
Spring 2011
firstVIEW

24–25, 194
MARC JACOBS
Fall 2012
Fairchild Photo
Service/Condé
Nast/Corbis

26–27, 194
CHANEL
Spring 2012
Haute Couture
firstVIEW

28–29, 194
LOUIS VUITTON
Fall 2012
firstVIEW

30–31, 195
MAISON MARTIN
MARGIELA
Fall 2000
Marina Faust

32–33, 195
W<
Spring 1997
Courtesy of
Walter Van
Beirendonck

34–35, 195
RAF SIMONS
Spring 1999
Courtesy of
Raf Simons

36–37, 196
LOUIS VUITTON
Spring 2013
firstVIEW

38–39, 196
HELMUT LANG
Fall 1993
hi-art/Courtesy
of Helmet Lang

40–41, 196
ALEXANDER
MCQUEEN
Fall 1996
Anthea Simms

42–43, 196
THOM BROWNE
Spring 2014
Dan and Corina
Lecca/Courtesy
of Thom Browne

44–45, 196
JOHN BARTLETT
Fall 2001
Laura Foos/
Courtesy of
John Bartlett

46–47, 197
CHLOË SEVIGNY
FOR OPENING
CEREMONY
Fall 2013
Jonathan Baskin/
Courtesy
of Opening
Ceremony

48–49, 197
DOLCE & GABBANA
Spring 2000
firstVIEW

50–51, 197
SUSAN CIANCIOLO
RUN
COLLECTION,
1995
Cris Moore

52–53, 197
LOUIS VUITTON
Fall 2011
Anthea Simms

54–55, 198
IMITATION OF
CHRIST
Spring 2013
Cheryl Dunn

56–57, 198
CHANEL
Fall 2010
firstVIEW

58–59, 198
MAISON MARTIN
MARGIELA
Fall 1997
firstVIEW

60–61, 199
MARC JACOBS
Fall 2007
Jason Szenes/
epa/Corbis

62–63, 199
VIKTOR & ROLF
Fall 2002
firstVIEW

64, 199
RAF SIMONS
Fall 2001
Els Voorspoels/
Courtesy of
Raf Simons

Gatefold 1A, 199
CAROL CHRISTIAN
POELL
Spring 2004
Giulio Cunico/
Courtesy of Carol
Christian Poell

Gatefold 1B &
1C, 199
MARC JACOBS
Fall 2013
firstVIEW

65, 200
ALEXANDER
MCQUEEN
Fall 2003
Anthea Simms

66–67, 200
JOHN GALLIANO
Spring 1996
firstVIEW

68–69, 200
BERNADETTE
CORPORATION
Spring 1997
Marcelo Krasilcic

70–71, 201
ALEXANDER
MCQUEEN
Fall 2001
Anthea Simms

72–73, 201
MAISON MARTIN
MARGIELA
Fall 1995
Marina Faust

74–75, 201
JEREMY SCOTT
Fall 2001
firstVIEW

76–77, 201
X-GIRL
Spring 1994
Ricky Powell

78–79, 202
LOUIS VUITTON
Spring 2014
Anthea Simms

80–81, 202
IMITATION
OF CHRIST
Spring 2001
firstVIEW

82–83 202
ALEXANDER
MCQUEEN
Fall 2006
Andy Paradise/
Getty Images

84–85, 202
PRADA
Fall 2013
designboom

86–87, 202
SUSAN CIANCIOLO
RUN
COLLECTION,
1997
Marcelo Krasilcic

88–89, 203
GUCCI
Fall 1996
firstVIEW

90–91, 203
YOHJI YAMAMOTO
Fall 1998
Anthea Simms

92–93, 203
VPL
Spring 2015
Ruthie Abel

94–95, 203
ALEXANDER
MCQUEEN
Spring 2004
Anthea Simms

96–97, 204
BRUCE
Fall 1998
BRUCE

98–99, 204
THOM BROWNE
Fall 2011
Dan and Corina
Lecca/Courtesy
of Thom Browne

100–101, 204
MAISON MARTIN
MARGIELA
Spring 1996
Ronald Stoops/
Courtesy of
Maison Margiela

102–103, 204
PRADA
Spring 2014
Giuseppe
Cacace/Getty
Images

104–105, 205
ADAM KIMMEL
Fall 2010
Charles Duprat/
Courtesy of
Adam Kimmel

106–107, 205
RICK OWENS
Spring 2014
Valerio
Mezzanotti/
Courtesy of
OWENSCORP

108–109, 205
JOHN GALLIANO
Spring 1995
Anthea Simms

110–111, 205
OPENING
CEREMONY
Spring 2015
Julia Cervantes/
Courtesy
Opening
Ceremony

112, 205
JEAN COLONNA
Spring 1996
Courtesy of
Jean Colonna

Gatefold 2A, 206
LOUIS VUITTON
Fall 2013
Catwalking/Getty
Images

Gatefold 2B/2C,
206
A.F. VANDEVORST
Spring 1999
AF Vandevorst

113, 206
JOHN GALLIANO
Fall 2009
firstVIEW

114–115, 206
COMME DES
GARÇONS
Spring 1996
Eric Gaillard/
Corbis

116–117, 207
CHANEL
Spring 2012
Pascal La
Segretain/Getty
Images

118–119, 207
OLIVIER
THEYSKENS
Fall 1999
firstVIEW

120–121, 207
VIKTOR & ROLF
Spring 2001
Anthea Simms

122–123, 207
MARC JACOBS
Spring 2016
Lee Van Put/Marc
Jacobs
International

124–125, 208
CHANEL
Fall 2013 Haute
Couture
Anthea Simms

126–127, 208
ALEXANDER
MCQUEEN
Spring 2001
firstVIEW

128–129, 208
IMITATION
OF CHRIST
Spring 2003
Anthea Simms

130–131, 208
HUSSEIN
CHALAYAN
Fall 2000
Corbis

132–133, 209
CHRISTIAN DIOR
Fall 2005 Haute
Couture
IMAXtree

134–135, 209
ALEXANDER
MCQUEEN
Fall 2009
firstVIEW

136–137, 209
GIVENCHY
Spring 2014
Bertrand Rindoff
Petroff/Getty
Images

138–139, 209
RODARTE
Spring 2010
firstVIEW

218

220

Alix Browne is currently the features director at W magazine and an adjunct professor at the School of Visual Arts in New York in the Fashion Photography Program.

Acknowledgments
I would like to thank all of the designers whose visions inspired this book and whose time and generosity made it possible. In particular, Helmut Lang, Dries Van Noten, Karl Lagerfeld, Ann Demeulemeester, Raf Simons, Viktor Horsting and Rolf Snoeren.

A special thanks goes to Alexandre de Betak and Stefan Beckman for their insights.

A very special thanks goes to Raja Sethuraman and his incredible team at Gloss without whose work this book would not have been nearly as spectacular.

Thank you Charles Miers, Ellen Nidy, and Maria Pia Gramaglia at Rizzoli.

Thank you Sarah Kalagvano for your doggedness, and Francesca Grassi for your finesse.

And most of all, thank you Poppy for your patience.
This book is for you.

First published in the United States of America in 2016 by Rizzoli International
Publications, Inc.
300 Park Avenue South
New York, NY 10010
www.rizzoliusa.com

Editor
Ellen Nidy

Design
Francesca Grassi

Photo Research
Sarah Kalagvano

Pre-Press
Gloss Studio: Raja Sethuraman and Magnus Andersson, Sean Ross, Kelcey Alonzo,
Mina Pekovic, Jovanny Murillo, Laxman Sethuraman

ISBN-13: 978-0-8478-4875-1
Library of Congress Control Number: 2016943506
2016 2017 2018 2019 2020 / 10 9 8 7 6 5 4 3 2 1

Printed and bound in Italy
Distributed to the U.S. trade by Random House